JAN VAN EYCK

The Play of Realism

JAN VAN EYCK

The Play of Realism

CRAIG HARBISON

REAKTION BOOKS

Published by Reaktion Books Ltd
79 Farringdon Road
London ECIM 3JU

First published 1991, reprinted with corrections 1995, 1999
Copyright © 1991 Craig Harbison

Distributed in USA and Canada
by the University of Washington
Press, PO Box 50096, Seattle,
Washington 98145–5096, USA

Designed by Humphrey Stone
Photoset by Rowland Phototypesetting Ltd
Bury St Edmunds, Suffolk
Printed and bound in Great Britain by
BAS Printers, Over Wallop, Hampshire

British Library Cataloguing in Publication Data
Harbison, Craig
Jan Van Eyck: the play of realism.
I. Title
759.9493

ISBN 0-948462-79-5

Contents

✤

Preface and Acknowledgements

I am very interested in the moral values expressed through people's lives – their daily habits and behaviour. Great art like that of van Eyck deals with these matters in particularly telling ways; it does not, in my view, only operate on a grand or abstract plane, somehow remote from an individual's immediate material concerns. In this book I seek to define the peculiar kind of human quandary, or stories, embedded in these paintings. I like to think that to some extent I have let the paintings do the talking; yet, it is certain that I have heard one particular accent with which they utter their messages. That accent corresponds above all to what I perceive to be their moral or ethical dimension. What and how do the images tell us about that which van Eyck and his patrons believed to be important? And what in particular do the images show us about the way they reacted to things in the world that mattered to them? What did they feel and portray as good, and what bad – and what relation did these judgements have to the world at large? I believe we must look to the immediate environment of both the artist and his patrons for help in understanding the imagery, and not just to writings or ideas that had circulated for centuries and in some cases become cultural commonplaces. For fifteenth-century religious art it is important to pay attention to popular practice, perhaps even more than to exhaustive theological commentary.

I have tried to pursue this kind of analysis in an incremental, inductive fashion, building up a picture through a range of observations and descriptions. I did not start with a general notion of what the preoccupations of these people would be – except that I felt they would be complicated and many-sided. The themes of pretence and scepticism, for instance, only emerged as I worked with the material. Regarding the eventual organization of the contents of this book, here I have tried to maintain some of the sense I had of the ways the images themselves suggested avenues of speculation and research.

I have tried to personalize and politicize these paintings, but without setting up rigid polarities. In specific ways they may present timeless truths, and yet simultaneously have a very particular social, political or religious charge. The Catholic Church in the fifteenth century was not a uniformly benevolent force any more than it was exclusively an instrument of repression and exploitation. It was both, and, to an extent because of that, more. I believe that an excessively polemical or one-sided stance towards the art

robs us of much about it that is intriguing and also very human. For the most part, I simply wanted to know how those portrayed – or imagined as participating – in van Eyck's works both lived and felt, in ordinary, human terms. I have tried to understand how his art was both stimulated by and helped to create contemporary attitudes. Ethical judgement is surely conditioned by a particular ideology, but it is not merely a function of it. It is the constant combination of the personal and the institutional that is one of the crucial elements of this art. My aim is to play out such a tension further than has been attempted hitherto.

In the course of writing this book I have benefited from the help of many individuals. They have answered specific questions, provided references or offprints and engaged in stimulating conversations. I am grateful to all of them – Maryan Ainsworth, Robert Baldwin, Michael Camille, Iris Cheney, James Cheney, Rafael De Keyser, Dirk De Vos, Dana Goodgal-Salem, Christine Hasenmueller, Jeffrey Jennings, Robert A. Koch, Susan Koslow, Barbara Lane, James Marrow, James Mundy, Myra Orth, Carol Purtle, Mark Roskill, Jeffrey Chipps Smith, Leo Steinberg, Bill Stern, Anne van Buren, Eric Vieland, John Ward, Jean C. Wilson and Joanna Ziegler. I have also received help in obtaining photographs from Molly Faries, Hans J. van Miegroet and Herbert Sarfatij. In particular, Jacqueline Folie has many times promptly answered my queries about problems with photographs. I appreciate very much the cooperation of all the present-day owners of works illustrated herein, their permissions to reproduce these works, and their answers to my various questions about them.

Jacqueline Folie and Micheline Comblen-Sonkes made my research trip to the Institut Royal du Patrimoine Artistique, Brussels, a pleasure. Peter Hecht was a gracious and helpful host when I stayed for four months in Utrecht to use the facilities of the Kunsthistorisch Instituut and the Library of the Rijksuniversiteit te Utrecht. Much of the research and writing of this book was undertaken while I held a National Endowment for the Humanities Fellowship and during sabbatical leave from the University of Massachusetts, Amherst. I am very thankful for the support of the Endowment and the University, especially Dean Murray Schwartz and the Research Council there. Edla Holm and the staff of the University's Interlibrary Loan Office were extremely helpful on a number of occasions.

Joseph Koerner kindly read an earlier version of the text and made numerous helpful comments; my wife, Sherrill, has too – many times, in fact. Over the past few years I have enjoyed trying to explain what I was doing to my inquiring children, Hanne and Colin.

I

Introduction

One purpose of this book can be stated simply: to evoke the human dimension of Jan van Eyck's paintings. His incisive realism invariably suggests something personal or actual, and the more one looks at his paintings the more significant the individual people represented in them appear to be. There is George van der Paele (illus. 23), for example, the powerful psychological centre of this work, or Nicolas Rolin (illus. 61), kneeling without patron saint before the Virgin and Child, or the Arnolfini-Cenami couple (illus. 8), posed full-length, who are engaged in some sort of interchange in a contemporary interior. Who were these people? And what might they have made of the images painted for them by van Eyck?

My concern with various details of van Eyck's own life, and with those of his patrons, is not novel. Almost every recent study of his works includes interesting details drawn from the lives of these individuals. In addressing the issue of biography, my purpose is neither sensational nor journalistic, however; I am not bent on presenting new or startling information about the men and women represented in van Eyck's paintings. Where biographical details have been introduced in the recent past, the tendency has been to deploy them in a very literal or restrictive fashion – a detail of this or that person's life was said to be illustrated by a detail of this or that painting. In response to this, some writers seem to have become wary of contaminating the art with minute biographical data, which, in their view, trivializes it. Because of this, much information, readily available, has been set aside. I have tried to avoid these two pitfalls, one of which is to ignore information, the other to use it in too simple and causal a fashion. What I have looked for is not so much the influence of life on art, as the resonances between them, the ways in which they can be said to interact more freely and creatively. I am concerned not just with biographical data, but also with the information we can derive from it about the habits and attitudes of individuals, and of society at large. There is an element here that could be described either as popular culture or as mass psychology. Certainly, there were patterns of behaviour current at various levels of society in the Netherlands in the fifteenth century that van Eyck's patrons must either have particip- ated in or resisted. That, too, is part of the human interest of the paintings.

By taking such an approach, I found myself in disagreement with some currently popular views of early Netherlandish art. These paintings have not often been treated

anecdotally, as 'stories' woven around the lives of those individuals portrayed in them. For some observers, the paintings are not stories about individuals, they are about religious ideology, about the precise and repetitive definition of orthodox Christian doctrine and legend. They have been subjected to systematic iconographic analysis in order to find out the literary sources (invariably religious) of their subject-matter. A consciously applied system of religious meaning (initially called 'disguised symbolism') was thought to operate through the realism of these works, conveying traditional Christian doctrine in a programmatic fashion. Christian doctrine was laboriously elaborated and commented upon throughout the Middle Ages. It is thought that in northern Europe in the early fifteenth century, artists such as van Eyck had begun to set about providing a clever and complex visual equivalent for the accumulated theological wisdom.

This may, in part, have been the case in some commissions, especially those executed for a conservative ecclesiastical establishment. Van Eyck's own, and exceptional, *Ghent Altarpiece* could fit this category, acting as a theological treatise (illus. 89, 90). But the general implications of this view of the art of the time for the vast majority of smaller, private lay commissions are more troubling, if not untenable. There is no extant documentary evidence for extremely complex, preconceived programmes of theological discourse in Netherlandish art. Is it not more likely that lay people would have been drawn more to the readily accessible meaning an image held, and to its aesthetic aspects? Would they not have felt a very personal involvement in paintings they themselves commissioned? It also seems probable, as some scholars have suggested, that the religious associations provoked by these images would have been developed in free and individual ways.

Traditional iconographic analysis of early Netherlandish art often attempts to interpret all the details of a work in a way that intensifies a primary religious meaning. An interpretation seems best if even small elements in the design can be said to reinforce its central religious message. Ideally, then, everything in the image – and the world – becomes subject to a hierarchy of religious belief. The Church may have wished to exercise this kind of control – it may have been the goal of many a theologian – but the history of the time does not bear this out; nor do the works of art themselves. Early Netherlandish art, van Eyck's in particular, did not uniformly support the views of the Catholic leadership. Even the most sincere apologist of the period would have found that a difficult task, if only because of the Church's own internal conflicts – the reverberations of the Great Schism. Neither can van Eyck or his lay patrons be considered as merely extensions of Scholastic theology and symbolic thought. The Netherlandish world was far too diverse and complex for that. Van Eyck's own astonishing profusion of realist imagery leads me to believe that the simplistic notion of an orderly renunciation of the world does not hold for many fifteenth-century lay people.

I do not want to exaggerate the rebelliousness of northern Europe's fifteenth-century artists and patrons. These people did not turn away completely from medieval ecclesi-

astical convention, but they did invariably manipulate these conventions for personal ends. While we cannot say that social or religious tension and conflict was positively relished, it was present none the less. The Arnolfinis wished to appear conventionally pious, while still insinuating themselves into the world of courtly romance. George van der Paele wanted to use the Church for his own financial ends, while at the same time he espoused the power of personal prayer. The donor in the Dresden *Triptych with the Virgin and Child* (illus. 81) clearly delights in juxtaposing a text stressing renunciation with a saint whose costume presupposes aristocratic indulgence. The donor of the Berlin *Virgin and Child in a Church* (illus. 87) wishes to participate in the pilgrimage craze of cult statues seemingly come to life, although he cannot claim to have had a specific miraculous vision. Over and again, van Eyck's apparent realism contains within itself a playful or ironic attitude towards the relations between the individual, society, religion and artistic representation. Clearly, social and religious ideals were changing at this time, and artists and patrons were interested in more than just the status quo. A part of van Eyck's inventiveness lies in the ways he imagined that traditional religious mores could be manipulated or altered to fit changing historical circumstances.

My disagreement with those critics who imagine van Eyck to have been primarily a traditional, if sophisticated, theologian does not lead me to adopt the opposite point of view – to claim him and his patrons as no more than worldly, manipulative entre-preneurs. I have tried hard to avoid replacing a restrictive religious model of interpreta-tion with one that is overly secular. In a work such as the *Virgin and Child with George van der Paele*, I do not see van Eyck and his patron as having thrown aside all traditional Christian notions about salvation – the importance of good works, renunciation of excessive worldly desires, devout prayer, and so on – and substituting a new mercantile ideal, in which everything becomes a case of economic bargain-hunting. Certainly, van der Paele was a financially successful member of the papal curia. Certainly, we should be alert to the fact that attitudes toward money were changing. No longer was it thought of as a set amount, which simply needed to be divided up between worthy parties: even the Church increasingly recognized that the money supply could grow, and thus dramatically alter the circumstances (and status) of individuals or institutions. Money became increasingly significant in the process of salvation: it was used to buy indulgences and clerical positions, to pay for masses for the dead, for people to go on pilgrimages and for paintings that displayed one's piety. But I believe such paintings reveal that money, like prayer itself, was only one element in a complex play.

The notion of an absolute and knowable hierarchy was crumbling. This might have led conservatives or radicals to fear the advent of a sinful and permissive era, or even the possible overthrow of the existing social order – the world turned upside down. In my opinion, van Eyck's view of the world was not this alarmist; rather, both he and his patrons navigated between these extremes, at times playing them off, one against the other. It is this complexity, a fertile interaction of forces, that gives the life and art of this

time its flavour.

In the fifteenth-century Netherlands, people toyed with their new-found wealth while continuing to acknowledge traditional forms of piety. Both were transformed in the process. Van Eyck suggests how the worldly ideals of his times were changing, largely by a kind of ironic detachment or playfulness. Meaning in his works is a result of his patrons' own changing notions, notions about the expected results of earthly striving. Selfconscious, amused at their own pretence and daring, van Eyck and his patrons were also wary of encyclopaedic claims to knowledge, piety or salvation. One view, recently put forward, sees this era as a time of increased scepticism with regard to sense perception. During the Middle Ages many people maintained that the appearance of things themselves was a key to understanding their inner truth and meaning. This is the view from the outside in. The Scientific Revolution of the later sixteenth century and seventeenth changed that to one in which prior knowledge of inner structure and logic was first sought; this led in turn to an informed interpretation of outer appearances: things were viewed from the inside out. In between the medieval attitude and this later position was a time of doubt, provisional opinion and the search for new truths. In an analogous way, van Eyck presented his contemporaries with a complex, at times ambiguous, view of the value of appearances for understanding the meaning of life.

In recent years art-historical analysis has become increasingly demanding in terms of its complexity, specificity and precision, whether works are studied in terms of their subject-matter or their historical context. In many ways this is a positive development. Rather than vague impressions and free associations, we now expect closely reasoned connections to be drawn between art and history. Who would oppose the argument that we should be as detailed and as specific as possible in our elucidation of the relation between art and the conditions of its production? Certainly, in this book I try to bring out what I feel are some of the historical complexities – still unexplored – connected with van Eyck's paintings. Part of my aim was realized by pursuit of the established belief that we should question the purpose of any and every detail in each Eyckian creation. Still, I feel there are dangers inherent in pursuing ever more demanding and complicated forms of contextual analysis.

Carefully structured rational analyses of an art-historical context can focus on religious issues or on more materialist, technical concerns. Either way, the results can be disappointingly similar: a feeling that the innate power of the image has somehow been compromised. Complete and detailed historical analysis often effectively denies that the way art works is, at least in some measure, surprising, as well as incapable of being defined with absolute precision. While I would not advocate an approach determined by personal whimsy or self-projection, the analysis of an art as personal as is van Eyck's must make some allowance, within the appropriate historical framework, for the personal – in the sense of the intangible and of the imaginative.

2

Van Eyck's Realism

When looking at a painting by van Eyck, we are invariably struck by the depth and detail of its illusion. We know that his contemporaries stood and gawked – as we today do – at the convincing, seemingly limitless, variety of his visual effects. There are the fuzzy curling locks of hair of childhood (illus. 30), the heavy woollen weave of oriental carpets, the crisp folds of satin brocades, the rich translucence of hand-blown glass (illus. 28), and the misty mountains of an expansive panorama (illus. 62). We are simply enthralled by his visual cunning on both a large and a small scale. What is this detail – and our consequent fascination – all about? For one thing, in his art van Eyck seems to have behaved like a child with a new toy: he could not have enough of it, if only because it was new. His instinct for discovering fresh ways of representing the world must have overwhelmed him. It was so for his contemporaries, and remains so for us today.

It is also true that the myriad objects and details in van Eyck's works seem to have been painted with remarkable skill and accuracy. We believe he must have carefully studied these things, so vivid is their portrayal. In turn, it seems logical to assume that his depiction of the larger world was rendered with equal care, and that he based his settings on actual locations. But although it is clear he must have studied specific interiors, as well as landscapes, it is not at all certain that he ever portrayed a real scene or interior in its entirety. Scholars have combed Europe looking for the church interiors and landscapes that appear in some of his paintings. All to no avail. Van Eyck's paintings do not present precise locales, nor specific historical events. However much he may have based them on visual observation, they are not documentary records of his world.

I will not push this matter further at this point; that is what I attempt to do throughout the rest of this book. Nevertheless, it may be useful to set out a few related suppositions, both those I myself employ and those to which I run counter.

However innocent it may sometimes appear to us, the realism of early Netherlandish painting is a highly charged affair, in its detail as well as in general structure. The painted world is always carefully constructed along certain artistic and psychological fault lines. There may, for example, be a superficial similarity between van Eyck's four images of the seated Virgin and Child (illus. 23, 45, 61 and 81); but this should not blind us to the fact that each one is carefully arranged spatially and compositionally, both on

the surface and in its imagined depth. The architecture in particular, as we will see, is always adjusted to fulfil distinct demands. There is, finally, an air of unreality about these images, overall and in detail. In van Eyck's art the perceptual and the conceptual are constantly and deliberately intermingled; and no single-minded or systematic increase over the years in the lifelikeness of his images can be discerned.

If true, the above comments shed light on the reason why observers are so struck by the careful differentiation of detail in van Eyck's works. What we sense, in effect, is that the most minute detail, as with the overall image, is itself ideal, or hyperreal. Looking into van Eyck's world is somewhat akin to perpetually living through those crystal-clear days that follow a spell of rain or humidity. Similarly, van Eyck's realism is unnatural in its dazzling clarity and profusion. He allows us a view of an ideal condition, ideal in its particulars as well as in its overall composition. This is van Eyck's truth – the incredible depth and detail of colour, light and texture that only his paintings give. This truth does not pretend to be some simple or objective reality that we can routinely verify in the world 'out there'; it is the artist's own elevated and idealized vision of things.

For the present I wish to stress the technical achievement embodied here. With his remarkable technical facility, van Eyck clearly took the medium of oil glaze into new areas. He gave technique a new prominence. (He was a technical wizard, perhaps even versed in alchemy, as some contemporaries evidently thought.) Certainly his is an unusual artistic pretention – to manage all that he did simply by applying thin glazes of pigment to a piece of wood. It is no accident that this amazing painterly pretence tallies so nicely with the social, political, economic and religious pretensions of his clients.

Today, for the purposes of rational historical analysis, we try to objectify and carefully distinguish such concepts in art as realism and symbolism. Over the last fifty years, especially, these concepts have been thought to be at work, jockeying for position, in early Netherlandish painting. We consider Netherlandish art to be realistic because, we claim, its artists strove to produce a visually accurate image of the world in which they lived. In some ways this may indeed be true. It would be difficult not to believe that some early Netherlandish artists, van Eyck among them, discovered a new, interesting and convincing way to portray the visible world. But there are many ways in which such a belief in greater visual accuracy would be a self-deception, even wrong. One problem with accepting such a belief is that we would be led to view the 'new' situation in too dramatic and simplistic a fashion. From another point of view it is argued that the fifteenth century witnessed growing demands for realism, but without it being made clear what this might mean. It is even claimed that van Eyck was responsible for 'the final conquest of reality in the North'.

To some extent it is understandable how such views have come about. We are quick to use the hindsight granted us by our having acknowledged that there was a nineteenth-century Realist tradition in European art. As a consequence of this, fifteenth-century art can be understood to have been heading in the direction of realist

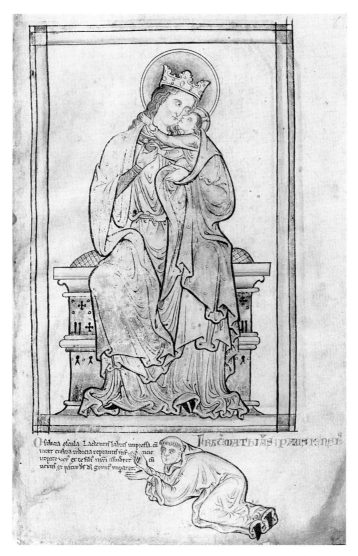

1 Matthew Paris, *Virgin and Child with the Artist
Kneeling Below, c.* 1250. *Historia Anglorum.*

description, which we believe was carried on through into the nineteenth century. And, if we compare medieval imagery with fifteenth-century art, we perceive the latter to be quite different: more involved with the visible world, and less tied to conventional or formulaic representations of things. Such an analysis is, however, both simplistic and anachronistic, confounding a complex period by judgements about it which are based on former styles and subsequent 'results'. Van Eyck's work shows us that the formulas that often controlled medieval representation continued to hold sway in fifteenth-century imagery. This is especially true in the case of his *Virgin and Child by a Fountain* (illus. 86), for example, which derives from an iconic model quite similar to that used by Matthew Paris, a thirteenth-century English artist (illus. 1).

Analysis of realist image-making has often proved to be inadequate, for several other reasons. A building-block theory of realism – the notion that artists systematically added realist vocabulary to their repertory – is an ideal situation remote from artistic daily life. The history of Western art shows us that there was never a single pre-ordained goal for representational art to achieve. Unfortunately, we tend to gloss over this situation by promoting the notion of off-beat artists pursuing expressive byways, which can then be played off against a more literal or straightforward idea of realist image-making. From the pool of fifteenth-century Netherlandish artists we single out certain individuals as more expressive in their realism than others: Roger van der Weyden sets up artificial arches or walls in order dramatically to close off his figure compositions (illus. 58); Hugo van der Goes uses differences in scale and spatial awkwardness in order to plumb human psychology (illus. 79). Thus, we come to believe that some artists were more selective and deliberate than others in their artistic distortions. They are thought of as commentators on the mainstream realist tradition.

Van Eyck's work has suffered greatly from being considered all too mainstream, as having been too objective and specific in his realistic effects. Even if we are forced to admit he did not portray identifiable buildings or interiors in his paintings, we cling to the assumption that his work is documentary in other aspects, certifying contemporary customs, for example, or medical conditions. In one way or another, van Eyck's perfect technique has all too often seemed to us to imply perfect imitation, for we easily apprehend the selective imagination that some other fifteenth-century painters brought to bear on the world. Our explanation of van Eyck frequently avoids the notion of selectivity, and seems to claim that the artist simply opened his eyes. In a sense, this situation is the result of our own system of categorization: if we promote a concept of objective realism, then we need an artist, in this case van Eyck, who most fully embodies it.

Van Eyck's work is also forced to be the perfect embodiment of the other ruling concept of early Netherlandish painting – symbolism. His work is said, miraculously, to be at once perfectly real and utterly symbolic. Within academic analysis and discussion it may be possible to distinguish *what* is portrayed in a painting from the *way* it is portrayed. Within art history we routinely (if wrongly) talk about subject-matter as distinct from style. In a painting, of course, these features do not exist independently of one other. Similarly, we must remind ourselves constantly that in van Eyck's paintings the meaning or symbolism does not exist separately from the portrayed structure of the world; it is, in fact, inevitably and completely embedded within it.

It is the artificial organization of realism and symbolism into separate categories that has led to the deceptive notion that symbolism can be disguised, or hidden, within realism. It is simply not clear how these two concepts could be *experienced* as different things in the visible world, or in works of art. What we might envision, however, is a number of quite different experiences of the world. On the one hand, what one sees may be thought to have some specific religious significance. On the other, it may be

thought to have only a factual or descriptive meaning. Or, again, one could be said to experience both possibilities simultaneously if, say, one felt there might be a religious meaning embedded *in the world*, but remained uncertain as to whether or not it could be proved to exist. And with the decline in the fifteenth century of a Scholastic tradition of the rational proof of the tenets of faith, and the rise of philosophic Nominalism, which stressed the reality of particulars, we might be tempted to see this last attitude as the most appropriate one for this kind of art. But we should be clear that this would require us to make more allowance for scepticism than is normally granted.

When discussing van Eyck's work, art historians often distinguish between the attention paid to surfaces – quite literally, to the surface of things – and to depth, to the complex religious meanings which are said to lie beneath the surfaces van Eyck so lovingly crafted. Realism and symbolism, surface and depth, style and content – we seem hopelessly caught in a web of related or overlapping dichotomies. These, in turn, determine our understanding of the way van Eyck's art works. In this book I try to avoid such categories. Some have postulated that van Eyck's symbolism is hidden by the realistic surfaces of his imagery. I disagree. Others have felt that his detailed descriptive style is somehow in conflict with a thousand years of Christian tradition. Again, I disagree. I prefer to explain van Eyck's images as having been manipulated throughout, in order to serve a great variety of ends, both human and divine. The social situation of his patrons, the condition of the Church and its various observances, an awareness of individual power and influence – all these and more contributed to van Eyck's highly charged pictorial realism.

For an artist and an environment governed by a complex interplay of pretence and scepticism, what would it mean to paint realistically, to paint true to life? My discussion of van Eyck's life and works is meant as a partial answer to this question. I have tried to think about his artistic realism in fifteenth-century terms, an attempt which is perhaps foolish, if not impossible. My determination to see with the eyes of a fifteenth-century artist does not mean, however, that I want to claim some special or absolute historical objectivity for my view. Nevertheless, I would like to feel that I am more accurate in my presentation of contemporary religious life than some art historians have been. Still, the experience of realism in art is clearly a very subjective affair. The way one understands the 'reality effect' of an image is itself a highly charged process. But I do not think this should stop us from trying, imaginatively, to see with a different pair of eyes. The best way of accommodating this approach is to take van Eyck's realism very seriously, but not simply at face value. His is a subtle means of narration. The way the images are constructed, the stories they contain, tell us something of the complexities of fifteenth-century culture.

Realism in van Eyck's work is most often felt to have some proof value, value as evidence in helping to establish an historical fact or supporting a religious doctrine. I would rather propose that it was meant to have a negotiating or exchange value, allowing

a dialogue to take place between artist, patron, work, world and, finally, the spectator today. What would the world be like if it were the way we see it portrayed here? Van Eyck's paintings can best be understood as complex historical narratives which, as this question suggests, we must simultaneously accept and interrogate. The realistic effect of these works is true, if only because it makes such a great story.

When Nicolas Rolin (illus. 64), van Eyck's patron, founded the hospital at Beaune, he said that he sought 'by a favourable trade to exchange for celestial goods temporal ones'. This is part of the religious mentality of van Eyck's environment. I think we should take Rolin's – and van Eyck's – religious strivings, their desire to negotiate personal salvation and eternal life, seriously. At the same time, we must observe these ambitions in a wider socio-historical context. We must provide both a context for, and a critique of, them. We do not need to debunk religion, but we do require more than just the presentation of the official Church story or doctrine. We need to investigate contemporary practice and behaviour and gain a full sense of contemporary religious experience, however presumptuous or fanatical it may have been. Van Eyck's paintings are about people struggling in the world, people about whom remarkable stories can be told. This artist's realism suits and expresses it all.

3

The Artist's Place at the Burgundian Court

Before we can examine more fully the world of van Eyck's images, we need to understand what his life was like at the Burgundian Court. He was, after all, at that time the chief embodiment of a famous and successful Court painter. This meant that the main source of his income was Duke Philip the Good. From surviving documents we can also surmise that van Eyck, as a Court artist, was forbidden by the rules of the Bruges painters' guild from working in the open market; for the most part, his non-ducal work was limited to people who were in some way connected with the Court. Thus, his income and status was more or less defined by his posts at Court: painter to the Duke, and *varlet de chambre* (chamberlain), a title and salary given to many servants at Court – grocers, for instance – which means that van Eyck was not ranked particularly high among its servants. We can say that his position provided him with a fairly good income: in 1432, seven years after entering ducal service, he was able to purchase a stone-fronted house in Bruges.

What did van Eyck do to earn this income from Duke Philip? From the outset, Court records state that he was to be available 'to execute paintings whenever the Duke wished him to'. The Burgundian Court moved from residence to residence, and the Duke seems to have been constantly engaged in remodelling or redecorating one or other of his numerous dwellings. Especially during the early years of his association with the Court – the later 1420s – van Eyck was at the Duke's call, staying at various places in order to assist with particular projects. To some degree this way of life continued into the 1430s, after van Eyck had married and bought his home in Bruges. Several times he is recorded as having received payment from different ducal residences, suggesting (we know for sure only in one case) that he actually had been working at them. In 1435 a ducal letter mentions 'certain large works' requiring van Eyck's attention; these 'works' probably involved interior design and decoration.

Did van Eyck design or execute wall paintings for Duke Philip? Possibly, for we know the Duke often had such paintings undertaken in his mansions. Did van Eyck polychrome or gild sculpture for these places? Perhaps, for we know that in 1432 he polychromed statues depicting the counts of Flanders for the city of Bruges. Another, especially intriguing, avenue of expression for van Eyck's creative talents was the design

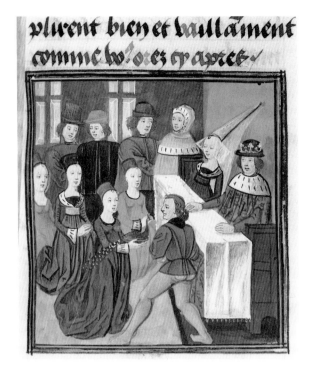

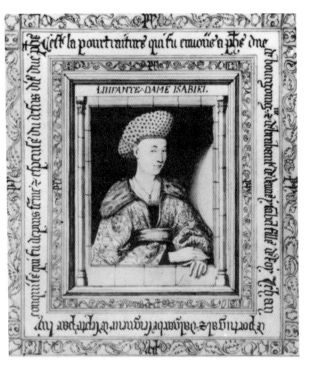

2 Anonymous French or Flemish artist,
A Royal Feasting Scene, late 15th century,
from *The Romance of Cleriadus and Meliadice*.

3 Anonymous 17th-century artist
after Jan van Eyck's *Portrait of
Isabella of Portugal* of 1429.

and production of Court festivities, banquets, food decorations and *tableaux vivants* (see illus. 2). At one of the Duke's banquets held in the mid-1430s, a huge pie was brought in, from which a man emerged dressed as an eagle, whereupon countless doves were released which then settled on the tables. We know that other important ducal painters conceived and executed such extravagances. Even though none by van Eyck are specified in the surviving documents, it is likely he also participated in courtly obsessions of this kind.

The kind of works van Eyck most often made at Court are not at all like those from his hand which survive today; these are mostly small panel paintings. Did he also produce small portable paintings for the Duke? We know that he did on at least one occasion, although we cannot be certain whether or not this lost work was executed on panel or canvas. In 1428–9 van Eyck accompanied a group of Burgundian ambassadors on a trip to the Iberian peninsula. There they hoped to negotiate the Duke's marriage to Isabella of Portugal, daughter of King John I. From a detailed contemporary chronicle of this initiative, we learn that van Eyck made a portrait of the Princess to send back to the Duke, of which a copy survives (illus. 3). This undertaking corresponds with what we know of aristocratic patronage of panel painting in general: noblemen and women, from the Duke on down, wanted portraits of themselves and their relatives; they sought to form and maintain a compelling genealogical record.

I will return several times to the question of who commissioned what kind of painting, especially where I discuss the patronage of such Burgundian Court functionaries as Nicolas Rolin (see chapter 12). But first we need to consider carefully the roles of the Court and the higher (hereditary) nobility. While contemporary documents show that the Court was the principal employer of painters in the Netherlands, there are remarkably few specific references to panel paintings – hardly any, in fact – in Court inventories. This does not necessarily mean that panels were rarely displayed in courtly settings, for they may often have been, but appear in the inventories only as 'precious objects'. It does suggest, however, that panels were not routinely singled out for special attention. The major exception to this were portraits, both of living family members and ancestors. These were intended to form a part of the historical record; thus their frames were often appropriately inscribed in order to certify their origin and to ensure accurate identification of the individual portrayed.

The nobility favoured the traditionally elitist art media – tapestry, metalwork (gold and silver) and richly decorated manuscripts. This we learn from their inventories and wills. Such items were far more costly, and thus more prestigious, than the more recent invention of panel painting, produced for the first time in its fully developed form by van Eyck and his contemporaries. From inventories and wills we also learn that those nobles who did happen to own panels seem not to have considered them to be particularly important, for they were passed on to retainers or servants, and not inherited by family members, as one's most precious possessions normally would be.

It seems reasonable to conclude that van Eyck was not routinely in the business of providing the Duke of Burgundy with small portable paintings, whether canvas or panel. We might, in other words, take more seriously than is usually done the fact that there is no definite record of van Eyck executing panels for him. I do not think it accidental that today no painting exists by van Eyck in which the Duke is shown adoring the Virgin Mary. If he made such a work, almost certainly it would have been highly prized, since the Duke and others repeatedly praised van Eyck's artistic genius. What we need to consider, however, is the fact that the Duke did not give top priority to such a task. Several panels he either owned or donated are known; but in the first half of the fifteenth century, panel paintings do not appear to have satisfied the Court's extravagant taste. If the nobility did commission small-scale, two-dimensional images, they were in the form of illuminated manuscripts. Those relating to Court life provided something akin to a report from the field, a historical record of ducal or noble activity (illus. 19); other illuminated manuscripts were intended to aggrandize the Duke by stressing his place in the line of succession, and by drawing analogies between his activities and the heroic deeds of his ancestors, real or imagined (examples of this include the histories of Charles Martel and Girard de Roussillon). In neither case were these manuscripts a means of public self-definition or display within a fifteenth-century context, in the way van Eyck's panels were.

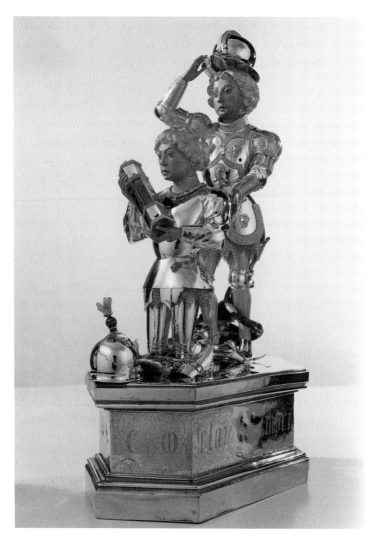

4 Gerard Loyet, *Reliquary of Charles the Bold*, 1467.
Cathedral of St Paul, Liège.

About thirty years after van Eyck portrayed George van der Paele with SS George and Donatian adoring the Virgin and Child (illus. 23), Duke Charles the Bold (Duke Philip's son) commissioned a gold reliquary for Liège Cathedral (illus. 4). In this finely wrought piece of metalwork, the kneeling Charles is presented by St George, a figure clearly borrowed from van Eyck's *Virgin and Child with George van der Paele*. It is not accidental that Gerard Loyet's version of van Eyck's prototype is made of precious metal with discreet enamel touches, rather than being a painted representation of such costly materials, for only dukes and a few nobles could afford the cost of such works. Representations aside, only the nobility owned the woven, worked, carved or moulded things themselves. Understandably, then, they did not rush to buy independent representations, mere illusions, of them.

For Duke Philip, van Eyck was engaged on 'certain large works'. What were these important projects? Clearly, the Duke placed great importance on his very way of life, which was, in part, a self-consuming spectacle. Contemporary accounts of conspicuous display – costumes, heraldry, floats, food – can provoke a stifling feeling of revulsion in the reader, for every aspect of Court pageantry was not only beautifully designed, it was very elaborately executed. Literary accounts of these events were carefully recorded, for part of the thrill of ducal life must have been the ephemeral aspect of its nature. The conspicuous lifestyle was based, in large measure, on an enormous appetite for consumption – but of food as well as of temporary works of art. For the Court, its foodstuffs comprised one of the highest form of art. We would not err in imagining the Court consuming a cake designed, decorated, perhaps even painted, by van Eyck, the greatest artist of the day.

The goal toward which Burgundian Court routine strained was not that of a representation of itself painted on a wooden panel. The Duke and higher nobility were not mute observers of their own society; they were, above all, its most insatiable consumers, distinguished by the fact that only they could afford the more precious objects artists and craftsmen produced. They did not immediately appreciate or require the more complex story-telling held out by painted panels.

We might, then, come to a different understanding of the fact that van Eyck's extant works do not record directly his life at Court. The nobility, and the Duke himself, did not in all probability encourage him to use his illusionistic skills in order to recreate or record their way of life. That was not what they considered to be the highest calling of an artist. They wanted van Eyck's talents to be more immediately present in their midst. Others at Court, such as those functionaries who had risen from the middle class, did commission panel paintings from him. And in these works van Eyck gave to their lives, and to their ambitions, all the glitter they could imagine, but not, perhaps, own.

Van Eyck was himself a Court functionary, an individual from the middle class who had no inherited wealth, and whose children would have none either. The Duke was quite adroit at forming and maintaining a large functionary middle class, composed of individuals who could do well in his service and to whom he was often quite loyal, but who were, nevertheless, totally dependent on his favour. It is often remarked how nicely the Duke balanced van Eyck's position between subservience and respected independence. The artist was expected to be at his employer's beck and call; yet it was made clear how honoured the Duke felt himself to be in having such a genius in his service. Philip went out of his way to see that van Eyck was well remunerated; yet, we should remember that on several occasions van Eyck was forced to plead for back pay, and even threatened to take his talents elsewhere if he were not paid more. In addition, he was never given a particularly elevated rank in the Court bureaucracy.

Such was the life of a functionary, perhaps successful and honoured for much of the time, but always liable to have his pension reduced in times of disfavour or ducal need.

We can suppose that such a person would be pleased with what he had, but remain insecure. Such a circumstance would provide us with a further reason for van Eyck's use of a motto – *als ich can* (as [best] I can). It has been suggested that when van Eyck added these words to the frames of his pictures, he was imitating the nobility, who alone had mottoes by right, while at the same time humorously affecting humility on the subject of his remarkable artistic creations. This is, surely, an appropriate combination to attribute to the Burgundian Court's most highly regarded painter. It adds further meaning to van Eyck's motto that the painterly skills referred to in it were most appropriate to the artist himself – his ability to visualize his life and that of his middle-class friends at Court.

Of one of those friends, van Eyck bequeathed us a telling record: 'Jan de [Leeuw] who, on St Ursula's day / opened his eyes for the first time · 1401 / I am now painted by Jan / van Eyck · It can be seen when he began · 1436'. Thus van Eyck cleverly inscribed the frame of his portrait of the Bruges goldsmith who became Dean of the gold- and silversmith's guild five years after this likeness was made (illus. 5). De Leeuw is portrayed with a sign of his occupational craft – a delicate gold ring set with a red stone. In his inscription the painter chose to play on the importance of sight for him, his sitter and the spectator. One further fact about de Leeuw heightens our interest in the presumed relation between the goldsmith and his painter: when in 1455 the citizens of Bruges decorated their house-fronts to honour the returning Duke Philip, it was de Leeuw who supplied the prizes awarded to the most tasteful examples.

Like de Leeuw, his fellow craftsman, van Eyck was extensively involved in designing and making luxury objects; his extant panel paintings are proof of that. Both men were also caught up in the arts of decoration, whether of houses (as in de Leeuw's case) or tournament floats. As an aspiring Court functionary, van Eyck pursued a career quite different from that of de Leeuw, in that van Eyck's was both flashy and new. So was the craft of panel painting by which we remember him today. An analogy can be drawn between the painter's life and his art. Perhaps this is also one of the factors that lies behind his uncanny ability to see, and then to embody, the needs of his patrons: for he had them too.

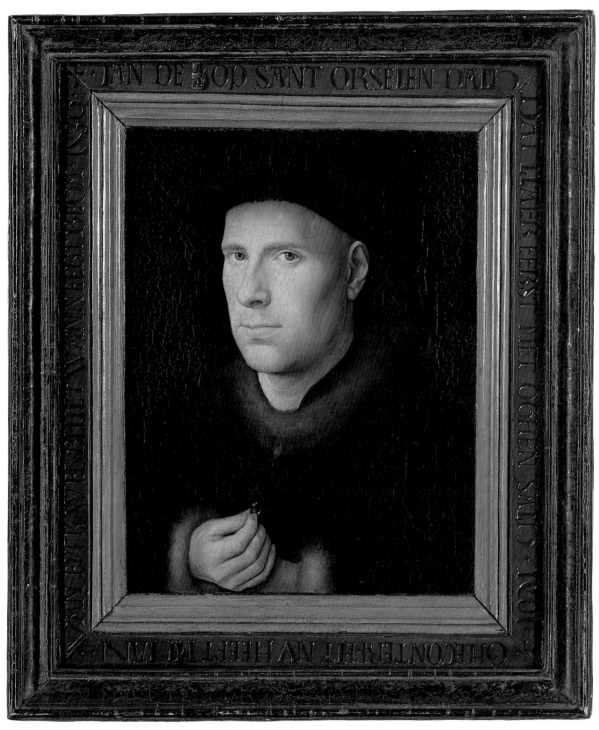

5 *Portrait of the Goldsmith Jan de Leeuw*, 1436.
Kunsthistorisches Museum, Vienna.

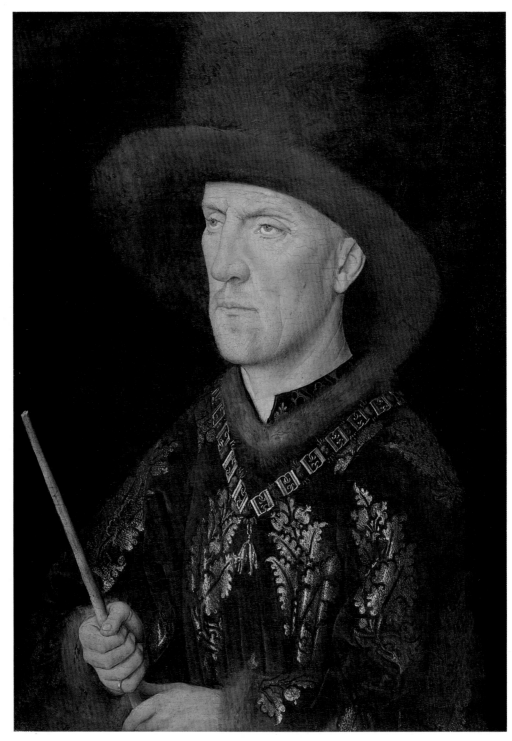

6 *Portrait of Baudouin de Lannoy*.
Gemäldegalerie, Berlin.

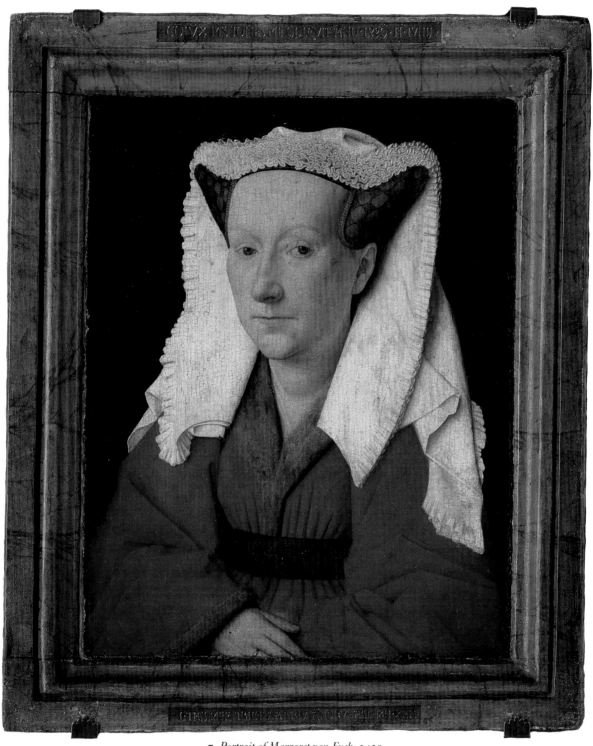

7 *Portrait of Margaret van Eyck*, 1439.
Groeningemuseum, Bruges.

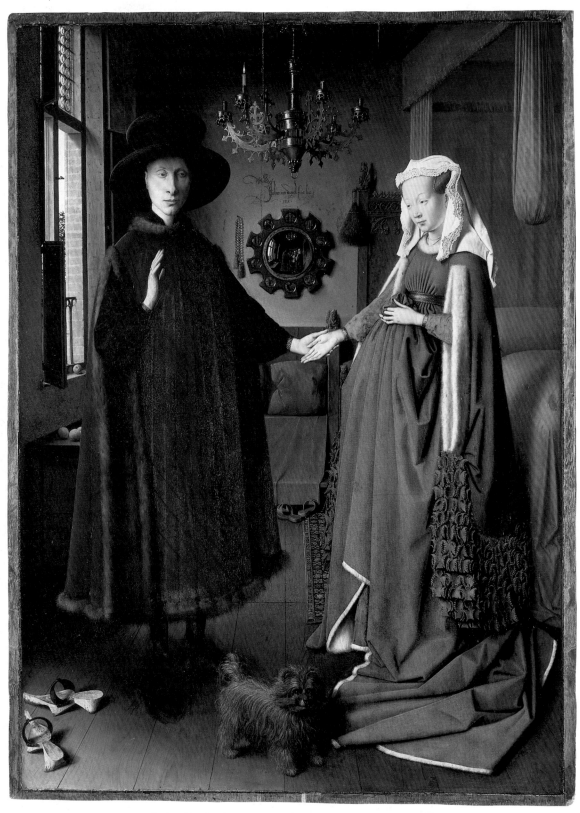

8 *Arnolfini Double Portrait*, 1434. National Gallery, London.

9 *Arnolfini Double Portrait*, detail (opposite).

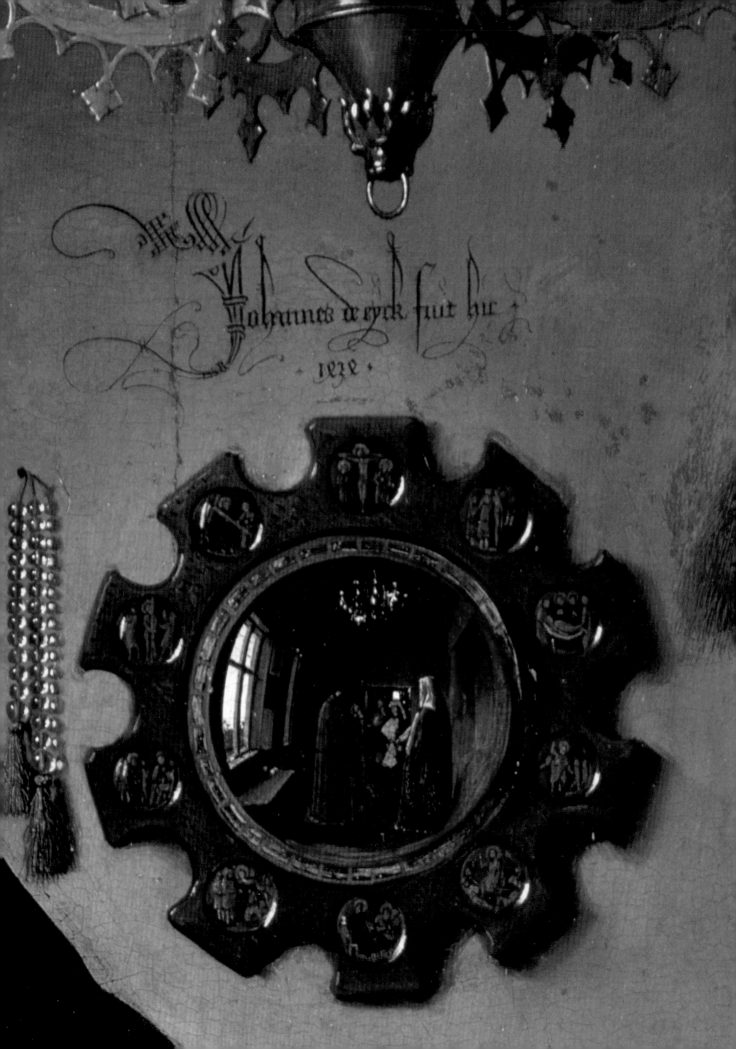

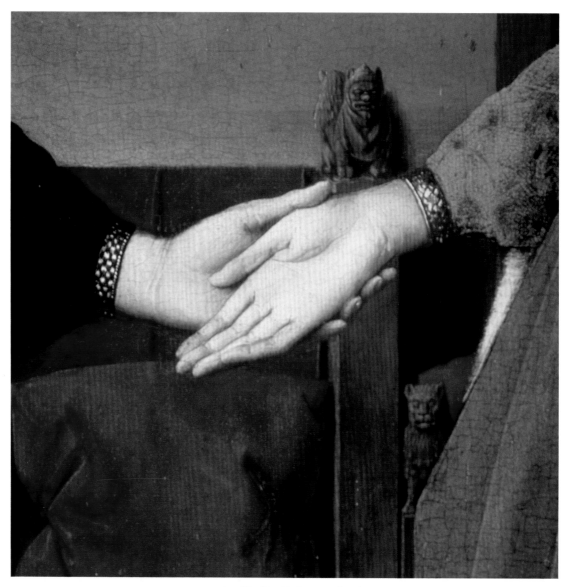

10 *Arnolfini Double Portrait*, detail.

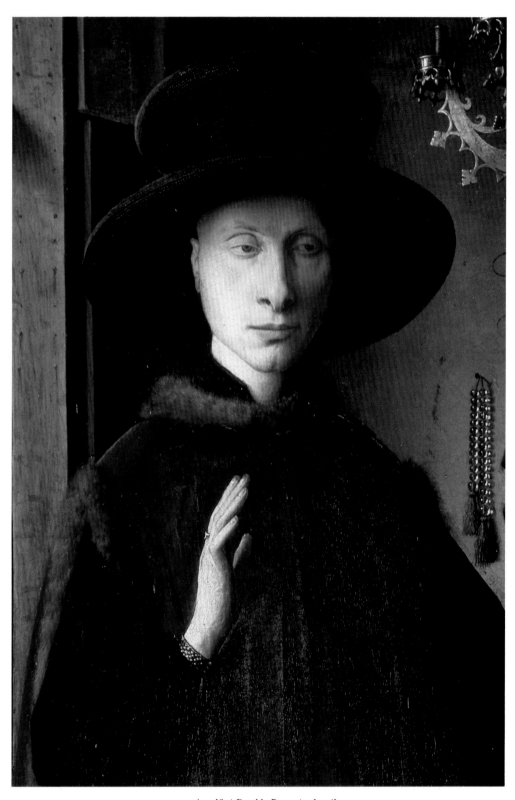

11 *Arnolfini Double Portrait*, detail.

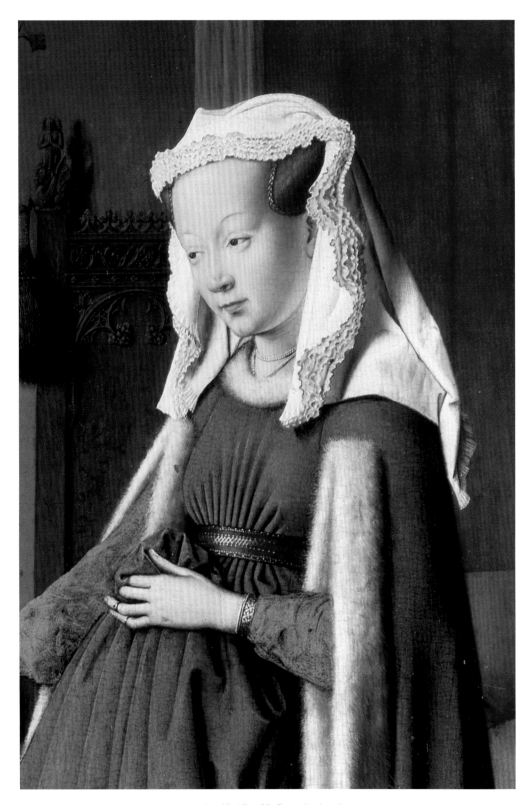

12 *Arnolfini Double Portrait*, detail.

4

An Italian Courtier's Story

Van Eyck's place at the Burgundian Court can be assessed by examining the double portrait of a young couple he painted in 1434 (illus. 8). It has been suggested on more than one occasion that in this picture van Eyck depicted himself and his wife; this idea is based largely on the unusual form the artist's signature takes in the painting: inscribed (like a large graffito) on the far wall of the chamber are, in Latin, the words 'Jan van Eyck was here / 1434' (illus. 9). While I think it certain this inscription does not mean the work is, in part, literally a self-portrait, it does certainly serve to emphasize his role in the image. I will return to the question of this signature, this courtly device, a little further on; here I must emphasize the way it injects the painter into his work. Van Eyck is the only fifteenth-century Northern painter who routinely signed his panels. Even within this unusual practice, the *Arnolfini Double Portrait* is a special case. Here, in a rare example in early Netherlandish art, the artist's signature is not simply inscribed on the picture's border or frame, but instead forms an integral part of the pictorial illusion. At the same time, it very specifically draws our attention to the artist's role in the creation of this illusion. This, it proclaims, is Jan van Eyck's world.

The *Arnolfini Double Portrait* is unique in other ways as well. It is the only fifteenth-century Northern panel to survive in which the artist's contemporaries are shown engaged in some sort of action in a contemporary interior. It is indeed tempting to call this the first genre painting – a painting of everyday life – of modern times. What brought about such a development in the Netherlands in 1434? I think we will see that it was almost certainly the result of a correspondence between the wishes of a social-climbing Italian patron and the observations of a self-involved and ambitious Court painter. The evidence for the particular identity of the couple portrayed dates from about a generation after their actual deaths; it is reliable evidence, but not absolutely so. First, however, we should see what in more general terms van Eyck seems to be showing us, before turning to the ways it relates to particular lives.

The *Arnolfini Double Portrait* is so beguiling that few have been able to resist its spell. Two people, a man and a woman, stand before us. While they themselves do not openly acknowledge the presence of any observers, the dog at their feet does. We discover by looking at the mirror depicted on the back wall that there is a second couple involved, who are observing this scene: we can see the reflection of two men who are entering the

room, one of whom is dressed in red, the other in blue. Such tiny observers seem to be one of van Eyck's trademarks found in several other of his paintings (illus. 62, 131). But neither in the *Arnolfini Double Portrait* nor anywhere else does the presence of such observers break the spell held in the painter's crystalline air. Light is crucial; it subtly enlivens the scene. It seems to float through the room; intriguing details are singled out without van Eyck having to introduce overly theatrical, spotlit effects. The result is to draw our attention to details almost without our being aware of the manipulation, or at least without our necessarily being aware of how very carefully and deliberately a network of correspondences has been drawn over the picture surface.

The *Arnolfini Double Portrait* is, above all, an image of contrasting pairs, even opposites: male/female, outside/inside, cherry tree/bed, prayer-beads/dusting-brush, candle/dog. Some of these pairings seem to be in a state of responsiveness; others are not. The man and the woman, loom large; they are carefully poised in the picture's foreground. The swag formed by their joined hands perfectly answers the actual form of the mirror hanging on the far wall. This mirror, however, could not in reality serve its purpose at the low level in which van Eyck has positioned it in order for it to fit within the bow of the couple's arms. This sleight is just one example of his formation of an illusionistic – and illusory – web of relationships between persons and objects: everything falls neatly into place, on the surface and in depth, simultaneously. This interior is van Eyck's representation of an ideal place, one finely calculated in its visual and narrative effects. The image itself is highly charged, and not at all in an accidental or straightforward documentary way. There was nothing in the world existing in quite this form until it was imagined and set forth by this particular artist.

The vividness of the many details in this painting helps to elicit an intimate narrative from a timeless emblem. I think we rightly want to know just what it is that is taking place here. Let us start with the obvious. What is most palpable is an image of the relation of the sexes in the fifteenth century. The man is deliberately placed nearer the window, the aperture for exterior light and for the sights and sounds of activity in the street. The woman's draped form is an extension of the bed; she is passive and internally directed. This man and this woman wish to have children. They have removed their shoes before getting into bed, as some other couples in fifteenth-century pictures are shown to have done (illus. 13). The man's wooden clogs are sharply lit in the foreground; the woman's red slippers are half-hidden. A bared foot has been a common indicator of sexuality or fertility during many periods; in the fifteenth century, for the feet of women, in particular, to touch the ground was supposed to help ensure fertility. In this painting, the single candle and the dog are also to be understood as indicators of sexual passion: a marriage candle was lit next to the bed of newly-weds in order to promote fertility; dogs, which of course freely copulated in public, were held up by priests as examples of unbridled lust. The figure carved on the bedstead may have been intended by van Eyck to represent St Margaret, who, having been freed from a

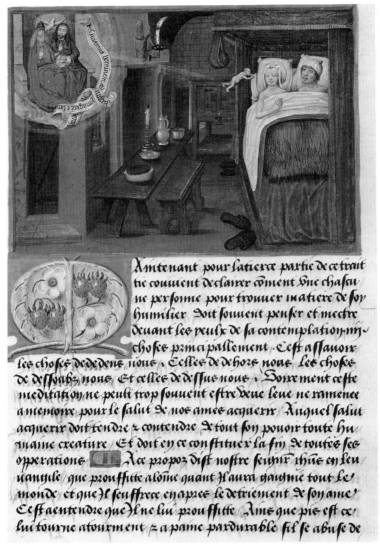

13 Anonymous French artist, *Couple Receiving a Child from the Trinity*,
c. 1453, from Jean Mansel, *Traités divers.*

dragon, was made the patroness of childbirth, the guardian of the womb's fruitfulness. The man appears gently to greet or bless the woman; some have even supposed he purposefully sanctifies the fruit of her womb. The woman responds by lifting her voluminous green robe, indicating, at least, her desire to become pregnant. Thus, almost all the leading features of this painting can be said to suggest a concern with sexuality and, more particularly, with fertility.

On the surface, it also appears that this is not the kind of couple that would engage in ribald sexual behaviour. They seem to be aware that, for the Catholic Church, the justification for marital passion between a husband and his wife was that of the Passion of Christ on earth; the couple may give their bodies to one other, in part because Christ

gave his body for the faithful. Thus, portrayed around the convex mirror on the far wall are the ten scenes of Christ's Passion, from the Garden of Gethsemane to the Resurrection (illus. 9). The painting can be said to be tied to a traditional religious attitude in other ways as well. The calm, even sacramental, quality of the couple's gestures is reflected in contemporary religious paintings. One, made soon after van Eyck's picture, is probably based upon it. Usually attributed to Roger van der Weyden (illus. 14), the picture in question, an *Annunciation to the Virgin Mary*, is staged in a room very like van Eyck's idealized bedchamber. This *Annunciation* is the first Netherlandish panel to portray such a scene in a full-blown contemporary bedroom; the artist seems to have encountered van Eyck's *Arnolfini Double Portrait*, and to have understood it as indicating both the theme of expectant birth and that of an associated religious solemnity.

14 Roger van der Weyden (attrib.), *Annunciation*, *c.* 1440.
Musée du Louvre, Paris.

In van Eyck's painting the man is given the controlling gesture: he calls forth his wife's fecundity. In some ways she seems to be a humble and responsive handmaiden to her husband. For example, on the rear wall hangs a set of crystal prayer-beads. Such beads were a typical engagement present from a prospective husband to his desired wife, and were meant to symbolize the requirement that women remain quiet and devout. Women were also expected to manage and maintain the home, hence the dusting-brush shown hanging from the bedstead. The carved figure next to the brush may be a representation of St Margaret; it might, on the other hand, be St Martha, who is also on occasion depicted with a dragon. St Martha would be appropriate here because she was the patron saint of housewives. From the misogynist male point of view, a woman's role was that of prayer and the supervision of housework in silence. As the daughter of Eve, she was ever capable of tempting men into eating of the fruit of

Paradise, which here is alluded to by the oranges – 'Adam's apples' – on the window-sill and chest. The figure of Eve in van Eyck's *Ghent Altarpiece* holds up just such a fruit in order to tempt Adam (illus. 90). The idea of the female as temptress was a pervasive middle-class or upper middle-class stereotype of the period.

But are we, in van Eyck's image, confronted by members of the middle class? Are these humble tradespeople of Bruges? All the decorative artefacts in this chamber indicate that this is not the case. Although they are not unusually ostentatious, this couple leaves little doubt in the minds of most viewers that they are well-to-do, even courtly, both in manner and accomplishment. Inventories of the period reveal that the type of exquisite Anatolian rug laid down in the place of honour by the bed was one of the most precious possessions an individual could own. The elaborate mirror with its enamelled Passion scenes and the finely wrought brass chandelier are, equally, signs of wealth. Oranges – the fruit of Kings – seen on the window-sill and chest, were costly imports from the South. This couple's dress is also carefully gauged: the restrained colours of the man's clothing correspond to those favoured by Duke Philip of Burgundy; and a similar large felt hat can be seen in another van Eyck portrait, worn by the Burgundian courtier Baudouin de Lannoy (illus. 6). The woman's voluminous fur-lined robe, while not made of a particularly costly fabric, has enormous sleeves with elegant dagging. The type of little lap-dog at her feet was the constant companion of noble women (illus. 19).

One of the most striking aspects of this painting is its formality, its ritualized solemnity. The image is heraldic: it is hardly accidental that, in joining hands, this couple, along with the objects surrounding them, seem to form a living coat of arms. More particularly, life at the Burgundian Court was governed by a highly developed sense of etiquette. All actions were carefully regulated; the Duke prided himself on his dignified and restrained appearance. Extant images of Court festivity (illus. 15) show the kind of finely calculated movements that van Eyck's couple also exhibit. Contemporary illustrators dwelt upon the contrast between courtly propriety and servile intemperance (illus. 16); whereas courtiers sit quietly, with their hands folded or politely raised, middle- and lower-class individuals uncontrollably gesticulate. The couple in the *Arnolfini Double Portrait* were clearly intent on being portrayed observing the niceties of courtly etiquette: there are no untoward or extraneous gestures here. This refined posturing can be observed in several of the artist's other works as well. The sense of detachment from others, as well from as the self, by means of carefully controlling facial expressions is already indicated here. This couple give the impression they are really trying to be good and proper.

The demeanour of van Eyck's couple is not only somewhat courtly in its formal rigidity. The picture as a whole is in the tradition of Court portraiture and manuscript illumination. An early seventeenth-century engraved portrait of one of the early counts of Brabant and his wife is remarkably similar to van Eyck's double portrait; and it too

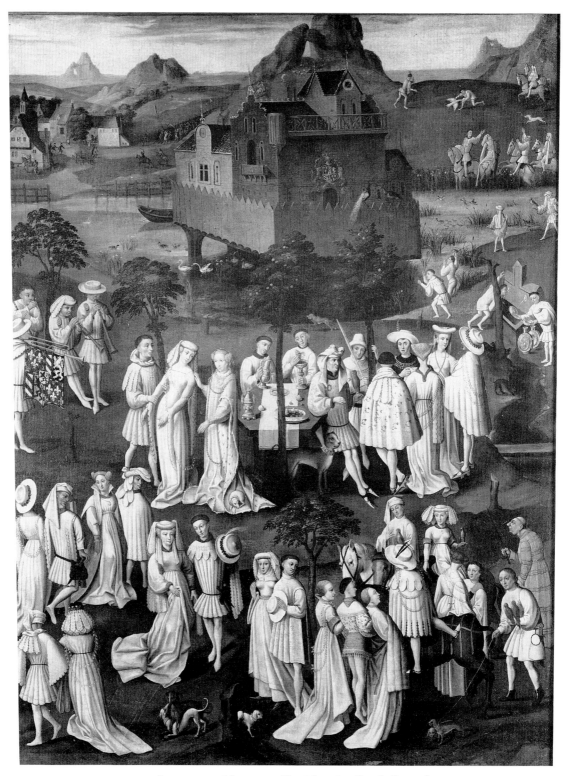

15 Anonymous 16th-century Flemish artist, *Courtly Scene of Philip the Good*. Château de Versailles.

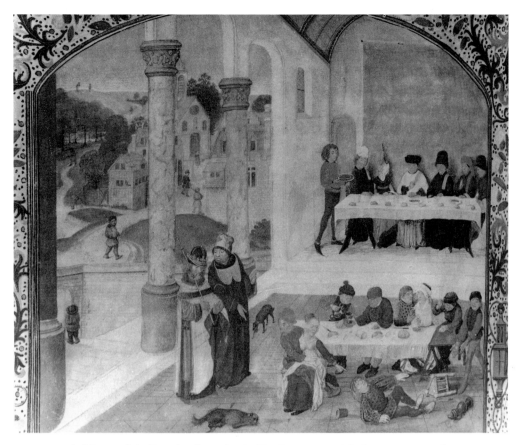

16 Master of the Dresden Prayerbook, *The Temperate and the Intemperate, c.* 1480,
in Valerius Maximus, *Facta et Dicta Memorabili.*

includes a lap-dog and a convex mirror (illus. 17). It is assumed that van Eyck was
employed by Duke Philip to paint similar portraits of his ancestors and relatives.
Perhaps this resulted in a prototypal image, on which both the *Arnolfini Double Portrait*
and the Brabant engraving may have been modelled. There is a tradition of present-
ation miniatures in early fifteenth-century French and Flemish manuscripts to which
van Eyck's *Arnolfini Double Portrait* interior is related (illus. 19). In these illuminations
we find many of the crucial elements of his panel painting: the interior with its air of
tranquillity and repose, the bed, the floor covering, a household pet, windows providing
an enticing prospect of the world outside, and elegantly attired courtiers. The sense
given of these scenes as historical, albeit conventional, social documentation is similar.
These courtly illuminations are the only examples we have of such imagery prior to van
Eyck's painted panel. His work must be understood as having drawn, in certain ways, on
this tradition. We should note, however, that he enlarges upon this rather straightfor-
ward kind of depiction with two seemingly opposed ideas: on the one hand there is a
timeless armorial quality, and on the other, a rich sense of detailed narrative, achieved
through individual objects and compositional relationships.

It is my belief that the *Arnolfini Double Portrait* was shown around at Court by its proud owners. Both the artist and the patron intended that it should appeal to courtly taste; this succeeded so well that its forms and ideas became part of the repertory of later Court imagery. Two examples of this phenomenon are particularly intriguing. The first is a manuscript of the *Thesiad* executed for Duke René of Anjou, who for a period in the mid-1430s was held in ransom by Duke Philip. A presentation miniature in the *Thesiad* manuscript shows a woman before a bed receiving a book (illus. 18); the whole scene is remarkably similar to that by van Eyck. Clearly the artist – who may have been René himself, trained by van Eyck – wanted to capture the latter's well-developed ability to project a courtly ethos. In the second example, another manuscript, the third in a four-volume set of the *History of Charles Martel*, there is a scene of the author David Aubert at work in his study, while behind a column Duke Charles the Bold spies on the writer (illus. 20). What interests us most in this miniature are the objects arranged on the far wall, in imitation of those in van Eyck's panel: chandelier, convex mirror, dusting-brush and crystal beads are all present. Clearly, Charles the Bold's painter knew and admired van Eyck's *Arnolfini Double Portrait*, confirming that van Eyck's formal arrangements and conventions were appreciated within a subsequent courtly ambience, as was his interest in creating a plausible image of contemporary life. Van Eyck's choice of objects, his sense of historical documentation and his reportage were all stimulated by, and admired by, the Court of Burgundy. But we might also note that van Eyck's models were invoked and applied somewhat unthinkingly by his followers.

There is, however, one particularly intriguing difference between the *Arnolfini Double Portrait* and the later manuscript miniature which depicts David Aubert: in the latter, the inscription on the wall is in fact Duke Charles the Bold's own personal motto: 'Je lay emprins'. Van Eyck may have been in charge of the panel he painted, but in the case of those manuscripts made for Duke Charles, the Duke himself took command. Van Eyck's flourishing script is elegant and aristocratic; by no means is it merely the kind of signature one normally finds on a legal document, as has sometimes been claimed. (The signature could not have functioned in a legal fashion anyway, because it does not specify the exact day of the year 1434.) What is more interesting is the fact that the Duke of Burgundy must have interpreted it as a kind of motto or trademark, by which the artist claimed his status in his creation.

There is one other telling courtly touch in this painting by van Eyck. Seen just above the couple's joined hands on the panel's surface – though, of course, in fact deep in the depicted space – is a pair of grinning, gargoyle-like figures (illus. 10). One of these carved finials faces us; the other, in disgrace, is turned towards the wall. Disgrace may be too strong a word here. Certainly, this detail adds a touch of mockery to an apparently solemn scene. It seems as though the couple's (presumed) pledge of fidelity is being laughed at. Such mockery played an integral part in the attitudes held towards love and sexuality at the courts of northern Europe, and at the Burgundian Court in

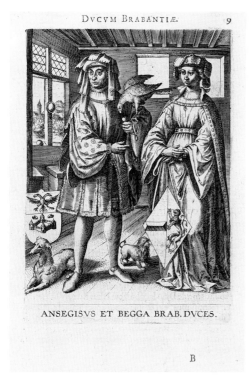

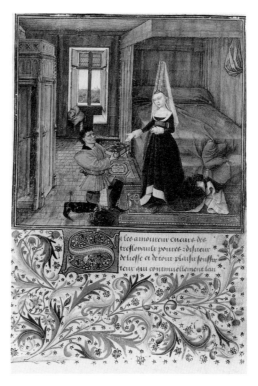

17 Anonymous Flemish artist, *Duke of Brabant Ansegisus and his wife Begga*, c. 1600, in Hadrian Barland, *Ducum Brabantia Chronica*.

18 Anonymous artist working for René, Duke of Anjou, *Presentation Scene*, c. 1460, from *The Thesiad*.

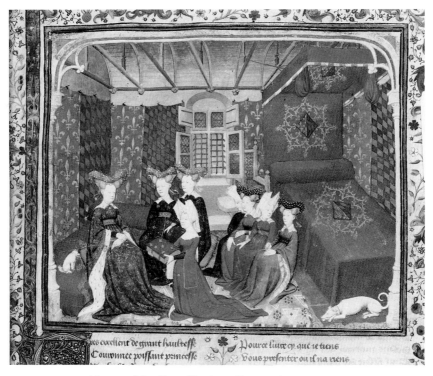

19 Master of the City of Ladies, *Christine de Pisan Presenting her Work to Isabeau of Bavaria*, c. 1410–15, from Christine de Pisan, *Oeuvres*.

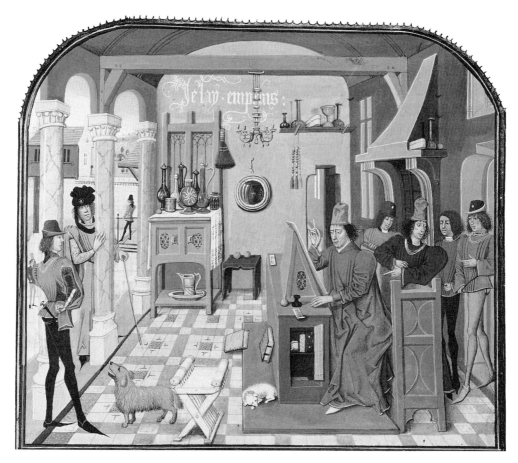

20 Attributed to Loyset Liedet, *Charles the Bold Surprising David Aubert*, 1468, from David Aubert, *Histoire de Charles Martel*.

particular. Contemporaries have left records of witnessing obscene grinning at noble wedding feasts; and later miniatures show solemn wedding processions belittled by fools and jesters (illus. 21). Duke Philip and his courtiers composed a remarkable series of love stories, *Les cents nouvelles nouvelles*, in which spouses are repeatedly portrayed as deceitful and cunning. The grinning carved finial in van Eyck's double portrait is unlikely to have been intended as a knowing comment on a specific deceit, however; rather, it again indicates that both the artist and his patron were alert to social conventions, including those of courtly love and sexual expectation. Thus, etiquette at Court included cracking a knowing smile, however slight, when the worlds of sexuality and piety met headlong.

Van Eyck's couple may well have sought to be pious. No doubt they were concerned about resisting temptation and evil. Yet, the image van Eyck crafted for them clearly presents them as prosperous and adroit individuals. They did not select an ecclesiastical setting for their portrait; and I do not think they allowed a simple or single-minded religious attitude to rule their image, or transform their lives into a theological exercise.

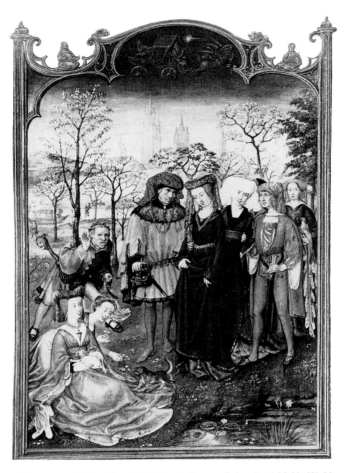

21 Anonymous Flemish artist (Ghent-Bruges School), *A Noble Wedding Procession (The Month of April)*, *c.* 1514, from the *Grimani Breviary*.

For this couple, and for growing numbers like them, life must have been about enjoying the world, about coping with its demands while furthering one's ambitions and taking what steps seemed necessary to ensure personal salvation. In this situation, although the Church may have insisted on straightforward renunciation, lay people increasingly found their own, more complex, solutions. Theirs was a response determined by a whole mesh of aims and ambitions. Some were sexual or social, others were religious. Van Eyck's image weaves their drives and desires into an inextricable whole.

Perhaps it is time to consider the identities of the couple for whom van Eyck made this famous double portrait. Early in the sixteenth century, about a generation after this couple had died, the man's name was recorded in a court inventory: 'Arnoult-fin'. (The painting by then belonged to the ruler of the Netherlands.) Commentators have always taken this name to be a French version of the Italian surname Arnolfini. And, conveniently, in the early fifteenth century there were several members of a Lucchese merchant family of that name in northern Europe. We must also take account of van Eyck's attachment to the Burgundian Court and his work for those who were in some

way connected with it. There is only one member of the Arnolfini family sufficiently powerful and wealthy – and firmly enough connected to the Court – to qualify here: Giovanni di Arrigo Arnolfini, a merchant born *c.*1400, who lived in Bruges from about 1421 until his death in 1472. His wife, Giovanna, was the daughter of another powerful Lucchese merchant, Guglielmo Cenami, who had been active in Bruges earlier in the century, but who in 1434 was living in Paris, where Giovanna was born. She died in 1480, eight years after her husband. Unfortunately, we do not know exactly when they married; neither the contract nor any other legal document connected with the marriage survives. From their presumed dates of birth it does seem likely that their marriage took place sometime around 1434. And even if van Eyck's painting is not the documentary record of a wedding ceremony, it clearly involves so many issues surrounding marital union that it would seem logical to consider it to be a marriage portrait. The date, 1434, does link it chronologically with the most likely period in which Giovanni Arnolfini and Giovanna Cenami would have married. Thus, on the calculations of their presumed ages and known marital status, as well as on the basis of the first documentary reference to the painting, van Eyck's double portrait seems almost certainly to portray this particular couple around the time of their marriage. What makes the Arnolfini/Cenami identification of van Eyck's sitters all the more attractive is the fact that much of what is known about this couple's attitudes and way of life seems only to reinforce and add further significance to what we can deduce from the image itself.

In a politically motivated marriage such as this one was, a marriage linking two powerful Italian families living in northern Europe, children would have been of crucial concern. We know that, unfortunately, the couple died childless. Although I believe that one likely function of van Eyck's image was to act as a kind of fertility device, whether or not these two people had already encountered problems in conceiving children by the time van Eyck painted their portrait is unknown. We do know, however, that other paintings made around the same time were intended in part as a plea for children. In a miniature already referred to (illus. 13), the heavenly Trinity is shown granting a couple's fervent request. Another miniature, from the early fifteenth century, shows a French princess, Marie d'Harcourt, the wife of the Duke of Guelders, receiving the angelic salutation 'O milde Maria'. The scene has been plausibly interpreted as a first person Annunciation, Marie having assumed the Virgin Mary's blue robe and taken occupation of a *hortus conclusus*. (Marie's presumption proved to be pathetic, for she too died childless.) The Louvre *Annunciation* attributed to Roger van der Weyden (illus. 14) was at one time supplemented by a female (now male) donor on a left wing and, on a right one, a scene of the Visitation, with the Virgin Mary and Elizabeth touching one other's swollen bellies. Infertility is a difficult fate to bear, and it must then have led to many private prayers as well as these more vivid visual appeals.

But Giovanni Arnolfini and Giovanna Cenami did not commission their portrait solely to help stimulate their reproductive potential. They were conventionally pious

people who, we know, supported religious confraternities in Bruges; and they went to some lengths to endow masses to be said for their souls after their deaths. It is clear from their own lives, as well as from this painted image, that religion was something to which they subscribed seriously, if not exclusively. Also of importance to them were their social pretensions. Other Italian merchants in Bruges may have remained tied to their own circle of expatriates; Giovanni Arnolfini was not among them (illus. 11). He is recorded selling costly fabrics and tapestries to Duke Philip of Burgundy on numerous occasions from 1423 on, and to the Duke's courtiers. He lent money to the Duke in 1446. By 1465 he was councillor, major-domo and chamberlain at Court. From 1446 until 1460 he was allowed by the Duke to collect those tariffs on goods imported from England which arrived via Gravelines. According to the Court historiographer, Arnolfini made a fortune from this privilege. In fact, he so impressed Louis, the Dauphin of France, during the Dauphin's residence at the Burgundian Court, that upon his accession (as Louis XI) he made Arnolfini a councillor and Governor of Finance for Normandy. Arnolfini became a naturalized French citizen in 1464. Clearly, he was ambitious. The Court historiographer portrayed him as privy to ducal consultations and negotiations; that is what his honours and titles also imply.

We might say that, in one aspect, van Eyck portrayed Arnolfini as a merchant who could be trusted, someone who was in sympathy with aristocratic aspirations and display. Arnolfini chose to mimic courtly attitudes and customs (including that of love); he was able, gravely, to present his wealth and a seemingly innate sense of propriety. He knew full well how, at least conventionally, to appear pious. He was a foreigner fashioning a self-image which at once was bold and accommodating, a self-image which would appeal to, and impress, the Burgundian nobility. Van Eyck's painting served Arnolfini's personal and religious pretension, just as surely as it promoted his and his wife's social and pecuniary hopes and expectations.

I doubt that at the time van Eyck was painting his portrait of this couple, that either of them intended to be unfaithful to the other. But a certain amount of unfaithfulness, or at least romantic dalliance, was expected of those who followed the fashions of courtly love. In 1434 the Arnolfinis were a young couple bent on forming and raising a family, while continuing to enhance their own social status. Unfortunately, as I have said, their ambitions as parents were frustrated. We know from other cases of the time that barrenness was often given as the reason for a husband's unfaithfulness. Such behaviour may have been caused by a general sense of frustration, or by an individual's need to prove he was able to sire offspring, legitimate or otherwise. Whether such impulses entered Giovanni Arnolfini's mind or not, we know that he did have at least one extra-marital love affair, which occurred late in his life. In 1470 the woman involved finally took him to court, in an attempt to regain some jewellery he had given her. She also revealed that she had been promised a pension and several houses – interestingly enough, the very treatment that Duke Philip afforded his own mistresses.

As for Giovanna (illus. 12), she also entered more fully into the sexual politics to be found at Court. We have one interesting record of this: a courtly ballade or love poem, for which she was demonstrably the subject, since her full name is spelled out in an acrostic, in this case the first letter of each line of the ballade. It is impossible to say whether or not she and the individual who commissioned or wrote these plaintive, if routine, verses ever consummated their passion. One (improbable) suggestion is that the poetic admirer was actually her own husband. But whoever was responsible for the poem, and for whatever reason, its very existence, like the known evidence of Giovanni Arnolfini's love affair, places this couple in the courtly ambience of sexual intrigue. And that ambience is something we find is being hinted at by means of the carved finial in their portrait.

Van Eyck's realism has many layers, the result of observation, convention and propaganda. It subtly conveys the continuity of desire that runs through the fabric of these people's lives, joining up what we might separately consider as strands of their existence – their personal, religious and social ambitions. In addition to this, van Eyck's image – and other early Netherlandish paintings as well – can and should be read, in part, as continuing dialogues between art and reality. We must take seriously the fact that the relation between art and reality can change or grow more complex over time. What an image indicates about a relationship may not always have been fully apparent to its artist or the patron. Objects – images – have an afterlife, a predictive ability. Thus, another aspect of the realism of van Eyck's paintings must be the way the desires each represents either fulfil themselves in reality, or do not.

In one early eighteenth-century Spanish inventory (by this time the *Arnolfini Double Portrait* had found its way into the royal collection in Madrid), van Eyck's painting is recorded as having an inscribed frame 'with verses from Ovid which told how the couple deceived each other'. This probably means that a quotation from Ovid's popular *Ars amatoria* was adapted for the painting's frame. It seems to me unlikely that such an inscription, revealing, in effect, the couple's later amorous exploits, would have been placed on the picture or its frame at the time it was finished. But it is also difficult to believe such an inscription would have been added centuries later, by which time any knowledge of the sitters' lives would have been lost. We might remember that the painting was probably shown around at Court, and was in turn influential on later Court art. Stories about the *amours* of the Arnolfinis would also have been relished at Court. While the painting itself was clearly not intentionally prophetic on the subject of infidelity, it is still possible to see how for some people it could have hinted at that eventuality. Someone who knew of these amatory matters might well have enjoyed adding just such an inscribed frame.

By looking carefully at van Eyck's *Arnolfini Double Portrait* we learn many things about his sitters and their world. In one way the reason this is so seems simple: its painter had an eye for the kind of significant detail that can reveal something of the complexity of the

lives these people led. If we can learn anything from this painting, it is that it is fraught with many motives – of the individuals portrayed as well as of the artist himself. Van Eyck's images are rich narratives of worlds both seen and unseen, real and illusory, public and private, sacred and secular; worlds which overlap and are ultimately indistinguishable. To an extent, it is as though he conflated the separate parts of a painting made a century before, for example Jean Pucelle's *Annunciation* (illus. 22). Van Eyck may be thought to have overlaid the scene of courtly romance (young couples playing a game of tag), which Pucelle had relegated to the *bas-de-page* of the main religious image. Pucelle clearly distinguished between the realms of divine love (above), and earthly love (below). Van Eyck, on the other hand, seems intentionally not only to juxtapose, but to mingle the timeless and the timely, the archetypal and the present day. He cleverly manages to convey religious devotion within a story of social manipulation and courtly play. With the *Arnolfini Double Portrait* van Eyck bequeathed us a compelling view of the intricate relations between sexuality, religion and social standing in northern Europe in the early fifteenth century.

22 Jean Pucelle, *Annunciation, c.* 1325,
from the *Book of Hours of Jeanne d'Evreux,*
Queen of France.

5

The Ecclesiastical Compact of a Secular Canon

꙳

One of two paintings by van Eyck still in Bruges, the city that was his home for much of his life, is also his largest and most elaborate work, apart from the *Ghent Altarpiece* (illus. 23). Its breadth, including the original frame, is almost 177 centimetres (70 inches). It is replete with various rich brocades, metalwork, semi-precious stones, (carved and polished), inlaid tiles, a thick carpet, glass, fur, flowers and feathers. Despite its multitudinous textural effects, there is clearly a human, psychological centre to the work in the form of its donor, a secular canon named George van der Paele. The various glances and gestures by others in this painting focus on this man; however much our eyes may wander, we are always brought back to his finely lined countenance (illus. 24). The message seems to be: Whatever more general artistic and theological connotations this painting may have, however much it may, visually and intellectually, reward our gaze, it is, above all, one which had a good deal of special meaning for the patron.

George van der Paele kneels at the steps of a marble throne, which is backed with cloth and a canopy of honour; the seated Virgin and Child quietly acknowledge his presence. Van der Paele is, somewhat comically, presented by his awkward patron St George, whose imagined clanking armour may have startled the Christ Child – at least that is one explanation given for the St George apologetically tipping his helmet to the holy pair. To our left, St Donatian, the patron of van der Paele's Bruges church, stares somewhat grimly across. It is not only the rather cramped composition that makes us sense some telling personal drama is taking place here. All the participants are intently engaged in playing their parts. There is little overt sentimental appeal, yet subtle calculations of placement, gesture and detail keep us alert to psychological interaction and significance.

It is also appropriate to see in this work an individual's story, because the panel, at least initially, was a private one. Van der Paele held a benefice at St Donatian's in Bruges; as a secular canon of this church, he made many well-documented gifts of art works to it – a reliquary, several breviaries and various other ecclesiastical objects. But there is no record that this painting by van Eyck was donated to St Donatian's during the Canon's lifetime; it is first documented as being in that church in the mid-sixteenth

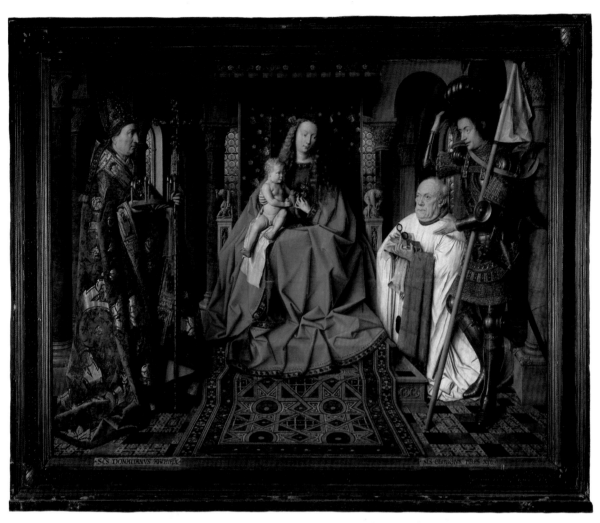

23 *Virgin and Child with George van der Paele*, 1434–6.
Groeningemuseum, Bruges.

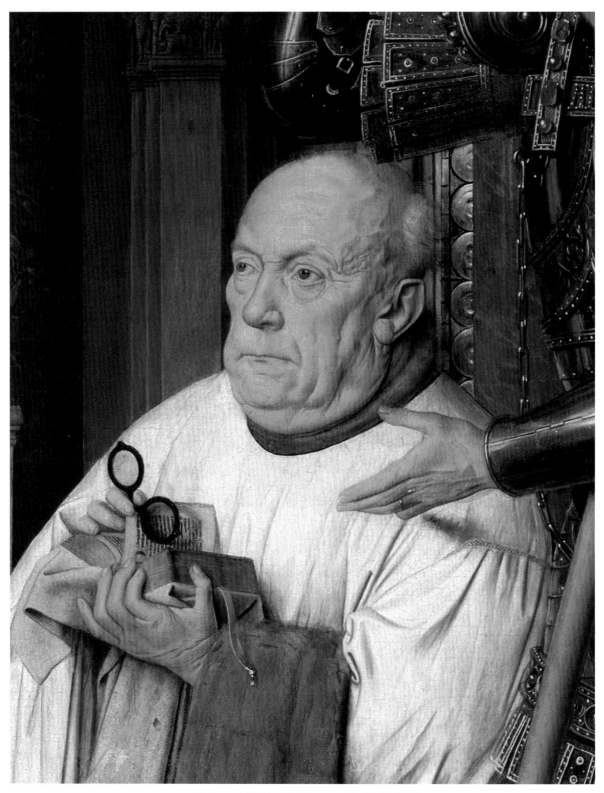

24 *Virgin and Child with George van der Paele*, detail.

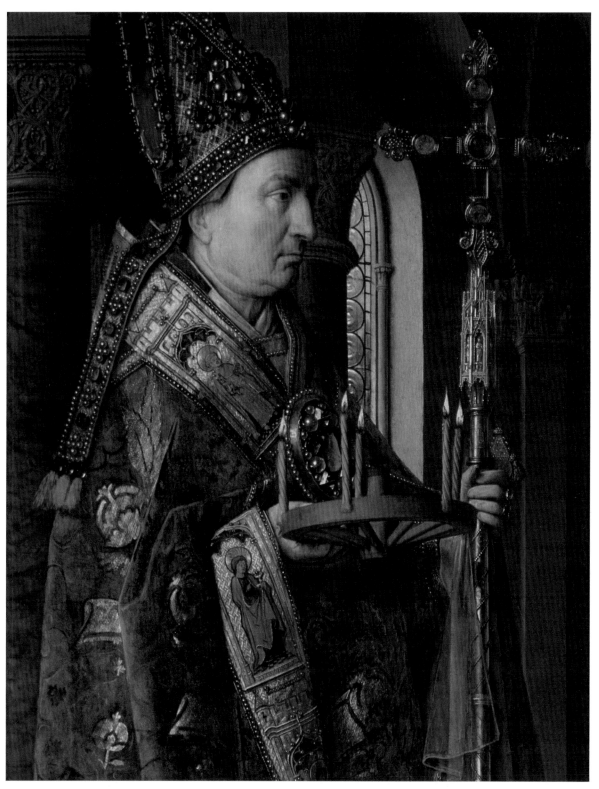

25 *Virgin and Child with George van der Paele*, detail.

26 *Virgin and Child with George van der Paele*, detail. 27 *Virgin and Child with George van der Paele*, detail.

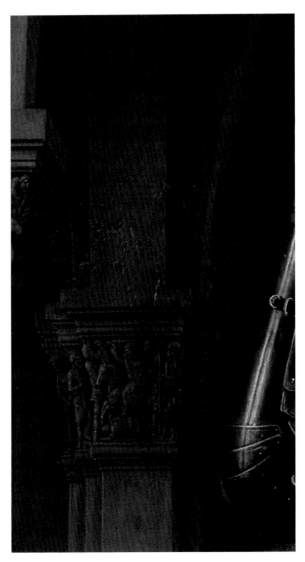

28 *Virgin and Child with George van der Paele*, detail.

29 *Virgin and Child with George van der Paele*, detail.

30 *Virgin and Child with George van der Paele*, detail.

31 *Virgin and Child with George van der Paele*, detail (opposite).

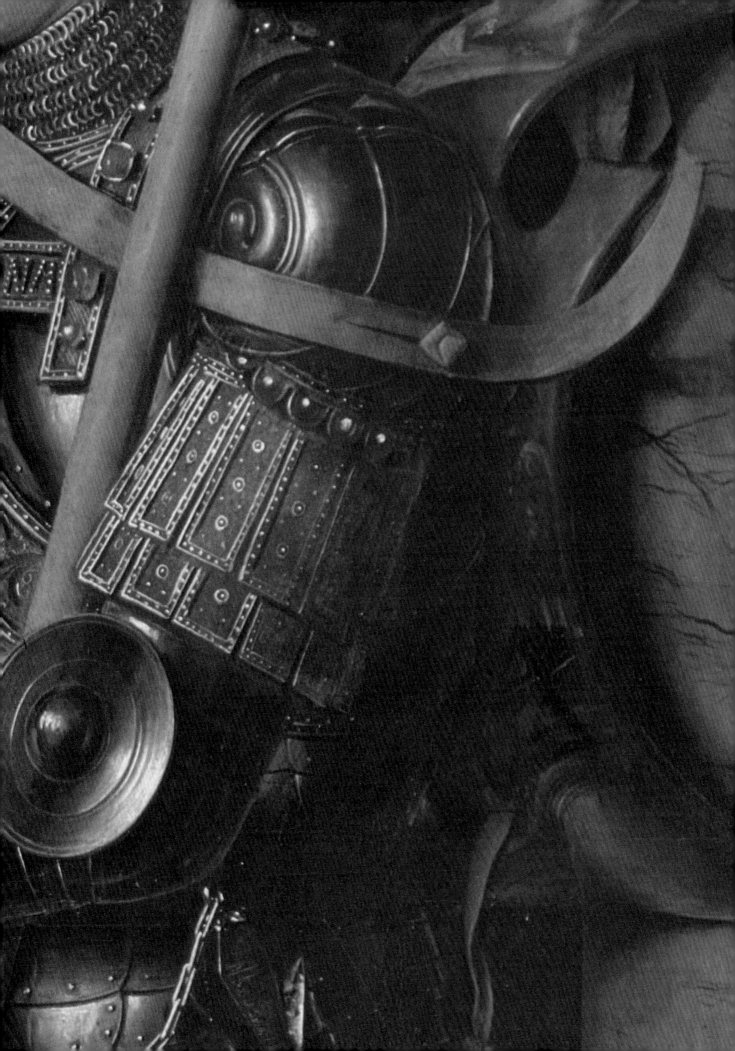

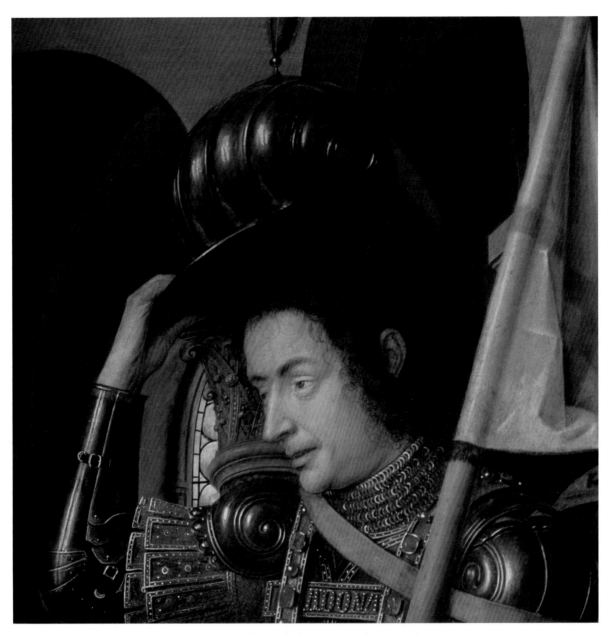

32 *Virgin and Child with George van der Paele*, detail.

century. It is hard to believe that such an impressive gift, if made, would have gone unmentioned by the church's scribes. What seems more likely is that the panel was retained by the patron during his lifetime and only left to St Donatian's in his will, a document which, unfortunately, has not survived. From the late sixteenth century, the work served intermittently as a public altarpiece in St Donatian's. This, too, is not indicated as having been an original function of the painting in the fifteenth century or early sixteenth. Surely van der Paele wished, even knew, that the image would in time become a public memorial to him? In the painting itself he remains the spider at the centre of his web – not the physical centre (van der Paele is not that bold) – but the emotional and psychological one. Our first task, then, is to see how this individual's life and activities might be said to live in the image, how the image can be seen to reflect the concerns and complexities of van der Paele's mortal existence and immortal aspirations.

So who was this man? Van der Paele was for most of his adult life a scribe (or *abbreviator litterarum apostolicarum*, as it was at one time phrased) in the papal curia at Rome. He was neither a priest nor a theologian. He was never ordained, never able to say mass, remaining a secular canon throughout his life. Secular canons had only to swear allegiance to the Pope and the Catholic Church; their religious duties consisted of attending church services and saying daily the divine offices. They were permitted to live in private dwellings, and to enjoy the income from often far-flung benefices. Holding benefices allowed them to draw salaries from numerous parishes, much as today's more wealthy people receive an income from a variety of financial investments. Canons were not required to be, and often never were, in residence at any one of the churches from which they received an income. A good indication of the corporate nature of late medieval piety, they were part of the Church bureaucracy that collectively prayed, as it were, for all Christians, delivering their public daily devotions in support of the Church's battle to save both the living and the dead. They demonstrated the Church's belief in shared guilt, the weight of which could be eased by spreading the burden across the broad shoulders of successive generations of the faithful – faithful secular canons, among others.

Van der Paele was probably born in or near Bruges around 1370, and he died there in 1443. By 1387 he had received his first prebend from the Roman Pope Urban VI. Between 1377 and 1417 the chair of St Peter's was claimed by rival candidates in Avignon and Rome. When Bruges sided with Avignon in 1394 van der Paele lost his income, but two years later he joined the papal curia in Rome under Boniface IX. During the following decade his loyal work as a Roman papal scribe was rewarded with salaried benefices in Carnia, Cologne, Strasbourg, Liège, Tournai and Maastricht, among other places. At a time of great political turmoil in the Church, with three popes eventually claiming legitimacy, van der Paele successfully rode the waves of change. When a group of cardinals met in Pisa to elect what they hoped would be a single

successor to the rivals of Rome and Avignon, van der Paele went over to serve the successive Pisan popes, Alexander V and John XXIII; both rewarded him with further benefices. When the universally recognized Martin V was elected in 1417, van der Paele turned to serve him. The following year Martin allowed van der Paele to trade two of his benefices in Cologne for a highly remunerative one in Saint Omer.

Van der Paele retired from the papal curia to Bruges in 1425. By this time he was an extremely wealthy man, living in a spacious house on the Mallebergplein. His was a life of richly rewarded loyalty to the then shifting fortunes of the papacy. His religious duties in Bruges during his retirement were, as usual, minimal – that of saying the offices – and by 1432 he had ceased any regular participation at St Donatian's Church. In 1434, as a consequence of his advanced age and ill-health, he was freed of all obligations there. In return for being allowed to keep his income from St Donatian's, he agreed to establish other chaplaincies in the town.

Van der Paele's life was often taken up with administering various financial arrangements he made with the Church. Several times he negotiated new or improved benefices for his relatives in Bruges. His uncle, brother and nephew all received remuneration for their services as canons at St Donatian's. Van der Paele was guaranteed income from his multiple prebends despite the fact that he resided in none of them, except St Donatian's at the end of his life. In that particular case he quickly negotiated his way out of his public religious duties. He did this by agreeing to use the wealth gained from his benefices to establish others. Thus, following his immersion in the complex corporate structure of the Church, van der Paele clearly became adroit at using the papal bureaucracy for his own personal and family ends.

Such manipulation was one of the reasons that the papal practice of creating and multiplying the secular clergy was increasingly criticized. Clearly it was a political tool, and not purely a religious one, in the hands of both the Pope and his beneficiaries. It is perhaps fair to say that for many in the fifteenth century, the secular canons represented the chief abuse of the vast wealth and power of the Church and, more particularly, the Pope. One justification for these offices – the concept of a collective body of prayers – failed to convince growing numbers of Christians, who were taking their religious beliefs much more personally. In addition, critics charged that many of the secular clergy were poorly educated. Between 1350 and 1450, 282 secular canons served at St Donatian's in Bruges, about fifty being present in any one twenty-five year period. Of these, 182 of them (almost 65 per cent) had received some university education; but only 126 (44 per cent) had undertaken advanced academic work. Van der Paele did, in his later life, receive the title *magister*, usually reserved for those with some university education. In his case this may well have been an honorary appellation given for his many years of papal service. There is no record of his enrolment at any university in northern Europe, and no papal document mentions his having held an academic degree. At best, then, his was a semi-learned clerical position. Certainly, during his

Church career, whatever van der Paele's intellectual abilities may have been, they were outstripped by his political acumen. One can be reasonably sure that a man in his circumstances would have been aware that at least some contemporaries must have perceived his official status to be questionable on both political and intellectual grounds.

The painting that van Eyck made for Canon van der Paele may be said to reflect this patron's corporate ecclesiastical orientation in a number of ways. Perhaps the most pointed device in this regard is the inscription that mentions the donor. The frame for this painting, which was made by the artist, contains in the corners the coats of arms of the families of van der Paele's father and of his mother, and it is painted as though it were carved, with inscriptions referring to the main characters in this visual drama – with the striking exception of the Christ Child. On the left, we are briefly told about the life of the patron saint of the church in Bruges with which the canon was connected: Donatian 'now enjoys the glory of God', the inscription informs us. The exploits of van der Paele's patron saint are recounted at the right, along with the reminder that St George 'triumphed over death'. On the upper part of the frame van Eyck painted his favourite Marian hymn from the book of the Wisdom of Solomon – and this hymn is also found on the *Ghent Altarpiece* (illus. 90), the Dresden *Triptych* (illus. 81) and the Berlin *Virgin and Child in a Church* (illus. 87). The Latin inscription on the lower section of the frame supplies vital information about the donor: 'Magister Georgius de Pala, canon of this church, has ordered this work by Johannes van Eyck, painter, and he has founded two chaplaincies as part of the choir of the clergy, 1434. Completed in 1436'. These words have been thought, with good reason, to tell us why van der Paele commissioned this painting – to commemorate the foundation of a chaplaincy – or at least that was the occasion on which he commissioned it. In 1434, the year van der Paele retired from all active involvement in the Church (his income continued, nevertheless), he founded a perpetual chaplaincy elsewhere in Bruges as well as, we learn from the painting, in St Donatian's. He not only gave the latter a large sum of money to pay for the clerical position, he also fitted it out with vestments, liturgical books, metalwork and other ecclesiastical furnishings. This foundation was specifically approved by the Pope in 1438. In 1441 van der Paele again paid St Donatian's a large sum in order to found a second chaplaincy; this one was also richly endowed with ornaments, including an altar table, reliquary, monstrances, and vestments embroidered with the donor's coat of arms. This second foundation post-dates van Eyck's painting; and the inscription on the painting was, in 1441 or later, changed so as to refer to van der Paele's *two* chaplaincies. Van der Paele apparently wanted the text surrounding the image to reflect accurately the plurality of his endowments. The first chaplaincy was founded in order to have masses said three times weekly – a requiem mass for the dead, a daily mass and a votive mass to the Holy Cross – as well as prayers for the donor. The second chaplaincy added the stipulation that prayers be said for van der Paele, for his dead brother (a former canon there), and for his family as a whole. There is here a specific family appeal

but, more important, there is also the assumption that the Church collectively will take care of its faithful, both in this life and the next.

In the second half of the fourteenth century, and throughout the fifteenth, there was a general obsession with the saying of masses for the dead. It was certainly common to will money to the Church in order to pay for a specified number of masses for oneself after death. Some lay people became rather extravagant in the number of masses they sought to finance (25,000 in some cases). It was left to a few very wealthy nobles, and more especially to those clerics at the top of the Church hierarchy – the Pope and the curia – to endow, and even richly fit out, a perpetual clerical position solely for this purpose. With the Pope's explicit approval van der Paele was promoting this fashionable obsession in a particularly aggressive, institutional fashion.

Van der Paele was lavish in adding altar cloths, antipendia, a gilded chalice, plate and a spoon, silver flasks, monstrances and candlesticks to his clerical endowments. In the painting he commissioned from van Eyck, such richness of ecclesiastical ornament is largely assumed by St Donatian (illus. 25). Painted thread by thread, consuming almost one third of the painting's format, his rather fabulous blue and gold garment probably reflects one of the actual glories of the Bruges church: two blue, gold-brocaded copes with the figures of the Apostles embroidered on the borders are recorded in its inventories. Instead of the usual bishop's crozier, St Donatian in this image holds a bejewelled processional cross, perhaps another indication of van der Paele's particular bias: the endowment of his first chaplaincy specified for masses to be said to the Holy Cross, and there was a relic of the Holy Cross in St Donatian's.

In van Eyck's painting there may be other signs, no longer recognizable, of Canon van der Paele's personal ecclesiastical experience. Certainly crucial in this vein is the scene's imagined location and composition. For the first time in (an extant) Flemish painting, van Eyck has assembled a company of ecclesiastical and holy figures and patrons in a church interior. Many times over the years commentators have wondered whether or not the kneeling van der Paele was being shown in a particular, potentially identifiable, building. But except by rather vague analogy, no one has been able to identify this painted interior as a specific Flemish landmark, nor as a remote archetypal building, such as the Church of the Holy Sepulchre in Jerusalem. Visually, what seems most remarkable is van Eyck's tightly bound spatial composition, into which the earthly donor has been fitted like a piece in a superior jigsaw puzzle. The compactness of the scene has often been remarked upon, including the fact that St George ends up rather awkwardly, almost comically, trampling on the Canon's white surplice. Yet, the most obvious implication of such a compacted arrangement has not been registered: van der Paele's world was – in his life and in his image – a narrowly bounded ecclesiastical one. It is in this institutional structure – building and observance – that van der Paele rests his case.

This type of sacred conversation painting – transpiring in a church setting – complete

with donor, clerical or otherwise, became something of a commonplace as the century progressed. But the type is never repeated in this way in van Eyck's *oeuvre*. His Lucca *Virgin and Child* in Frankfurt are seated alone, and not in a church (illus. 45). The setting of the *Virgin and Child with Nicolas Rolin* (illus. 61) is a palatial rather than an ecclesiastical interior. The donor in the Dresden *Triptych* looks on from a distance, isolated on the perimeter of what seems to be an ecclesiastical structure, but one without clerical inhabitants (illus. 81). Van Eyck's last two, standing, Virgins (illus. 86 and 87) are not immediately flanked by donors, whether without or within the church. Should we then take for granted the ecclesiastical compact that van Eyck presents to us in the van der Paele painting? I think not. The donor's life was lived too much within that quite earthly institution for this to have been the case.

What we are meant to see – what, in fact, we do see – is something that lies midway between the actual church of St Donatian in Bruges and the timeless ideal of the Church, some sort of Heavenly Jerusalem imaged in medieval architectural terms. For van der Paele the Church was much more actual, tangible, than this idealizing concept, but not actually confined to any one specific edifice. The idealized realism of van Eyck's work is not a disguise for something else; nor is it a botched attempt at archaeological exactness. For van der Paele the Church was real enough for him to invest much of his great wealth in its forms, in its garments and in its collective hopes for the future. Van Eyck constructed in turn a perfect image of the close-knit corporate endeavour to which van der Paele had dedicated much of his life.

Small sculptural details may also be meant to stress the power of the Church in both spiritual and earthly realms. On the right arm (to our left) of the Virgin's throne is a sculpted group of Cain killing Abel (illus. 26), which can be taken to allude to Christ's death; for the Church this is, in turn, embodied in the priestly saying of the Mass. The same meaning might be indicated by the historiated capital in the far recesses of the painted space, just to the right of Donatian's cross (illus. 25). Here, most clearly portrayed, we see the Sacrifice of Isaac, and also, perhaps, the meeting of Abraham and Melchizedek. (The latter scene is unclear, being partly obscured and in shadow.) Both of these Old Testament episodes were commonly understood to predict the sacrifice of Christ, again embodied in the Mass for which St Donatian here seems prepared, in his role as high priest. On the other side of the painting are scenes of victory: Samson rending the jaws of the Lion on the left arm (our right) of the Virgin's throne (illus. 27); David's defeat of Goliath and, perhaps, Abraham's defeat of the Elamites, or the armies of Chedorloamer, on the distant historiated capital (illus. 29). These events held out the Church's promise of resurrection, and the defeat of the Devil and death; they may also have reinforced the mission of St George, supporter of the Church Militant, and the Church as a political and military force with which to be reckoned.

While it is true that this painting presents us with the ideological asssumptions of a tightly knit institution, it is also important to acknowledge that there is an opening in this

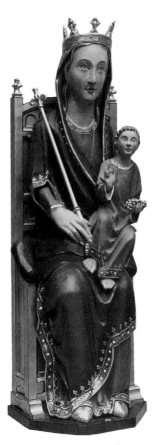

33 Anonymous 12th-century artist, *Our Lady of Tongeren*.
Treasury of the Church of Our Lady, Tongeren.

composition, in this carefully orchestrated circle of characters. The Virgin is highly stylized, flattened and angular, even somewhat smaller than the other participants, and, above all, she is presented frontally to the spectator. This is a cult image, frequently remade (see illus. 33), with the object of veneration surrounded by her adherents, a group which, if we choose, we can join. Despite the fact that the enclosing colonnade in van Eyck's painting seems to be in the form of a full circle, and despite the fact that it is, of course, relatively small (we can hardly step directly into the image), we are still included: the institution of the Church remains open. This, I think, is one of the most telling indicators of the corporate character of this image. Its institutional function might be said to culminate in the presentation of the body of Christ to all of the faithful. It is important to note that this is not just the donor's vision of himself, such as van Eyck embodied in his *Virgin and Child with Nicolas Rolin* (illus. 61). In van der Paele's work we see a more intentionally propagandist image. The Canon has paid for something to be put before us that will be capable of serving collective purposes, including the body of the faithful over time. The straightforward presentation to the spectator of the Virgin and Child helps to make that point.

There is in this painting a clear indication of van der Paele's faith in the institution of the Church – the Church Priestly and the Church Militant. But the power of this institution not only comes from the piety of a single individual. It depends as well on collective worship, on the cult's availability to the masses. Van der Paele's specific history depended on the mingling of these forces. Just so, the history of his times involved an intriguing combination of the personal and the corporate in religious observance. Van Eyck's image may suit his patron, but it clearly also concurs with the widespread increase in private devotion, as well as with the popular adoration of cult statues. The artist is not only attuned to large and small, the archetype and the individual, in the technical realm; he is versed in religious ideology as well. Here is a painter who can envision the congruence of a particular person's needs and the potent shared purposes and assumptions of his contemporaries.

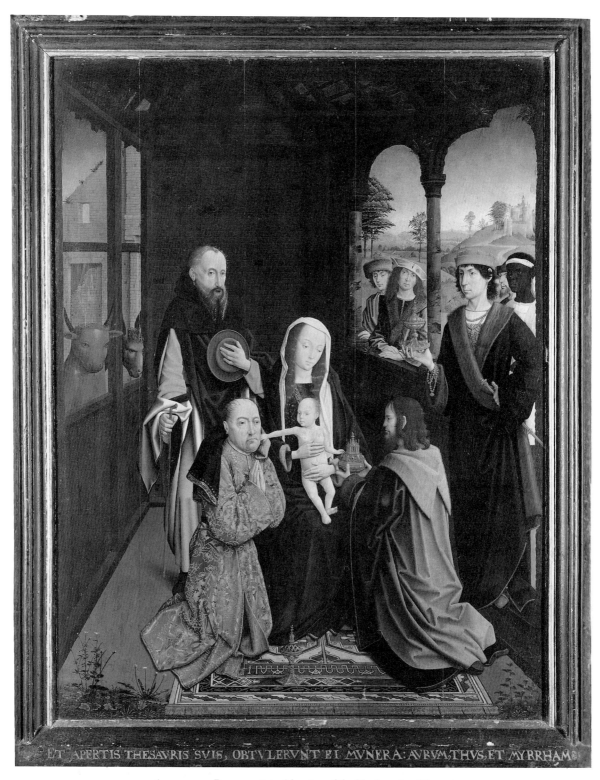

ET APERTIS THESAVRIS SVIS, OBTVLERVNT EI MVNERA: AVRVM, THVS ET MYRRHAM

34 Anonymous Bruges artist, *Adoration of the Magi*, early 16th century.
Groeningemuseum, Bruges.

6

Private Devotion in a Schismatic Church

The arrangement of the Virgin and Child in the painting commissioned by George van der Paele contains a clue to the important and intriguing internal conflict within this image. These two holy figures literally seem to be pulled in opposite directions (illus. 30). On the one hand, they form a timeless, and somewhat diminutive and remote, cult group (illus. 33); on the other, they are clearly emotionally drawn to the Canon: they would seem to represent his vision, his longing, as they, in turn, long for him. Is this situation to be judged as an aspect of the artist's developing style? Some of the figures, such as that of the Virgin, do appear wooden, too harshly modelled and cold. Some critics have seen the Virgin's stiffness as simply the stage van Eyck had reached in his development as an artist. I believe, however, that in this painting both artist and patron were consciously torn by seemingly conflicting aims – corporate on the one hand, private and personal on the other. Van Eyck needed to make the Virgin appear somewhat distant and timeless, yet simultaneously amenable to the Canon's immediate psychological needs.

Is this painting a vision of the beatitude granted to all faithful Christians, the spectator included? Or is it simply van der Paele imagining his personal immortal state? I believe this quandary cannot be resolved here. Chancellor Rolin, clearly, is having his own vision, which we – since he and his painter have allowed it – may witness (illus. 61). In the Dresden *Triptych* the issue is resolved through compartmentalization (illus. 81): in the *Triptych*'s centre panel is the envisioned Virgin and Child; donor and saints politely wait in the wings. We are free, without any conflict, to think of the Virgin as our vision, a vision that is identical to those in the wings. In his painting Van der Paele wished to present a cult image directly to the spectator, thus lending support to his beloved institution; and yet he retains some special personal relation with this vision of religious truth.

The conflict between these two aims can be illustrated in another way. In the eighteenth century, van Eyck's painting was several times referred to as an 'Adoration of the Magi'. No doubt this was a rather unstrenuous response, a reflection of the painting's material splendour, for images of the Magi worshipping Christ were typically occasions for great displays of various costly fabrics and objects. This response does also indicate the complex nature of the spiritual pretensions of van Eyck's work. There

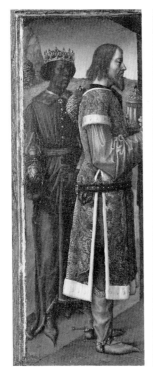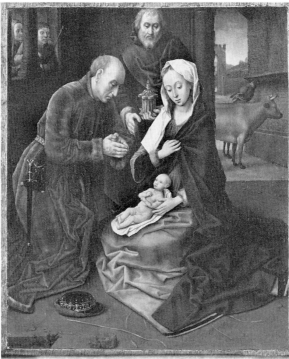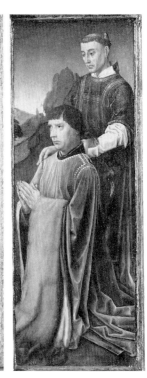

35, 36, 37 Attributed to Hugo van der Goes, *Adoration of the Magi*, c. 1475.
Collection of the Prince of Liechtenstein, Vaduz.

was a tradition of Adoration scenes in the fifteenth century and early sixteenth in which
the donor posed as a magus, or donors as the Magi. One of these images in Bruges
seems to derive from the van der Paele painting (illus. 34). The tradition of a donor
posing as a magus should be distinguished from those representations in which the
donor is shown standing or kneeling nearby, and reliving or envisioning the scene – as
the spectator too might be stimulated to do (illus. 35–7). Van der Paele has, then, had
himself depicted as a kind of privileged magus – one who also wants his personal vision
of, and participation in, religious truth securely institutionalized.

The problem is, perhaps, that the institution of the Church was far from secure
during van der Paele's lifetime. No doubt it took great political acumen for the Canon
not simply to emerge alive from the papal curia after the Great Schism, but also in good
financial straits. Nevertheless, the experience must have left its mark. The papacy
survived, but not unscathed, and more and more people, perhaps van der Paele among
them, chose to look to themselves, and to their own feelings, for comfort – in addition to
that collective justification held out by the Church. The growth of private devotion in
the late Middle Ages and on into the fifteenth century was not only a widespread but
also a complex phenomenon. To some extent it can be seen as a response to the
Church's disarray, as rival popes appointed and dismissed clerics throughout Europe.

Let us return for a moment to my premise that the van der Paele *Virgin and Child* does

in some ways embody its donor's belief in an ecclesiastical compact, in the crucial role of the clergy saying masses and prayers for the faithful, both dead and alive. But if that were the sole, and somewhat simplistic, purpose behind an image, a different choice would no doubt have been made, different from that we see now embodied in van Eyck's painting. For the purpose of supporting the power of the Church *alone*, a more likely choice would have been a representation such as Roger van der Weyden executed for the beleaguered Bishop of Tournai (illus. 38). Faced with poor attendance, and a lack of regard for both the institution and the hierarchy that ran it, this particular cleric found an artist able to imagine a spacious church interior dominated by a vision of the Crucifixion, which in turn guides and justifies the Church's complex sacramental system of salvation, filling aisles and apse. All that is missing are great numbers of the faithful.

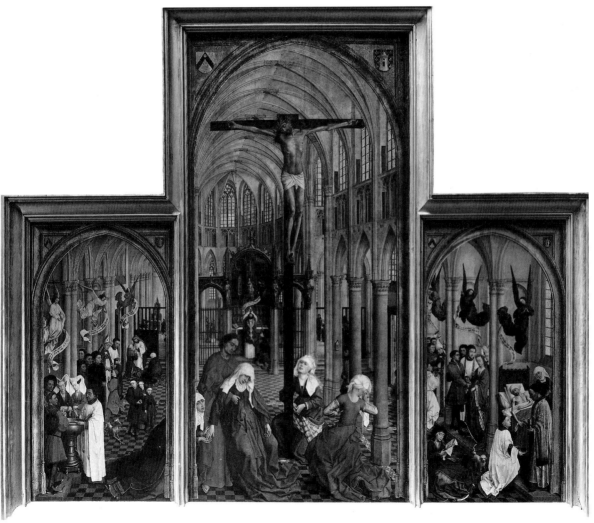

38 Roger van der Weyden (?and assistants), *Seven Sacraments Altarpiece, c.* 1445. Koninklijk Museum voor Schone Kunsten, Antwerp.

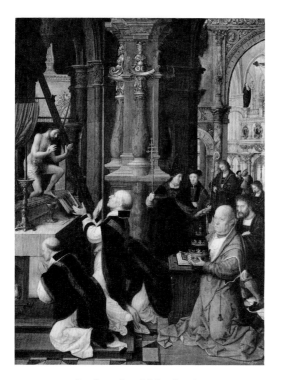 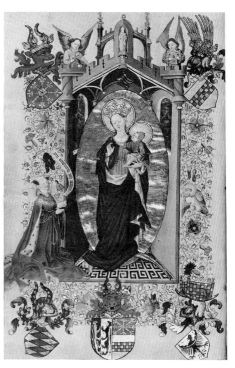

39 Attributed to Adrian Isenbrant,
Mass of Saint Gregory, early 16th century.
Prado, Madrid.

40 Master of Catherine of Cleves, *Catherine
of Cleves Praying to the Virgin*, c. 1440, from
the *Book of Hours of Catherine of Cleves*.

Or, in order simply to support the Church hierarchy, van Eyck could have been asked by van der Paele to paint the archetypal clerical and sacramental image of the Mass of St Gregory. Gregory prayed for the truth of Catholic doctrine on the Mass to be proved to a doubter; his prayer received a dramatic answer when Christ actually appeared on the altar. Often in the fifteenth century and early sixteenth, clerics commissioned such images, and had themselves included as bystanders holding the Pope's – Gregory's – tiara. The message was this: faithful cleric, faithful institutional promise. In fact, there is a painting of the *Mass of St Gregory* now in Madrid, probably dating from the early sixteenth century, which shows a clerical donor – who certainly looks like George van der Paele – kneeling in the foreground holding Gregory's tiara (illus. 39). Does this image reflect an earlier original? Or was it commissioned by the cleric's family at some later date? Does it really represent van der Paele as Gregory's faithful attendant? (Alternative suggestions for the donor's identity have been put forward.) Whatever the case, its existence sheds interesting light on van Eyck's panel. In comparison to the Madrid work, van Eyck's is not as narrowly institutional, it is not as single mindedly supportive of the clerical hierarchy; in van Eyck's image, van der Paele is certainly not represented trying to wrest control from their hands. There stands the bishop St Donatian; and there, too, are the additional clerical positions, referred to by inscription,

which the Canon has so richly endowed. Yet, I believe, van der Paele hedged his bets. There is an edge to this painting, an edge stemming in large part from the personal devotional stance which the Canon is given.

Van der Paele did not simply give the Church an image of its own institutional splendour and doctrine. Nor did he found chaplaincies with the sole intention of having requiem masses recited: he stipulated that prayers for himself and his family should be added. Institutions can, of course, be bent in personal directions. Many lay people at the time seem to have done this by paying for numerous masses to be said for their own souls; although the clergy still had to carry out such wishes, it was, after all, the rapidly multiplying and time-consuming demands of the lay parishioners that were being attended to. By catering so fully to lay wishes, the clergy ultimately relinquished some of its power. The obsession with, and encouragement of, private prayer and meditation had a similar result. Learned clerical advisers lost favour in an atmosphere where 'learned ignorance' flowered.

In van Eyck's painting the Canon kneels alone, holy book in hand, running over his prayers and meditations. It is not one of the established sacraments of the Church that has brought the Canon into contact with the divine; what we are witnessing is the most popular lay religious device – and image – of the fifteenth century in the Netherlands: through private prayer the donor is granted a vision. Sometimes such a vision can be iconic, a timeless image of the sacred (illus. 40); at other times it can be narrative, an event from Christ's life or that of the Virgin (illus. 49). Either way the message is direct and accessible; the laity are shown to have powerful psychological resources of their own.

I do not want to exaggerate the importance of Canon van der Paele's personal prayers and meditations as envisioned in van Eyck's painting. Nor do I want to overestimate the private nature of the religious experience that this image might be seen to advocate. For all that, however, the painting does imply van der Paele wanted the best of both worlds, the institutional and the personal. For all its ecclesiastical pomp and circumstance, the work does evidence a search for private epiphany and personal justification. Van der Paele emerges from this painting as having not been at all immune to the attractions of the spiritual movement known as the Modern Devotion.

This movement is perhaps the best single indicator of the direction of popular piety in the Netherlands in the last quarter of the fourteenth century (when it was founded) and throughout the fifteenth. It had both lay and clerical components. Lay men and women could join either the Brethren or the Sisters of the Common Life, while priests belonged to the Windesheim Congregation under the rule of St Augustine. In either case, the guiding principle of religious life – private prayer and meditation – was the same. Work, for the most part, consisted of copying devotional handbooks. By the end of the fifteenth century the movement of the Modern Devotion consisted of close to a hundred foundations. During the Council of Basle (1431–49), which was in progress at

the time van Eyck was painting, the legitimacy of the spiritual life fostered by the Modern Devotion was discussed and approved.

In van Eyck's painting, van der Paele is not portrayed participating in a sacramental ritual: no priest saying mass is present. Rather, the Canon kneels devoutly, clutching the devotional book he has obviously been reading. He has removed his spectacles for a moment of private meditation; his eyes stare somewhat blankly into space. The result is that which was sought by many pious lay people in the Netherlands during the fifteenth century: to have a vision of the divine in response to one's private prayers and meditations, without formal ceremony, without priestly intercession.

But the situation is not as simple as that, either from the point of view of the adherents of the Modern Devotion, or that of van der Paele. Those who promoted private devotion, such as the movement's leaders, were often most critical of the lives of secular canons. How, they wondered, could one lead a godly life in private, if one remained surrounded by the Church's earthly riches? The so-called father of the Modern Devotion movement, Geert Groote (*d*.1384), specifically renounced the benefices he had received early in life. The Brethren and Sisters of the Common Life, as their name implies, led lives of simple poverty.

Van der Paele, on the other hand, insisted on a demonstrative illustration of his costly institutional life. It is no accident that van Eyck created a pictorial space resembling the precious, hot-house bubble of a terrarium. It is only fitting that some later observers mistook this gorgeous scene for an Adoration of the Magi. The inscription at the bottom of the painting indicates that van Eyck spent about two years on the work: commissioned in 1434, it was not completed until 1436. A close inspection of the material splendour of the scene it depicts, confirms the belief that he must have expended countless hours building up the translucent oil glazes that came to represent velvet, fur, metal and glass. From contemporary records we know that in 1434 van der Paele claimed to be ill; perhaps he was fearful of dying. Why not, then, choose one of the seventy or so other painters who practised their craft in the first half of the fifteenth century in Bruges, many of whom no doubt worked far more rapidly than the meticulous van Eyck? As it turned out, the Canon did not choose a painter who could give him an attractive if rather plain image (illus. 41), one which would have been more quickly executed than a picture by van Eyck. Even judged by van Eyck's lifelong repertory of luxurious effects, the van der Paele panel is unusually ostentatious and elaborate. Clearly, van der Paele was not the kind of wealthy clerical patron who would have been satisfied with a simple devotional relief showing him before the Virgin, such as can still be seen in the Church of Our Lady in Bruges (illus. 42). Both van Eyck and his patron seem to have been determined to prove that one's high material status can be proclaimed at the same time as a humbly devout pose is struck. In the resultant image these two religious aims have been consciously brought together, creating a combination that may have been offensive to some, paradoxical to others and highly pleasurable

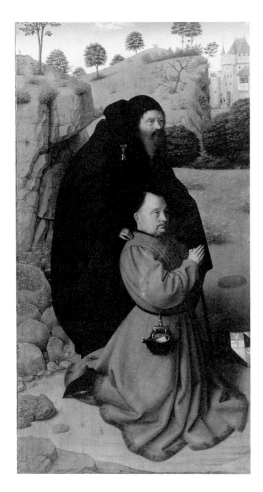

42 A funerary relief of *c.* 1483 in the Church of
Our Lady, Bruges.

41 Petrus Christus (attrib.), *St Anthony and a
Donor*, *c.* 1445. Statens Museum for Kunst,
Copenhagen.

to at least a few. This was also a combination that increasingly had to be defended by the ostentatious papal curia.

As I remarked earlier, for much of his life, that is from 1425 until his death in 1441, van Eyck was an official court painter to Philip the Good, Duke of Burgundy. As such, he was not subject to scrutiny by the painters' guild; but in turn he was apparently only allowed to work for patrons who were in some way connected with the Court. What this may have meant, in effect, was that the way to approach the artist with a request for a painting was through some courtly connection or other. How could Canon van der Paele have accomplished this? The Church of St Donatian in Bruges was, in fact, what might be called a ducal stronghold. In the late 1430s and 1440s its large clerical establishment was even headed by provosts who were the bastard sons of the Duke of Burgundy. In return for his loyalty to the papal see, the Duke was allowed to name favourites for benefices throughout Flanders. This was the case with St Donatian's, in which the Duke had a special interest. Van der Paele, in turn, took advantage of the connections between the Court and St Donatian's in order to gain access to the Duke's painter.

The Canon must have gone to some lengths to obtain van Eyck's services, and he insisted on employing them in the creation of a work of almost unparalleled material display. We often assume that van der Paele (or van Eyck) did this simply for the glory of God. Why not get the most elaborate work possible, if one could afford it? Christian commentators had already struggled with this question during the preceding centuries. Some, including Abbot Suger of St Denis, were ecstatic over the material splendour with which the Church could be enhanced – all done, they felt, to lead the mind, through sensual experience, to contemplate the even greater beauty of the divine. Others, such as St Bernard of Clairvaux, were contemptuous of those who were drawn to worldly extravagance: 'if people are not offended by the intricacy [of much ecclesiastical art], at least they should be embarrassed by its cost'. Should van der Paele – and van Eyck – be taken as latter-day Abbot Sugers? The answer, I think, is no, and on two counts – external circumstances and the evidence contained within the image itself.

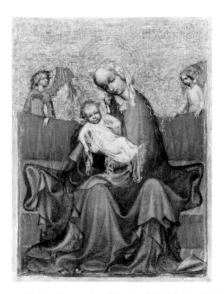

43 Anonymous Bohemian artist, *Virgin of Jindrichuv Hradec, c.* 1400.
National Gallery, Prague.

In southern Germany and central Europe in the 1420s there was increasing criticism of the popular and elaborate Beautiful Virgin (*schöne Maria*) paintings, especially among the followers of the reformist John Hus (illus. 43). The seductive beauty of such images was felt to lead all too easily to an improper, idolatrous worship of a mere material object. Leaders of the Modern Devotion were also very wary of image worship. Some even advocated an image-free ideal of meditation, in keeping with their vows of simplicity and poverty. To us today, such thinking might be considered to have culminated in the iconoclasm of the sixteenth century, in which, no doubt, many very rich and costly fifteenth-century panels were destroyed. Few people in the fifteenth century took the issue that seriously. And there is no evidence that van Eyck or his

clerical patron had direct knowledge of any early fifteenth-century questioning of the value of ostentatious religious imagery. But there is a strong element of pretentiousness, almost effrontery, in van Eyck's painting. In its combination of devotion and display, there is also something like an answer, perhaps not fully realized or articulated, to reform-minded critics.

There is the fact that van der Paele is himself projected, magus-like, into the psychological centre of this work. Further, he is shown holding spectacles, complete with a case, hanging by two strings from his prayer-book. Did he actually wear spectacles? Perhaps he did have a problem with his eyes, as some modern experts have speculated, but it was certainly not necessary for him to be shown with spectacles in this image. The other portrait we have (presumably) of him – the *Mass of St Gregory* in Madrid – does not include them. In van Eyck's painting, the spectacles seem to indicate van der Paele's learning, his Jerome-like sagacity. But, we remember, van der Paele had received little, if any, advanced education. The learning he displays is thus more apparent than real, and this representation of scholarship was perhaps, in part, meant to counter criticisms of ignorant secular canons. And there is the fact that van Eyck shows van der Paele having removed his spectacles, thus indicating the intensity of his devotions, his inner vision. But we also know that this pious image of the donor was begun the same year in which he actually pulled back from such devotions, at least in public. The image seems compensatory, even self-serving.

It is usually thought that van der Paele was relieved of his meagre religious duties because of his age and ill-health; that, after all, was the official explanation at the time. But the Canon lived on for a further eleven years; he never, as far as we know, resumed his duties. It is difficult to gauge the nature of any individual's piety, yet it is true that some people, as they feel death approaching, become more visible and profuse in their pious exercises. In some ways, at least, van der Paele's behaviour does not conform to this stereotype. He did not, after all, declare that he was no longer able to say the offices, and then meekly retire home to die. Wealthy, old and infirm as he was, he still insisted on receiving his income from the Church. His negotiations toward that end do not seem like the actions of a dying man, one unable even to say the divine offices.

Van der Paele seems to have chosen a very calculated and pretentious way of using religious art. He did not simply commission a beautiful painting for a church in order to impress the faithful. He himself is thrust in among the holy figures it depicts. He is shown as pious in an idealized way; and his other lavish ecclesiastical gifts, such as vestments, are alluded to, at least. The painting was initially a private treasure; but, as even the inscription informs us by referring to the donor as a 'canon of *this* church', it was also meant to stand as a final, glorious public legacy. It commemorates endowments which, through specific prayers, it was hoped would secure salvation for van der Paele and his family. And all this was only made possible because of the complex financial negotiations conducted throughout the Canon's life between him and his Church.

7

The Function of Religious Belief for van Eyck

From what I have said earlier, one might be tempted to conclude that van der Paele, and van Eyck in portraying him, were no more than worldly schemers. It has seemed to some that this estimate might legitimately be made about other patrons of the artist, for example Chancellor Nicolas Rolin. I think it would be an exaggeration to see either these patrons or this artist as simply ambitious political manipulators, with little or no sense of religious striving. What I wish to do, then, is define more precisely the religious feelings that van der Paele did seem to have, and the way these were made visible in van Eyck's painting. I think, too, that in general, similar points could be made about van Eyck's other patrons. And, to some extent, he must have shared and promoted certain values which he held in common with a number of his contemporaries.

One social anthropologist has proposed that religion helps to sustain people, to guard them against a feeling of helplessness or enveloping chaos, in three ways: (1) When we are at the limits of our moral insight or ethical understanding, religious belief can help us to make sound moral judgements, which can be used to confront problems of injustice or unfairness in the world; (2) When we are at the limits of our endurance or strength, it can help us – not to avoid suffering – but to learn how to suffer, and this involves the problem of pain in the form of illness, mourning or death; (3) When we are at the limits of our analytical capabilities, it can give us the assurance that things are explicable, that order and meaning, even absolute lucidity, can be reached or discerned. In Einstein's words, religion can reassure us that 'God does not play dice with the universe'. What happens, then, if we use such a scheme to help us understand van Eyck's work, especially that undertaken for Canon van der Paele?

(1) Van der Paele does not seem worried about the inequities of life. They are referred to and subsumed by the institution of the Church. Some in the fifteenth century may have found his personal wealth and morality questionable. But for van der Paele, morality was not, I think, primarily a personal issue. Moral judgement has been separated from private experience. It is instead a corporate matter: it is a question of the Church being true to itself and to its members, praying for their souls and their eternal condition. Is the Church as a collective body tending to, nurturing the souls of, its devout? Van der Paele's loyalty to the Church, his continuing support for it, and his proclamation of its encompassing magnificence, are sufficient for him. He does not

44 Anonymous Utrecht artist, *Calvary of Hendrik van Rijn, c.* 1363.
Koninklijk Museum voor Schone Kunsten, Antwerp.

consider it the function of religious art to deal further with issues of personal morality or justice. I think we will see that the same can be said of Nicolas Rolin.

(2) 'In the year of Our Lord 1363, on the day before [the feast of] St Boniface and his companions, Hendrik van Rijn, provost and archdeacon of this church, and founder of that altar, died. Pray for him'. This is the inscription found at the bottom of an epitaph panel, no doubt paid for by the cleric it memorializes, which was made to hang in his church, St Jan's in Utrecht (illus. 44). Van Rijn had had an eventful career: for a period of time he was denied his clerical position, and presumably income, because of his political loyalties within the Church – not unlike some of the events in van der Paele's own life. Overall, however, van Rijn certainly had a prosperous career, able as he was to

endow an altar and pay for an elaborate painting. The panel still has its exceptional original frame, painted as though it were encrusted with huge jewels. The whole background of the work itself, except where there are figural elements, is plastered with pieces of gilded, embossed leather. The cleric himself, kneeling at the foot of the Cross, wears a vestment on which is embroidered his coat of arms – an interesting parallel to Canon van der Paele's fitting out of his chaplaincies at St Donatian's with vestments embroidered with his own coat of arms.

In certain ways this painting of and for Hendrik van Rijn can be said to resemble that of van der Paele – both in its material display and as evidence of personal ambition. But van Rijn kneels beneath a large and expressive figure of the suffering Christ. The cleric himself is small, looks somewhat pathetic, and is presented in profile. Now he is dead; we are asked to pray for him. However rich and personally aggrandizing the image is for the cleric, it finally calls for an emotional response. We too will suffer and die; our death, like that of both Christ and van Rijn, will also, hopefully, be mourned.

Canon van der Paele may be ill; to a physician today his painted physiognomy may even be seen to contain the tell-tale signs of his illness. Certainly that is not a judgement a fifteenth-century observer could or would have made. His is not a pathetic image. Nor has he chosen to make his work a painted epitaph, although it has in modern times wrongly been interpreted as one. Unlike documented epitaphs, such as that of van Rijn, the van der Paele panel contains no direct reference to the donor's death, or to the desire that prayers be said for his departed soul. As it happens, a separate grave relief was eventually made for van der Paele. But more to the point, the image painted for him by van Eyck leaves the issue of suffering aside as a private experience, which is the way van der Paele treated it, by retiring from active duty when he became sick. Van der Paele's religion may ultimately have made more bearable whatever aches and pains his body had been subject to. For him, religious art need not make a public declaration of human frailty. The truth of religious faith is more timeless than passing ailments, more real than physical complaints. In a strange way, in a world and in an image which seems so materialistic, it really is a case of mind over matter.

(3) It is all too easy to assume that an artist such as the one Hendrik van Rijn employed shows us a world physically more bare but spiritually far richer than van Eyck's. That would only be the case if one believed the problem of suffering to be somehow more profound than an intensely disciplined religious understanding of the world, which might even lead to the neutralization of pain. Can we really penetrate the secrets of religious faith, the truth of religious belief, so that pain and death seem no more powerful than the small marble statues placed by van Eyck on the Virgin's throne (illus. 26, 27)? These sculptures are clearly not meant to make us wince or feel pain, as the object of Hendrik van Rijn's devotion does. But to what do van Eyck's sculptures direct us? What religious concepts or ideas might be said to reside within them? I believe the most plausible explanation of their presence is that they reinforced ideas about the

Church Priestly and the Church Militant. Yet, other possible references have been suggested, and more will no doubt be made in the future. Van Eyck's imagery invariably calls up a scrupulous kind of theological rumination. Do the number of jewels or the variety of floor patterns and textile designs in this and other of his paintings have religious significance? In this artist's work many far-flung theological explanations seem plausible. His detailed world appears to be charged with possible, complex spiritual meaning.

The *Virgin and Child with George van der Paele* certainly reveals that van Eyck and his patron were fascinated by human pretension, human powers of divination and ratiocination. What they sought was not so much an intuitive feeling as an apparently detailed exposition of religious truth, something that might still reassure the baffled and delight the most critical of minds – something elegant and pure, finely conceived, subtly planned. Not less spiritual than those who would make of religion either a morality play or a psycho-drama, but certainly differently focused, differently aimed. In a time as fractured, as schismatic, as the early fifteenth century was, many people did seek comfort in religious belief, but the comfort they sought, and found, was certainly quite various. Some may have believed in self-denial, others in self-aggrandizement. Some may have trusted their emotions, others their minds. Van Eyck has for many years been considered the most intellectual of the early Netherlandish painters; and in that sense we may still not have penetrated all the intricacies with which he filled such images as the van der Paele painting. Perhaps that was not the point. Still, in this frame of mind, it is that possibility – even fantasy – we want held out to us. That van Eyck gives the fantasy of a complete rational explanation for religious belief so much reality is one of his greatest achievements. We do well to recognize the pretention, as well as the illusion, that lay behind such a goal in the early fifteenth century. Certainly at that time this ideal was considered by most people to be increasingly outdated, if not finally unattainable. In van Eyck's work it seems as much the promise of a complete explanation for all things seen, and unseen, that compels, as it is the actual production of such an explanation – which, in any event, was remote.

8

The Doctrine of Mary

Van Eyck painted four images that have come down to us of the seated Virgin and Child. They were executed over a short span of time – between 1434, when the van der Paele panel (illus. 23) was begun, and 1437, the date of the Dresden *Triptych* (illus. 81); the Lucca and Rolin paintings (illus. 45 and 61), are almost universally thought to lie within this period of production. In three of these works a donor kneels before or near the Virgin and Child; two have other, accessory, holy figures as well. One of the four is a relatively simple and direct presentation of the divine pair to the spectator alone; this is the so-called *Lucca Madonna and Child*, now in Frankfurt. What do these four different but chronologically closely linked images show us? What basic visual information do they share, and what sort of meaning is initially suggested?

The dominant visual element in all of these compositions is a rigid, seated figure clothed in what can only be described as a huge red mantle. The overall impression in each case is, in fact, of a large piece of folded cloth, rather than a person. This same thick and richly red material wrapping each figure is so massive that, except in the tiny Dresden *Triptych*, one gets little sense of any underlying human anatomy; perhaps one simply has to assume that there is a real body, however small, beneath. The effect is ultimately unreal, otherworldly. There is nothing humanly subtle or sinuous in this repeated figure. Van Eyck has created a goddess-like being, a piece of voluminously draped furniture, the embodiment of a throne. In three of the works the Virgin is seated on a throne, at least to judge from the armrests. But whereas human rulers are often dwarfed by their magnificent furniture, this woman, in the sense of her physical and material display, is more than a match for the throne which envelops her. She fills it and, notably in the Rolin painting, becomes one with it. She seems the natural incarnation of supernatural sovereignty. Her massive scarlet costume visually defines this.

The Virgin is a block, a shelf, a surface on which the Christ Child can be displayed. She is a massive Romanesque seat of power able to support and present the ruler-to-be. It is sometimes said that the Virgin is portrayed in the guise of a cult statue (compare illus. 33). Yet, even this analogy fails to do justice to the massiveness of her form. Trying to imagine the Virgin's body under her robe gives us some measure of how literally puffed-up her appearance is. This is an unprecedented kind of visual propaganda within an apparently realistic style of representation. No other fifteenth-century

Netherlandish painter presented her with such enormous and calculated dignity. Why in the 1430s would an artist seek to give the Virgin this monumental, regal quality? Why would she be so completely, protectively, draped in the signs of her office, immediately prior to her coronation as Queen of Heaven?

The Virgin Mary's massive formality and regality can certainly be related to the social ideal of these images. Although they were not, as far as we know, painted especially for the nobility, they exude an aristocratic or courtly ethos. This artist and his patrons surely believed that the appearances of power and wealth set forward by the nobility were a fitting model for the Virgin Mary. In van Eyck's work she has been drained of ordinary humanity in order to embody a social ideal of courtly decorum and presentation. His massive Virgins convey pointed religious meaning as well. On the frames of two of these paintings – the van der Paele panel and the Dresden *Triptych* – van Eyck has included his favourite Old Testament hymn to the Virgin:

She is more beautiful than the sun, and above all the order of the stars; being compared with the light, she is found before it. She is the brightness of everlasting light and the unspotted mirror of the power of God (Wisdom of Solomon, 7: 29, 26).

Again, the image in these words is one of supernatural perfection, flawlessly apparelled. One realizes this is no ordinary human subject.

Along with the notion of the Eucharist, the Doctrine of Mary was one of those most often discussed and debated in the fifteenth century. She had, of course, conceived Christ in purity and in a state of virginity, but was she in turn immaculately conceived by her mother, Anne? Was she, like Christ, an integral part of the divine plan of redemption, come to undo the sin of Eve, as Christ was to undo the sin of Adam? During the fifteenth century at the time van Eyck was painting these images, a high-point in discussions about the Immaculate Conception of the Virgin was reached between 1435 and 1439 during the Council of Basle. The Council finally ruled in favour of the Immaculate Conception in 1439. By that time the Pope had withdrawn his representatives, since he was unwilling to accept this or any other decision by the Council, which he felt sought to limit his power; the Doctrine of Mary's purity had to wait until the mid-nineteenth century to receive its eventual papal blessing. This controversy in the 1430s has more than a passing relevance for van Eyck's works. At the Council various theologians came forward in support of the doctrine of the Virgin's immaculate conception, for which they cleverly interpreted passages in the Old Testament, the writings of the Fathers of the Church and other patristic sources, as well as drawing on miracles for which the Virgin was held to have been responsible. In opposition were those who steadfastly held that the Virgin could not be exempt from the universality of original sin.

There are several ways that van Eyck can be said to present a rationale for the doctrine of the Immaculate Conception. Most significantly – visually – he shows the

Virgin to be such an ideal, otherworldly being that one could hardly doubt her power to overcome human limitations. The inscriptions represent the need for precise verbal meaning. They do not outline an original theological position; they are repeated, almost by rote, throughout the artist's career. They do fall in an area which, at the time, was controversial and which needed clarification. They express a point of view that at the time had to be proved and then officially accepted by the Church. Van Eyck's use of his favourite hymn does not by any means explain the function of these paintings; it does not tell us what the entire image is about. But it does signal a complex verbal issue, of which the visual artist has given us a compelling and original image.

Other special elements in these paintings no doubt also allude to the issue of the Immaculate Conception. Lions are carved on the Lucca Virgin's throne (illus. 46), reminding the informed viewer of the throne of Solomon, which in the Bible is described as having been adorned with many lions; in occupying this throne the Virgin is seen to be as wise as the fabled King Solomon. Mary's divine wisdom knew of her part in the plan of redemption, her role as the new Eve, come to undo the Original Sin of the First Parents. In the Christ Child's hand and on the window-sill in the Frankfurt painting is what appears to be the fruit of Paradise, that which tempted Adam and Eve. Carved on the throne in the van der Paele panel (illus. 26 and 27) are the figures of the First Parents themselves. On the Virgin's lap, beside the Christ Child in the Bruges painting, is a green parrot. As a talking bird, the parrot was thought to speak, appropriately, the word 'Ave', the beginning of the angelic salutation 'Ave Maria, gratia plena' (Hail Mary, full of grace). 'Ave' is also 'Eva' in reverse. Mary is the new Eve, taking her place in the redemption of sinful humankind. Her pure, sinless condition might also be the subject of allusions: the crystal carafe and brass basin in the *Lucca Madonna* (illus. 47). Her body was not defiled by the birth of Christ, just as light, passing through the carafe, does not shatter the glass. The wash-basin might indicate her spiritual, as well as physical, cleanliness.

Elements such as the chair carvings and 'still-life' details do not, I think, make up an elaborate and preconceived theological programme; they are combined here with many other, disparate, ideas and interests, stemming from both artist and patron. They certainly inform us of the need to support the Doctrine of Mary that some in the fifteenth century felt. Such people found sometimes quaint, sometimes dramatic, visual means to give presence to their belief in Mary's purity and grace, and, ultimately, in her Immaculate Conception. Although in van Eyck's work there are occasional smaller features alluding to the Virgin's purity, they are certainly not the most original aspects of his creations. What is original and visually striking is the monumental and formal nature of his presentations. His blatant visual propaganda about her size and shape does more to convince us about the Virgin's power than any one of his clever details. Ultimately, the total intrigue and impact of this image resides in both elements: the physical magnificence of the work is found in the larger conceptions as well as in the smaller

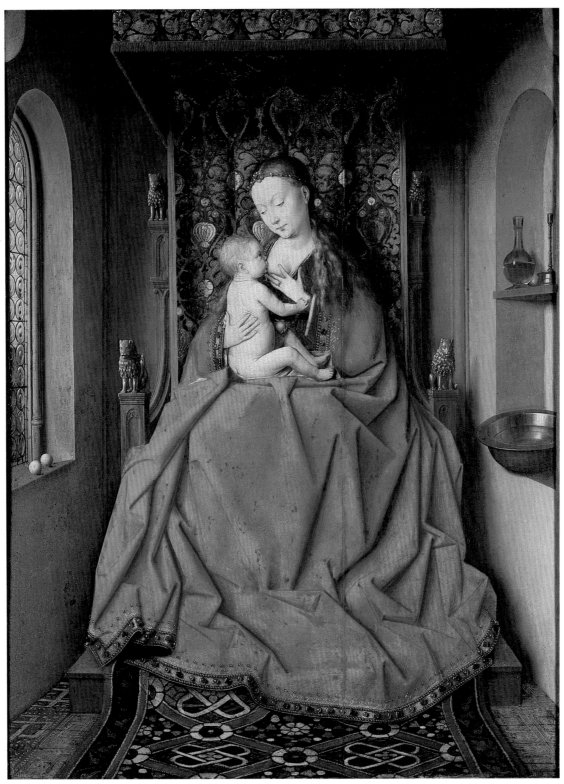

45 *Virgin and Child in an Interior (Lucca Madonna).*
Städelsches Kunstinstitut, Frankfurt.

46 *Lucca Madonna*, detail.

47 *Lucca Madonna*, detail.

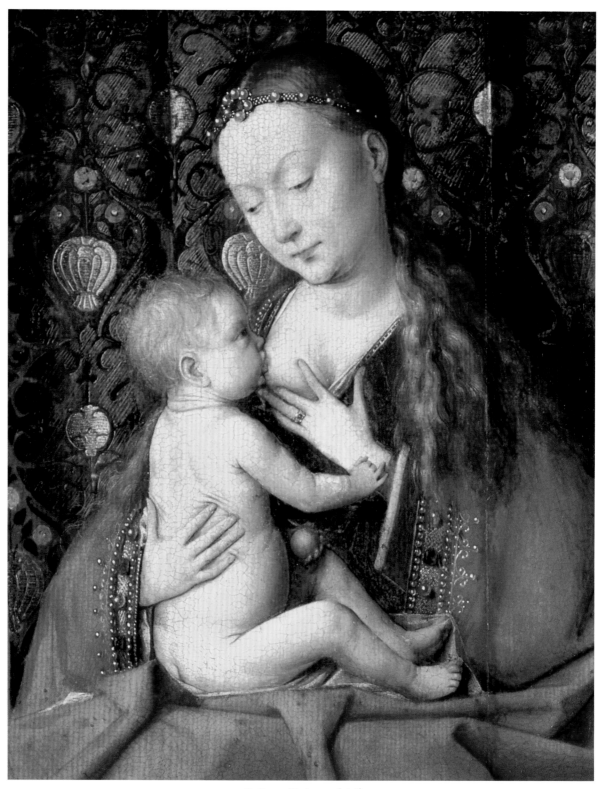

48 *Lucca Madonna*, detail.

supports. It is doubtly reassuring when physical size and display seems to be backed up by fine intellectual reasoning. Still when one looks at a work like the *Lucca Madonna*, what is most striking is the care and calculation taken in its composition, and the sense of ceremony. It might be wrong to say the details are totally secondary, for the casual placement of a few objects in this image makes one sense its overall symmetrical rigidity the more. A contemporary viewer must have seen here an ideal of courtly solemnity impressed upon the Queen of Heaven.

For van Eyck's paintings, it is important to recognize the controversial nature of the Marian ideology found in them. This, literally, puffed-up image of the Virgin is so for good reason. She needs this kind of support – visually impressive, and at times verbally pointed – to win her case. Van Eyck's seated Virgins can certainly be understood as traditional images of devotion, objects of individual worship and prayer. At the same time they are both subtly and strongly tuned to contemporary thinking, and draw a relation between social status and religious controversy. More than simply record, they advocate.

9

The Sacrament of the Altar

The appeal of the Virgin Mary in van Eyck's work to some extent rests on her ability to present and display her son. In the Lucca and van der Paele images (illus. 23 and 45), her knees form a convenient ledge on which the Child can perch. In the Rolin painting (illus. 61), a slit in her huge mantle opens, and she seems to push the Child out through it. In every instance the body of the Child has been stripped bare. His mother may wear a robe large enough to contain several people, but his swaddling cloth is small and, in any case, has been removed. When van Eyck chooses to show the Virgin standing, the Child is wrapped in cloth (illus. 86 and 87); in his seated images, Christ's nakedness is depicted in vivid detail. Once he is held to his mother's breast; once he is presented to the viewer in profile – directly facing the donor, Nicolas Rolin; and twice he is revealed, frontally, to the spectator. In these two frontal images the painter has spent as much time accurately detailing the Child's tiny genitals as he has any other object. This baby lives and breathes, blesses, touches, smiles. He is active, alive and human, while his mother remains passive, superhuman. Why? Why, at the same time that his body is so fully and precisely portrayed, is there only one small inscription (on the Dresden *Triptych*) referring to Christ – as opposed to the spotless radiance of the Virgin? Are these paintings not about Christ, about *his* body, about the vision we might have of *his* mission on earth – to live and die as a human being? Perhaps that is too obvious, even sentimental to write about. Perhaps, also, it is not controversial.

The large red robe worn by the four seated Virgins refers in part to Christ's blood, first shed at the circumcision and, later, on the Cross. But it also suggests the Virgin's own blood, which flowed when Christ was born. By contrast, the two standing Virgins van Eyck painted later in life are both dressed in blue – and the child's body is partially covered. The red colouring of the seated figures suggests both the human and sacrificial dimension of these scenes. Christ is not yet circumcised – he never is in Renaissance art. To present him as circumcised might have been thought too much of a defilement for his perfect and complete human form. Sculpted figure groups refer to Christ's sacrificial role here. Scenes of death, sacrifice or exposure are contrasted with victory and triumph over great odds: Cain killing Abel appears in the van der Paele panel (illus. 26); the Sacrifice of Isaac in the van der Paele panel and Dresden *Triptych* (illus. 25 and 82); the pelican plucking her breast and bleeding so that her young might

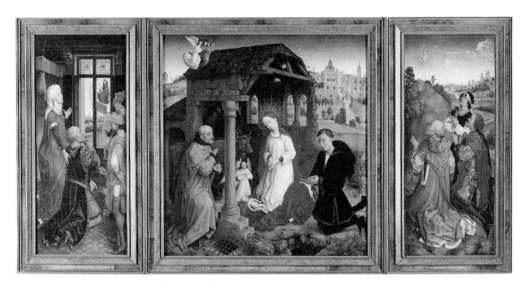

49 Roger van der Weyden, *Triptych with the Nativity (Bladelin Triptych)*, *c*, 1445.
Gemäldegalerie, Berlin.

live is also shown in the Dresden *Triptych* (illus. 82); and the Drunkenness of Noah, a
sign of Christ's shame in the Passion, in the Rolin work (illus. 64). All are portrayed on
the left-hand side of the composition in which they feature. On the right-hand side we
find victorious images: Samson forcing open the Lion's jaws, as Christ did the gates of
Hell, appears in the van der Paele panel (illus. 27); David's defeat of Goliath is also
featured there and in the Dresden *Tryptych* (illus. 29 and 82), where the Phoenix
Rising from the Flames is also found. These are eloquent testimonies to the power of
the body of Christ.

It is a truism to say that lay as well as some religious people throughout the late
Middle Ages placed an ever-increasing emphasis on the humanity of the Son of God. In
art this often led to poignant portrayals of Christ's infancy. Images of the baby Christ as
a vision of the donor are found repeatedly in early Netherlandish art, perhaps nowhere
more concertedly than in Roger van der Weyden's *Nativity* triptych in Berlin (illus. 49).
Here, in the centre of the triptych, the donor's vision of the new-born Child is matched
in the wings by the Emperor Augustus' vision of the Child held forth by his Mother, and
by the Magi's sighting of the Child as a star in Heaven. In another mid-fifteenth-
century Flemish image, found in the prayer-book of Duke Philip the Good, the Christ
Child is displayed – even his human sexuality is specifically displayed – on an altar, for
the edification of his parents and friends (illus. 50). This scene stands for the
presentation of Christ to the high priest Simeon in the Temple, but, in this represen-
tation, it has been turned around to become the Child's physical revelation to his
followers.

Such devotion to the human body of the Christ Child is not sophisticated in
theological terms. It betrays a rather simple and affective piety, which had it roots in the

50 Jean Le Tavernier (attrib.), *Presentation in the Temple*, *c.* 1454–5, from the *Book of Hours of Philip the Good of Burgundy*.

51 Master of the Munich Golden Legend, *Patroness Receiving Communion*, *c.* 1435, from a French Book of Hours.

52 Anonymous South Netherlandish artist, *Adoration of the Sacrament*, late 15th century. Koninklijk Museum voor Schone Kunsten, Antwerp.

53 Attributed to a painter of the Gold Scroll Group, *Adoration of the Sacrament*, *c.* 1440, from a Bruges Book of Hours.

eleventh century and twelfth, surfacing with even greater force in the fourteenth century and fifteenth. Van Eyck's seated Virgins, holding their young charges, are in part a reflection of this impulse. These four paintings are about the fifteenth-century search for Christ's humanity. The painter reveals his emotional side, his anti-intellectualism (if, within the context of his century, we can call it that), in the small figure of Christ. This child, innocent and alive, revealed in his still perfect human form, will bleed, repeatedly, before his death and resurrection. Here, blood, sacrifice and even resurrection seem pale metaphors for the truth of this vision, this human revelation. Van Eyck says: Christ was a baby, small and helpless in his presence, but grand and impressive in his mission. His mother supports and nourishes him; she too is part of the plan. But the plan is simple, childlike; primitive, in fact, like a peaceable kingdom.

Modern viewers are tempted to see van Eyck's four seated Virgins as symbolizing Church ritual, the Mass. In this way the Virgin stands for the altar and the Christ Child for the eucharistic wafer. One might even speculate further on the role of the Virgin – her priesthood – as she offers up Christ's body to donor or spectator. Today these works are often thought of as altarpieces, works which were hung over Christian altars; although, so far as we know, none of van Eyck's six images of the Virgin and Child originally served that purpose. His paintings are said, however, to reveal the complex ideology of the sacrament of the altar which some Catholic theologians had, over the centuries, constructed.

For several reasons I believe that this view of these images is misconceived. Not the least of these reasons is the fact that artists at that time were perfectly capable of painting images of the Mass – the patron partaking of the wafer, the adoration of the host – if they so chose. Such is the case with the *Mass of St Gregory* (illus. 39), discussed above in relation to the van der Paele painting, and with numerous prayer-book illustrations of donors eating consecrated wafers (illus. 51). Such is also the case with a later fifteenth-century Netherlandish painting in which the Pope is shown holding the precious wafer encased in a monstrance, while angels sing its praises (illus. 52), or with other manuscript illustrations of similar scenes (illus. 53). This is certainly not what van Eyck has portrayed. Nor, I think, does he mean for us to approach his paintings as though they were merely clever, realistic versions of these obvious sacramental images.

To most lay people in the fifteenth century Christ was increasingly thought about in human, physical, terms. He was worshipped and adored in all his human parts – eyes, breast, toes and even foreskin. This focus on physical matter, Christ's human existence, led in one direction to *imitatio*, the imitation of Christ – his feelings, experiences, and especially his Passion, over and again. In another direction it resulted in the adoration of various signs or symbols of his body thought to have been left on earth. In Antwerp, for example, a relic of the Holy Foreskin was worshipped with increasing fervour from the mid-fourteenth century. Bruges, on the other hand, had a precious relic of the Holy

Blood, which continued to bleed on specific occasions. Blood was a particularly prominent motif in late medieval art and religion – the blood of Christ's humanity: its power proved his divinity. The eucharistic wafer became a kind of relic of Christ's body, encased in a monstrance, repeatedly displayed for the faithful. Hosts that bled were best, and there were reports throughout Europe of such miraculous occurrences. Pope Eugenius IV gave van Eyck's patron, Duke Philip the Good, a miraculously bleeding host (illus. 54), and Philip had a chapel built at Dijon to contain it. These events illustrate an obsession with the physical manifestations of Christ's body on earth, which I think van Eyck also betrays.

54 Anonymous French artist, *Miraculous Host of Philip the Good,*
c. 1435, from the *Book of Hours of René of Anjou.*

We know today how many hosts and how much ablution wine was consumed during the early fifteenth century in the various Bruges parishes, including St Donatian's. The amounts seem small, when one considers the size of the population at that time. Only about ten per cent of the people regularly participated in the sacrament. This was due, in part, to the ever more complicated notions put forth by the clergy about when and how lay people could partake of the sacrament, including the necessity of such things as a full confession. The extravagance of their feelings about the body of Christ was then, almost by default, expressed through their adoration of the idea of the Real Presence of Christ in the consecrated wafer. While the Church increasingly placed restrictions on their consummation of the host, the populace at large clamoured for prolonged

elevation at the moment of transformation. The reserved host that had been trans-
formed into Christ's body had to be kept and displayed: Corpus Christi processions
were extremely popular. The goal became that of simply seeing the body of Christ; it
was not so common actually to partake of the sacrament. Theologians may have been
debating, in rather abstruse terms, the exact nature of the relation between Christ's
body and the substance of the wafer. Many lay people, as well as some mystics,
continued unheeded in their, sometimes naive, search to *see*, to have a vision of the body
of Christ itself. From the eleventh century and the twelfth, many people began to have
visions of the radiant Christ Child when the host was elevated during the Mass. All this
indicates a desire, and in some ways a need, to cut through the sacrament, to penetrate
to what some felt was the reality beyond it, something which should not be obscured by
the Church's rigmarole.

The sacrament of the Eucharist was an ecclesiastical symbol, or reminder, of the
Body of Christ. According to Catholic doctrine, the wafer, upon consecration, became
the real body of the Saviour. In the popular imagination, the purpose of the ritual was to
get at the body itself. Van Eyck might be said to paint the reality of this search; in his own
way he penetrated to the reality behind the eucharistic symbol. From this point of view,
the host was a later representation of the real body that van Eyck lays before us.
Likewise, an actual altar in a church repeats – re-presents – the support that, in the
image, the Virgin gives to Christ's body. It is not, however, the reverse that is true: the
lap of the Virgin does not simply symbolize the altar. What we see in van Eyck's work
was meant to be more essential than any merely earthly ritual. If, as is sometimes said,
these paintings were symbolic of the Mass, then they would symbolize a rite which, in
certain ways, is a construction, or metaphor, for what they represent in literal terms.
Why would an artist go through such roundabout visual and mental gymnastics? Why,
as one critic has asked, at the moment when aspects of Christianity seem to have been
taking on a broader appeal, would such an involved system of symbolism be invented?
Why not cut through the intervening rigmarole and penetrate right to the heart of the
mystery of the Faith?

Some authorities in the fifteenth century were in fact worried about excessive
adoration of the eucharistic wafer – too much attention to the sign and not enough to the
reality of Christ; rather than worship a piece of bread, people should think on Christ's
earthly life, declared Nicholas of Cusa, an admirer of the early Netherlandish painters.
If van Eyck's paintings were indeed disguised meditations on the sacrament of the
Eucharist, then they too might be said to be guilty of such liturgical idolatry. But his
works can be seen as a response to such criticism, in the way that they pay more
attention to the body of Christ itself than to the ecclesiastical symbol of it.

These images do – and are meant to – remind us of the eucharistic rite, the wafer and
the altar. Clearly, the host is one form of the Body of Christ that, according to Catholic
theology, continues to be present on earth. That sacrament is one means by which the

Body of Christ is made manifest to the faithful. Any painting concerned with the incarnation of Christ and his subsequent sacrifice might want to call to mind the eucharistic ritual, in order to remind the spectator that the ritual is one that is also meant to produce a vision of the body. The ritual might then be called a current analogy for the archetypal scene imagined by the artist. The ritual is, therefore, something else to think about; it is not the symbolic core hidden within the visually accessible nature of the image.

This is the opinion expressed by some theologians in the fifteenth century. Writing in the 1480s about the relation of Christ's sacrificed body on the Cross and the eucharistic wafer, Gabriel Biel observed that although the historical body of Christ was thought to be present in the Mass, the sacrifice on Calvary was not reiterated there, it was only symbolized: the Mass represents Calvary, but the Crucifixion does not represent the Mass. The reiteration of Calvary that takes place in the Mass is not of the historical nature of the Crucifixion, 'because the meritorious value of the oblation of Christ in the sacrament of the Mass is much less than that of his sacrifice on the Cross'. I believe a similar point might be made about van Eyck's favoured images of the Christ Child. Although this Child may be represented in the Mass, although a vision of him can accompany the elevation of the host, the Child, the body itself, is much more than its representation in a eucharistic wafer. On the one hand, the Christ Child is a vision of something everlasting, in its particular human form, while on the other hand, the communion wafer refers to a ritual that is particular and earthly but seeks, at least for a moment, to touch the eternal. It is in the realism of van Eyck's images that attempts are made to illuminate this situation.

We have become used to undervaluing the realism of early Netherlandish painting: it is often thought to be no more than a vehicle for some greater meaning. But realism is, finally, the reason these images came into being. Van Eyck's images of the seated Virgin and Child are not representations of something else, something other than what we see. They are, to begin with, just that – a representation of what we see, or at least what we hope and pray we might see. In all the devotional literature of the time, the pious are never urged to imagine some complicated abstract concept, a metaphor; they are not told to meditate on the eucharistic wafer. Rather, the faithful are asked to see the thing – the life and body of Christ – itself. These paintings, then, gave the spectator a new way of understanding the Mass. The Mass, too, could become a way of seeing the body of Christ. With the help of these images, the sacramental metaphor was made more believable, more real, more true for van Eyck's patrons.

10

The Patrons of Domestic
Religious Imagery

❧

Let us look more closely at one of van Eyck's seated Virgin images, which seems to place particular stress on the issue of Christ's humanity. The *Lucca Madonna and Child* (illus. 45) is the most simple, most stripped-down rendition of the seated type of Virgin and Child by him to have come down to us. In a rigidly symmetrical composition, extreme even for this most orderly of artists, van Eyck presents two figures whose human interaction is carefully embedded in compositional formality. The geometric clarity of form is overwhelming. It makes one wonder why the artist has not shown us a simple flat ceiling for his imagined chamber; instead, small corner colonnettes, which bend toward the panel's top, seem to suggest that the room is rib-vaulted. One would say that the setting is domestic, if only because there are no obvious ecclesiastical elements or furnishings. Yet, I think we must also acknowledge the fact that the artist has not painted a space whose location is unequivocal. Does the rib-vaulting suggest a domestic chapel? Or is it merely a relatively private prayer-space in a larger ecclesiastical building? This concentrated image of the Virgin nursing Christ may incline us to favour the domestic argument, yet the work's formal grandeur clearly takes us beyond any simple, homey, description of place.

As the artist's most domestic – and yet most anonymous – image, the *Lucca Madonna and Child* presents a particularly challenging question about patronage: is there some way of telling who commissioned this work? To whom would it have meant to appeal? Its popular title – which refers to the Italian city where it was found in the nineteenth century (it was then in the collection of the Duke of Lucca, who at that time was a Bourbon) – is sometimes thought to mean that it must originally have been an Italian commission. Van Eyck was certainly patronized by at least one Italian merchant from Lucca – Giovanni Arnolfini – and, in general, his works excited great interest south of the Alps. Even if the patron of this work was an Italian, we would still be left with unanswered questions: was it a man or a woman, bourgeois or upper class, cleric or lay? How might the patron's gender, and his or her political and religious leanings be evidenced in the image?

Who stood to gain – and how – from the development of realism in early fifteenth-century Netherlandish panel painting? Is there a way that the growth of realism can be

said to reflect, or be stimulated by, the interaction of men and women, rich and poor, religious and lay? These are questions not often asked about this type of art. Perhaps these works seem altogether too elitist to be much concerned with controversial social, political or religious matters. For many people today, van Eyck's paintings seem to operate on a very high level of disinterested intellectual and religious striving. But could this artist's paintings be made to reveal some of the social and political tensions that we know existed at the time between, say, the nobility and the urban middle class? Or the sexual tensions that existed between men and women? Or the religious tensions between cleric and lay?

Within the development of visual realism in Flanders in the fifteenth century, we could separate out the use of middle- and upper-middle-class domestic settings and objects in religious scenes. Most images were becoming more accessible, more believable, in their relation to the visible world, but some in particular contain contemporary, but more humble, details and environments – wooden chairs, tables, shelves, fire-screens, brass pitchers and basins, flat or bare walls and ceilings. We find this kind of thing specified in contracts by the middle of the century: it is requested that beds, for example, are to be portrayed as they are found in the homes of *seigneurs* or bourgeoisie. The surviving paintings from 1425–50 that would be included in this category include the Mérode triptych (illus. 55), the *Virgin before a Firescreen* (illus. 56) and the Leningrad diptych and Heinrich Werl wings, all of which are usually attributed to the Tournai painter, Robert Campin; and the Ince Hall *Virgin and Child*, attributed in the past to Jan van Eyck (illus. 57), and the Louvre *Annunciation*, attributed to Roger van der Weyden (illus. 14).

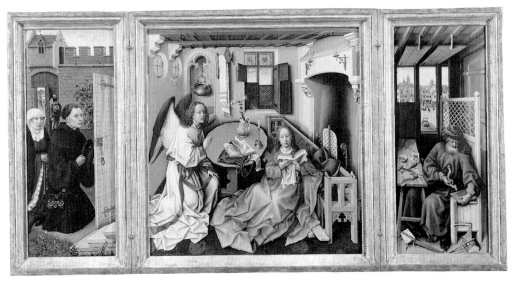

55 Attributed to Robert Campin, *Triptych with the Annunciation (Mérode Triptych)*, *c.* 1425. Metropolitan Museum of Art, New York.

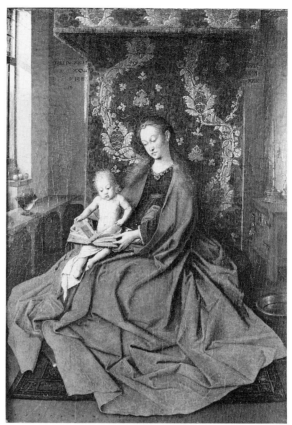

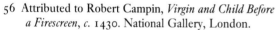

56 Attributed to Robert Campin, *Virgin and Child Before a Firescreen*, c. 1430. National Gallery, London.

57 Anonymous 16th-century (?Spanish) artist, *Virgin and Child in an Interior (Ince Hall Madonna)*. National Gallery of Victoria, Melbourne.

Traditionally, then, the invention of this form of domestic imagery has been credited to the founding fathers of early Netherlandish painting – Robert Campin, Jan van Eyck and Roger van der Weyden. But all of these works have been seriously doubted as being executed by the hand of such well-known masters. The Campinesque works are questioned on stylistic and technical grounds; the Ince Hall *Virgin* cannot be an Eyckian work, on the basis of technical evidence; and the Louvre panel has for many years been considered stylistically problematic. It is quite possible, then, that domestic religious imagery was not first conceived by a small group of prominent painters who were, as far as we know, engaged in work for a relatively elite clientele. (Even Robert Campin, often cited as the archetypal middle-class painter, was patronized by the municipality of Tournai as well as the local nobility.) What seems just as likely is that bourgeois imagery came from the minds and brushes of the numerous other middle-class artists working at that time in various Flemish cities, including Tournai, Bruges and Brussels – artists who are repeatedly mentioned in the archives but from whom we have no documented or authentic works. Today we might tend to describe these artists as 'followers' of the leading masters. But this would not be accurate in the narrow sense of the word, only in a more contemporary, generic sense, owing to the way art was practised in shops, guilds, and areas of town that were under the dominant local stylistic influence.

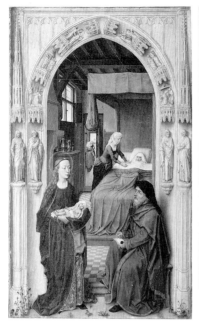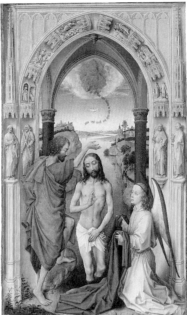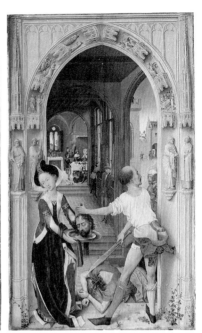

58 Roger van der Weyden, *St John Altarpiece, c.* 1455.
Gemäldegalerie, Berlin.

If this is true, then domestic imagery might well be taken as a sign of the social forces in motion at the time, of the desire of the rising middle class to appropriate realism for its own purposes. By the middle of the century, artists like Roger van der Weyden may have absorbed this type of imagery, for example in works like the Columba (illus. 74) and St John triptychs (illus. 58), and certain rather prominent middle-class artists like Petrus Christus and Dirk Bouts may have used it repeatedly. But for almost a generation (between 1425 and 1450) it did not appear in any works verifiably executed by the leading masters.

What does this mean for our understanding of van Eyck's *Lucca Madonna and Child*? He presents us with a space clearly constructed for the sole purpose of venerating the divine pair. A large regal canopy and cloth of honour, oriental rug and painted floor tiles fill out the space; this is not by any means an informal bourgeois environment. Yet, certainly within van Eyck's career, and also within the history of early Netherlandish painting up to 1450, we would not be wrong to call this a rather spare, domestic-seeming image. It does not have either the palatial or the ecclesiastical grandeur of any of van Eyck's other surviving religious interiors. It may not be meant to be middle class, but that does not prohibit it from partaking to some extent in a simpler, more straightforward bourgeois ethos. The objects in the niche to the right, the brass candlestick and basin and glass vase (illus. 47), are not elaborate or highly ornamented. It is their solidity and visual simplicity, their tangible everyday quality, that the artist brings out.

Domesticated religious imagery is one of the best examples of the increasing ability of fifteenth-century Flemish society to appropriate personally and socially whatever religious message was deemed important. One's world, one's way of life, was in a very real sense justified by being, at one's own request, the setting for the highest truth. Was van Eyck's *Lucca Madonna and Child* commissioned by a prosperous upper-middle-class individual solidly placed in city affairs, the owner of an elegant new house in town? Or was it destined for a person of noble birth, of perhaps a more dissolute or extravagant lifestyle, one who was happy to pre-empt some of the simplicity-with-solidity which characterized many of his socially mobile – and rising – contemporaries? Although the first is more likely, we should acknowledge that both scenarios are possible here.

The *Lucca Madonna* is also van Eyck's most personal, maternal, image. It is like a portrait of the holy pair, engaged in an act indicative of their intimate human relationship. One critic has even suggested that this may be a likeness of the artist's wife, Margaret, and one of their new-born children (she gave birth in 1434 and 1435). While the face of the *Lucca Madonna* bears some resemblance to the artist's portrait of his wife (illus. 7 and 48), it is still an idealized countenance, and it would be hard to believe that the image was meant simply as an honorific portrait. The possible relation between Virgin and wife does suggest, however, that van Eyck was taking the suckling motif quite personally, quite seriously.

The Virgin nourished Christ, as he in turn will nourish the faithful. Milk flowed from the Virgin's breast as blood flowed from his side. The Child holds a fruit, something else to be eaten, to give nourishment. As was usual in art at this time, the Virgin's breast in van Eyck's painting is small and awkwardly placed – it is an attribute of nourishment. That does not prohibit the Virgin from visibly pressing it in Christ's direction, enabling him greedily to suck it, filling his cheeks with the warm milk. This is a clear focus on the nurturing mother and the needy human infant. A strong emphasis on spirit as food, on spirit as body – bleeding, flowing, suffering and transforming – is found in women's devotional writings from the twelfth century onward. Men had visions of the lactating Virgin too – such as St Bernard's Virgin, who squirted her milk straight at him (illus. 59). But it was clearly women who consistently and repeatedly felt and described such nurturing imagery most vividly. Writing in the fourteenth century, Catherine of Siena even described the wound in Christ's side as a breast from which the faithful must nurse.

It is the combination of milk and blood in van Eyck's painting that is suggestive here. It is not only a nursing Virgin or a bleeding, soon to be circumcized, Child, but the two together, of necessity related, even made parallel. Does van Eyck's intense, overlapping food imagery suggest a female patron for the work? Or a male patron who wished to participate in the growing focus on such an imagining? It is not possible to say whether it was a man or a woman who commissioned the painting. Nor with certainty can we say that the work has a specifically female bias or appeal to it. Whereas much late medieval

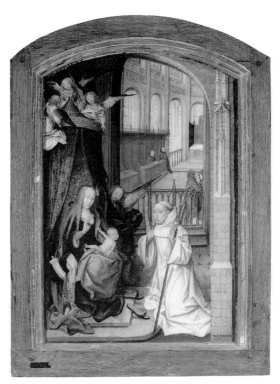

59 Master of Delft, *Virgin and Child with St Bernard, c.* 1500.
Rijksmuseum het Catharijneconvent, Utrecht.

devotional imagery emphasizing nurturing was generated by women, some certainly came from men. There is just a possibility that when putting together the painting's elements, van Eyck, or his patron, was not only aware of such writings, but of their predominantly female origins and appeal.

All of van Eyck's religious paintings, the *Lucca Madonna and Child* in particular, can be said to represent a trend in art to visualize, in ever more believable terms, an alternative to traditional Church-based worship and ceremony. In this painting we seem to be far from the laborious performance of the sacraments required by the clergy (illus. 38). This is a private world of adulation and prayer. Van Eyck's religious mysteries may be related – but they are not identical – to those under strict clerical control. I am not aware of any evidence from the fifteenth century of a cleric complaining that a lay person's private devotion was leading to a dereliction of parish duties. We do know that the clerical hierarchy worked diligently to control and restrain other forms of popular religious expression, such as pilgrimages and processions. We also know that clerical complaints were often voiced about poor church attendance, especially at Mass. But did any of the clergy at that time see the increasingly private nature of prayer, the ever-present personal devotional handbook or image, as a threat to their organized communal fellowship? Probably not – as long as they felt, like Canon van der Paele, that they could control and participate in these more private affairs.

I have suggested above that van der Paele was to some extent pre-empting the power of this personal devotional movement. Van Eyck's *Lucca Madonna* is perhaps the artist's strongest statement of interest in modern devotion. This calm, maternal and domestic-seeming image brings religious life home. But to whose home is it brought? That of the lay person, or of the cleric (whether secular or regular)? Van der Paele's commission would indicate that we cannot rule out the possibility that the *Lucca Madonna and Child* was paid for by a member of the Catholic clergy. On the other hand, perhaps we should imagine a lay woman as the patron, like the one who commissioned the Book of Hours now in London (illus. 60). Is van Eyck's image as likely to have been commissioned by a male cleric as by a lay woman?

My reason for engaging in such speculation is to highlight the notion that this artist's religious images, even rather anonymous looking ones like the Lucca panel, can be seen to reflect a patron's wishes, either by promoting his or her actual position and sensibilities, or by appropriating those sensibilities admired in someone else. Issues of gender, social class or clerical perception are embedded in the images. These are not asexual, apolitical or mere traditional religious works. Patrons in the fifteenth century had self-interests, which moved from promoting themselves as they were, to promoting themselves as they might wish to be, perhaps more in tune with the strong forces moving through and altering their society at the time. In the *Lucca Madonna and Child* we are confronted with an image that can be judged to be van Eyck's most domestic, lay and female-oriented work. Does this mean it was commissioned by an Italian merchant's wife? Whatever is the case, a variety of interpretations of this painting would have been available to contemporaries, each of whom brought to bear on it a particular wish or desire, with regard to both their present and their future life.

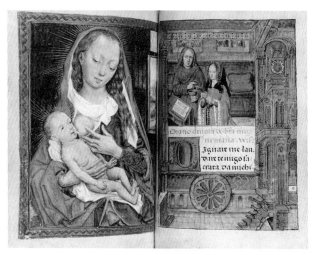

60 Anonymous Bruges artist, *Joanna the Mad at Prayer before the Virgin and Child*, c. 1500, from the *Book of Hours of Joanna of Castile*.

11

The Confession of Chancellor
Nicolas Rolin

In addition to the many costly donations he made throughout his life, both to his parish church in Autun and to the hospital he founded in Beaune, Nicolas Rolin did not miss many opportunities to exercise his materially rich and ostentatious taste. Despite having been born (in 1376) into a bourgeois family in Autun, at the height of his career Rolin claimed to have come from a noble background. When he died in the town of his birth in 1462, aged eighty-six, he decreed an elaborate three-day mourning rite 'en publique vue du monde', as well as his final burial costume:

. . . a white shirt, rich doublet, hose, new shoes, a velvet robe, a sword buckled on one side, a dagger on the other, golden spurs on the feet, a hood at the neck, a hat on his head, and above all a golden pin on the front of his hat.

All this was duly recorded by the Burgundian court historiographer, Georges Chastellain. Van Eyck's painting of Rolin (illus. 61) corresponds in many ways with such Court-inspired displays of contrived construction and finery. The space van Eyck imagines gives the impression of being both rich and ample. The richness comes from beautiful inlaid floor-tiles, delicate carvings on capitals and mouldings and a variety of effects from coloured and bull's-eye glass. The feeling for amplitude comes from the additional spaces we glimpse through openings to the left, right and centre. In actuality, the central space in which the Chancellor and the Virgin and Child are posed is a constricted one – a hothouse bubble, carefully contrived for the kneeling and seated figures. Judging from the size of the floor-tiles, Rolin and the Virgin are barely six feet from the arcades. If they stood up, it is doubtful whether they could comfortably move through any opening. As do the capitals above Rolin's head and the filigree object held over that of the Virgin, the space itself crowns and surrounds this human and divine interaction. Like a crown, the room can be taken to signify the Chancellor's reward for providing clever and well-calculated services to Court and Church.

How can we evaluate this sense of material success, alongside the apparent piety of Rolin's devotions, together with the piety exhibited by the Chancellor's other donations and charitable foundations? Was he sincerely interested in reviewing and spiritually improving his life, or was he an opportunist, anxious to strike another deal – 'to

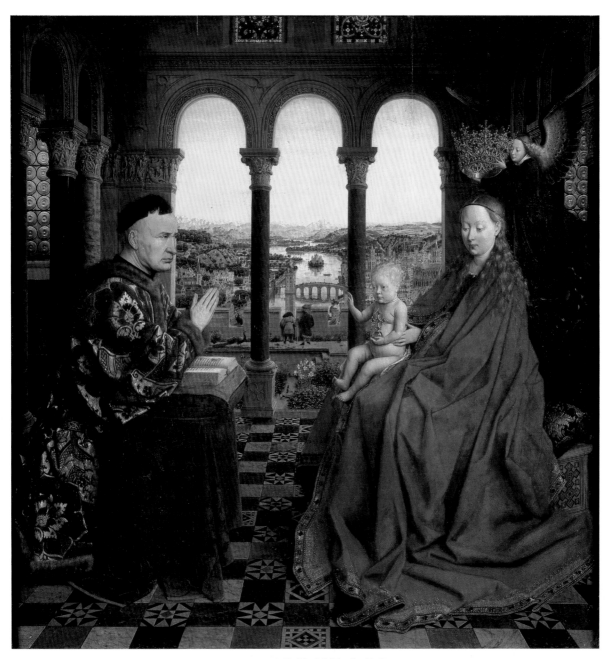

61 *Virgin and Child with Nicolas Rolin*.
Musée du Louvre, Paris.

OVERLEAF
62 *Virgin and Child with Nicolas Rolin*, detail.
63 *Virgin and Child with Nicolas Rolin*, detail.

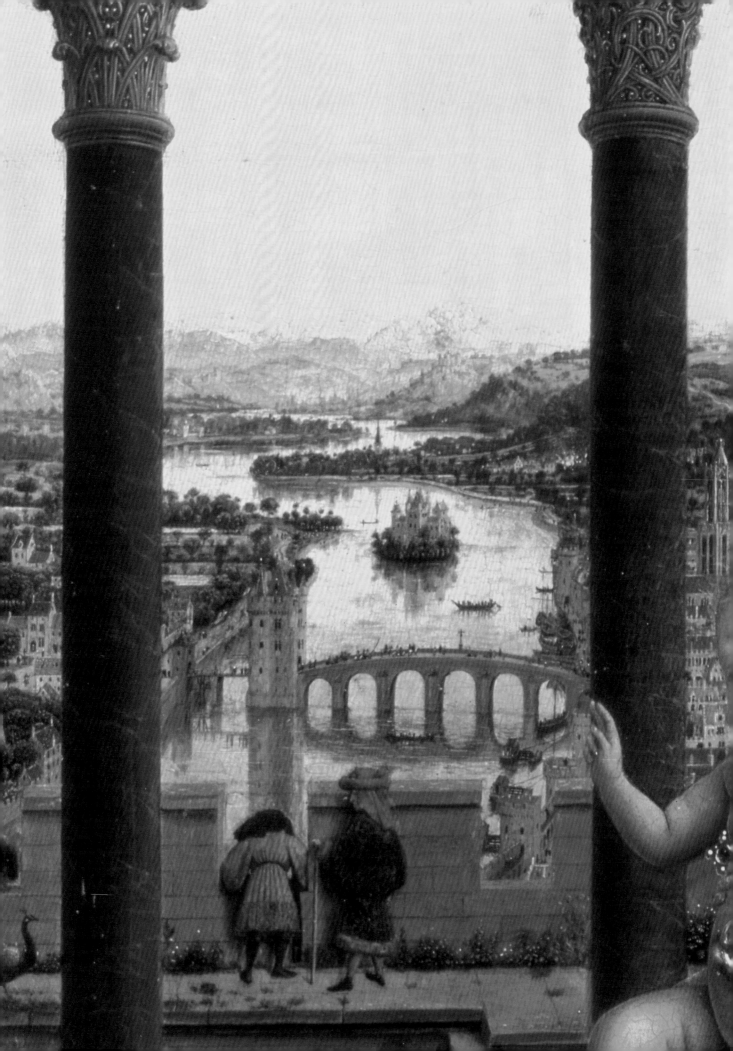

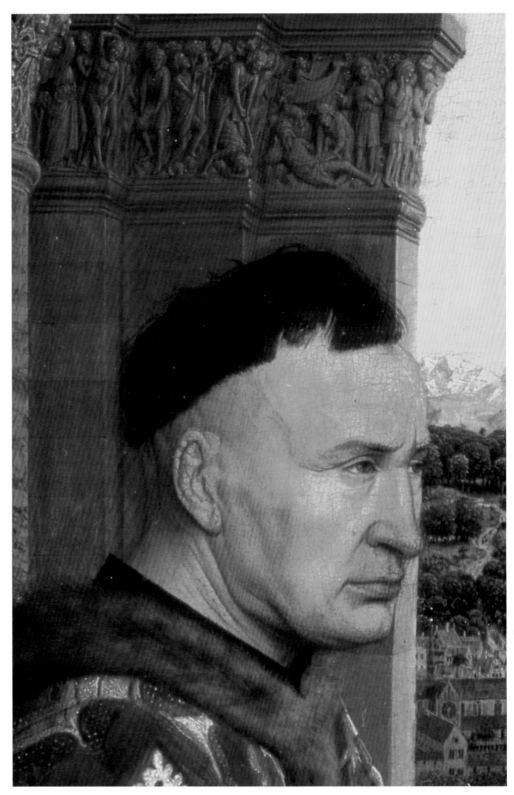

64 *Virgin and Child with Nicolas Rolin*, detail.

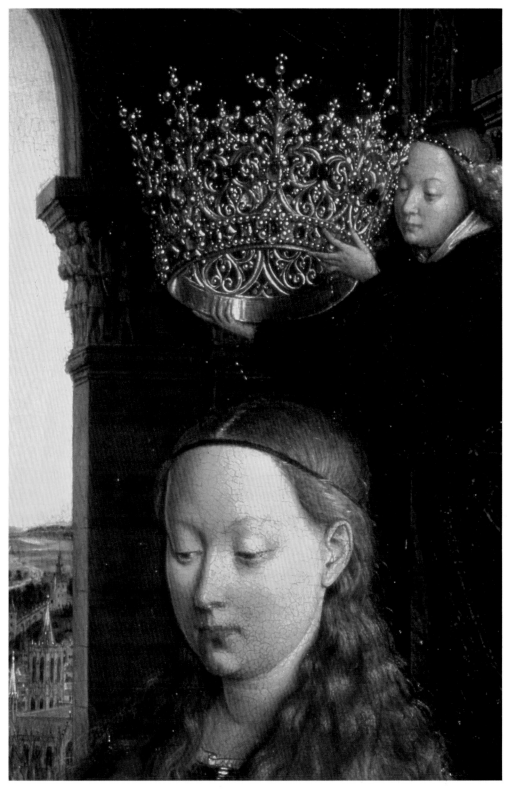

65 *Virgin and Child with Nicolas Rolin*, detail.

66 *Virgin and Child with Nicolas Rolin*, detail.

67 *Virgin and Child with Nicolas Rolin*, detail.

68 *Virgin and Child with Nicolas Rolin*, detail.

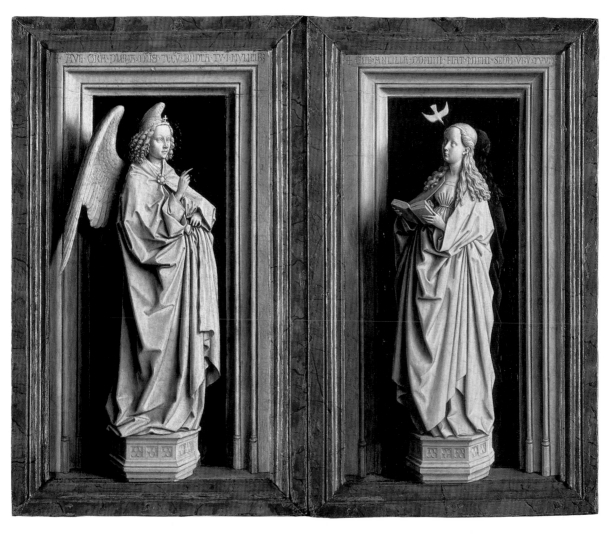

69 *Annunciation Diptych*. Thyssen-Bornemisza Collection, Lugano.

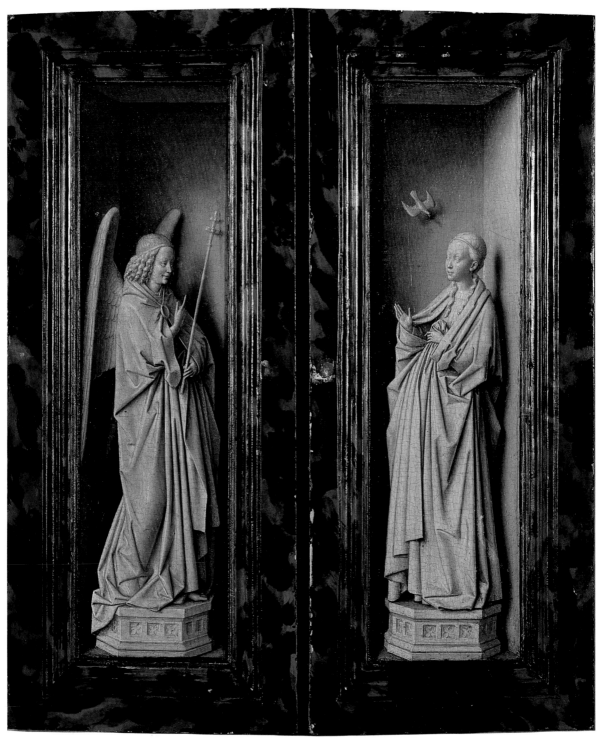

70 *Dresden Triptych*, exterior.

71 *Virgin and Child with Nicolas Rolin*, reflectogram detail of Rolin's purse.

exchange for celestial goods temporal ones', as it was stated in the foundation charter of the Beaune hospital?

Van Eyck's painting itself is replete with complex messages. Here the Chancellor is even more perfectly attired than he dictated he wished to be at his death. We also know that the artist and his patron had originally contemplated including a large purse, trimmed with gold ornament, which was to hang at the donor's side. It can now only be seen with modern technical means, under successive layers of paint (illus. 71). Was it a sense of pious propriety that kept this purse out of the finished work? Outside the room in which Rolin kneels and the Virgin sits is a beautiful sunken garden. It might reflect the horticultural interests of a rich patron; this was the way it was interpreted in a creative copy of van Eyck's work made later in the century by the Master of Ste Gudule (illus. 72). Or it could be a *hortus conclusus*, an enclosed precinct dedicated to the Virgin. On and in front of the crenellated wall of this garden are three peacocks; these birds were understood to be Birds of Paradise, but they were also indicators of worldly pride and ambition. The crenellated wall, situated as it is high above the city, has been

72 Master of the View of Ste Gudule, *Virgin and Child with a Female Donor and St Mary Magdalen*, *c.* 1470–90. Musée Diocesain, Liège.

explained as placing the foreground confrontation in a spiritual watchtower. In Bruges at that time, such fortress-like touches were to be found on several of the most grandiose mansions, complete with little roof-houses, and perhaps also roof-gardens, above them (illus. 73). Is the donor very much above the earth in spiritual terms – or only from a physical, earthly point of view? Is that a paradisiac landscape, complete with a glistening river of life, which we see extending into the distance (illus. 62)? Or is it

73 Anonymous Flemish artist, *View of the Prinsenhof, Bruges,*
from A. Sanderus, *Flandria Illustrata,* 1641.

simply a vista, just a sign of the vast seigniorial holdings of the Chancellor – which included (formerly noble) properties at Beauchamp, Ougne, Monetoy, Savoisy, Chaseux, Beaulieu, Saisy, Bragny, Monron, Salans, Fontaine-lez-Dijon, Pruzilly, Aymeries, Raismes, Virieux-le-Grand, Gergy, Muz, Chazeux, Ricey-le-Bas, Polisot, Chailly and many others, mostly within Burgundy.

From all these properties Rolin received large rents as well as various rights of use. Rolin, in fact, amassed one of the largest fortunes of the day during his service under the dukes of Burgundy. Following in the footsteps of his older brother Jean, he was a lawyer at the court of the Parlement de Paris by 1401. His brother became attached to the Burgundian house, and by 1408 Nicolas was serving as a lawyer to the Burgundian Duke John the Fearless. Eleven years later the ambitious Nicolas Rolin had achieved the highest rank of any simple lawyer in the Burgundian bureaucracy. With the assassination of Duke John in 1419, and the accession of Duke Philip the Good, Rolin's career received a tremendous boost. He was knighted, and made Chancellor by 1422. For the next thirty-five years Rolin reigned supreme at the Burgundian Court; its historiographer observed that he had the role of 'regardeur de le tout'. Rolin acted as one of Philip's chief political negotiators with external enemies and with rebellions by Burgundian citizens and the nobility. Richly rewarded by the Duke for his loyalty, Rolin took advantage of every position he occupied. When, late in life, the Duke became displeased with him, Rolin still kept his title and his incomes – the appearance, if no longer the substance, of authority.

Many observers believe they have discerned aspects of Rolin's life in van Eyck's painting, either via illustration or allusion. The assumption is not unreasonable, considering the scale on which the donor is conceived within the image. His overweening lifestyle would almost certainly have made him eager to commission an image that in some ways was autobiographical. The vineyards covering the green hills in the distant landscape seen through the left hand arch are, perhaps, important in this regard (illus. 63): some of the very best Burgundy wine was produced on land belonging to Rolin. His religious patronage was reserved for his parish church in Autun, the church of Notre-Dame-du-Chastel, which, unfortunately, was destroyed in 1793 during the French Revolution. Rolin's lavish donations to this church included vestments, a baptismal font, candelebra and a bejewelled crown of gold, which may be reflected in van Eyck's crown for the Virgin. Rolin's large mansion, as well as the adjacent parish church, stood in the shadow of Autun Cathedral, which was dedicated to a locally honoured saint, Lazarus. Deep in the painting's landscape, just above Rolin's hands, stands a humble church; while in the city across the river – partially hidden by the foreground Virgin – is a gigantic cathedral, surrounded by many of the city's smaller churches. Rolin seems to be presenting the smaller outlying church to the Virgin as a gift, just as donors who either had built or furnished an ecclesiastical edifice are shown doing in earlier medieval art.

Perhaps the church Rolin apparently presents to the Virgin is his own parish church, dedicated to her. Some observers have suggested that it is another, specifically monastic, church, founded as a result of the Treaty of Arras, which Rolin was instrumental in negotiating in 1435. Additional small details in the image have also been felt to refer to this historic event. Or, it might be that the appointment in 1436 of Rolin's son, Jean, as bishop of Autun Cathedral caused van Eyck's painting – which includes a cathedral-like building behind the Virgin – to be commissioned. (Rolin himself did increase his patronage of the church of Notre-Dame that year.) Some of these relations between biography and image may seem far-fetched, as well as very narrowly determined; however, the fact that they are so often mentioned illustrates an important aspect of the reception of this work. Today, Rolin and his actions seem larger than life. Surely he would have wanted his accomplishments, even his way of life, shown forth in an image such as this? Or, might not a great political achievement, such as the Treaty of Arras, have prompted him to commission one? Again, uppermost in his mind may have been a notable religious success – the naming of his son to the bishopric of Autun. Whether political or ecclesiastic in character, there is the suggestion here of some precipitating event that has fed into the production of a partly autobiographical work.

That is the case with many literary autobiographies in the fifteenth century, as well as in earlier and later times. A crisis or notable event in one's life leads one to reflect not just on the particular, but on the pattern. Is that, at least in part, what Rolin intended to do with his commission – to consider some particular circumstance of his life, as well as

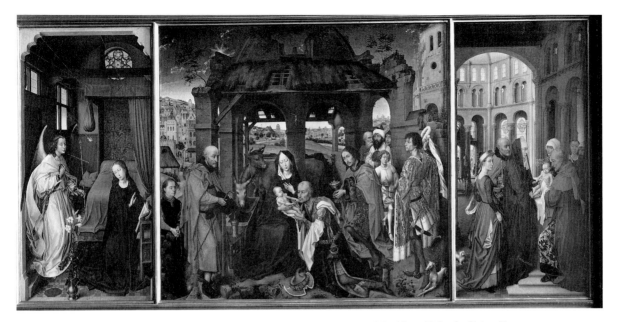

74 Roger van der Weyden, *Triptych with the Adoration of the Magi (Columba Triptych)*, *c.* 1455. Alte Pinakothek, Munich.

to review his progress thus far? What means, then, would have been available to help him (and van Eyck) order his reflections? What behavioural model could he have followed in trying to give some account of his life, his aims and ambitions, both for this world and the next?

The chief way that such a goal was accomplished by lay people in the early fifteenth century was through the sacrament of penance – confession. In fact, the production of manuals for confession reached a peak at just this time. Whether the sacrament was observed frequently or but once a year, the penitent had first to review his or her life, identifying sins and their circumstances. According to the manuals, this review was to be conducted in an orderly fashion. The penitent was to survey the Seven Deadly Sins – Avarice, Envy, Pride, Luxury, Gluttony, Anger and Sloth – and determine which applied. Other corrective schemes involved the Ten Commandments, the Seven Works of Mercy and the Twelve Articles of the Creed. Had these been followed as faithfully as possible? Had one availed oneself of the Seven Sacraments, the Seven Cardinal Virtues, and the Seven Gifts of the Holy Spirit to Mary? What sins had one committed by means of the Five Senses? The penitent's path was to move from exhortation to interrogation of his or her conscience, ending in satisfaction, usually through prescribed prayer, and priestly absolution. This very flexible system might help us understand the structure of numerous early Netherlandish paintings. Patrons who are shown kneeling with prayer beads can be thought of as doing penance as a result of their confession (illus. 74).

Confession was no doubt a powerful instrument of social control, making the faithful

obedient to the Church's goals for itself and society. For Nicolas Rolin, confession must have been an act of personal religious obedience as well as one agent of this social power and control. He does get what he wants. Although he might have employed any one or more of the approaches suggested in the manuals – for the abuse of the Senses, for example, or the use of the gifts of the Holy Spirit – van Eyck's painting seems first and foremost to imply a concern with the Seven Deadly Sins. Human sin, presumably shared by the Chancellor, is recounted and exorcised.

This is exhibited, for instance, in the drunkenness or gluttony of Noah, which is shown on the historiated capital just above Rolin's head (illus. 64). It is not too great an imaginative leap to discern a connection between the representation of the effects of wine on Noah and Rolin's vineyards in the distant landscape. This does not mean that Rolin is himself confessing to drunkenness; perhaps he simply feels penitent about producing the wine that causes inebriation in other men. The scene of the debauched Noah is only the final episode in a sculpted history in this picture of human sin. The carved reliefs over the donor's head begin by showing the sin of the First Parents (Pride), indicated by their expulsion from Paradise. Between Adam and Eve and Noah is Envy, the sin of Cain, demonstrated by his slaughter of the more favoured brother, Abel. Is it accidental that Rolin and van Eyck begin their discussion of the capital sins on these carved capitals? Treatises on the Seven Sins (*les septs peches capitaux*) were written in the fifteenth century; examples were owned by the Duke of Burgundy. By displaying the Seven Sins specifically on the capitals the artist invites us to contemplate the entire sequence.

To the clearly illustrated sins of Pride, Envy and Gluttony, might be added *luxuria*, referred to by the rabbits crushed beneath the columns in the arcade leading to the garden (illus. 68); rabbits were thought to be extremely sensual animals, owing to their prolific rate of reproduction. The heads of roaring lions on the foliate capitals behind Rolin perhaps refer to the sin of Anger (illus. 67). Still, it does not appear that artist and patron have managed, even discreetly, to catalogue all Seven Deadly Sins. Sloth is nowhere to be found: Rolin, the ambitious functionary, works as industriously as do Adam and Eve, after their humiliating expulsion, in the capital relief. And reference to Avarice has been carefully avoided. Amassing as large a fortune as he did, this is one sin of which Rolin might readily be accused. But perhaps his financial designs were too grandiose for even him to acknowledge avarice, certainly in a public forum: the proposed purse at his side was, of course, expunged from the image. The point, then, is that not all the sins are included, as one might expect if the donor were simply following the manuals.

Rolin's image of himself receiving absolution from Christ does bear an interesting relation to other portrayals of the sacrament of confession (illus. 75). We might rightly be struck by Rolin's presumption at kneeling to receive the blessing not only of his confessor, but of the solemn Deity himself. But I do not believe van Eyck's image

75 Circle of the Master of Claude de France, *Renée of France at Confession*, c. 1520, from *Pétites Prières de Renée de France*.

should be taken so literally – a simple illustration of the Chancellor involved in this sacrament. There are too many other things at work in this image; and the artist has by no means defined a complete penitential performance. The fact that Rolin is confessing within an arcaded space might call to mind the loggias of justice attached to town halls, where people accused of crimes confessed before the local judges. Of course, the Chancellor is not admitting to criminal behaviour, and his judge is not a secular one. The unusual use of the loggia motif might still be meant to recall the secular proceeding, even as it places Rolin's action above and beyond secular control. I do think we can say that this representation is carefully gauged in relation to themes and ideas associated with confession. There is enough indication that sin was on the donor's mind, that he wanted to present that sin to, and have it absolved by, the holy pair. He prays for forgiveness – his prayers would have been prescribed by his confessor as a form of penance. And then he commissions a painting that is, in part, a portrait of Nicolas Rolin, the penitent.

A strict confessional interpretation of van Eyck's work would also be an exaggeration, on both his and our part, if only because of the effaced purse. Whatever else it is – and it is much else – for Rolin, this is a selective confession. We might reasonably see him, like many people of his time, as wanting very much to appear penitent. This painting gives us no reason to believe that his penance was insincere; it is just incomplete. Ultimately,

he could not publicly renounce all his worldly pretensions. This would mean not being able to indulge his taste for fine apparel, both in the painting and at his death. It also might mean refusing to take all the blame – specifically, to be penitent for the sin of avarice. Keeping his purse out of the image was a way of not confessing fully. This is not the sin of an impious person, but of a very human and self-involved one.

People such as Rolin discovered through the late medieval penitential process that they were not saints: they were unable to renounce the world. Rolin himself could not give up his gold brocade. People also found that they did not want to expose all their sins in the process; they did not want to shoulder all the responsibility. Rolin could very well give up being identified as a man who paraded around with a large money-bag hanging from his waist, despite the fact that it was probably true. In making his confession he ends up proving his humanity, with all the presumption and self-interest this implies.

This is quite different from what we found with Canon van de Paele, unless we want to claim that showing the Canon in a humble devotional pose was meant to indicate his admission of having sinned in this way – by avoiding saying the offices – and that he will try to do better, as he is in the image. There is no litany of sinful behaviour depicted in van der Paele's panel, as it is in Rolin's. In van der Paele's work, Cain's murder of Abel is extracted from the narrative of the Fall to stand on the arm of the Virgin's throne as a reference to Christ's death. In the Rolin painting, Cain and Abel are integrated into a string of vicious events. A sinful life may be only partially rehearsed by Rolin, but it is completely hidden by van der Paele. Both images are certainly full of pretension, but oddly enough Rolin emerges as the more frail and human, despite van der Paele's advancing years and illness. Rolin has only his confession to support him; van der Paele has his Church.

In Rolin's painting, the Christ Child adds a sense of male vanity and aspiration. Although naked, with his fully human body presented directly to the Chancellor, the Child holds an orb and blesses, exemplifying both a specifically male political prerogative and a male priestly function. Recent technical examination has shown that the Child's raised arm was originally lower (illus. 76). Clearly, the patron required that the artist adjust the gesture – and its grant to Rolin of divine absolution from his sin. Other patrons were portrayed receiving priestly forgiveness; Rolin feels powerful enough to receive absolution directly from Christ. It has been suggested that the Virgin is about to be presented with the Crown of Life, indicating her role as a model of sinless living on earth. This notion is based on the fact that such suspended crowns are found in other fifteenth-century Flemish paintings where inscriptions proclaim the function of the Virgin as a role model. It is an attractive idea in van Eyck's painting because it would reinforce the confessional nature of the image, as Rolin searches for a way to address his sins.

It is tempting to relate Rolin's devotional stance here to the general history of confession in the fifteenth century and early sixteenth. Rolin seems typical of many of his contemporaries in the way his penitence is both fearful and manipulative. By

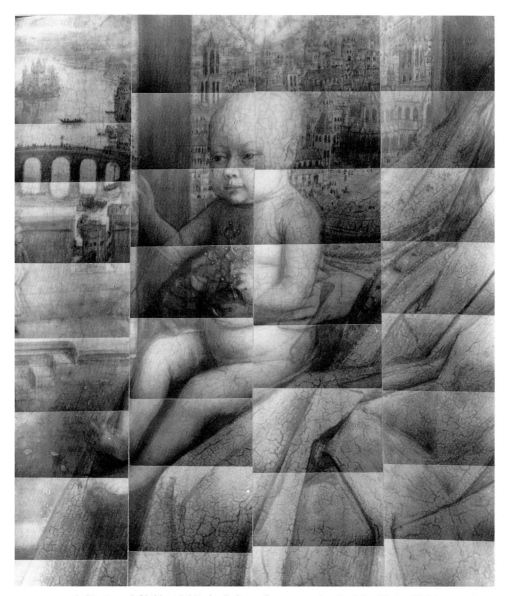

76 *Virgin and Child with Nicolas Rolin*, reflectogram detail of the Christ Child.

dramatically altering the Catholic penitential system and instituting a general congregational confession, Protestant reformers in the next century sought to combat both these elements. They wanted to make the experience reassuring: unconditional forgiveness was always available to the true penitent, they claimed. There was no need to wonder about that. And Protestants felt that neither those making, nor those hearing, the confession should be able to gauge the results to their individual earthly advantage; one could not earn specific rewards for specific penitential behaviour. The way Rolin calculated his stance would have been an example to reformers of the need to simplify and redirect the exercise of confession.

Another indication of Rolin's determination to receive instant gratification for his pious efforts is found in the intended location of van Eyck's panel. Along with almost all of the Chancellor's other ecclesiastical donations, it eventually went to the church of Notre-Dame-du-Chastel in Autun, probably to his mother's family chapel of St Sebastian, which Rolin had refurbished in 1429–30. In 1436 Rolin gave the church as a whole a large endowment. In 1450 he persuaded the Pope to raise the status of his parish church and to name him its official patron. Rolin was buried in the church; his epitaph there identified him as the building's patron, responsible for founding its masses and offices. Although there is no specific record of it, we must assume that van Eyck's painting went to the church at the time of Rolin's death. The church of Notre-Dame-du-Chastel was a world in which Rolin reigned supreme. Here he was not subject to ducal whim; his donations were not lost in the vast ancient space of a cathedral like the nearby St Lazarus. Rolin chose to patronize a religious foundation where his gifts would not be forgotten, where his piety would not be swallowed up in a greater whole.

Rolin was certainly guilty of the sins of pride and ambition:

He always harvested on earth as though the earth was to be his abode for ever, in which his understanding erred and his prudence abased him, when he would not set bounds to that, of which his great age showed him the near end.

These are the words of Georges Chastellain, the Burgundian court historiographer. Another moralizing contemporary remarked that the 'chancellor was reputed one of the wise men of the kingdom, to speak temporally; for as to spiritual matters, I shall be silent'. Already in the fifteenth century, the nature of Rolin's piety, especially in relation to his personal power and ambition, was a topic of speculation. In van Eyck's portrayal, Rolin kneels, without his purse, saying his prayers, raising his hands and his parish church toward what he thinks is divine. He gets a response, a blessing of power and might. The landscape vista reinforces this. The Chancellor's rich interior and his garden also lend their support to his worldly appearance. Yet he, like Adam and Eve, Cain and Abel, and Noah and his sons, admits to sin – even if in a somewhat perfunctory manner and, as the confession manuals formulated it, only partially.

Van Eyck's painting could clearly be understood as a traditional devotional image, a patron praying to the Virgin and Child. Like many contemporary works, it could be related to popular, if quite general, devotional texts. I also mentioned earlier the way this image shares, with many others by van Eyck, a focus on both the Doctrine of Mary and the Body of Christ. In addition to all this Rolin seems to display a particular impulse toward confession. And the very way this emerges from the image, through a process of revelation mingled with concealment, further ties the feelings of both artist and patron to the required but fearful notion of penance. This is a kind of personal history, which the subtle illusion of van Eyck's oil glazes seems able almost miraculously to convey.

12

Patronage by Burgundian
Court Functionaries

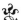

Nicolas Rolin is the chief example of a type of bureaucratic functionary who was extremely important in the social and political history of the Burgundian territories – indeed, for the flowering of early Netherlandish panel painting as well. Beginning in the last quarter of the fourteenth century, and continuing for about a century, the Burgundian dukes maintained a large bureaucracy of lawyers and financial advisors to administer their lands. These men made up various administrative councils and chambers, the chancellery and the courts. Their duties were not precisely defined, but these duties did bring with them great financial rewards. Most interesting is the fact that these functionaries were largely, if not exclusively in some cases, drawn from the bourgeoisie. Clerics did have some part in the ducal government, but were almost completely excluded from financial posts. Nobles were also members of the highest council, but played little part in the judicial system or in the overall management of the ducal domain. What the dukes of Burgundy did, and Philip the Good in particular, was to create a functionary class, newly rich, whose social position and success was totally dependent on ducal appointment. Hundreds of them worked for the Court; in 1422 there were about one hundred in the province of Burgundy alone.

These well-educated, middle-class bureaucrats were able to reap substantial financial rewards during their service under the Duke – land, rents and beautiful houses, lavishly fitted out. If, however, they fell from favour with the Duke or his close advisers, they lost them. Rolin was by far the most successful of these functionaries. Others included Pierre Bladelin, Jean Braque, Jean Gros III, Hippolyte Berthoz, Barthélemy à la Truie (Alatruye), and Jean Chevrot. All of these men, or their families, commissioned works from fifteenth-century panel painters. These are complex and varied images. Pierre Bladelin appears in the centre of a work by Roger van der Weyden in which all three panels are focused on the contemporary obsession with lay visions and meditations, here shown to be analogous to similar experiences in ages past (illus. 49). Perhaps it was Jean Braque's wife, Catherine, who commissioned the triptych (now in the Louvre, Paris) from Roger van der Weyden to memorialize her recently deceased husband. Jean Gros III is shown praying to the Virgin in one of Roger van der Weyden's archetypal, but now dismembered, personal devotional diptychs (illus. 77). Hippolyte

Berthoz and his wife watch from the left wing of a triptych as Berthoz's patron saint is torn apart by horses in the central scene (illus. 78). Barthélemy à la Truie and his wife had their portraits painted and elaborately inscribed (versions now in the Musées Royaux, Brussels), while Jean Chevrot is depicted by Roger van der Weyden helping to administer the sacraments in a spacious church interior (illus. 38). Such works illuminate the multiple creative purposes for which these men and women used panel paintings.

These functionaries were, in fact, the single most important social group promoting and patronizing the panel painters. In general in early Netherlandish painting, commissions by lay patrons outnumber clerical by more than two to one. And among identifiable lay patrons for surviving works executed between 1425 and 1475, twice as many came from the Court functionaries as they did from the nobility. Also, many prominent works have unknown donors who appear, by dress and demeanour, more like functionaries than nobles; these include the donors in Roger van der Weyden's Vienna *Crucifixion* triptych and the Columba *Triptych* in Munich (illus. 74), as well as the donor of van Eyck's Dresden *Triptych*, discussed below. The fully documented works form what must be admitted is a small sample: only about twenty patrons can be

77 Roger van der Weyden (?and assistants), *Portrait of Jean Gros*,
c. 1450–60. Art Institute of Chicago.

78 Dirk Bouts and Hugo van der Goes, *Triptych with the Martyrdom of St Hippolytus,*
with the Donors Hippolytus Berthoz and Elizabeth van Keuverwijck, *c.* 1470–9.
Cathedral of St Sauveur, Bruges.

identified with certainty in works that have come down to us from this time. But that is
the condition of early Netherlandish painting: a small amount of documentation on
which we must base not firm conclusions, but reasonable hypotheses.

The Court of Burgundy is sometimes described as having been the chief employer of
artists. Yet Court records reveal remarkably few specific payments for panel paintings;
references in ducal inventories to panels are equally rare. Surviving documented
commissions for panels by the nobility consist primarily of portraits: Robert de
Masmines by Robert Campin (Berlin), Baudouin de Lannoy by van Eyck (illus. 6), and
Philippe de Croy by Roger van der Weyden (Antwerp) are examples. The Court and
nobility continued to favour the traditional, and expensive, media of tapestry, goldsmith
work and manuscripts. Aside from a portrait of a prospective bride, we do not know of
any specific commission for a small portable painting given by Duke Philip the Good to
van Eyck, his Court painter.

Van Eyck was himself a functionary, although not a financial or judicial one. He, like
other functionaries, may have harboured noble aspirations – as his use of a motto
suggests. Van Eyck and other such functionaries were not usually in line to be knighted.
They may have elicited feelings of rivalry from the nobility; they certainly had difficulty
entering the hereditary noble class of the Burgundian realm. There was some
discussion at Court about concepts of nobility that were not hereditary, and this may
reflect the power and interests of the functionaries. Having gained the wealth and

prestige of a courtly functionary's status, these men had forever left the middle class. They lived in grand city houses, such as the one in Bruges, still extant, which once belonged to Pierre Bladelin. At different times in their careers they would incite the enmity of city dwellers drawn from their own middle-class backgrounds. Such was the case, for instance, with Jean Gros and Hippolyte Berthoz.

This combination of elements – in particular, middle-class origins and noble aspirations – led many of these functionaries, including Rolin, quite naturally to patronize panel painters. Reasons for this are abundant. In the first place we might consider the issue of novelty itself. Here is a class whose origins and growth correspond chronologically almost exactly with that of panel painting. In the late fourteenth century and early fifteenth, panels were increasingly executed throughout northern Europe. It was clearly a new and exciting artistic medium, one ever more technically refined, and rich and complex in the effects it could achieve. Similarly, the functionary class was then newly developing. The traditional media – gold, tapestry and manuscripts – continued to be practised. Sets of tapestries were the most costly and highly prized of possessions: the dukes spent huge sums on them; Rolin also bought a set. Panel painting was really the only art that the functionaries could see as being their own, as coinciding with their own rise to power, an art mirroring their own pretensions and illusions.

Functionaries increasingly developed a taste for noble living, for ease, comfort and display, although they were less often able to commission the most expensive objects. Is it too much to imagine that panels appealed to them because, in part, they allowed the functionaries to maintain the illusion of having rich brocades, fine metalwork, or various stone and wooden objects and textures as part of and central to their own lives? It was admittedly a cost-effective solution. Panel painters, such as van Eyck, made images which seemingly contain objects made of precious metal, glass, cloth and fur; they produced illusionistic paintings of sculpture which could truly trick the eye (illus. 69, 70, 81 and 89). Not only was their great technical skill thus displayed, it allowed them to offer patrons a combination of sculpture and painting, otherwise no doubt more difficult and more expensive to obtain if one had to employ several craftsmen and pay for the actual carving of the sculpture. Such considerations would likely have been in the minds of the Duke's financial officers.

Early Netherlandish panel paintings were a bit flashy and glittering, like a child's new toy. Due to rapid technical developments – sometimes erroneously credited as solely by van Eyck, the legendary inventor of oil painting – these works were able to accommodate demands for a great number of effects – textures, objects and illusions of one sort or another. Wealthy, and often quite powerful, ducal functionaries existed in something of a no-man's land. As Rolin himself discovered, the greatest power and influence could, for a functionary, suddenly and rather dramatically wane. The functionaries were a group of people who were particularly aware of their own abilities, their own personal

success stories, but who, at the same moment, were also alert to the illusory nature of this power, the delusions of grandeur that could spell one's undoing. Rolin, we recall, was criticized by one contemporary for being insufficiently aware of the precariousness of his position. These paintings provided a perfect means of expression for a painter and a patron concerned with form and substance, but who were also aware of the ways these are moulded by an individual, and subject to the vagaries of time and changing perception.

It is certainly true that painted panels are something that many others also desired; in addition to clerics and nobles they included patrician city dwellers such as Jodocus Vijd, who paid for the *Ghent Altarpiece* to be finished (illus. 89 and 90). Philip the Good did, after all, go to some lengths to retain van Eyck as a Court painter. The artist was certainly proud of that connection and, like any other functionary, would have done whatever necessary to remain within the ducal entourage. But the Duke did not, so far as we know, exploit van Eyck's talents as a panel painter, nor did any other noble patron. Nor do surviving works indicate that clerics repeatedly and inventively used panels to proclaim the might of their institution. Only Jean Chevrot's *Seven Sacraments* altarpiece, commissioned from Roger van der Weyden (illus. 38), stands out as an example of clerical propaganda.

Private devotion was the guiding, lay religious ideal of the fifteenth century, for which panels were crucial. This ideal was taken up increasingly by the bourgeoisie and urban dwellers. It was also from the start adopted by foreign merchants, most of whom were from Italy. It would be possible in this way to see many different social groups interacting to promote panels – in particular, panels that were not simple portraits, but that told complex stories, usually within the context of a religious scene. Still, the functionaries stand out as the single group most responsible from the start for bringing panels to the fore. They are the first to allow us to formulate the notion that panels might even have been the chief medium of the day – which surely, in some ways, they were not, considering the continued noble patronage for, and extremely high cost of, tapestries, manuscripts and metalwork.

Many forces can be said to lie behind the use of visual realism in early Netherlandish painting. With the social situation of Burgundian court functionaries we have one especially provocative arena in which realism and pictorial illusion find remarkable resonances. Drawn from the middle class, but now moving beyond it as they rubbed elbows with, and in ways attempted to join old, established and wealthy noble families, these functionaries could well have seen panel painting as being remarkably suited to their purposes. It gave the glow of fine crystal to their pretensions. It was new, a child of the time – as were they. Even its illusionistic value would not have been lost on them – as indulgence in visual effect tinged with transience, even morality. The insights of panel painters could and did apply to many people at the time, but to no one group did they apply more poignantly than to the functionaries.

13

Literary Sources for van Eyck's Art

❧

In recent times it has been thought that most of van Eyck's panels contain an almost indescribable wealth of symbolic allusion: the rabbits crushed beneath the columns leading to the garden in Rolin's painting (illus. 68), for example, are taken to be an allusion to sensuality, and the necessity for keeping sensuality under control. Should we go on to interpret other carved animals in a similar way – the lions behind Rolin's head (illus. 67), say, or the intertwined dragons crawling over the central garden arch (illus. 66)? The case of the decoration of these three garden arches is indicative of the interpretive problem. At the left, arching over from the scene of Noah's drunkenness, is a carved design of grape clusters and leaves; in the middle arch we find the dragons; and in the right arch is what looks like a curving rose motif. Are these all intentionally part of a preconceived symbolic programme? The grapes *might* refer to Noah's sin, and the roses to the Virgin's purity. But what might the significance of the dragons be? Did the artist intend that viewers should puzzle over the possible meaning of each and every painted detail?

Taken together, the three arches leading out of the Chancellor's room might recall the three persons of the Trinity, although what part that would play in the work's overall meaning is open to debate. Should we proceed to see the seven supports on the distant bridge as also symbolic, alluding perhaps to the Seven Sacraments that Rolin should consider as he prepares his confession? The peacocks may seem relatively straightforward in their dual allusion to Paradise and to Pride. Should we search for similar meaning in the two magpies in the middle of the garden? Are the species of flowers, and even their number, significant? And what about the number and pattern of floor-tiles in the foreground, which some scholars have seen as charged with meaning? What is so striking here is the sheer fecundity of imagery (all of which, conceivably, is symbolic detail). Once one begins, the possibilities seem almost infinite, but also somewhat undisciplined. Heads protrude from capitals, animals are squeezed beneath the bases of columns; everywhere one looks, something is happening. Is all this richness and profusion in the visible world purposefully programmatic in meaning?

In addition to their proliferation, there is another characteristic of some of van Eyck's details that needs to be stressed. We can clearly see the Old Testament scenes carved on the capitals over Rolin's head, but what about the scene above the Virgin's head,

half-hidden in shadow (illus. 65)? At present, detailed study leads several scholars to believe that the historiated capital beyond the Virgin and Christ represents Abraham and Melchizedek, an Old Testament pair thought to prefigure the sacrament of the Eucharist, since the priest Melchizedek brought the warrior Abraham some sustenance – bread and wine – prior to one of the latter's battles. This is a particularly popular interpretation with those scholars who see much eucharistic symbolism in the painting as a whole. It serves to contrast Noah's sinful use of wine with a proper, sacramental one, exemplified by the holy pair in the foreground as well. Only thirty-five years ago this half-hidden scene on the right of van Eyck's painting was not clearly understood as portraying Abraham and Melchizedek: several scholars were convinced that the kneeling figure was a woman, and that the scene either depicted Esther before Ahasuerus or the Justice of the Emperor Trajan. More recently, that of the Queen of Sheba before Solomon has been suggested. The fact is, that even in enlarged photographs, the detail is not at all easy to read. It is, especially, neither clear nor explicit in the original painting. In an analogous fashion, the room where Rolin kneels could be located in a castle on a Burgundian hillside – such a building is often seen in the background of early Netherlandish paintings (illus. 78) – or it may be an imaginary setting in a symbolic watch-tower, invented only for the Chancellor's ideal devotions. Why did van Eyck leave so many options open? Why, at times, does he hint at so much and yet tell us, with any certitude, so very little?

This mystification may be modern, and due to ignorance: we are often told that if only we were as wise in Biblical lore and Christian exegesis as van Eyck and his contemporaries were, then the veil might be removed from our eyes. But this supposition does not sufficiently account for the fact that the artist himself has in many cases placed the veil between the spectator and a perfectly clear, theologically learned reading of the image. It is as though van Eyck himself wished to create an aura of infinite symbolic reference, rather than necessarily specifying it, utterly and completely. It is not our ignorance that has made a shadow fall on, or a crown come in front of, the capital beyond the Virgin in the Rolin painting. Van Eyck has kept even his learned contemporaries from having an easy time of it. Perhaps he thought that, as St Augustine wrote many years before, 'hidden meanings are the sweetest'. But this is more than hidden; this is forever unclear – even with the help of modern photographic enlargements. On the surface the painting declares: here is an image rich in reference, far-flung in (possible) symbolic connotations, but hardly transparent in its meaning, and seeming to challenge straightforward exegesis. The great variety of interpretations that modern scholars have given this work also suggests this.

Rolin is saying his prayers, almost certainly the Little Office of the Blessed Virgin Mary, a popular spoken exercise. We believe it is this particular Office, one of the most frequently recited at the time, because phrases from it are inscribed on the hem of the Virgin's mantel. In order to construct this image did patron and artist together turn to a

complex systematic exegesis of this Office, one written several centuries before? If they did, isolated details in such a commentary could have caused them to include details in the image. This would mean that artist and patron wanted other, later, viewers to experience the image itself as a learned commentary. The painting would thus be a comment on the Office, rather than a vivid embodiment of a multi-faceted act – saying the Office as penance – along with all the complex motivations and results of that endeavour.

In addition to monkish medieval exegesis, there are other avenues within the immediate context of their lives at the Burgundian Court in which this patron and this artist might have sought inspiration for their religious symbolism, for the suggestion of a romantic mystery of meaning in a religious context. These avenues correspond directly to the known lifestyle and interests of both patron and artist. One fifteenth-century manuscript contains an elaborate poem to the Virgin, the *Louenge à la très-glorieuse Vierge*, written, according to the manuscript source, by Georges Chastellain, historiographer to Philip the Good, and a courtier known to both van Eyck and Rolin. The poem, running to more than 650 lines, is a complex litany to the Virgin. Its content and approach is remarkably appropriate to the Rolin painting, even though it did not serve as a source for the painting, since it almost certainly dates from about the middle of the century. What is relevant here are not so much specific phrases, lines or references within the poem; it is, rather, the exhibition of a frame of mind, an attitude toward symbolic richness that is not at the same time dogmatic.

Here are some of the poem's features that appear, in the light of van Eyck's works, to be significant (long and rambling, the poem is almost infinite in its imagery and references). The author begins by stressing his desire for an achievement of 'sensual clarity'; he loves the pleasure and glory of the world. He tells us he leads an active life. There are reference to clerics who have written extensively in their attempts to penetrate the mysteries of the Blessed Virgin; but, the poet observes, the Virgin's 'secret riches' remain. Adam, Abel, Abraham, David, Solomon, Judith and Esther are all called upon; their sin, sacrifice, law, harp, throne and humility are all related to the Virgin. Fruits, flowers, stones and gems sing her praises, illustrate her powers: 'Tu es le vray paradis voluptaire'.

At one point in the poem it is claimed that the sun does not cast shadows in the Virgin's domain; at another, that the sun and moon – both present in Rolin's painting – honour her. There is in this poem no logical, over-arching progression of ideas or explanations. A profusion of thoughts and images simply follow one another. The complex writings of the clergy are several times mentioned, but issues of doctrine – 'science augustine' – are quite different from what the poet claims he is interested in. I think the same can be said of the artist. It is not that Chastellain and van Eyck were unaware of doctrinal commentary; on the contrary, they were no doubt both alert to it and able to benefit from it (at least in a scattered fashion) for their own imagery. On the

one hand, we have the goal of precise meaning and exposition; on the other, a free, poetic association of disparate images and motifs. In Chastellain's poetry, even more than in learned commentary, a great number of widely scattered references may be present; but their precise sequential and theological meaning may, nevertheless, have been a matter of some indifference. I think this can also be said of van Eyck's painting.

The relation between painting and religious courtly poetry cannot be drawn too tightly, and not only because of chronological considerations; however, it is interesting to know that in 1465 Chastellain provided an inscription for a painting. He clearly was interested in, and knowledgeable about, painted imagery; Chastellain's written work indicates his love of the visual. He, like Rolin and van Eyck, was also a Court functionary whose origins were middle class. A poem may be like a painting, but in this case a visual artist would have little reason to make a picture register exactly in the way that Chastellain's poem reads. What we may point to is a similarity of outlook and disposition, but not identical thinking or minutely mapped influences. This poet, like this painter, employs passing symbolic allusions, rather than a programmatic commentary.

In order to accept the idea that a painting is replete with complex, consistent programmatic symbolism, we need to be able to point to something structural in the image itself that supports this. There should be some large compositional element, or interaction between elements in the work, which makes the meaning essential, integral, incontrovertible. The image should not simply be composed of a mass of details that can be cleverly analysed but are constantly shifting in their relation, depending on which learned source one happens to light upon. The only essential and unequivocal thing of this nature in the Rolin painting is the connection between a red-robed Virgin and naked Christ Child – a vision on the one side, and Rolin and his narrative exposition of sin – a confession – on the other. All the additional elements seem visually and thematically accessory, and open to a broad range of interpretation. This work may contain complex symbolic reference, but, if so, it remains to an extent unclear, intentionally difficult to read with precision.

Rolin is shown in his painting probably reading, as I have said, the Little Office of the Blessed Virgin Mary. This, in part, is composed of some of the most beautiful and evocative of the verses in the Apocrypha (Ecclesiasticus, 24: 13–15):

Like a cedar on Lebanon I am raised aloft/like a cypress on Mount Hermon/like a palm tree in En-gaddi/like a rose bush in Jericho/like a fair olive tree in the field/like a plane tree growing beside the water/Like cinnamon, or fragrant balm, or precious myrrh/I give forth perfume.

A lay person reading such verses in such an Office would have sensed how very much it was like Chastellain's *Louenge*: the sensual appeal, the multiplication of natural image and allusion is similar. Do the verbal and visual exercises in painting and poetry produce a complete learned explication? In the Middle Ages some learned exegetes did

attempt to explain how doctrinal concepts could be uncovered in the ancient Biblical poetry used in the Offices. Similarly, some more recent scholars have tried to provide an account of van Eyck's painting in which it is seen as a systematic theological exposition. I do not think that van Eyck worked in this way, but I also think both Rolin and van Eyck would have delighted in having this kind of interpretation applied to their painting. The artist clearly cultivated the aura of symbolic richness, the prospect of understanding penetrated, which his work offers in abundance.

The foreground structure of the painting operates through popular devotional concepts – penance and lay visionary experience. Personal references are included. The glory of the artist's technique is accentuated. Some rather standard symbolic allusions are made – for instance, the garden, peacocks, rabbits, church and the reliefs concerning sin. Beyond that, symbolic reference seems as though it could be almost infinite but, at the same time, remain veiled, intriguingly incomplete. One is sometimes reminded more of later, subjective, Symbolist art than one is of the erudite programmes, the *summas*, of medieval cathedrals. It is not just that van Eyck selected certain images and not others for this particular patron; it also seems a personal game of the artist, who reveals his longings as much by what he retains or obscures as by the plenitude of what he gives. Van Eyck wants his religious mysteries and metaphors taken seriously. Yet, the truth of it all may be found as much in what we sense as in what we finally can claim, with any certainty, to know.

14

Physical Format and Verbal Inscription

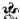

The three-part work by van Eyck now in Dresden shows the Virgin and Child enthroned in the centre panel, with St Michael presenting a male donor at the left and St Catherine standing sedately on the right (illus. 81). This arrangement may seem similar to several others in the artist's career, the van der Paele and Rolin panels in particular (illus. 23 and 61). But the Dresden painting is van Eyck's only surviving triptych. This physical form was perhaps the most common, as well as the most important, for a religious painting in the fifteenth century – a central image twice as big as its two hinged wings, which could be folded and secured over it.

Why did this tripartite form, and its extension, the many-panelled polyptych, rapidly gain such popularity? No doubt there are at least several reasons. To begin with, the folding format meant that the work could be collapsed into a box-like shape for easy storage or transportation; such a box protected its contents. Multi-panelled works were also made in response to a desire to tell complicated stories. In some extant examples there are as many as eight separate scenes, neatly ruled off by a raised framework, on the two wings alone. Even when the central and side spaces were continuous, artists used the framing to provide clear divisions between parts of the same story. What happened on the wings preceded, or directed one's attention to, the central scene, as we see in Hugo van der Goes's Portinari *Triptych* (illus. 79). Here, in the background of the left wing, the Holy Family is seen making its way toward Bethlehem, while in the right wing's distant landscape the Magi are seeking directions to the same goal.

One of the most common uses for the wing panels is that found in both the Portinari and the Dresden triptychs: to contain donors and/or attendants, but also subsidiary saints, those saints who are not thought of as directly participating in, or contributing to, the main event. In van Eyck's Dresden work, the heavy, 'marbled' and illusionistically carved frame of both the centre and side panels keeps the donor at a certain distance from the object of his wonder. The frames here also conveniently correspond with the arcades that separate the depicted space of the central panel from those at the sides. On the exterior of van Eyck's work, the more boldly modulated frames, which look almost like tortoise-shell, neatly separate the figures of the Angel Gabriel and the Annunciate Virgin (illus. 70). The space in which these two sculpted figures stand is continuous behind the frame. But by so lavishly colouring the frame, the artist seems to have

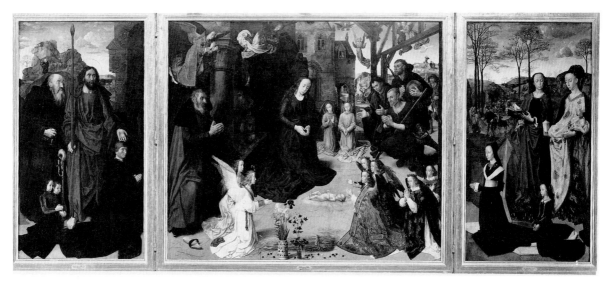

79 Hugo van der Goes, *Triptych with the Adoration of the Shepherds (Portinari Triptych)*, *c.* 1475–6.
Galleria degli Uffizi, Florence.

80 Anonymous artist, *Office of Penance*,
c. 1492, from a Flemish Book of Hours.

delighted in its sheer enclosing quality: it sections off, for ease of comprehension, the key elements in this religious drama. There is a visual logic to the use of the frame by early Netherlandish painters. They want their images to be easily read, like a cartoon strip. Parts are clearly, often sequentially, related, and they are simultaneously physically distinguished and separated.

Certainly there are also religious meanings that could be attributed to the frames and, in more general terms, to the multi-panelled works, especially triptychs, which they enclose. Frames can give a work a precious, reliquary-like appearance. This is particularly true of van Eyck's gold, marbled, carved or inscribed frames. Some fourteenth-century German altarpieces did house relics on their wings, and recollections of just such a function no doubt existed in the fifteenth century. There may also have been a changing liturgical purpose served by some winged altarpieces: as the Church progressed through its calendar, it may have seemed desirable to have a type of decoration that could also be altered. But the seasonal change in the triptychs would be slight, their relation with the liturgy flexible, if not actually vague.

The most specific suggestion made in this vein is that the often subdued grey-toned exteriors of many early Netherlandish triptychs were a form of mourning, a Lenten observance. This would have had a particular application to those works where the exterior panels were painted as *grisaille* imitations of sculpture. We know from contemporary documents that at some places during Lent, white mourning cloths, sometimes painted with a red cross or with faint grey, were hung over the normally colourful church decorations (illus. 80). This practice may have suggested to painters the restraint that they often exercised on the outside of their folding works. But *grisaille* imitations of sculpture on the outside of triptychs could not be, solely, a Lenten observance. Clearly, these exterior panels would be seen at times of the year other than Lent. Van Eyck himself made a diptych of the Annunciation (illus. 69) entirely in *grisaille*, which, presumably, was not meant only to be viewed during Lent.

We do not have any documentary evidence about the use made of early Netherlandish triptychs during a religious service. We simply do not know precisely at what point they were opened, or when they were closed. In general, it would seem reasonable to think of revelation and incarnation in connection with these folding triptychs; thus the Annunciation, the first event in the Incarnation of Christ, is more frequently found on the exterior. The subject of these religious works, in terms of motif, colour and environment, is one of progressive display, moving toward the fully coloured embodiment found at the centre. Greyish tones give way to varied light effects and colouristic brilliance. This is a transition specifically made from Lent to Easter, but found more generally in the Christian concept of Incarnation.

Van Eyck's Dresden *Triptych* is so small that we can be fairly certain it did not serve a public liturgical function, especially not in a great building, such as is represented on its interior. Only about 13 inches (33 cm) high and about 21 inches (55 cm) wide when

open, this was a precious and private devotional work. It was even small enough to be held in the hands and carried around, like a reliquary. In that sense, its elaborate frames and beautifully carved statuary are appropriate. These sculpted elements add a sense of rich ornamentation, or costly display – significant ingredients in some examples of van Eyck's art. The Dresden *Triptych* is the smallest of van Eyck's richly decorated works. Perhaps, in part, that explains why this characteristic seems so accentuated here.

Then there is the relative plainness of the Dresden *Triptych* exterior, with only a few shining white stone surfaces. The somewhat gaudy red and black frame of the exterior helps prepare us for the vibrancy, the glittering ornament found everywhere on the interior. One can only wonder at the skill, patience and sophistication that made such a panoply of riches possible. And yet, while coming to terms with this work we must also recognize something about it that is quite simple: it is a reliquary case for the tiny body of Christ. It is the mysterious but elemental idea of Incarnation that is governing here, quickly gleaned by moving from the cold stone of the exterior to the warm, living glow of the interior. In some ways this is van Eyck's most ornate painting. It is also the one most fully imbued with the simple popular piety that longed, in a non-intellectual, unadulterated way, for a vision of the Christ Child, an elemental embodiment of his redemptive mission, his sacred heart.

The Virgin and Child in the Dresden *Triptych* stand for the concept of Real Presence, as do many of the other divine pairs in van Eyck's work (illus. 23, 45 and 61). All of van Eyck's seated, red-robed Virgins are massive and solidly built; all the Christs are human and fully articulated. In the Dresden work we have a Virgin whose robe sweeps across in front of her, forming two mounds as it falls over her very large knees. Her small hands delicately but noticeably grasp the fuzzy haired baby, holding him up for all to see (illus. 82). This female is the most physically vital of all van Eyck's seated Virgins, the most active, involved and articulate. The same can be said of the Christ Child: he uses his hands – with his left he holds what looks like a bunch of grapes; in his right is a scroll inscribed 'Discite a me quia mitis et humilis corde' (Learn from me, for I am meek and humble in heart). The grapes – if that is what they are – reinforce Christ's sacrificial mission, as do the blood-red robe and the carvings on the throne – the pelican, at the left, plucking its breast to feed its young, and the phoenix, at the right, rising from the ashes. The banderole operates in a similar arena, except that its position here requires somewhat greater explanation. This banderole is a distinctive and unusual feature in van Eyck's surviving mature paintings. On the exterior of the earlier *Ghent Altarpiece* prophets and sibyls are accompanied by inscribed scrolls (illus. 89); both are traditionally marked with some inscribed reminder of their prophecies. Oddly, what seem like Old Testament prophets standing over the capitals in the centre panel of the Dresden *Triptych* do not have banderoles. In the *Ghent Altarpiece* there are an almost oppressive number of lengthy inscriptions; in this work, quite unlike the Dresden *Triptych*, written explication is exhaustive. It is not an initial stimulant but a final effect.

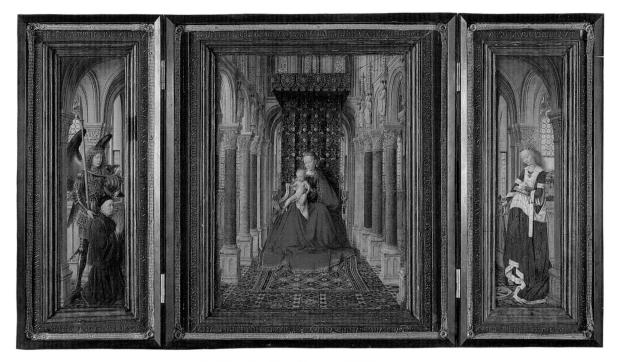

81 *Triptych with the Virgin and Child*, 1437.
Gemäldegalerie Alte Meister, Dresden.

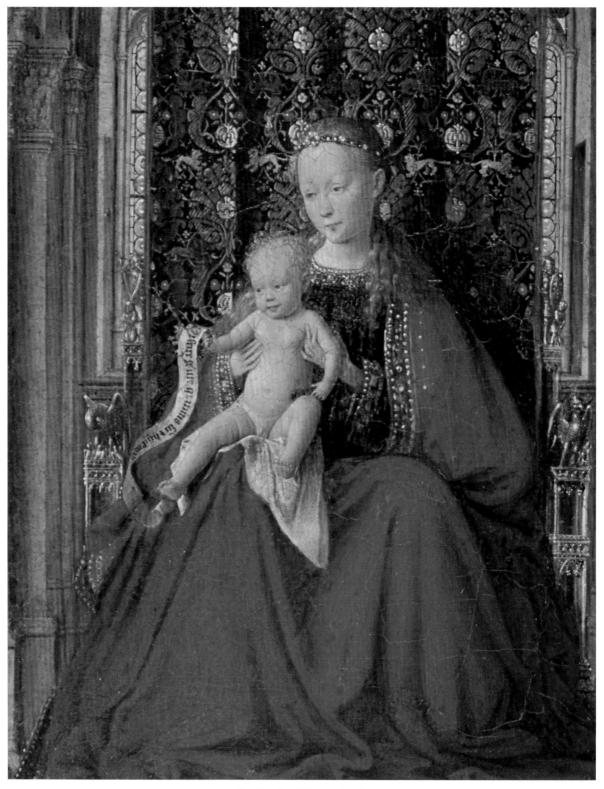

82 *Dresden Triptych*, detail.

83 *Dresden Triptych*, detail.

84 *Dresden Triptych*, detail.

85 *Dresden Triptych*, detail.

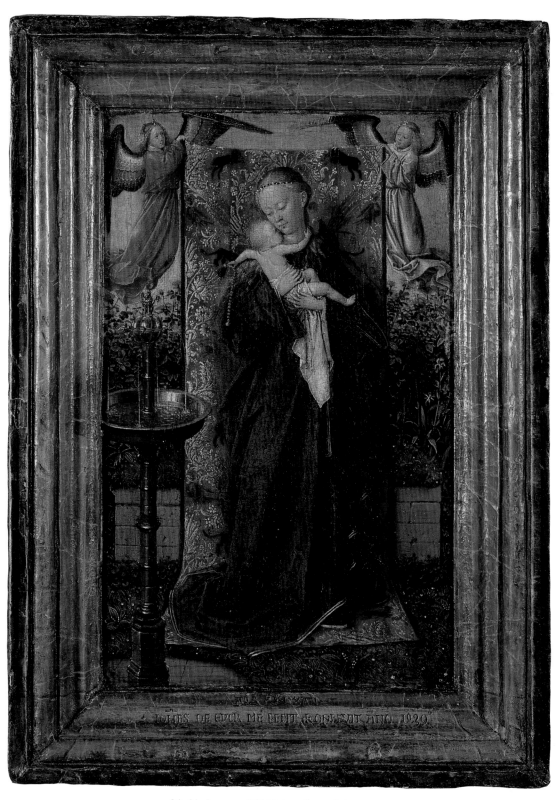

86 *Madonna and Child by a Fountain*, 1439.
Koninklijk Museum voor Schone Kunsten, Antwerp.

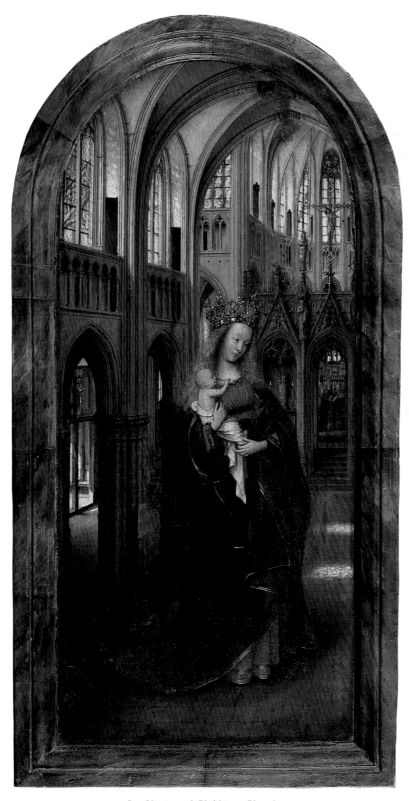

87 *Virgin and Child in a Church.*
Gemäldegalerie, Berlin.

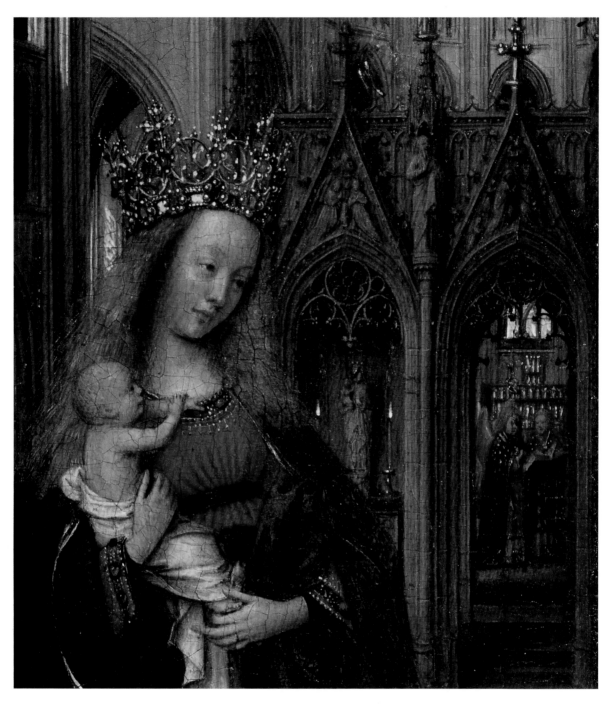

88 *Virgin and Child in a Church*, detail.

89 *Ghent Altarpiece*, completed 1432, exterior. Cathedral of St Bavo, Ghent.

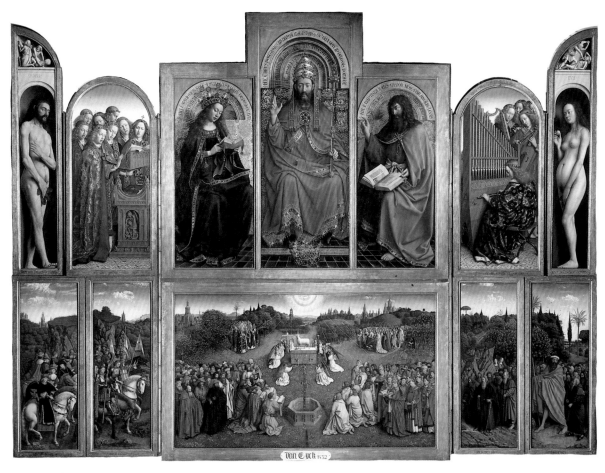

90 *Ghent Altarpiece*, completed 1432, interior. Cathedral of St Bavo, Ghent.

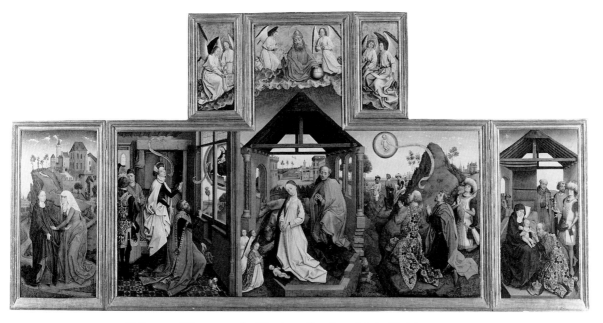

91 Follower of Roger van der Weyden, *Altarpiece with the Nativity, c.* 1450–75.
Metropolitan Museum of Art, New York.

It is often felt that, as the century progressed, banderoles became an increasingly archaic feature of early Netherlandish painting; to modern eyes they do not seem to agree with the increasing demands for visual realism, for specific recognizable genre details. By the later sixteenth century, after the initial controversial phase of the Reformation had passed, banderoles almost entirely disappeared from representational art. But for the fifteenth century, we might consider a case such as that of Roger van der Weyden's *Nativity* triptych in Berlin (illus. 49). This work was originally planned to include banderoles issuing from the two Christ Child figures on the wings, as well as from the Tiburtine Sibyl on the left. These have been revealed only by modern scientific analysis – infra-red reflectography; they are also found on a contemporary copy of the Berlin work (illus. 91). As he worked on his *Nativity*, Roger painted these bands out, thereby leaving the message to be understood solely in terms of the images themselves, their visual and thematic interrelationships. The absence of verbal clues does make the parenthetical composition of Roger's wings more noticeable, and the overall theme of visions is thus rendered more distinctly visual. The thrust of the work is not narrowly – theologically or textually – defined. It is allowed to float more freely in our mind's eye.

Roger van der Weyden was an artist who could also use banderoles to define more fully the dogmatic nature of a work: he did this both in the *Seven Sacraments Altarpiece* (illus. 38) and in his three-part *Mary Altarpiece*. Throughout the fifteenth century and early sixteenth banderoles were very handy devices when a specific theological programme needed to be presented. In fact, the appearance of a banderole in any work

92 Master of the St Barbara Legend,
Epitaph of the Nun Janne Colijns, *c.* 1491.
Gemäldegalerie, Berlin.

93 Anonymous Brussels artist (?after Vrancke
van der Stockt), from *Exercitium super
Pater Noster*, *c.* 1447–50.

of this period should be a sign that something more than a generalized, open-ended
religious meaning is at hand. Such a meaning may be theologically complex and
rigorous, as in Roger's works; or it may be more popular, the direct expression of a
prayerful state. An example of the latter is found in the epitaph panel of Janne Colijns,
painted in the 1490s by an artist today identified as the Master of the St Barbara Legend
(illus. 92). Here, amid an embarrassment of scrolls, divine and human figures carry on a
direct and unsophisticated dialogue, which is continued around the frame and below
the figural scenes. This panel is reminiscent of the numerous popular woodcuts
executed in the Netherlands in the fifteenth century, many of them replete with
inscribed banderoles (illus. 93). These are works intended for a semi-literate audience.
The banderoles might even have served the purpose of teaching viewers to read: a few
carefully chosen, oft-repeated words, neatly positioned by recognizable figures, may
have helped with reading skills, as much as they were a product of them.

Banderoles in early Netherlandish art can thus be seen as serving two apparently
different purposes: to define Catholic doctrine precisely, and to provide a more
elementary expression of popular piety. In van Eyck's Dresden *Triptych* these two
approaches come together. I do not think we can attribute complex doctrinal signifi-
cance to van Eyck's banderole; it does, however, serve to specify more fully the interest
that this picture exhibits in the Body of Christ.

15

A Litany to the Sacred
Heart of Jesus

The Biblical passage from the Gospel of St Matthew on the banderole in van Eyck's Dresden *Triptych* refers specifically to the heart: 'Learn from me, for I am meek and humble in heart'. Devotion to the Sacred Heart of Jesus was initiated by German and Flemish nuns in the twelfth century and thirteenth; and it increased in popularity in the fifteenth. It was one of the clearest manifestations of the late medieval focus on the humanity of Christ, his tenderness and compassion; he had to have a heart, a heart that through its generous suffering offered the promise of salvation. Like the doctrine of the Immaculate Conception, devotion to the Sacred Heart had to wait for several centuries to gain official Church recognition. When a litany for the Sacred Heart was established, not surprisingly one of its main texts was the one from Matthew that van Eyck had used.

In van Eyck's painting the donor's gesture is, initially, a puzzling one (illus. 84): his hands are not held together in prayer, as for instance are those of Nicolas Rolin (illus. 61); nor is he clutching his prayer book, as is George van der Paele (illus. 23). Rather, while Michael, his patron saint, stands by, this donor's hands are parted in wonder and expectation, invocation and response, more like a litany, a request for humble access, than a simple prayer. Devotion to the Sacred Heart was often experienced as a process of supplication, a sequence of prayers, bringing one by steps closer to what was considered the core of Christ's humanity, a plea for entry into the side wound, and thence to the Sacred Heart itself.

The man's position in the Dresden work can be said to be compositionally determined: he is confined to one wing of the *Triptych*. But once again in van Eyck's imagery, it reinforces the particular psychological thrust of the account. The Virgin's position back in space, away from the picture plane, emphasizes the physical, and spiritual, process one needs to go through to reach that sacred kernel of religious feeling and expression. The combined notions, visually presented through composition and gesture, of pleading, progressive access and wonder are consonant with the growing devotion to the Sacred Heart of Jesus. The way van Eyck constructs the space of the Dresden *Triptych* might thus be related to the idea of a litany, or series of supplications, leading toward a goal. It might also suggest some analogy with the structure of Christ's

heart, the rounded side spaces or chambers leading to the main vessel itself. We cannot claim with certainty that this artist and his patron consciously articulated a physical or spatial way to illustrate the concept and the worship of the Sacred Heart. In their interest in this devotion they did not literally follow visual models that included a representation of Christ's heart (illus. 94). But just as George van der Paele can be said to be concerned with his ecclesiastical compact (illus. 23), and Nicolas Rolin with the crown he will receive as a result of his confession (illus. 61), the Dresden donor can be said to respond to Christ's challenge, verbally presented in the painting, to learn from his heart. The painter in his turn did not lay out a theological programme or simply follow established visual traditions; rather, he sensed underlying affinities and desires.

'Learn from me', the Christ Child implores. If we look for a responsive chord to this plea in the general picture of fifteenth-century devotional life, it would be found, first and foremost, in such a work as Thomas à Kempis's *Imitation of Christ*. Over and again Thomas instructs the devout to be obedient, submissive and humble, to listen to Christ's voice within their own hearts. The phrase from Matthew's Gospel quoted by van Eyck could almost be taken as Thomas's motto. The message of this passage in Matthew is primarily one of the humility and simplicity of divine wisdom: Come all who are burdened and oppressed; his yoke is easy, his burden light. Commentators, especially those devoted to the Sacred Heart, took this claim to be one of deliberate contrast to the vain science of learning, the burden of scholastic endeavour. In this section of the Gospel of Matthew, Christ was preaching against the scribes and Pharisees, those masters of Old Testament erudition. The cause of a humble devotional life was championed by those in the fifteenth century who were implicitly opposed to the tremendous labours of the Scholastic tradition. The leaders of the monastic branch of the Modern Devotion, the Windesheim Congregation, were among those who wrote most fervently and often of their devotion to the Sacred Heart.

If we try to enter the simple ascetic world of these devotional writers – such as Henri Harpius, Jean Mombaer or Thomas à Kempis – we are soon made aware of just how far we are from the world van Eyck has pictured. The pleadings of these men are tense and full of suffering. The heart is approached through the five bleeding wounds of Christ. The imagery can be sensual, but it is not delicate and pretty, not materially rich or aesthetically pleasing. Van Eyck seems carefully to have extracted a few appealing ideas from a religious context altogether more physically and emotionally challenging. Van Eyck's is a selective appropriation of devotional ideals. The sweetness of the concept of the Sacred Heart can be, in his world, removed from the overwhelming sorrow of Christ's Passion. Images of sacrifice and resurrection are rendered as sparkling sculptures on the Virgin's throne: the pelican in her piety or the phoenix rising from its ashes (illus. 82). The tender notion of Christ's humble heart transforms forbidding thoughts into something truly light and easy, viewed in a locale congenial to a young man whose delicate gesture both pleads and wonders.

The banderole in Christ's hand was, I think, meant to call to mind popular devotion to the Sacred Heart. We can use the term 'popular' here to indicate a theological stance that is not rigorous or systematic. Van Eyck's work can be seen to visualize a simple devotional stance. Even prayer books are not required for the donor. All that is necessary is that phrase, a verbal jumping-off point to one who 'is meek and humble in heart'. In general, devotion to the Sacred Heart of Jesus is a good example of popular religious life that is not theologically complex or sophisticated; it hardly required elaborate proof or justification, as did the doctrine of the Immaculate Conception. This aspect of the religious message of the Dresden *Triptych* is not unlike a simple devotional woodcut of the fifteenth century in which the Christ Child is shown seated before the Sacred Heart surrounded by references to the Five Wounds of his Passion (illus. 94).

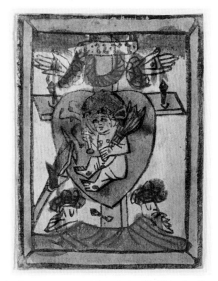

94 Anonymous South German artist, *The Christ Child in the Sacred Heart, c.* 1450–70. National Gallery of Art, Washington, D.C.

Van Eyck's Christ Child is surrounded by statues alluding to his suffering. This comparison might help us see that there is a core of popular piety in van Eyck's work that shines through its material splendour. Yet, when we look at the Dresden *Triptych*, our senses are overcome by the finely wrought enclosure created for the five human and divine figures. The viewer is left with what we might describe as an ironic relation between these different elements, the simplicity of Virgin, Child and inscription and the ornateness of setting and accessories.

Who was its patron? It is commonly assumed that the man presented on the left wing paid for the triptych, and also that he was Italian. The latter supposition was at first based on the presence of the arms of the Genoese merchant family, the Giustiniani, in the corners of the frame. But these arms have been shown to have others, now illegible, beneath them. The Giustiniani family may have been later owners of the work, but no

member of that family originally commissioned it. Does the subsequent Italian ownership mean that it was originally commissioned by Italians? We do not know. The man in the painting is dressed in the height of Burgundian fashion, complete with the latest haircut. This style could have been followed by either an Italian or a Northerner in the ducal entourage.

If the nationality of the man represented is at issue here, so too is the question of whether or not he was the one who paid for the work. Usually we assume that a person depicted in a painting paid for its execution. A person's presence is taken as a proprietary gesture: he was put in because he owned the panel. Yet we also recognize that an appearance in a painting makes a variety of comments on a person's social, political and religious standing, a standing which other members of the family may have been as interested in seeing promoted, or preserved, as the person was himself. One scholar has suggested that van Eyck's Rolin painting was commissioned by the Chancellor's son Jean, who had become a cardinal in the Church shortly before. The painting would in that case reflect the son's wishful thinking about his father's piety.

In the case of the Dresden *Triptych* we are faced with the dilemma caused by the prominence given to St Catherine (illus. 85). Normally, if a husband were painted on one wing with his patron saint, his wife would be accompanied by her patron on the other. In van Eyck's work there is a female patron saint, but no wife. Is this man simply unmarried? – something which is possible, but unlikely, for a man of his age. Other suggestions have been made in response to this anomalous situation. The painting was perhaps commissioned by the man as a gift to his wife, to be kept by her in his absence. This is an especially appropriate notion if the man was a merchant who had to travel in the course of business. Or the wife could have commissioned the painting, either to keep for herself or to send with her husband to protect him and to stimulate him in his devotions while away.

Although speculative, these suggestions do raise the interesting possibility that a female patron may have been responsible for this work. In this connection it might be observed that, as noted above, women originated the devotion to the Sacred Heart in the twelfth century and the thirteenth, and continued to promote it vigorously in the following centuries. Still, men certainly meditated on this concept. There are, for instance, several portraits from the late fifteenth century that show a half-length male image before a distant church prospect, either an exterior view, or an interior with Mass in progress (illus. 95). The man is holding an open heart-shaped book, a possible reference to his devotion to the Sacred Heart of Jesus.

One way to address the concerns of the man that van Eyck painted on the left wing of the Dresden *Triptych* is to examine his portrayal of the saint on the right. Perhaps the man in this triptych had a special devotion to St Catherine. She is presented in this work as a princess. This is part of her legend. St Catherine was a princess of Alexandria who converted to Christianity; she became extremely learned and was able to dispute with

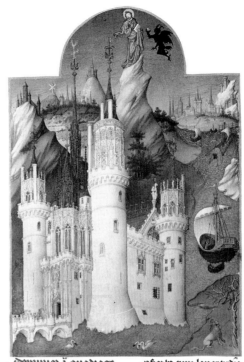

95 Master of the View of Ste Gudule,
Young Man Holding a Book, c. 1480.
Metropolitan Museum of Art, New York.

96 The Limbourg brothers, *The Temptation of
Christ*, c. 1415, from the *Très Riches Heures de
Duc de Berry*. Musée Condé, Chantilly.

the great pagan philosophers of her day. She was miraculously rescued from death on a
spiked wheel, which is shown shattered and lying at her feet in van Eyck's painting;
eventually she was beheaded with the sword of martyrdom, which the painter has her
hold at her side. In the panel she wears a crown. Even the Virgin in van Eyck's works
rarely has such a regal attribute. Catherine's blue velvet gown has large ermine
trimmings, as well as a bib, train and small panels which fall from, and wind gently
around, her arms. This costume was old-fashioned in 1437 when the painting was
executed; to contemporary eyes it would have given the saint the appearance of
someone wearing her grandmother's wedding dress. Catherine's prayer book has
delicate gold clasps with tassels on them; her necklaces are simple but elegant. A gold
chain with red stone clasps serves as a low-slung belt. This woman is an almost overly
refined example of noble artifice. It is worth noting that the window behind her is the
only one in the painting to be partially cut away to reveal an enticing prospect of
aristocratic dwellings and an expansive landscape. One is reminded of the miniature in
the Duke of Berry's *Tres Riches Heures* where the Devil tempts Christ by a vision of one
of the Duke's favourite castles (illus. 96). Is this Catherine's earthly domain as princess

that we see beyond the window? If Catherine has been tempted by worldly riches, she shows no sign of having resisted.

An inscription running around the frame of the triptych's right wing discusses her exploits. It ends by claiming 'nuda nudum est secvta certis Christum passibus, dum mundanis est exuta' (Naked she followed the naked Christ with sure steps, while of worldly things she was stripped bare). Certainly at first glance this seems an odd characterization for van Eyck's St Catherine, who gives no visual hint of such ascetic inclinations. Only the naked Christ Child in his humility seems to answer to this verbal description. Why would van Eyck and his patron employ words that run counter to the visual message? We find here again what might be called an ironic or mocking tone in van Eyck's work.

The phrase that begins the passage quoted above – running up the left side of the triptych's right wing – is a commonplace in medieval ascetic writings: 'Nudus nudum Christi sequi' (Naked to follow the naked Christ) is a formula found in Latin first in St Jerome, then in numerous examples throughout the Middle Ages. Its frequent use was in order to characterize an ideal life of poverty and withdrawal from material pleasures. In the twelfth century especially, it was a virtual commonplace in devotional writings. One of its most prominent incarnations in the fifteenth century is in chapter 37 of Thomas à Kempis's *Imitation of Christ*, which contains Christ's explanation of 'How Surrender of Self Brings Freedom of Heart':

Strive for this, pray for this, desire this one thing – that you may be stripped clean of all selfishness, and naked follow the naked Jesus, dying to the self that you may live in me forever.

This comes at the end of the chapter; at the outset Christ had said that 'as you yield yourself unreservedly into my hands, I will grant you even greater riches'.

Some observers might conclude that this is what van Eyck was trying to show: after the renunciation of earthly things comes the even greater glory that he has painted, a heavenly vision awaiting the truly devout disciple of Christ. That the heavenly vision is imagined in earthly terms is, in this view, only a sign of our human limitations, not of the artist's pretensions. Catherine's rich finery might also be explained as historical accuracy: she was a princess, according to sacred legend. And the quoted passage, using the formula *nuda nudum* – was useful to the artist – it was part of the antiphons said at Vespers on the Feast of St Catherine. Was van Eyck merely using the standard liturgical phrases? Were these words only meant to lead to the notion of transcendence – a transcendence of the material world through a superabundance of visual riches? Full as it is of material splendour, van Eyck's painting may be thought to be a pious anticipation of the even greater splendour that awaits the devout worshipper, the patron of this work, in the hereafter.

There is little reason to doubt that van Eyck and the original viewers of his painting would have been flattered by such an evaluation, pleased by its appreciation both of his

craft, as well as of their piety. Not all of his contemporaries would have agreed. Those who championed the *nudus nudum Christi sequi* formula – St Bernard, Thomas à Kempis and the mendicant Franciscans among them – surely would not? Could van Eyck and his patron have been blind to the way this painting flaunted material indulgence while calling for renunciation and withdrawal? At the very least, artist and patron were not afraid of confronting the paradox. This painting does more than allude to a distant, archetypal challenge; it verbalizes one lifestyle and visually parades another. Van Eyck and his patron seem determined to indulge both their fashionable ways and their longings for affective, even ascetic, piety. There is no need to claim that this demonstrates insincerity, only a very particular humanity.

Perhaps van Eyck and his patron intentionally sought to co-opt some of the spiritual power of popular devotion of the sort found in the *Imitation of Christ*. Perhaps both artist and patron did want to learn from these humble guide books, and from the meek and lowly Christ Child. But they saw no reason for such an endeavour to involve renunciation and real poverty, as Thomas à Kempis and others claimed it did. So they ended up proclaiming that St Catherine renounced everything, and that she was also a fabulously beautiful and well-attired princess, ruler of all she so demurely surveyed. It is the selfconsciousness of this stance that I think is crucial. Others had claimed that the material world and its riches could glorify God. Others had tried to envision heavenly beatitude and yet fell back, humbly, on material analogies. But that is not what van Eyck does – or what his patron responds to. The words from the feast-day liturgy of St Catherine did not have to be posed in such an aggressive, even shocking, way. Christ's meekness and humility did not have to be accentuated, visually and verbally, in such a physically ornate setting. The prim and polite donor did not have to be so exacting in his behaviour. In the Christ Child's case it was appealing to make the body small, naked and helpless; in those of Catherine and the donor, it was not.

Van Eyck was no doubt rightly proud of his ability to manipulate religious devotion for his donor's ends. There is a sense of liberation, of personal power and ambition sought and fulfilled, which should not be denied. The Sacred Heart is contemplated in a gorgeous reliquary shrine, and St Catherine follows the naked Christ in her most elegant apparel. She and the donor do not need to stand bare and contrite, offering their hearts before Christ, as we see in other contemporary religious productions (illus. 97). The inscription around the centre panel of van Eyck's triptych begins with his usual hymn to the Virgin, to which is added:

As a vine I have brought forth a pleasant odour, and my flowers are the fruit of honour and riches. I am the mother of fair love, and of fear, and of knowledge, and of holy hope (Ecclesiasticus 24: 23–4).

We read of holy hope, the fruit of honour and riches. We look at the palatial interior, observe the ermine-trimmed garb of the princess, and we quickly escape any of the ascetic strictures that other elements in the painting might suggest.

It would hardly be true to say that van Eyck and his patron want nothing to do with the rigours of Christianity. They do seem involved in their religious beliefs and in their religious lives. Still, the juxtapositions they set up may sometimes seem a bit playful; the confrontation of word and image in the Dresden *Triptych* does, I think, enter that sphere. A personal work, a personal devotion, a personal indulgence. What made, and still makes, the image work is not what we might, all too readily, call its impiety, its window-dressing. It concerns, rather, its freedom and its choice, its sense of being able to appropriate various devices from various well-springs of religious power. These people, the artist and his patron, know how to make Christ's call to follow him, and Catherine's determination to heed the call and leave all behind, not threatening but cute.

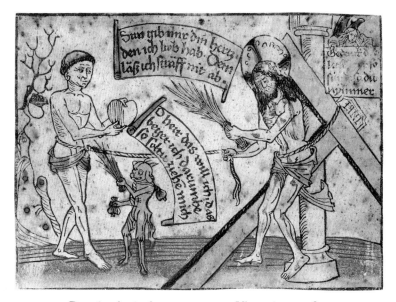

97 Devotional print by an anonymous Ulm artist, *c.* 1480.
Kupferstichkabinett, Berlin.

16

Architectural Style and
Sculptural Symbolism

The adjectives ecclesiastical and palatial have both been applied to the edifice portrayed in van Eyck's Dresden *Triptych* (illus. 81). It is extremely difficult to say just what kind of building it is, or what function it had. There is a central hall, not too large, only a little wider than the Virgin's throne. This hall is squared off at the far end, and is surrounded by a subsidiary space, with a round-arched colonnade separating the two areas, and a balcony above. At the points where the donor kneels and St Catherine stands, other smaller hallways lead off at right-angles from the Virgin's hall. Are we confronted with a nave, aisles and small transepts of a church or chapel? Or is this a palatial audience chamber, basilica-like in its arcades and its tributary spaces? The stained-glass windows in the second storey and the statues over the columns in the central space might at first suggest an ecclesiastical setting. But both are also to be found in palatial residences. Perhaps we are in a palace chapel.

An important point here is the real lack of absolute clarity. When portraying a church or a house, however magnificent, other artists at this time included some identifying detail – a bed, a chair, a chest, a confessional, an altarpiece or a prayer-board. Van Eyck himself could and did do this. The *Arnolfini Double Portrait* (illus. 8) is specifically located outside a church; the *Virgin and Child in a Church* (illus. 87) is set in the midst of a Gothic cathedral. But the Dresden *Triptych* remains somewhere in-between. In this work van Eyck seems more concerned with establishing the delicate psychological and physical relationship of donor and holy figures – the wonder and the worship in separate chambers – than with specifying absolutely just what kind of edifice it is that all inhabit. It is first and foremost an environment of the imagination and the heart.

In addition to this kind of spatial idealization, van Eyck has also not chosen to portray what today we would call a classic, clearly distinguishable, expression of architectural style. Perhaps our notions of the typical stylistic expression of the eleventh century and the twelfth – Romanesque and early Gothic – as opposed to the High Gothic of the thirteenth century and fourteenth, are just modern art-historical constructs. In the fifteenth century there may in fact have been very little sense of an orderly progression of architectural style, which today we feel is such an important feature of the Middle Ages. In all his ecclesiastical and palatial edifices – except for the Berlin *Virgin and Child*

in a Church – van Eyck seems to enhance an essentially Romanesque structure with subsidiary Gothic elements. The stylistic features of his buildings are difficult to define with precision. Column bases are adorned with what today we would be inclined to describe as Gothic blind tracery. The columns themselves are heavy, polished and multi-coloured, with rich foliate capitals – quite unlike what is found in a typical Gothic building. Above the columns in the Dresden work, statues stand surmounted by pointed canopies with delicate finials – a Gothic touch. For van Eyck's work, one senses that the application of such stylistic labels is of questionable value.

Is it possible that for this artist a particular architectural style had a specific religious connotation? Some scholars have proposed that at times van Eyck and other early Netherlandish painters exhibited a remarkable degree of historical and symbolic understanding in their use of architecture. When important for their purposes, they could identify one style – Romanesque – with events from the time of the Old Testament, and another, later, style – Gothic – with events from the New. Alternatively, it has been proposed that for van Eyck the chronologically distant Romanesque style could take on general connotations of the physically remote Heavenly Jerusalem, a fitting location in which earthly and divine forces might meet. If nothing else, these theories place appropriate emphasis on the highly manipulative attitude that governed the representation of the world, and architectural style in particular, in these images.

Here I would like to put forward another suggestion of the way that van Eyck's architectural style might be said to be historically alert. We might first acknowledge that in moving from the van der Paele panel to the Dresden *Triptych* (only a short space in time), the artist might be seen to have developed and elaborated his own distinctive approach. The raised bases of the columns become ornamented; mouldings are added to the arcades; stained glass appears. In the four works portraying the seated Virgin in an interior setting (illus. 23, 40, 61 and 81), van Eyck can be seen to have displayed an architectural style that is distinctively his own, solid and yet highly decorative, suggesting both Church and wealthy lay establishment, a perfect complement for the competing aims and functions of the panels as a whole.

There is clearly something old-fashioned about the architecture that van Eyck chose to create for and in these images. In Bruges, where he lived, van Eyck had important models of a more recent, streamlined and soaringly vertical style near at hand. The Church of Notre Dame, begun in the late thirteenth century, was subject to major building campaigns in the mid-fourteenth century and late fifteenth (illus. 98). The Cathedral of the Holy Saviour had a similar building history (illus. 99). Clearly, van Eyck was not trying to imagine in most of his works an equivalent to these almost contemporary Gothic structures, with their compound piers, tall vertical arches, soaring colonnettes and ribbed vaulting.

For an edifice with structural and stylistic features like those depicted in the Dresden *Triptych*, we can more profitably look to the nearby city of Tournai. Here the great

98 Nave of the Church of Our Lady, Bruges, built *c.* 1212–1230.

99 Nave of the St Sauveur, Bruges, built in the
13th and 14th centuries.

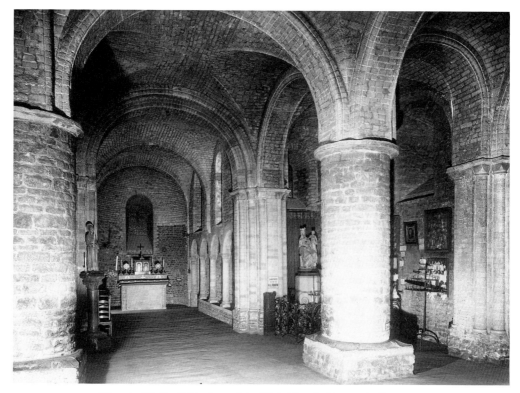

100 Chapel of St Basil (Basilica of the Holy Blood), Bruges, built 1139–49.

twelfth-century Cathedral is ringed by a series of impressive Romanesque – or in modern stylistic terminology, Transitional – parish churches. In these buildings we find a combination of round and slightly pointed arches, as well as a combination of column and pier supports, columns supporters with heavy foliate capitals, and blind triforium arches (illus. 113). It is by no means the case that van Eyck created architectural portraits of these twelfth- and early thirteenth-century Tournai monuments. These churches do have a stylistically heterogeneous and, in fifteenth-century terms, archaic character, and this combination is close to van Eyck's work in flavour, if not in every detail. He envisioned a more lavishly encrusted interior, and yet he may well have learned something from the primitive and even, to our eyes, sometimes awkward strengths of the Tournai buildings, which were then about 250 years old. His subsequent swing to the more soaring architectural style of the Berlin panel (illus. 87) also suggests that he had been conscious of cultivating another manner at an earlier time.

In Bruges van Eyck could hardly have failed to notice the difference between the slender and lofty new Church of Our Lady, and the powerful, massive forms of the mid-twelfth-century Basilica of the Holy Blood (illus. 100). He might not have considered this difference in terms of the stylistic phases recognized today by art historians; he might not have known the exact dates of construction, renovation and decorative

addition. What he saw in the earlier work and, I think, tried to capture in his predominantly Romanesque interiors, was a sense of weight and order, of massive underpinnings and foundations, and an idea of earlier Christian worship.

Such a feeling would have nicely reinforced his general preoccupation with the simplicity and directness of a vision of the Body of Christ. We can be even more pointed in our analogy between van Eyck's use of architectural form and his concept of the liturgy. Throughout the twelfth century and early thirteenth, as the Gothic style developed, understanding of the sacraments, especially the Eucharist, was increasingly intellectualized. As the Scholastic method grew in substance and use, a physical experience of the rite was superseded by a textual critique. More and more, the ritual was discussed in elaborate metaphorical terms. Dependence on religious intellectualism in high or learned culture replaced that on oral performance, now increasingly attributed to popular culture. By the fourteenth century, even among intellectuals, the tide once again had begun to turn. Scholasticism was on the decline. The rising lay population continued and even increased its focus on visual apprehension itself.

It is my belief that van Eyck's mature art reveals him to have been sympathetic to the greater emphasis on physicality, as opposed to rationality, which characterized his age as a whole. One of the artist's early works, the *Ghent Altarpiece* (illus. 89 and 90), might be replete with rational theological significance. His later images of the Virgin and Child seem more and more to exhibit slightly less forbidding intellectual interests. This kind of sympathy with his times might also have been unconsciously manifest in his choice of architectural style. Van Eyck probably did not have precise knowledge of developments in late medieval architecture, nor was he, in all likelihood, fully acquainted with the historical growth and change of Christian theology in the three centuries before his own. I do not mean to claim that he chose a form of architecture clearly associated with a particular intellectual stance, an architecture which would have been thought to refer to a time when people had expressed a congenial view of the Eucharist. What might have happened, however, was this: in searching for an environment suitable for a direct oral and performative understanding of the Eucharist, van Eyck might have looked back to an earlier time. Here he found buildings more physically impressive than the current, airy Gothic interiors. In the artist's heavily worked Romanesque buildings, we find something firm and massive, something quite different from the highly refined and intellectualized Gothic interiors produced from the thirteenth century to van Eyck's own time.

It seems to me unlikely that van Eyck cared, or was able, to make his retrospective architecture correspond exactly with a period in time when particularly appealing views on the sacrament had been expressed. A certain precise frame of mind does not of necessity correspond to a certain grammar of design or ornament. But perhaps he was aware that in earlier, more fundamentalist, times there had not been such an emphasis on intellectual interpretation as there was in the High Scholastic, or High Gothic,

period. If van Eyck had been solely intent on creating a parallel between architecture and idea, he would have had to produce much more primitive edifices, stripped of later ornamentation, actually resembling the simple carved forms of the Chapel of the Holy Blood (illus. 100). Other considerations obviously intervened. He was not a painter of great expanses of bare or rugged stone walls; his and his patrons' love of material splendour was too great for that. He did still manage to go back, to capture some of the historical, as well as psychological, reality of an earlier architectural style, and of a corresponding popular religious mentality.

One other feature to be found in several of van Eyck's Romanesque interiors is particularly intriguing. In the background of the van der Paele panel and of the Dresden *Triptych* there are historiated capitals (illus. 29 and 83); while in the foreground of these works the columns are capped by rich, largely abstract, foliate designs (illus. 28). If van Eyck was concerned to provide a complete rational or religious explanation for his images, why would he do this – literally bury the secondary figural comments? Today we assume that these historiated capitals do make some comment on the larger scene. And from what we can make out in the van der Paele work, that seems to be the case, as I have mentioned with the episodes of Abraham and Isaac, and of David and Goliath. The example of the Dresden *Triptych* is more complicated. Not only are the figural capitals in the centre panel pushed as far back as possible, but they are so fragmentary and indistinct that the subject-matter still eludes us. The question becomes more insistent: if these details supply commentary that is important for our understanding, why were they not brought forward to where they could readily be seen?

Other early Netherlandish painters created elaborate arch motifs to contain a number of sculpted scenes, sometimes a whole sacred history (illus. 58). Such reliefs, capitals or archivolt sculptures are almost always in the forefront, and always, in any case, clearly articulated in the work of Robert Campin, Roger van der Weyden and Petrus Christus. Why did van Eyck pass up the opportunity to portray as figural those capitals that might easily be seen and thus readily understood? There is an element of playfulness here, as well as deliberate mystification, which I have mentioned several times already. Van Eyck wants the spectator to feel that there is more to the image than at first meets the eye. We sense this to be a work that will repay close and prolonged scrutiny. The way the artist deliberately hides the historiated capitals certainly contributes to this.

Yet, I think we must be alert to something more than the little mysteries – the diverting games – that artist and patron may be playing. We should not ignore the fact that the numerous heavily foliated capitals are prominent in the foreground of the van der Paele and Dresden works. Each capital is almost as big as any of the heads of either human or divine participants. These capitals have the kind of primitive life and energy that we do not usually associate with the intellectual refinements of van Eyck's art, especially as exhibited in an early painting like the *Ghent Altarpiece*. And yet, as van Eyck

matured, this seems to have been one of his intellectual refinements: the search for a telling way of alluding to the power of direct perception, unadulterated nature and the humanity of Christ.

In some ways van Eyck's Dresden *Triptych* might be judged naively physical, dwelling on substance, growth and the proliferation of one detail after another. The work can be said to place the extreme rational calculation of High Scholasticism very much in the background. That may be true, and yet clearly it does not account for the whole picture, the whole world that van Eyck and his patron inhabit. There may be some longing for the primitive, popular well-springs of the faith here, but these are not desirable without suitable decorative embellishments. Van Eyck's portrayal may be physical, but it is not, ultimately, naive. He was capable of looking around him and making astute judgments about architectural style and ornament. He was sensitive to historical distance and geographical proximity. He was aware of the power of ascetic ideals, although neither he nor his patron wanted them to disrupt their own material condition. He could judge intellectual, as well as emotional, claims. He was not the victim of Scholastic thought, any more than he was unduly subject to pangs of mystical withdrawal. In all these ways, the setting of the Dresden *Triptych* demonstrates, of itself, the artist's manipulative skills.

17

Van Eyck's Modern Icon

The two paintings of the Virgin and Child that van Eyck completed in the last two years of his life are remarkably different from the four seated figures executed previously. These two images, one of which is now in Antwerp (illus. 86), the other in Berlin (illus. 87), show the Virgin, who holds a tiny swaddled infant, standing in a garden in the first, and in the vast reaches of a Gothic cathedral in the second. She is dressed in both cases in a robe of cool and regal blue, with a simple sinuous gold border. She is still a voluminous figure but, at the same time, is increasingly ethereal. A soft atmospheric texture presides, rather than the earlier hard-edged form. To some extent the Dresden *Triptych* also has this quality, although there the Virgin's form is a weighted, pyramidal one, enclosed in a heavy and ornate architectural setting. In the Antwerp and Berlin panels van Eyck has followed the more painterly, light-filled brushwork of the *Triptych* further, into the overall structure and appearance of the work.

These two late panels not only show surfaces that glitter, but also forms that are pliant, subtly interacting with the surrounding space and air. The Virgin seems to stand suspended in each case; in the Antwerp painting she does not make any impression, crease or fold on the brocaded cloth of honour that lies on the soft ground beneath her feet. A pale blue sky and various plants fill the background of this work, while the cathedral in the Berlin panel is vast and filled with numerous effects of direct and indirect light. These elements provide a delicate atmospheric setting for the figures not found in the earlier, more geometrically designed interiors. The marmoreal silence of van Eyck's seated Virgins is, in the two late works, replaced with the suggestion of tinkling sounds – from a fountain in one, and the small, high voices of two angels chanting in the distant choir in the other. In opposition to the direct presentation of van Eyck's earlier Virgins, the composition of each of the two later images is set up on a diagonal. In the Antwerp panel the spectator's eye enters by way of the fountain in the left foreground; the artist ensured that this movement is read by placing a slanting, incised perspective pattern on the masonry base of the fountain. In the Berlin panel movement also proceeds from left foreground to right background, down the nave of a church.

The Virgin's tiny hands become more noticeable; their very delicacy seems now to belie any massive bodily structure beneath the blue robe. The Christ Child in both

works seems weightless. His mother does not clutch him firmly, as she had in all those images in which the pair is seated. The Virgin's hands seem barely to press against the Child's body; he too is an ethereal, buoyant bubble. In these works pains have been taken to move away from gravity and determination, from the implication of presentation and sacrifice. In the earlier paintings we are consistently confronted by the body of Christ. Now, in these images the Child's body is covered. The figures are pulled back into a luminous space that increasingly inhibits their being viewed primarily as powerful physical shapes on the picture surface. There is a distinct change of emphasis between the seated and the standing Virgins. The dominant concept earlier was physical, but now it is gently ethereal, visionary. Earlier, it was a drama of death and redemption; now it is a divine fairy-tale of transcendence. The two later panels are visually simpler, unified by a style of brushwork that is not as minutely descriptive of difference as it is evocative of inner harmony. This is the divine music of the spheres.

Van Eyck has at last painted two images that are truly mariolatrous, worshipping the divine Mother of God. It is the Virgin who speaks from these panels. She is not so much put on display as possessed by an innate nobility. With the exception of the texts on the frames of the van der Paele and Dresden works, never before in van Eyck's work had anything been so fully, so clearly and so single-mindedly a reference to the Virgin. Now, the support for the Virgin is the basis of the image. These standing Virgins transcend merely human bonds in order to embody a process that is the reverse of that of the Son: not a God insistently become man, but a woman who has been set apart, one who is able to overcome the physical limitations of Original Sin. Van Eyck's is now a concentrated vision of the Immaculate Virgin. This issue is the increasing focus of his art, a focus that has caused him in some ways to adjust his formidable powers.

For the visual change in the image of the Virgin that van Eyck effected in his final two portrayals of her, we might reasonably invoke some outside source of influence. Where would van Eyck have looked for inspiration for the distant standing image of divinity that he introduced in the Antwerp panel? One would not immediately think to point to what, in our eyes, is a highly stylized Byzantine icon (illus. 101). And yet, that is the source previous observers have, rightly, hit upon. His dependence on a Byzantine model for both the Antwerp and Berlin panels, but more especially for the former, can be demonstrated in several ways. First, however, it should be made clear that we are not certain which icon, or icons, van Eyck might have seen. The one now in Cambrai (illus. 101) arrived in the North in 1440; thus van Eyck could not have depended on it for his Antwerp work of 1439 if he had, throughout the mid-1430s, remained in Bruges. Perhaps van Eyck made a trip to Italy in about 1438; there he could have seen several icons with very similar characteristics (illus. 102). I will return to this possibility below. For now we can note that iconic formulas are extremely rigid, more or less standardized. Even if he had not seen the Cambrai picture by 1439, the icon or icons that he would have known could easily have been almost identical to it.

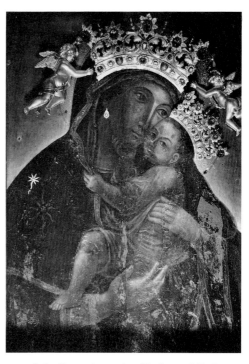

101 Italo-Byzantine artist, *Notre Dame des Grâces*. Cathedral, Cambrai.

102 Italo-Byzantine artist, *Madonna della Bruna*. S Maria del Carmine, Naples.

The core of the icon taken over by the fifteenth-century artist is composed in the following way: Virgin's head above and gently displayed hands below, with the Child in between, at least one of his knees raised, one arm extended toward the Virgin and his head in close contact with hers. In the icon we find the stimulus for the rather limp gestures seen in van Eyck's Virgin. The stylized, effortless quality of the Virgin's boneless hands in the Byzantine work is mimicked almost exactly by the Fleming. Van Eyck is carefully imitating this delicate interlocking of limbs: he must have been fascinated by the lack of weight and pressure, the timeless immobility, of the Eastern image.

In the icon the Virgin wears a large blue cloak with an elegant gold border; the Child is wrapped in his swaddling cloth, which hangs down from his thighs in strict vertical folds. These colouristic and drapery elements appear in van Eyck's works as well, although they are not simply copies. The same can be said of the relation between the heads of the two figures. A close visual connection between mother and child is found in both the icon and the Flemish panel, but van Eyck has subtly shifted its composition and its meaning. Byzantine icons that employ this formula – the *eleousa* type – invariably show both faces side by side, often looking appealingly at one other or at the spectator. The Christ Child is sometimes shown grabbing his mother's chin in a further sign of love and tenderness. Van Eyck has consciously toned down this loving relationship and its concomitant, frank emotional appeal. It is interesting to note that when Gerard

David creatively copied van Eyck's work, he had the Christ Child once again turn his head, thus involving the spectator more directly, as is the case in the icon (illus. 103).

Van Eyck wished to employ the sacred core of the earlier holy image. But for him it is a timeless expression of Christian truth, not a touching memorial to the love between mother and child. Whatever human sensibility the *eleousa* icons might originally have had, van Eyck was bent more on covering, rather than on eliciting it. His version of the icon is highly stylized, but within his own, newly calculated, Western terms. He employs the work abstractly, not for its telling psychology. He does not utilize such rigid drapery folds. The Virgin's head is not encased in a nun-like mantel. The golden elements in van Eyck's painting are not allowed to remain as flat metallic gold-leaf, gleaming on the surface. Most important, he replaces the gold background of the icon with flowers and sky; and the tight, usually half-length, composition is expanded to full-length. And yet, these changes are a way for van Eyck to create his own sense of idealism and distance in the work. Had he made a half-length image of the Virgin and Child in his own realistic style, he would have ended up, almost by necessity, accentuating the pair's earthly physical bond – a portrait of mother and child. This is the kind of image that Roger van der Weyden was later to perfect (illus. 104). What van Eyck wanted to learn from the

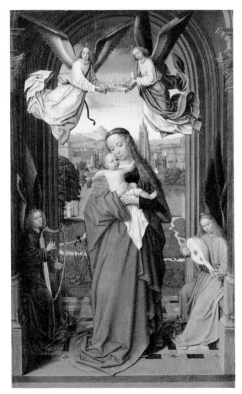

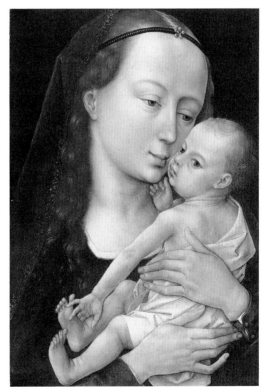

103 Gerard David, *Virgin and Child with Four Angels*, c. 1500–05. Metropolitan Museum of Art, New York.

104 Roger van der Weyden (attrib.), *Virgin and Child, c.* 1455. Museum of Fine Arts, Houston.

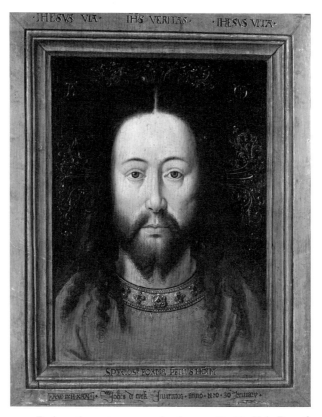

105 Early 17th-century copy after Jan van Eyck's *Holy Face* of
1440. Groeningemuseum, Bruges.

icon was quite different from this human truth. The distancing devices, including the
diagonally arranged compositions, are appropriate for his own style. For him, the
eternal message of the icon, its visionary distance, would thus be maintained.

He saw the Byzantine image as archetypal, original and truthful, a visionary work
with transcendent, even magical, power. That is a feeling that many today might find
was more obviously exhibited in his painting of the *Holy Face* of 1440, made a year
after the Antwerp *Virgin*. The *Holy Face* survives today only in later copies (illus. 105),
but there is little reason to doubt that these reflect an Eyckian original, perhaps even
several originals, produced on request during the last few years of the painter's life. In
these works we find rather exact reconstructions of the iconic model. Here van Eyck
was forcefully recapturing the true image (*vera icon*) of Christ's physiognomy, as it had
been passed down through the centuries in the very area of the world where Christ had
lived. In the Virgin and Child composition a more creative interplay of old and new,
traditional formula and personal invention, was utilized. In the Antwerp panel the
Flemish artist worked out how to paint a remote iconic image of truth in his own terms.

Contemporaries understood this. Throughout the fifteenth century van Eyck's
Antwerp painting was repeatedly copied. This was true of several of van Eyck's other

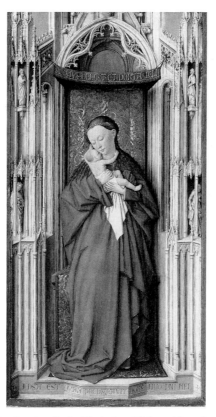

106 After Jan van Eyck, *Virgin in a Niche*, mid-15th century.
Metropolitan Museum of Art, New York.

figural compositions as well, for instance, the van der Paele *Virgin and Child*. But what happened to the artist's Antwerp work was different. At least eight very exact copies of this figure group survive, dating from van Eyck's own time to *c.* 1500 (illus. 106). This is certainly a tribute to van Eyck's impact on later generations. It is also possible that those artists understood his motive – that of trying to create his own modern icon. We know that Byzantine icons were laboriously copied by their north European owners, sometimes as many as fifteen times. The careful copies of van Eyck's figures could very well carry the same charge: their makers felt obliged not to adapt loosely but to record carefully the magic formula that van Eyck had both rediscovered and revivified. It seems likely that they knew both that van Eyck was working from an icon, and that he was intent on creating his own up-to-date equivalent.

The form of van Eyck's motto in the Antwerp panel is intriguing; it includes four pseudo-Greek letters: ΑΛΕ ΙΧΗ ΧΑΝ. The only other religious paintings employing pseudo-Greek forms are the lost *Holy Face* images. The motto appears on the Dresden *Triptych*'s frame, but in Roman letters. The Greek letters are also found on two early portraits now in the National Gallery in London (*Tymotheos*, 1432; and *Man in a Red Turban*, 1433), as well as on the artist's portrait of his wife, Margaret (illus. 7). It would

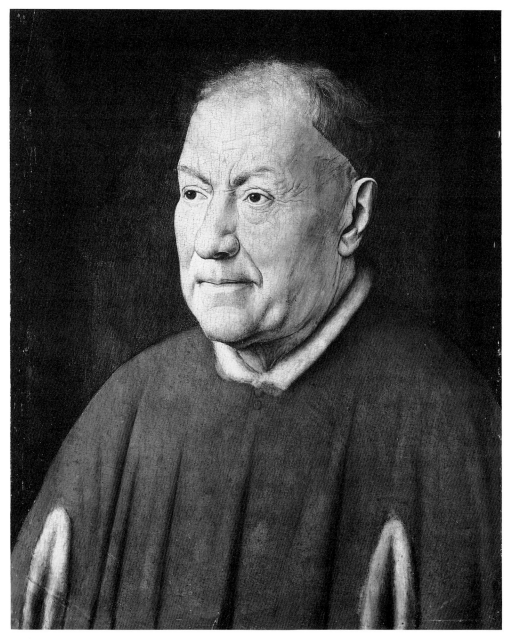

107 *Portrait of Niccolò, Cardinal Albergati,* (?)1438.
Kunsthistorisches Museum, Vienna.

be difficult to claim absolutely that these Greek forms had some special meaning. Certainly, contemporaries were fascinated by Greek characters and their seemingly magical power. Philip the Good owned several paintings done in the Greek manner with inscriptions *escripte en grec*, according to contemporary sources. There is, then, little doubt that van Eyck might have seen and been attracted to icons with rather mysterious Greek lettering. The script often took such forms like IC XN NI KA (Jesus

Christ is Conqueror) or ɪх хс но on (Jesus Christ, He who is). It is tempting to think that van Eyck's pseudo-Greek version of his motto conveniently mimics such religious insignia. His creative attitude toward the icon would thus be magnified.

In the Antwerp panel of 1439 van Eyck created an image of worship for the Virgin, rather than for her tiny son. He did this in a form directly, but also creatively, derived from a Byzantine prototype. The historical context of the time provided unique justification for this combination, and it raises interesting political questions about the intended audience for the work. The years 1438–9, when van Eyck first made his *Holy Face* icon and then his *eleousa* adaptation, mark the beginning of the Council of Ferrara/Florence. This Church Council called by Pope Eugenius IV was claimed by the Pope to be the legitimate relocation of the Council of Basle. The Pope had abandoned the Basle gathering in 1437, as it became increasing apparent that its leaders were determined to limit papal power and prerogative. Besides, the Pope was bent on holding discussions about reunion with the Eastern Orthodox Church, an issue of little interest to the conciliar Fathers, except as it might strengthen their hand against him. The Eastern emperor and Church were anxious to gain papal financial and military support for their continued battle against the Turks. The Basle Fathers wanted to meet the East away from Italian soil; over their objections, the Pope and representatives from the East agreed on Ferrara. In early 1438, amid great pomp and spectacle, the emperor and patriarch arrived first in Venice and then in Ferrara.

The man the Pope chose as legate to set up the Council and arranged various technical and diplomatic issues was the quiet and unassuming Cardinal Niccolò Albergati. He had already served as a roving papal diplomat on several occasions. Most recently he had played a significant role in helping bring about the Treaty of Arras of 1435, which made peace between King Charles VII of France and Duke Philip the Good of Burgundy. Van Eyck painted a portrait of him (illus. 107). It was identified as a portrait of Albergati, and said to have been painted in 1438, when it was in a Flemish private collection in the mid-seventeenth century, at a time when it still had its original gold frame. This judgement was no doubt based on an inscription on the now lost frame. It places the portrait in the opening year of the Council of Ferrara.

Duke Philip the Good not only had an interest in icons, as has already been pointed out, but also in assisting the Eastern Church as well. He was one of the strongest supporters in the West of a crusade against the Turks. After the Church Council was convened at Ferrara, Philip transferred his embassy from Basle to the Italian city. When the Burgundian delegation arrived, they disrupted the Council by failing to acknowledge the Eastern emperor in the course of their passage to pay homage to the Pope. The emperor was so incensed that he left the Council, and was only persuaded to rejoin it in Florence after the Burgundians had made a full apology. This apology included the presentation of letters, supposedly from Philip but actually manufactured on the spot, claiming that the Duke had a 'burning desire for union with the Greeks'.

The years 1438–9 were propitious for a Western artist to be interested in Eastern icons, especially, one would reasonably imagine, for an artist in the Duke of Burgundy's service. Could van Eyck have made a trip to Italy in 1438, perhaps as part of the Burgundian embassy to the Ferrara Council? That would explain the date of the Albergati portrait. Such a trip would have given the Flemish artist ample opportunity to view and learn from the artistic splendours of the Orthodox Church. It would also help explain the fact that the imitation stone frame of the Antwerp *Virgin and Child* finds its closest precedents in Trecento Italy. The most one can say is that no record known today makes it certain that van Eyck undertook such a trip. There is, simply, very little mention of his activity in the meagre court records surviving from the period 1437–41 – only one notice, in 1439, when he was reimbursed for some expenses undertaken on behalf of the Duke.

There is another important consideration in evaluating the original circumstances that gave rise to the Antwerp *Virgin and Child*. That is the brief that this panel provides for the doctrine of the Immaculate Conception. It was the Fathers at the Council of Basle, not the Pope, who championed Mary's cause. Beginning in 1435, the Council heard increasing support voiced for the Doctrine. The delegate who was to present arguments *against* the Immaculate Conception left the Council with the papal delegation in 1437. The following year the Fathers declared in favour of the doctrine, and stated that within the Church it was 'no longer allowed to preach or teach anything contrary to it'. The Pope did not follow the Council's verdict for another four hundred years. Throughout the later fifteenth century, those who favoured the Doctrine of Mary invoked conciliar support; it became an issue that was closely identified with the Council. Adherence to the decree of the Basle Council on the Immaculate Conception was found in those areas of Europe that were most strongly opposed to the Pope: parts of Germany and France, and Aragon and Savoy. On the other hand, Philip the Good, a firm papal supporter, forbade all those in his lands from following any of the Council's pronouncements.

In such a climate is it likely that a Marian image of the type van Eyck produced would have appealed to papal and ducal circles? The Pope and Duke may have felt no personal sense of outrage at van Eyck's painting, but could they have sensed a political threat? To us today, the little Antwerp panel may seem innocent, theologically innocuous. But that is not an entirely accurate view, historically. The image may not be blatantly propagandist; its simplicity and small size prohibit that. Nor does it present an elaborate treatise on the Immaculate Conception. Yet, in its own quiet way, it does elevate the Virgin to a very high level at a time when support for such placement had become a partisan issue.

Further political considerations are relevant here. Some staunch papal supporters, notably among the Franciscans, also backed the doctrine of the Immaculate Conception. Among them was Heinrich von Werl, professor of theology at the University of Cologne, an advocate of the Pope's power at the Council of Basle and author of a

treatise written in the mid-1430s favouring the Immaculate Conception. In addition, the Eastern Orthodox Church had long advocated the doctrine of Mary's Immaculate Conception. In some Western minds the notion of Mary's purity could have been connected more with longings for union with the East, than with fear of Western conciliar power.

It might be true that van Eyck's patron for his last two images of the Virgin was drawn from the same group as his earlier works; it might also be the case that this change in imagery indicates a new source, or sources, of patronage. An interesting connection in this regard is that between van Eyck and René, Duke of Anjou. René's abilities as a patron of art, perhaps even as an artist himself, far exceeded his political acumen. He was Philip the Good's feudal prisoner at Dijon in 1431–2 and again in 1434–7. After paying Philip a large ransom René repaired to Naples, where, in 1438, he became King of Naples and Sicily. The manuscript illuminations that belonged to, and perhaps were executed by, him frequently exhibit a strong Eyckian influence (illus. 18). René's taste for van Eyck's art probably developed during his Burgundian captivity. His interest in the East, which included Byzantine art, was also great: he owned an icon similar to that on which van Eyck's *Holy Face* is based.

When René was released by Philip and relocated in Naples, did van Eyck go with him, or at least pay a brief visit to the city? After René's installation, the impact of Flemish art in Naples was sizeable; van Eyck's works were especially prized. Also in Naples, van Eyck would have had the opportunity to see one of the famous *eleousa* icons on which his Antwerp and Berlin panels are based – the *Madonna della Bruna* (illus. 102). There is, however, no documentation to confirm that van Eyck visited René, or travelled in his entourage in 1438–9; the circumstantial evidence is interesting, but remains only suggestive.

Van Eyck's works are historically situated; in his day religious controversies and political antagonism raged. It would be an extreme hypothesis to say that his last Marian paintings resulted from the support of a new noble patron and a new geographical, political and theological context. There is no proof that this was the case, there are only some matters that might, circumstantially, suggest it. The wonder of van Eyck's images is that they manage to do so much in the religious sphere; they weave between extremes, between narrow dogmatic views on the one hand, and innocent pious platitudes on the other. After considering the patronage of the Antwerp panel we cannot, unfortunately, arrive at any firm conclusion, however attractive any such conclusion might be. There is still value in recognizing the possibilities inherent in the situation, however: the situation van Eyck faced in 1438–9 was a highly charged one – between East and West, between Pope and Council, and between various feuding noblemen. That van Eyck came down on the side of an iconic presentation of the Immaculate Virgin, even in as small and personal a work as the Antwerp panel, says something about this situation.

18

The Image and Experience
of Pilgrimage

In the small panel now in Berlin, van Eyck elevates the Virgin in ways unparalleled in his art (illus. 87). She is high-ranking, and remote. Her mantle of royal blue sweeps down to the floor with grace and ease; a large part of it is twisted up under her left forearm, where it is kept suspended. It may be thought she has the body of a thin, high-breasted courtly woman; she also displays on her head a heavy, encrusted crown. Her outline is large and elegantly curving; her charge, by contrast, is tiny, like a newborn babe. This Virgin and Child are contained within an exquisite Gothic cathedral, a building that in this case is unusually detailed, even for this most detailed of artists. It is hard to imagine how van Eyck managed to capture not just the detail but also the feeling of vastness and grandeur of such an edifice on a panel barely 31 cm (12 inches) high. One thing van Eyck has done to enhance this effect is to show us a diagonal view, which allows us to follow the side elevation of the building into space; another is to raise the choir, and the corresponding triforium arcade above. Thus the apse provides further visual interest and sense of height within the image, as well as a crowning motif for the Virgin. Indeed, as is often remarked, the entire building forms a kind of mandorla for Mary. Despite the minute and specific material detail, the building seems to be a sign of something immaterial as well; the fact that no mortal women or men are to be seen wandering through it supports this. All that can be discerned are two angels, viewed through the choir screen, who sing from a book they hold before them (illus. 88).

Perhaps the Virgin Mary's most telling feature is her size in relation to the encompassing interior: she reaches from the floor on which she stands to the arcaded gallery. If the building was an actual cathedral in northern Europe, this would mean her height was as much as 60 feet. Earlier this century, critics remarking on the Virgin's size found it to be awkward and disturbing, the sign of an immature artist as yet not in complete control of his skills or resources. Some later observers continued to believe that the work was an early one in van Eyck's career, related to late Gothic courtly manuscript illuminations. They recognized, however, that the scale of the Virgin was not meant to be visually realistic. They went on to hypothesize that this was intentional: the artist showed her as filling the building, quite literally, because she is meant to represent the Church figuratively.

— 169 —

108 Nave of the Basilica of St Martin-Notre-Dame, Halle,
built 1341–99.

109 Nave of the Basilica of Notre-Dame, Tongeren, built in the mid-13th century.

Another issue has loomed large in discussions of van Eyck's Berlin panel: did the artist represent an actual building, or is it the result of artistic licence? Various churches in Belgium and northern France have been put forward as the prototype on which van Eyck's minute but incredibly detailed interior is based – from Ghent to Liège to Dijon. Yet, the conclusion must be that van Eyck reproduced none, but learned from many. The raised choir, but not the raised triforium and clerestory, is found at Halle (illus. 108); the gallery running under the windows occurs at Tongeren (illus. 109); and so on.

Van Eyck's environmental settings are always intriguing: even in a simple scene like the Lucca *Virgin* we find the nice correspondence of recessed niches with thick exterior walls, into which translucent bull's-eye windows have been set (illus. 45). All of his other interiors contain subsidiary, surrounding or adjacent spaces that appeal to the spectator's imagination. In a similar fashion, contemporary architecture in northern Europe was rarely perfectly regular in design. Narrow confined hallways, for example, led to large living chambers (illus. 112); window embrasures were set deep into walls, creating rich and varied light effects. Irregular window sizes, floor plans and elevations fostered surprising, sometimes mysterious, effects (illus. 110, 111). There are certainly

110, 111 Plan and View of the House of Jacques Coeur, Bourges, built 1443–1453.

112 The House of Jacques Coeur, interior view.

things about van Eyck's interiors that are deliberately and specifically planned in relation to the depicted figures, their means of interaction, and the social and religious interpretation to be made of the image. Just as important is van Eyck's employment of spatial devices generated by new buildings constructed around him; they helped to enliven his images in a recognizable and cogent, that is to say, realistic, way. His are ideal, but believable, settings.

In the Berlin panel van Eyck shows us an angled view of the Cathedral, emphasizing the forest-like arrangements of pier-supports and the beckoning light effects. Intent on

emphasizing the mystery and visual pull of the building he also raised the choir, and its gallery and clerestory, to create further rhythmic and spatial variety. Van Eyck went to great lengths to recreate a physical experience, heightening the visual appeal and emphasizing the mystery and drama. This does not seem to have been the tactic of someone simply bent on reproducing a timeless hieroglyph of the Virgin as an embodiment of the Church.

Invariably, light in van Eyck's paintings is a crucial element. No other fifteenth-century artist captured such a variety of light effects, both near and far, direct and indirect. It has plausibly been suggested that the increasingly subtle and complex use of light is one of the chief developments that can be followed through his brief career. This is light that not only animates surfaces and creates textures but seems, literally, to enter via his brushstrokes. This is one of the reasons put forth for the now generally accepted late dating of the Berlin panel. Its brushwork is so light-filled, the effects so evocative and various, that it seems to be the ultimate expression of his art. Beams of light dance over walls and dapple floors. Did van Eyck observe such effects in the visible world and then somehow manage to portray it in paint on a panel? The answer, clearly, is yes. Did he also try to adjust or change this light in such a way that it would no longer merely be realistic but appear deeply symbolic? This question is not so easily answered.

Most Christian churches are oriented on an east/west axis, with the main door facing west and the apse or choir directed toward the rising sun. If the building in van Eyck's Berlin panel was orientated in this way, then the light entering from the left in the painting would, at least in the northern hemisphere, be a physical impossibility: the sun would never be high enough in the sky to transmit light through the north windows. Thus it has been construed that van Eyck was painting not sunlight, but the divine light of Heaven. But if we accept that he had a reasonable knowledge of north European churches, especially of those in the Netherlands, then one striking fact emerges: in two major churches near his home in Bruges, such 'northern' light is possible, especially in the summer months when daylight is altogether so long-lasting. In addition to this, numerous other smaller churches in the same region are oriented north/south; some of them even *face* east.

In Tongeren, the great Gothic cathedral (illus. 109) is oriented on a north-east/south-west axis, so that afternoon light penetrates via the left-hand windows of the nave. At Tournai the transitional Romanesque cathedral, with its Gothic choir, is oriented on a north-west/south-east axis so that, at least in summer, once again morning light enters through the left-hand windows of the nave. In addition, eight parish churches in Tournai were built on a north/south axis, and one, built to face the town square, is entered from the east (illus. 113). In all of these examples light easily enters the left side of the nave. It is the reversed church of St Quentin in Tournai, which

113 Nave of the Church of St Quentin, Tournai (built in the late 12th century), and the Choir (13th century).

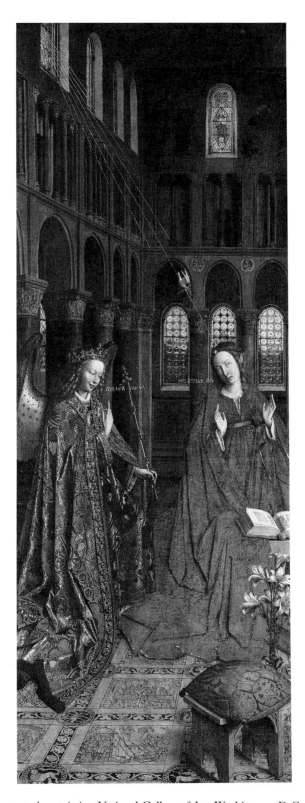

114 *Annunciation*. National Gallery of Art, Washington, D.C.

is entered from the east, that has plausibly been suggested as the influence behind van Eyck's other architectural creations, like that of the Washington *Annunciation* (illus. 114). Today's art historians have been puzzled by the architecture represented in this *Annunciation*: it shows what we are tempted to call Romanesque features (round-arched clerestory windows) above, presumably, Gothic ones (pointed arches at the ground level). We would usually expect to find that the 'later' Gothic features are placed on top of the 'earlier' Romanesque foundation. But van Eyck, like the builders at St Quentin, were not slaves of modern art-historical theory; they more freely interwove the different elements in their architectural vocabulary. Van Eyck's *Annunciation* shares so many features with St Quentin that we can reasonably conclude he had first-hand knowledge of it. If so, he would also have been very aware that in Christian churches light could well enter the windows on the left side of the nave as one faced the apse.

One must also take account, in the Berlin panel, of the compositional pattern. The Virgin looks and bends toward the right; our view down the nave is angled in that direction too. We are thus led to the donor wing in what we must presume was originally

115, 116 Bruges Master of 1499, *Diptych of Christian de Hondt*, 1499. Koninklijk Museum voor Schone Kunsten, Antwerp.

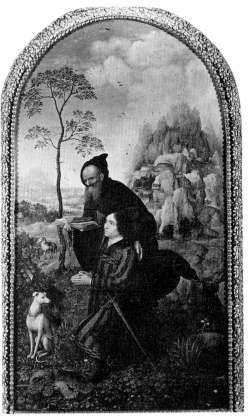

117, 118 Jan Gossaert, *Diptych of the Virgin and Child with Antonio Siciliano and St Anthony*, c. 1513. Galleria Doria, Rome.

a diptych (for examples, see illus. 115, 116 and 117, 118). Once the composition of the Virgin's panel had been set up in this way, with the Virgin facing toward the viewer's right, it was almost inevitable that the light in the image would fall from left to right. To have painted light cutting in behind the Virgin from the right would have undermined the strength of her stance. A similar consideration might have kept the artist from continuing the pools of light into the foreground. The two copies of van Eyck's work that preserve the original donor panel do not copy the light pools. This suggests that by the end of the century these light effects were not understood as an essential part of a complex programme designed in honour of the Virgin. The light in van Eyck's *Virgin in a Church* can thus be easily explained in earthly, realistic terms; it probably reflects van Eyck's knowledge of the existence of 'northern' light in Netherlandish churches, and it cannot in any case be said, unequivocally, to represent the symbolic light of Heaven.

And yet, I do not think we should underestimate the importance and suggestiveness of the light in the Berlin panel. There are several ways in which it determines the impact that the painting continues to have. It is so rich and varied, so visually intriguing, that it would be hard to imagine it as a carefully observed natural phenomenon alone. While we can recognize a psychological and emotional similarity between the depicted space

and other experiences in the physical world, there is still no absolute continuity between the two. By contrast, in many Italian works of the fifteenth century one has the illusion of being able to step into the painted image. This is achieved through an exacting use of linear perspective and, at times, a correspondence between the external light source and that portrayed within the image. None of these features are routinely found in Northern art, van Eyck's in particular. His perspective is often freely composed and expressive. The miniature scale of works like the Berlin panel prevents any but the bravest Alice in Wonderland from thinking she or he could easily enter the painted space. And light is a constantly shifting, subtly reflected phenomenon; it is not single and sharply directed. In van Eyck's work, as well as in that of many other early Netherlandish artists, we also are confronted with precious enclosing frames; in the case of the Berlin painting, the original frame, stolen in the nineteenth century, added about two inches (5 cm) of moulding on all four sides, thus sealing off the small image even more than today's 'marbled' half-sized replacement does.

How can we understand something so vividly realized and yet so precious, even magical, in its final impact? How can we be fully open to the descriptive nature of van Eyck's realism, and yet understand that his thinking and feeling did not stop with the myriad number of carefully defined surfaces with which he composed? Modern critical discourse on Eyckian imagery has set up two extreme positions: on the one hand, a descriptive realism of particulars; and on the other, a transformed symbolic realism, thought to convey insistently complex Church doctrine. Both views seem to miss the vital centre of the artist's work. This is a centre where visual and psychological experience is minutely particularized but never limited; where something appears – and is – actually alive and real, but at the same time endowed with powers beyond what we, in the twentieth century, have made into a rather more restricted concept of ordinary everyday reality. For people in the fifteenth century, the visible world was real enough to be as carefully observed and recorded as it is in van Eyck's paintings. It was also magical: the relic of the Holy Blood in Bruges continued to bleed on occasion, a practice it has given up in modern times; Philip the Good owned a miraculous bleeding host (illus. 54). Cult statues – the objects of pilgrimages – came alive, wept, nodded or bowed to faithful pilgrims. All these things were very much a part of life for people in van Eyck's day.

The church-halo with which van Eyck surrounds the Virgin was surely meant in some way to recall the symbolic connection made in the minds of many medieval Catholics between the Virgin and the Church. Our desire to recover van Eyck's real-life model for his painted edifice is not totally misdirected either: he went to great lengths himself to give a sense of tangibility to time-worn religious concepts. But van Eyck's light cannot be limited to a dogmatic meaning, and his interior is, finally, as magical as it is real. The way the artist plays with both construction and lighting in his painted image engages one's sense of religious experience in many ways. We sense the creative manipulation of our perspective and our environment. Here, as elsewhere in the artist's

work, we are meant to see not just the visible reality or the far-flung symbolic reference, but something, perhaps even more compelling, between and beyond these extremes. I believe that van Eyck's Berlin painting is, in important ways, what it seems to be – an ideal contemporary experience, not limited to any one time or place, but contemporary none the less. This is the experience of a pilgrimage to a Gothic cathedral, where a cult statue has come alive, growing, nodding, floating down the nave, responding to the pilgrim's fondest and most oft-repeated wish. This Virgin teaches the spectator not only about the intricacies of Church doctrine, but perhaps even more about the delicacy and immediacy of contemporary religious feeling.

It is impossible to say just how many people went on pilgrimages in the late Middle Ages. What is certain, however, is that this was one of the most common expressions of popular piety. Local cults could spring up quickly, provoked by the arrival of new relics or the discovery of a miracle-working statue. Local clerics promoted the cults as a way of getting both attention and donations for their institutions. The cult of Mary did not need relics – only statues, new or old. An interesting example is that of Our Lady of the Fountain. In 1403, when Philip the Bold, grandfather of Duke Philip the Good, was fortifying the coast at Dunkirk, a small statue was discovered, and presumed to be that of the Virgin. It attracted great devotion and was given its name because of a nearby fountain of pure water; later it became known as Our Lady of the Dunes. Perhaps it inspired van Eyck's painting of the *Virgin by a Fountain* (illus. 86). Such statues, housed in small shrines or set up in large cathedrals, could work hundreds of prodigious miracles each year. Histories of the Virgin's miracles were written and illustrated (illus. 119); records were kept in large ledgers, so that visitors to the sacred shrines would be suitably impressed.

In a niche in the rood screen of van Eyck's cathedral is a cult statue of the Virgin and Child flanked by two burning candles (illus. 88). Several observers have remarked how

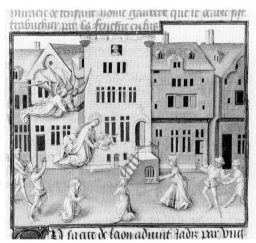

119 Workshop of Jean Le Tavernier, *Virgin Catching a Falling Child, c.* 1456, from Jean Miélot, *Miracles de Nostre Dame.*

121 A late 19th-century pilgrimage pennant. Halle.

120 Anonymous Netherlandish artist, *Virgin and Child*,
1479. Cathedral, Tongeren.

very like the gigantic foreground figure this small carving is. Perhaps it is no accident
that there are just two pools of light on the floor, paralleling the two candles, leading us
to conclude that the Virgin in full colour may in fact represent the divine presence
behind a cold stone statue. Marian cult statues were often adorned with large and
ornate crowns, and great masking robes surrounded the often pathetic and primitive
forms beneath. This is true of the miracle-working statue of the Virgin at Tongeren
(illus. 120). I should stress that the crown on van Eyck's Virgin is really unnaturally,
even awkwardly, large, as were those given to cult statues. In the fifteenth century there
were also pennants made for these pilgrimage sites, preserved today in later renditions.
The one for Halle shows a gigantic robed and crowned statue of the Virgin floating in
the sky above the large church there (illus. 121). Pilgrimage banners from other sites
portray church interiors with worshippers kneeling before a cult statue in a niche. It is
certainly suggestive that van Eyck's image finds such agreement with the treatment and
portrayal of cult statues in the fifteenth century. It is also interesting that van Eyck's
Berlin *Virgin and Child* interior is largely drawn from these pilgrimage sites, Tongeren
and Halle especially.

The three greatest painters of the second quarter of the fifteenth century in the
Netherlands all went on pilgrimages. Van Eyck was sent on a pilgrimage by and for the
Duke of Burgundy in 1426; Robert Campin was sentenced to undertake a pilgrimage to
Provence in 1432, as penance for adultery; and in 1450 Roger van der Weyden followed
the throngs of north Europeans pilgrims, including a large contingent from the Court of
Burgundy, on a jubilee journey to Rome. Philip the Good was also an avid pilgrim. He
travelled to one site alone, Notre-Dame-de-Boulogne, at least thirteen times between
1421 and 1467; these included trips in 1435, 1437 and 1438.

In the past, the trips these leading artists undertook have been studied for the impact such trips may have had on their style or on their use of small motifs. For artists, as well as others, the impact of a journey went beyond questions of style and motif. Their paintings clearly show this. Roger van der Weyden's *Virgin and Child in a Niche* is, like many cult images, set into the side of an existing building, to be worshipped by passing pilgrims (illus. 122). Later in the century Hans Memling depicted a prominent, and large, family from Bruges spilling into a partially opened religious building in order to worship an image of the enthroned Virgin and Child (illus. 123). Here in the landscape seen at the top left and right corners one can trace this family's journey as it approached the shrine. Coincidentally, standing at the left in this work is James of Compostella, the patron saint of the donor, with his pilgrim's staff and hat covered with pilgrim's badges. There are many other fifteenth-century images that are similarly concerned with the pilgrim's experience.

As the hat worn by Memling's St James suggests, pilgrims often purchased souvenirs of their journeys. These could be images of a saint, or of Christ's face, or of a standing Virgin flanked by saints and men and women at prayer. In these small metal badges the

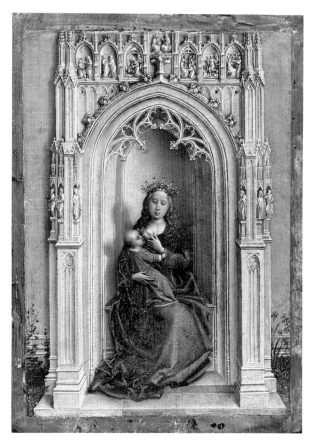

122 Roger van der Weyden, *Virgin and Child in a Niche, c.* 1435.
Thyssen-Bornemisza Collection, Lugano.

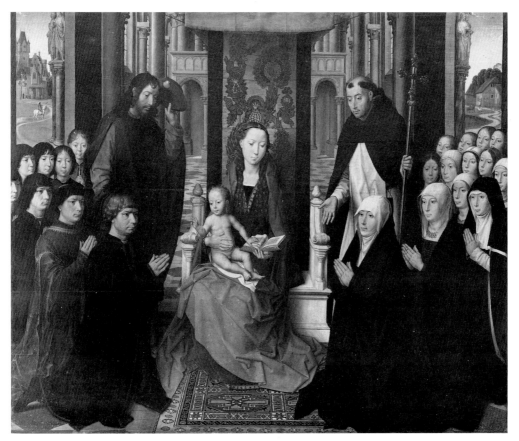

123 Hans Memling, *Virgin and Child with Jacob Floreins, his Family and
SS James and Dominic*, c. 1485. Musée du Louvre, Paris.

Virgin was surrounded or topped off by pinnacles, columns or arcades, a shorthand
method of referring to the shrine which housed her image (illus. 124). Here, in popular
art, is the equivalent of van Eyck's striking combination of Virgin and Church. As much
as it represents the ideal Catholic church, van Eyck's Berlin interior can thus be said to
depict the ideal pilgrimage goal, which is briefly referred to on pilgrimage medals as well.

Set into some pilgrims' medals were small convex mirrors, the magic device for
capturing and taking home the rays emanating from the miraculous object. Pilgrims
holding up these mirrors appear in fifteenth-century woodcuts (illus. 125). A mirror
was also the perfect way to capture a vast interior on a small surface; the curve of the
mirror had the effect of drastically condensing the space it recorded as well as reflected.
Van Eyck's desire to portray a Gothic cathedral on a foot-high panel could well have
been stimulated by such mirrors. Van Eyck's is a portable memory image, recording
forever the vision on its compact, light-filled surface.

In the fifteenth century people went on pilgrimages for various reasons. Pilgrimages
were used as a punishment or, to put it more positively, as a penance. One of the
greatest goals of the pilgrim was to receive indulgences; these were pledges from the

124 Fifteenth-century Pilgrim's
Medal from 's-Hertogenbosch,
by a Netherlandish artist.

125 Anonymous German artist,
Display of Relics in Nuremberg,
c. 1487, from *Heiligtum und
Gnade, wie sie jährlich in Nürnberg
ausgerufen werden*, Peter Vischer,
Nuremberg, 1487.

Church that released one from many years of purgatorial trial, for specific pilgrimages
were often begun (and continued to prosper) because indulgences were attached to
them. Great indulgences were given for pilgrimages to Rome; the one that took place in
1450 is a particularly good example. So many indulgences were offered, and so many
pilgrims flocked to the city, that a number of people were killed in the crush. Still, Pope
Nicolas V made so much money from the enterprise he was able to undertake some
extensive town-planning and artistic projects in the city as a result.

The actual progress of the pilgrim was meant to be accompanied by specified prayers,
again indulgenced. Tablets or plaques were hung in churches, and at other pilgrimage
sites, with prayers inscribed on them. Standing before these tablets and repeating the
prayers, brought remission of sins and even, it was promised, visions of the Virgin. Just
such a tablet hangs from the first foreground pier at the left in van Eyck's Berlin
cathedral interior. This prayer plaque was dutifully copied, and in one case made even
more prominent, in the two most important later versions of van Eyck's image
(illus. 115, 116 and 117, 118). It is, in fact, the only noticeable detail in this interior that
is not part of the building's structure or of the apparatus of the choir. Prayer tablets are

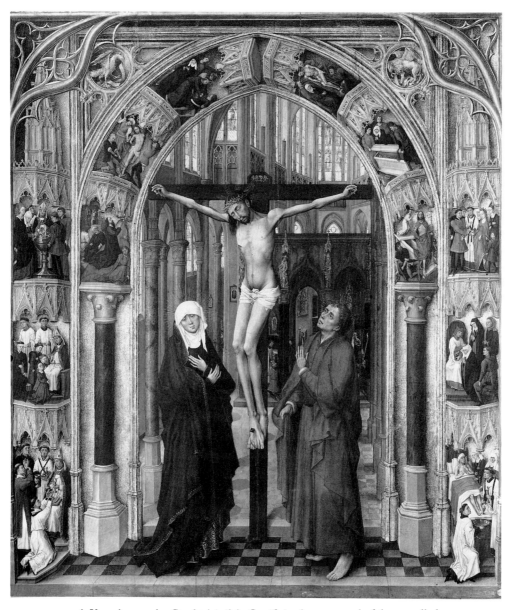

126 Vrancke van der Stockt (attrib.), *Crucifixion* (centre panel of the so-called *Cambrai Altarpiece*), mid-15th century. Prado, Madrid.

also found in Roger van der Weyden's *Seven Sacraments* altarpiece, where a pilgrim genuflects before the plaque while saying the prayer (illus. 38), as well as in Vrancke van der Stockt's *Cambrai Altarpiece* (illus. 126) and the Campinesque *Annunciation in a Church*, now in the Prado, Madrid. In a painting attributed to the later fifteenth-century Master of the St Catherine Legend, the saint receives a miraculous visit from the Virgin and Child after repeating a prayer, inscribed on an adjacent tablet, to a cult statue – which is, in turn, seen at the rear (illus. 127).

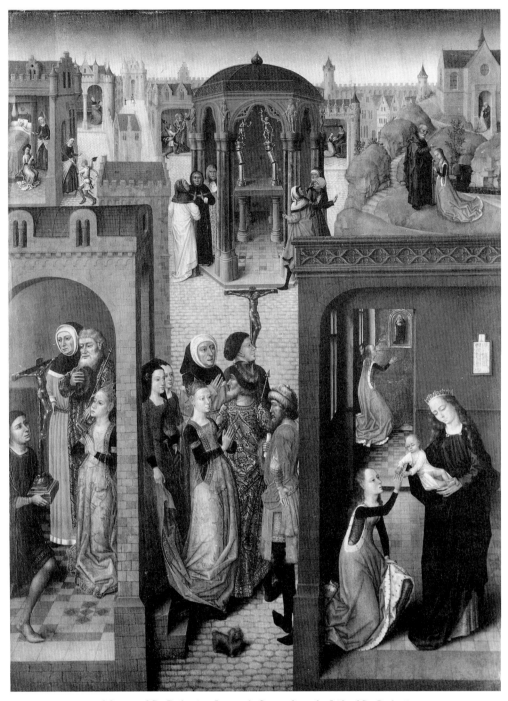

127 Master of St Catherine Legend, *Scenes from the Life of St Catherine,*
late 15th century.

The original frame of van Eyck's Berlin panel had, at the bottom, a motto extolling the Virgin: 'FLOS FLORIOLORUM APPELARIS'. Running around the other sides was part of a medieval nativity hymn, which can be translated as 'This mother is the daughter, this father is born, who has heard of such a thing, God born a man'. This was followed by 'ETCET', implying that the spectator was to continue intoning the entire prayer-like hymn. Some other artists at this time inscribed such hymns or prayers – the distinction was not a significant one in the fifteenth century – on the wings of devotional images (illus. 128). It was intended that the words be said in front of the painting, the text and

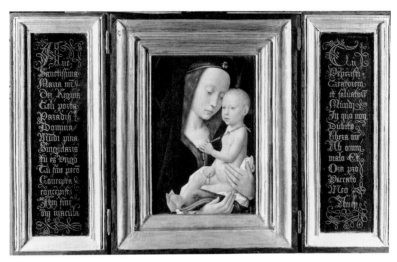

128 Workshop of Gerard David (?after Hugo van der Goes), *Virgin and Child with Prayer Wings*, early 16th century. National Gallery, London.

image reinforcing one other and creating the same devotional aura. We know that in some cases prayers thus inscribed were indulgenced, granting them a special potency. In fact, the indulgence was at times dependent on saying the prayer in front of the image. We do not know if van Eyck's words were also indulgenced, but the thrust of the combination – the inscribed frame and devotional image – is much the same. The words were clearly meant as an incantation, intended to bring the cult statue to life, if not necessarily granting an indulgence to the spectator.

For many, the notion of sight in connection with a pilgrimage really meant seeing the sights, in a tourist-like fashion. Travelling through the landscape, the pilgrim stopped at whatever shrines appeared along the route. This was often the only occasion many people had to get out and see the world. It may help explain why one of the later copies of van Eyck's work shows the donor kneeling in a landscape (illus. 118). As St Catherine herself did, one could at times stay in one's study, meditating on the cult image; it could, at least in one's mind, come to life. Mental pilgrimages were possible; later in the fifteenth century they were recommended by some adherents of the Modern Devotion. Perhaps that is why in one copy of van Eyck's work, the donor panel shows an abbot

kneeling in prayer in his bedroom (illus. 116). This pious individual believed he could perform his pilgrimage without leaving his blazing fireside. It is difficult to know whether or not this interior scene, or the landscape setting previously mentioned, represents van Eyck's original conception. Both examples cast further light on the theme of pilgrimage, as well on the way artists increasingly invented stories about the donors' lives.

Pilgrimages were popular with lay men and women; they were not so popular with the clergy, except as a means of raising money. Most learned Church observers were highly critical of the multiplication of relics, pilgrimage sites and indulgences. They were convinced that excessive numbers of shrines would rapidly dilute their religious impact, even their credibility; the Church Council warned against this in 1418. Thomas à Kempis observed that those who went on pilgrimages rarely became saints. This was putting it mildly. Leaving aside those people forced to go on expiatory pilgrimages by civil or ecclesiastical authorities, we are faced with a very disparate group of would-be pilgrims. It was said that young wives, escaping the strictures of recent marriages, went in order to engage in amorous affairs. Others admittedly went for the fun and adventure of seeing new places. Some claimed that women went because it was fashionable, and that they reacted hysterically when at the shrines. For such reasons, misogynist clergy felt that women should be prohibited from entering shrines or viewing their miracle-working objects. Noblemen classed pilgrimages with jousts, as pleasurable pastimes. The rich and powerful were incredibly ostentatious when they went on pilgrimages, taking with them huge quantities of delicacies and numbers of attendants, and complaining bitterly if they were not generously treated whenever they stopped. If in the fifteenth century one wished to engage in a religious activity that was beyond reproach, it would not have been a pilgrimage.

One might go on pilgrimages oneself, or one might pay others to go in one's stead. This could be done if the person obliged to go simply could not, or because a wealthy individual wanted to accrue the benefits of a pilgrimage, perhaps in the form of indulgences, for himself. The former case can be illustrated by the pilgrimages directed to be made in a last will or testament. One interesting example is that of King René of Anjou who, finding himself close to death and unable to fulfil a lifelong ambition to journey to the Holy Land, instructed his successors to send a substitute. Van Eyck himself provides us with an instance of someone being paid to go on a pilgrimage for the benefit of another: in 1426 Duke Philip the Good paid him 'to make a certain pilgrimage which the Duke has ordered for himself and in his name'. For those who believed that pilgrimages were being abused, this would have been a case in point.

It is hard to believe that van Eyck and his patrons were not aware of the high-minded criticisms voiced by men such as Jean Gerson, Chancellor of the University of Paris, about the supposed abuse of pilgrimages. Such abuse was no doubt one of the reasons some followers of the Modern Devotion proposed making a pilgrimage in one's mind,

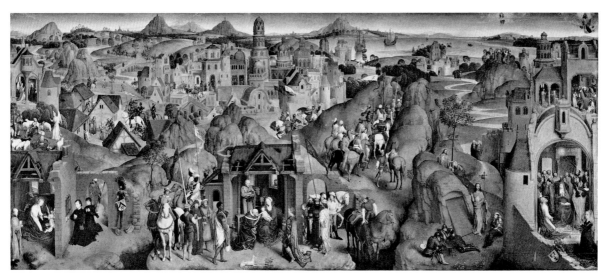

129 Hans Memling, *Scenes from the Life of the Virgin and Christ*, 1480.
Alte Pinakothek, Munich.

thereby avoiding the distractions and pretensions of the open road. It was an exercise one could perform in the quiet of one's own home. It might be tempting to see van Eyck's image in this light. Is that the way we should understand the donor panel where the abbot is portrayed in his own bedchamber (illus. 118)? Is this simply a question of interior devotion? The answer would appear to be no, and for several reasons.

The kind of mental pilgrimage promoted by the Modern Devotion was a lengthy and methodical affair. This was not an imagined quick trip to a familiar local shrine, but a long, arduous mental journey to the Holy Land, tracing the steps of Christ, especially in order to relive the Passion. This concept of a mental pilgrimage may help explain other fifteenth-century works, such as those by Hans Memling that show the path of Christ and his mother through the holy sites (illus. 129). But van Eyck's was a much simpler task, at least in terms of narrative: a vision of a cult statue. I am not aware that anyone ever suggested substituting a mental re-enactment of such a short local pilgrimage for the real thing, as a means of combating some of the problems that developed around the pilgrimage itself. Writers would have been much more likely in such cases to have eliminated altogether the notion of constant or repeated pilgrimage.

Van Eyck's is not a stern, moralistic view of religious feeling. It even seems as if it would be fun – to see the spectacle, take the enjoyable pilgrimage, visit the picturesque site, be filled with warm emotions stimulated by inviting and divine figures. This is not the kind of religious feeling that we can justify primarily by reference to learned theological commentary. Nor is it something that would have appealed to those fifteenth-century critics who eventually were to cause a dramatic reformation of Church attitudes and doctrine. Van Eyck's image of religion is an ideal, elitist and indulgent one.

19

Pretence and Scepticism in
the Fifteenth Century

❦

Van Eyck and his patrons constantly invite both our admiration and our concern. They are ostentatious, but in a way that involves a degree of self-awareness and scepticism – as opposed to dogmatism. Van Eyck repeatedly paints himself into his images: as a reflection in the mirror in the *Arnolfini Double Portrait* (illus. 9), as a reflection on St George's shield in the van der Paele *Virgin* (illus. 31), and as a turban-wearing observer of the distant landscape seen from Chancellor Rolin's crenellated wall (illus. 62). Clearly, this had something to do with van Eyck's feelings about his work, his claim to creative genius: he insists on being a literal part of the gleaming objects he portrays in paint. Surely, too, the aspiration of the artist goes beyond his art to a view of life. Van Eyck's love of visual density is an aspect of his acquisitiveness, his desire to encompass and possess the world, both large and small. His was also the life of a court functionary, serving at the side of a duke and his courtiers, longing for material display. Because of his extreme preciousness, van Eyck's illusions almost instantly become illusory. The minute we think about it, we realize how utterly impossible is the multiple illusion of his small panels; then the shamming quality of his art stands out. But this artistic possessiveness, which is to some extent deceitful, is not, I think, malicious. Rather, it is playful and ironic, born of a worldly and indulgent attitude toward himself and his circle of acquaintances.

I have tried to elicit from van Eyck's paintings a variety of religious themes and ideas to which he and his patrons were drawn, from private prayer to confession and pilgrimage. Still, it must be admitted that the six *Virgin and Child* panels that are at the heart of his work are remarkably similar in outward appearance (illus. 23, 45, 61, 81, 86 and 87). Perhaps the early, and poorly documented, part of van Eyck's career was full of interesting experiments of a more obvious narrative and dramatic character. While I have tried to present his mature art as inherently concerned with story-telling, this is not a judgement at which one could arrive after only a cursory glance at these works. Once he had crystallized his approach in an image such as the van der Paele *Virgin*, all his other works seem to form a series of variations on that theme: the same sorts of elements, the same sorts of effects, each subtly rearranged and gauged anew. All van Eyck's mature paintings look more like one other than do the equivalent works by any

other major fifteenth-century Netherlandish painter. They might at first glance seem the embodiment of a generalized and traditional devotional art.

There are several important ways of comprehending this homogeneity, ways of evaluating its underlying mixture of self-assertion and self-doubt. Van Eyck is probably the only fifteenth-century Netherlandish painter who painted his panels with little assistance. Modern technical examination reveals that a number of hands were at work on the paintings of most other artists during this period. But from their delicate and laborious underdrawing, to the many small adjustments made as the glazes were built-up, van Eyck's works are different, single-minded and completely his own. He was not only personally responsible for the labour, the craftsman's touch, but also for the idea. The homogeneity of his *oeuvre* is a deliberate attempt to produce over and again a trademark, to give an unmistakable stamp to the world he creates. Van Eyck's works are instantly recognizable: in part he operated within a narrow range of themes and subject-matter in order to make that so. Whatever generalized devotional stance may be present here, it is also van Eyck's artistic signature.

This sameness in appearance also has the effect of turning van Eyck's Virgins into timeless icons. They seem to have been treated as such, as they were faithfully copied numerous times by his contemporaries. We know that, in his later years especially, van Eyck was fascinated by icons from Byzantium. At the beginning of the 1430s his literal focus was more likely to have been cult statues, an interest he maintained throughout his career. In the case of both icons and statues he sought to capture the archetype, but in his own particular fashion. What seems all too clever here – could one even say deceitful? – is that the aspect which claims the image as by van Eyck overlaps the one that transports it to another, more eternal, spiritual realm. He manages to identify his personal genius with an idea of religious truth.

The sense of overlap in van Eyck's paintings is also very important to their social and psychological message. In earlier chapters I have outlined the way that his imagination moved freely between what we today might think of as distinctly public and private worlds. In the fifteenth century, social and religious boundaries were different, and probably in some ways looser than they are today. In turn, van Eyck's images seem bent on mingling worlds that we might feel should be carefully distinguished: sacred and secular, public and private, male and female, clerical and lay. Aspects of people's lives seem, in his art, to be constantly shifting their venues. Are Chancellor Rolin's vineyards (illus. 63) a sign of his earthly wealth, or an indication of his sinful human ways. Or are they both these things, and more, altogether? Does Canon van der Paele (illus. 24) place his trust in an institution or in an individual's prayers – or in both? My feeling is that van Eyck intentionally never came down on one side or the other. He deliberately conflated because, to put in bluntly, he and his patrons wanted the best of all possible worlds. They did not want to choose just one way to achieve their salvation; they wanted to use, and enjoy, them all.

Van Eyck's patrons aspired to be both worldly and devout. His art allowed them to simulate material riches as well as personal piety. This very pretention also reveals an underlying doubt. No one thing seemed to be good enough, no one source of power or support was sufficient to reassure these individuals. Van Eyck's is an art of scepticism if only because it is an art that has such great ambitions. This is not work that is exclusively rational in its approach to theology. This is not work that is exclusively courtly or materialistic. It is the obsessive combination of a layman's wealth along with claims to visionary powers and rewards that is telling. Religious dogmatism pales beside the individual human needs and fulfilments expressed and sought by these paintings.

Van Eyck's images are personal enclaves, where the donor and spectator confess and reflect on their earthly and heavenly potential. In this light, I do not think that modern observers who have discerned sophisticated theological meanings in his works are altogether wrong. Certainly van Eyck and his patrons were fascinated by the Church's somewhat out-dated desire to find or supply a doctrinal explanation for everything observed in the world. It is thus possible that at times they meant to allude to traditional Church doctrines through the use of apparently realistic detail. But to the extent that such a system of religious symbolism existed, it was only one of the many tactics used to bridge the gap between earthly pretension and presumed religious insight. Van Eyck's images do not only present traditional doctrine, which was used to justify a centuries-old Christian tradition. In their combination of pretence and scepticism, they are more complex and intriguing than that. They relate more specifically to the particular historical predicament of both artist and patron.

In van Eyck's art popular devotion exists alongside theological sophistication, or at least the assumption of theological sophistication. We might say that his goal was often to paint elitist, outwardly conformist, images of popular devotion. Time and again he drew on different aspects of lay piety, as it was directed at cult statues, or at the Real Presence of the Body of Christ in the Eucharist, at the Sacred Heart, at confession, pilgrimage, penance and indulgence. He did not illustrate or expound upon these phenomena systematically or completely, any more than his works illustrate Scholastic theology fully and consistently. Rather, all these things informed his and his donors' feelings in ways that suggest to us today the richness of fifteenth-century religious life, both in imagination and reality.

Van Eyck's patrons fervently prayed, alongside their sometimes fanatical lay contemporaries, that a miracle would happen, that a vision would be made manifest. And van Eyck's paintings must be said to hold out the promise that these things will occur. But we must still wonder: Where? When? And how can we be certain that this miracle will, or did, happen? It is in this very quandary that we find one of the most important justifications for van Eyck's particular kind of idealized realism. As I have mentioned several times, modern observers have been so struck by the painted views he left us that they have sought to find their exact equivalent in the world. But van Eyck never did paint

130 Master E. S., *Large Madonna of Einsiedeln*, 1466.

a specific building or a specific vista, however compellingly real his images may seem. How can we understand something so vividly realized and yet precious, mystical and, ultimately, ideal in its result? I think we must accept that van Eyck did not paint what we might call quaint votive images of actual miracles, as some other artists of the time did portray (illus. 130). He and his patrons sought to recall such events without simply reporting them. I think that, in a very real sense, this is due to the fact that, while they may have pretended to such powers they were, finally, a little doubtful that they could make them work, at least on demand.

The world in which van Eyck lived was still subject to miraculous events. Cult statues did occasionally seem to come to life, visions of the Christ Child during Mass were at times reported. Nevertheless, such things were on the decline. The Holy Blood relic in Bruges had liquified every Friday in the fourteenth century; but in the fifteenth century, only occasional miracles were attributed to it. Van Eyck did not paint specific miraculous events, if only because such events were increasingly rare, existing more as ideals than as actual facts. He did portray a world still subject to certain magical forces; his images are not just records of a more modern, discrete and mechanistic world. Yet, some of our present-day scepticism can be attributed to van Eyck too. Above all, he seems to have viewed the relation between faith and doubt with an ironic and knowing

detachment. He made the church in the Berlin panel (illus. 87) sufficiently similar to the great pilgrimage sites of Tongeren (illus. 109) and Halle (illus. 108) for knowledgeable contemporaries to have noted the similarity. But their knowledge would also have increased an appreciation of the painter's manipulative powers, even his playfulness and scepticism.

Van Eyck and his patrons wanted to evoke some of the miraculous forces at work in their world. They were also able consciously to observe and cleverly form what was before them. One thing they were forming, one thing they were struggling with, was a particularly virulent expression of one of the fundamental paradoxes of Christianity. How can admiration of the beauty of the physical world, and the power that it gives to some human beings, be matched with the notion that this must ultimately be renounced for some higher, other-worldly goal? In the fifteenth century this question received a dramatic realization in the use and abuse of indulgences. Van Eyck's paintings are implicated here in a number of ways. Through indulgences the Church literally sold time off from Purgatorial torment; salvation, or at least a more rapid road of approach to it, was available in return for earthly goods. As Chancellor Rolin put it, 'by a favourable trade', he would 'exchange for celestial goods temporal ones'. The money the Church gained from indulgences in part permitted the creation of non-resident benefices, such as those George van der Paele occupied. The purchase of an indulgence granted the buyer instant satisfaction in his quest for salvation. It is of little wonder, then, that van Eyck's donors seem to be demanding and experiencing such immediate gratification. And if money was able to buy salvation, then the monastic ideal of complete renunciation was not necessary. One could afford to play with resources. Specific indulgences were meant for specific purposes. Specific prayers promised specific visions. Rewards could be juggled with, as well as carefully identified.

One hundred years after van Eyck's time, all this was to be swept away. Even in his own lifetime there was widespread dismay at the abuse of indulgences. Still, few on either side of the arrangement – those who gave and those who received – were willing to part with such a useful and reassuring mechanism. But was it, in van Eyck's day, that reassuring? The more it was used, the more doubtful its use became; the less it seemed to satisfy and succeed. Just as some of the clergy had warned about the dangers of constantly creating new cult statues, over-production eventually diluted their effect. To such endemic and widespread scepticism about the nature and achievement of Christian salvation, van Eyck and his patrons added their own special perspectives – Arnolfini was a social-climbing Italian immigrant; van der Paele was a wily, secular canon; Rolin and the artist himself were talented but dependent Court functionaries. At times he and his patrons seem to have been doubtful about everything except themselves. Their insistence on personal powers and the weight of their multiple aims and ambitions makes one wonder if they did not, finally, doubt themselves too. For all his pretension to the contrary, van Eyck was a human, not divine, artist.

A Different Perspective in the *Ghent Altarpiece*

Today there are so many theories available concerning the meaning of objects in van Eyck's paintings, as well as in many other early Netherlandish works, that it is almost impossible to analyse each opinion when yet newer ones are presented. Van Eyck's Rolin *Virgin and Child* (illus. 61) is a case in point. Details in this work have been viewed from the perspective of different historical events, different theological treatises and different devotional practices. How is one to evaluate these conflicting and minutely reasoned claims about meaning? How is one to judge the relative merits of one extra-artistic source over another for the artist, especially when the references seem equally accessible to both artist and patron? It took many centuries for Christian commentators to arrive at the numerous available doctrinal concepts, and their corresponding elaborate theological interpretations, all of which were available to van Eyck and his patrons. One feature of the accumulated wisdom of late medieval theology was that almost everything that had been observed in the world was said to have some specific Christian meaning. It should not surprise us, therefore, that diligent researchers today can point to the fact that elements that van Eyck ended up portraying had at some time been said to have theological significance.

An important point that remains is that many historians of the fifteenth century in the North have accepted the notion that this is the sort of investigation we should always be conducting. It is now commonly assumed that all van Eyck's works are deliberately, minutely symbolic – that the artist's meaning rests not just in details, but in details meant to be interpreted in the light of a traditional, and often highly rational, system of theological discourse. The justification for the startling realism of the image is tied to this: at last a painter is able to construct the world in a way that corresponds to carefully developed Church doctrine or practice. This is the Scholastic dream come true. Not only can the visible world be subjected to this kind of analysis, but proof of such a world view is now possible because an artist was able to build up a picture of the world according to this system. But, we should ask, what system is this? And who, in the fifteenth century, espoused it and tried to live according to it?

A good subject for study in this regard would be Denys de Ryckel, commonly called Denys the Carthusian, who in modern times has been nicknamed 'the last Scholastic'. Denys lived in the Netherlands from 1394 until 1471. He wrote extensive treatises on

the Catholic liturgy, medieval hymns, the Mass, the Virgin, and the powers of the Pope and Council; in the modern collected edition, his writings run to forty-two volumes. His work was conservative, elaborate and, in essence, a capstone to the speculative theology of Thomas Aquinas. He vigorously and systematically opposed Church abuses, for instance the multiplication of non-resident benefices. He also held rigid views on the importance of the Church hierarchy; and, as was usual in Scholastic thinking, he championed the way of life of virgins (male and female), martyrs and doctors. For Denys, these saintly ways of life continued to hold out an ideal existence for the faithful Christian.

In both general and specific terms a patron such as Philip the Good, and a selfconscious artist such as van Eyck, would have found only slight support for their own way of life in Denys's view of the world. Philip clearly disagreed strongly with Denys's strict views on non-resident benefices; we can assume that George van der Paele did too. Denys's system was envisioned as being complete and self-sufficient. None the less it was largely irrelevant to the daily lives of the lay population, except as it proposed several possible, but increasingly remote, models of behaviour. How many lay people in the fifteenth century (Philip the Good and van Eyck included) continued to agree that the lives of virgins, martyrs and schoolmen – all traditional Church heroes – were best, and should be conscientiously emulated in whatever way possible? How many prospective individual patrons, lay and cleric alike, would have continued to commission works that espoused only the narrow traditional Church model?

One very prominent individual, it seems, did. Sometime before 1426 a large altarpiece was commissioned from the artist Hubert van Eyck, the brother of Jan (illus. 89 and 90). The work was completed by Jan himself in 1432 and paid for by Jodocus Vijd, a patrician city-dweller of Ghent, according to the inscription on the original frame. Many other aspects of this commission remain unclear, and probably always will. Several points about this commission can, however, be made with some assurance. No matter who originally commissioned the polyptych and no matter who painted what parts of it, the *Ghent Altarpiece* is the largest and most complex set of panel paintings executed in the Netherlands in the fifteenth century. On the exterior of the work (illus. 89), only ten relatively large figures are portrayed; they include contemporaries, *grisaille* imitations of sculpted saints, and semi-*grisaille* holy figures from the Old and New Testaments. Within (illus. 90), hundreds of figures populate twelve separate panels. They range from the massive and enthroned God the Father to the elders, bishops, confessors, martyrs, hermits, saints, knights and judges beside and below him, all of whom methodically lead us toward the central Adoration of the Holy Lamb. This work was clearly intended from the outset to be a spectacular public work of art. In this way it is distinctive, even unique, in van Eyck's career. The *Ghent Altarpiece* was not the prototype for his other works. No other painting by the artist was demonstrably intended to be publicly displayed in a church. No other work was so

obviously and consciously a complex display of Church personages and Church doctrine. No doubt in part because of its purpose and scale, this magnificent creation has remained in its original location since completion, one of the few fifteenth-century Netherlandish panel paintings, and the only work by Van Eyck, to be so honoured.

All of this points to a quite special set of circumstances. Unfortunately, we do not know exactly what these were, although several reasonable deductions can be made. The number of scenes, the variety of participants, the specificity of Latin inscriptions – these features collectively indicate that great care was taken in assembling and relating the work's various parts. We may not be able to claim with certainty that the ensemble was meant from the start to look the way it now does. Still, it was clearly not a random process that led to such expensive, time-consuming, visually impressive and literate results. Could the painter himself, or his patron – a local politician and businessman – have alone been responsible for this task? All modern scholars have concluded that this was not the case. The *Ghent Altarpiece* seems to be one instance in which a learned theologian advised the artist.

The most specific and detailed suggestion made in this regard is that van Eyck's adviser was Olivier de Langhe, the prior of the Ghent church in which the altarpiece was destined to hang. Not only is de Langhe a figure close at hand, he is also the author of a suitably erudite treatise on the sacrament of the Eucharist, an appropriate literary analogue for the visual complexities of the *Ghent Altarpiece*. De Langhe's thought also corresponds with the image in the way it presents a traditional view of the nature and necessity of Church ritual. As visualized by van Eyck, the saints, martyrs, prophets and highly placed ecclesiastics, both bishops and confessors, lead the strictly regulated religious and social groups that adore the sacrificial Lamb of God. A mystical vision of the Godhead – Paradise – is only accessible through the carefully mapped paths of traditional Church leaders and theologians. As expressed by de Langhe and reflected in the *Ghent Altarpiece*, these views do not take into productive account the opposition to speculative theology, nor the stress on private devotion, that had been growing in importance since the fourteenth century. They reiterate in a many-layered form the centuries' old claim of the Church hierarchy to absolute authority.

The theology of the *Ghent Altarpiece* may, in the fifteenth century, have been like a dinosaur today, an exaggerated relic of the past. But that view would seem to belie the artistic impact and novelty of the work. Why the first monumental public panel painting made in the Netherlands should be so traditional in its theological thrust is an interesting question. We might consider the fact that, at the time the work was executed, van Eyck's career was just beginning, and his brother, Hubert, was an artist of largely local significance. Both factors may be seen to support the suggestion that these artists could have been readily subject to a powerful and opinionated patron. About the patron, Jodocus Vijd, we know only a little; what is known suggests a person with no strong new ideas or affiliations, a person who was seriously committed to the institution

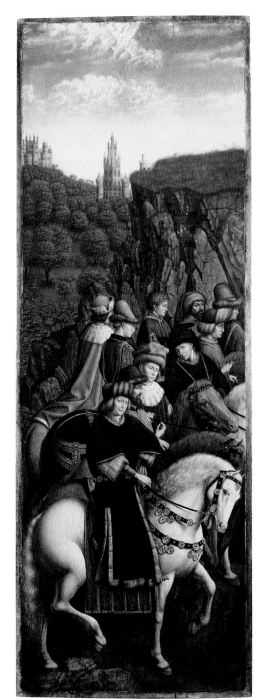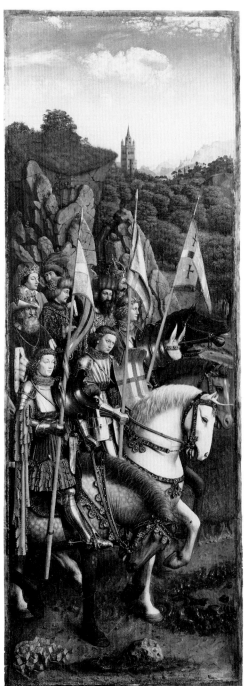

131, 132 *Ghent Altarpiece*, details.

of the Church and, in the final analysis, subservient to it. Vijd also wished to use the Church as had George van der Paele and Nicolas Rolin – for endowing masses for the souls of his wife, himself and his family. And yet he did not have the ambition to adjust to his own more personal devotional ends the means offered by the Church. What he might be said to have personally done was to have van Eyck include secular forces – the Just Judges and the Soldiers of Christ on the lower left two panels of the polyptych (illus. 131, 132). As a patrician leader of Ghent, Vijd might well have identified with these individuals – who, it must be stressed, take a secondary position in the hierarchical structure of the painting. In this sense Vijd seems to have been content to take his traditional, lesser, role in the carefully arranged procession of the faithful. This much the image he paid for tells us.

We should not underestimate the public nature and scale of the *Ghent Altarpiece*. It would seem natural in the case of a project meant to be housed in their midst, and for centuries to dominate their church, that the local ecclesiastical authorities would have been careful to consider and approve its message. It is even likely that one of their number, such as the prior, Olivier de Langhe, would have sought to determine that appeal. Further, it would not be unreasonable to suppose that in this process the authorities were deliberately countering, even excluding, any new lay developments in theology, stubbornly proclaiming their traditional and exclusive prerogative to be the foremost rulers on these matters.

From the only documented commission for a fifteenth-century Netherlandish *church* painting to survive in modern times, we know that Dirk Bouts was advised by theologians; he was told which were the appropriate prototypes for the Last Supper to be included on the wings of a triptych, thus propounding the eternal validity of the sacrament of the Eucharist. The situation with the *Ghent Altarpiece* must have been somewhat similar. Whether the ecclesiastical authorities in Ghent were consciously taking an aggressive stand, or whether they were simply proceeding, somewhat unthinkingly, along traditional well-worn grooves, the effect was the same as that seen in the painting by Bouts – a stress on traditional theological concepts. In the *Ghent Altarpiece* we find the proclamation of a view of religion and society that made only small allowance for diverse or changing lay interests. Its all-encompassing focus on a powerful ecclesiastical hierarchy was never again to be repeated in van Eyck's known works.

21

The Interpretation of Early Netherlandish Painting

Surely there are ways in which the slightly later van der Paele *Virgin and Child* (illus. 23) grows from a situation like that of the *Ghent Altarpiece* (illus. 90), ways in which it continued to exploit an ecclesiastical compact. Yet I hope to have made it clear that van der Paele's aims were quite specific, not just to his personal situation, but to the situation of the Catholic Church in the early fifteenth century. This includes the schism in the Church, as well as the growing importance granted to private devotion and prayer, especially by the laity. There is a subtle interplay of institutional and personal forces in the van der Paele work, and this should caution us against setting up an extreme dichotomy within van Eyck's *oeuvre*, or within fifteenth-century Netherlandish work as a whole, between the public ecclesiastical function of religious art and its private devotional aspect. At some times the Church may have been wary of lay power; at others it may have appropriated lay interests for its own ends. Lay people may have wanted to establish their own domain; and at the same time they may have felt a continued need to be connected to traditional sources of comfort and repose. Was it more likely that the elemental and unbiased feeling of choice, expanding possibilities and the play of different elements, rather than deliberately exclusive or confrontational behaviour, contributed to the creation of art works?

Is the growing interest in affective devotion always opposed by the speculative theology, as it was embodied most perfectly in Scholasticism? Is traditional bookish theology to be thought of as a thing apart from the obsession with indulgences, benefices, pilgrimages, relics and confession found in the fifteenth century? We face similar questions in our evaluation of the art. Is the notion of preconceived symbolic programmes in Northern painting at odds with the fifteenth-century's fascination with the realistic effects of this art? It is perhaps all too easy to see the issue as one of contrasts: either van Eyck was trying to develop a voice for something time-worn, a thousand-year-old Christian exegetical tradition, or he was bent on giving life to something new, a changing, questioning lay perspective on both sacred and secular matters. Are we right to oppose the world of medieval theological discourse to the new complexities of lay existence?

To some extent people in the fifteenth century no doubt felt such a contrast, or conflict. Certainly, Philip the Good and George van der Paele might reasonably have

sensed the sting of rebuke in Denys the Carthusian's denunciation of non-resident benefices. But it would be wrong to contend that Philip and Denys could not have discovered common ground in religious matters. The Carthusian's vigorous support of the Virgin Mary has been assumed to have stimulated some artists to paint very powerful pictures of her co-passion with Christ, her great suffering at the time of the Crucifixion. These too might have appealed to Philip the Good. Denys's treatises about Mary have also been said to lend credence to the worship of various cult statues of the Virgin. Philip the Good visited such a statue repeatedly during his life, and van Eyck envisioned them in several surviving religious images.

How then are we to evaluate van Eyck's images of the Virgin and Child? Was the *Virgin in a Church* (illus. 87) meant to visualize a theological concept – the Virgin *as* the Church – or, in contrast, was the work painted with such thinking present, but very much in the background? Are these two points of view mutually exclusive? And how might we determine their relative merit in any individual instance? To an extent, our answer to these questions might depend on our knowledge of the patron for the work. Was the painting intended to appeal to Philip the Good or to Denys the Carthusian? Would it have hung in a noble's bedroom or in a monk's cell? Such people might have shared some interests, but they would have had increasingly divergent priorities. In addition, different individuals might well have found quite differing meanings in the same work. It is even possible that the artist developed a type of imagery that was flexible, one that was capable of multiple meanings for a shifting, varied audience. Van Eyck may not have regularly painted for the open market, but he was certainly aware of the multiplicity of tastes to be found among patrons, and of the usefulness, at times, of being able to appeal to any and all of them simultaneously. The fact that a painting may be said by some observers today to be the deliberate embodiment of a theological concept, and by others to be only an indirect reflection of such discourse, may have its basis in this circumstance.

A patron for a work may have a crucial and distinctive impact on the form of its appearance. We must also remember that its impact may be an outgrowth of the patron's wish to appropriate some desirable quality from someone else in society, someone of a quite different background or set of aspirations. Patronage is crucial yet, in this period, both variable and malleable. We must know, or at least we must try to imagine, who might have commissioned each work. And yet that insight, once gained, may lead us to evaluate similar images in widely differing ways. Two things need to be stressed about this situation. In the first place, there is no substitute for a careful evaluation of the physical and visual makeup of each work. Second, precise and universally applicable meaning for an image may appear to be a present-day critical ideal; but it amounts to little more than a recipe for transparent meaning and, ultimately, tedium, and this would also have been true in the fifteenth century.

These two points deserve further elaboration. During the last fifty years problems in

the interpretation of early Netherlandish paintings, van Eyck's in particular, have arisen for two related reasons. Scholars have often assumed that the images put forth, above all, a universal religious meaning, one of interest and importance to any devout Christian viewer. And, just as significantly, it has been thought that such generally accessible religious meaning – in fact, that same meaning – could be embodied in images that looked, on the surface, quite different. It has been claimed that this situation was even to be expected. Since one is supposedly dealing with a consistent and complete body of belief, the same or similar aspects of these beliefs could receive quite different visual form over the centuries, especially toward the end of the Middle Ages. What this has given us is a method of analysis for fifteenth-century religious painting that presumes meaning was relatively standardized, and that this meaning, developed over the many centuries of the Christian era, could exist independently of visual form. This view proposed that Christian doctrines and ideas could be repeatedly illustrated without particular regard for the current or personal artistic idiom discovered in the image.

Such a scenario is possible, and it did at times occur. Doctrinal positions, as well as interpretative means for communicating them, were assembled throughout the Middle Ages in a way that made them continually useful and influential in the fifteenth century. Unlike the century that followed, this period did not witness a violent turning away from theological tradition, either in terms of the positions taken or the means of exegesis employed. Yet, of course there are always shifts of emphasis occurring, even in a set of beliefs as highly structured, and sometimes as rigidly hierarchical, as characterized medieval Catholicism. We need not go to the opposite extreme and see every work of religious art as the expression of an artist's or patron's personal fantasy, to realize that an approach that severely limits this possibility, right from the start, will fail to do justice to images, especially those produced in a complex experimental period.

Iconographical analysis of the sort often applied to the study of early Netherlandish art gives us very few ways of determining the relative merits of extra-artistic sources supposedly bearing on the meaning of a work of art. The fact that a literary source was available to an artist is hardly proof that he availed himself of it. In fact it has become increasingly apparent that artists such as van Eyck had a great variety of, sometimes conflicting, sources available to them; and that we need, therefore, to spend much more time determining why it was that certain sources might have appealed to them, and therefore why they would be relevant to our process of interpretation. That an external source – sometimes literary, sometimes not – may be determined to be relevant or appropriate is a difficult decision to make, largely because there would be many ways in which such relevance might be judged. A literary source, for instance, might tell the artist, and us, exactly which visual elements he was to include in his work; it might, on the other hand, set up a traditional model of thinking and imagining, which the artist was determined to modify, however subtly. Thus we inevitably come to the primacy of a

visual evaluation of the image. How else can we understand what response the artist had to an earlier literary source and what response he might have wished to evoke in the spectator's mind?

Van Eyck's paintings may embody some basic Christian truths, but that is far too general a statement to be of much help to us in understanding the peculiar power and fascination his works hold for us. We must reconnect the particular meaning with the particular form. Meaning in van Eyck's work, and in early Netherlandish painting in general, cannot easily be generalized about; at least this should not be the first goal of the art historian. And visual form cannot be a matter of indifference, or, again, dismissed as only the current stylistic idiom.

We must, today, try first to read the power of a work's visual language, and through that to see its special intellectual and emotional appeal. When we posit from the outset that an image is a metaphor of some general Christian idea, then we have reversed this logic. We have set up a transparent, rational, view of art, over and above the more slippery visual power of the image itself. We have become, like iconoclasts, wary of that visual appeal, seeking to control it even before we experience or understand it. If an artist actually thought that way too – that is, iconoclastically – he would either give up his art or severely limit its impact. Again, there is a contrast here between the fifteenth and sixteenth centuries: few artists in the fifteenth themselves felt, or were made to feel by their contemporaries, an outright fear of image worship. Van Eyck may not have wanted his image of the *Virgin in a Church* to be worshipped and adored as if it were a holy relic; still, the very look of this magical, reliquary-like creation should convince us that he was not adverse to drawing on that kind of experience when trying to attract his audience.

Medieval theological discourse is not opposed to the complex lay existence of van Eyck or of most of his patrons. This is true in the sense that there exists much complex theological discourse on such topics as the family, sexuality, the role of women in society, money, wealth and worldly position which art historians have hardly begun to explore in their attempt to provide a relevant and comprehensive religious background for paintings. But there is more at stake here than an expanded notion of the parameters of Christian theology and practice. We think, whether rightly or wrongly, that we need guidelines in our search for this extra-artistic wisdom. In some ways, we do *not* need guidelines: we simply have to be open, interested and able to look everywhere, and in the case of van Eyck, within the world of fifteenth-century men and women. And yet, if some people do, at times rightly, demand a reasonable sense of the boundaries for an interpretative endeavour, they must come as much as possible from the art itself and not simply from a prior intellectual stance, although that too is inevitably a factor.

Looking long and hard at the *Ghent Altarpiece* (illus. 90) stimulates us to make a special kind of search for the theological rationale for what we see. Looking at the Berlin *Virgin in a Church* (illus. 87) would, on the basis of the image, send us in a quite

different direction, one, I would say, more orientated towards a person's individual experience. That difference should not be minimized, however, even when we discover that the same text concerning the Virgin is found on both paintings. A text does not finally explain an image; it only provides us with another, in many ways equally problematic, context in which to try to gauge our feelings about the painting. Whether we use the text or not, we have first to articulate more fully our sensitivity to the visual image, not our knowledge of a metaphoric concept that we might, for some reason, feel is poised behind it.

We are rarely open to van Eyck's sweetly nodding Virgin, his sheepishly grinning St George (illus. 32), his wryly posed donors – all differentiated enough from one other, but not too much, to be able to inform us of their varied, conflicting, yet, at times, similar impulses. We view van Eyck's realism so seriously and single-mindedly that we miss its simple magic. We simply do not allow it to float freely, to work its own surprises upon us. Most people would recognize van Eyck's time as a complex one, full of intriguing ideas and possibilities. Our view of the art, by contrast, has often tended to lock it too rigidly into a single position. We have not cultivated the details and accidents of the imagery that might reasonably be thought to accompany the endings, and the beginning, of the threads that make up the fifteenth century. It was a time, like many others no doubt, when use, contemplation and renunciation of the world all played their part, even simultaneously, in an individual's life, in a single work of art. At this time, notions such as sifting and testing might well replace that of progressing from or toward a certain point.

I remain wary of approaching the paintings of van Eyck – and those of other early Netherlandish artists – with a predetermined set of expectations about the kinds of meaning and ideas concerning representation we should expect to find there. I am also anxious that the interpretations I have put forward in this book do not discourage others from developing new ideas about this complex period. The principles of approach that I myself have used, and which I would advocate for others, do involve a significant premise concerning the problematic nature of van Eyck's art: it is rarely simple, straightforward or single-minded in its religious allusions, and thus it contains numerous inconsistencies and experiments alongside its inherited traditions and conventions. It is this richness of reference, combining scepticism and pretence, that unites this art with its time. Van Eyck's world was one replete with personal and social pretension, the result of changing social situations and expectations. It was more opportunistic than dogmatic, and private devotion and personal mysticism rivalled traditional, church-going liturgical piety. The obvious lack of theological precision meant that both patrons and artists learned to live with equivocation: in art, allusions to complex intellectual speculation are often found to be tinged with a certain playfulness or irony. Clearly, this was not a time for inventing bold and all-encompassing theories of existence; rather, subtle shifts of emphasis took place that, with hindsight, we might

see as having helped initiate the modern era. These changes include the Reformation and the Scientific Revolution.

The early fifteenth century was a world of shifting moral values, in which wisdom and understanding appear to have been considered both as divine gifts and as natural human acquisitions – a world in which a strong sense of empirical perception was juxtaposed with an obsession with spiritual power. What, in particular, needs to be focused on here is the sense of suspension this generated, for van Eyck and his contemporaries found themselves able to maintain ambivalent feelings and sceptical thoughts. This sense of revelation – which, after all, is what was experienced – was, inevitably, far from uniform in its effects. This should not mean, however, that we fall victim to a special-interest theory of art history. Our view of the fifteenth century does not have to be minutely fragmented. Art-historical investigations do not have to turn into trivia contests, where the lowest common denominator of the art work – its status as a material object – becomes all-important. In the fifteenth century, works of art were certainly negotiating devices – between men, between men and women, and between the human and the divine. But that is also a sometimes crude and worldly way of viewing the situation. Is it not true that the beauty, as well as the meaning, of van Eyck's art lies in its illusion, in the artist's powers of representation? Van Eyck's is an elusive art in part because he was so bound up with illusions, both his and those of his patrons. His are never direct illusions of visible reality, certainly not in the religious paintings. We must always wonder – I do not think he allows us to be certain – what the relation is between his work and the visible world, and what its relation is to an unseen world of the spirit. These relationships are not, any of them, easily defined. The historical context helps in a narrative and evocative fashion as much as it does in a demonstrative one. We must continue to wonder at the way realism plays in and through the art of Jan van Eyck.

Bibliographic Commentary

1 Introduction

One author who draws extremely close parallels between events in the patron's life and the imagery of van Eyck is E. Keiser, 1967. Among those writers who have treated van Eyck's paintings almost exclusively as illustrations of Catholic theology after E. Panofsky, 1953, are J. Ward, 1975; A. H. van Buren, 1978; C. J. Purtle, 1982; and B. G. Lane, 1984. Some scholars who have suggested a freer attitude toward the creation of religious meaning in art include R. Berliner, 1945; and M. Schapiro, 1945. J. Marrow, 1986, found the Christian iconography of fifteenth-century northern European painting extremely conservative.

For changing attitudes toward money, see for instance, H. Baron, 1938; and J. F. McGovern, 1970. For interesting general treatment of the play element in culture, J. Huizinga, 1955. The notion that from the Middle Ages to the seventeenth century western Europeans changed from viewing things outside in to viewing things inside out (with the fifteenth century as a period of transition) is presented by A. M. Smith, 1990. S. Alpers, 1977, reviews the increasing demand of art historians to understand art as fitting into a specific historical context.

2 Van Eyck's Realism

The best fifteenth-century example of a critic who described van Eyck's detail with amazement is Bartolomeo Fazio in his *De Viris Illustribus* of 1456. Fazio's text is given in W. Stechow, 1966, pp. 4–5; commentary on it is provided by M. Baxandall, 1971, pp. 97–111. A recent, and I feel misguided, attempt to identify the background landscape in the Rolin *Virgin* is P. Schwarzmann, 1990. The fact that van Eyck did not paint specific locales, either interior or exterior, has been stressed by many authors, among them E. Dhanens, 1980, p. 222; and J. Snyder, 1985, pp. 100 and 109. For the portrayal of contemporary architecture in fifteenth-century Netherlandish painting in general see R. Maere, 1930–31. The legend of van Eyck's 'invention' of oil painting is treated by E. Dhanens, 1980, pp. 68–71.

E. H. Gombrich, 1962, p. 170, attributed to van Eyck 'the final conquest of reality in the North'. For the drawing of Matthew Paris reproduced as illus. 1 see S.

Lewis, 1987, especially pp. 423–25. What I have called a building-block theory of realism is put forward by E. Panofsky, 1953; it is to an extent countered by J. S. Held, 1955, especially p. 207. J. B. Bedaux, 1986, believes that the Arnolfini portrait documents contemporary wedding customs; B. G. Lane, 1990, believes the van der Paele *Virgin* documents the Canon's medical condition.

The view that van Eyck displays a perfect congruity of realism and symbolism is found in E. Panofsky, 1953, especially p. 144. E. Panofsky, 1957, especially pp. 19–20, related the particularist spirit of Nominalism to Early Netherlandish painting; I treat the subject somewhat differently in my 1984 article. Emphasis is placed on van Eyck's description of surfaces by S. Alpers, 1983. For the quotation from the foundation charter of the Hôtel Dieu in Beaune, built by Nicolas Rolin, see S. N. Blum, 1969, p. 47; see also the references to Rolin in § 11 below.

3 The Artist's Place at the Burgundian Court

In a document of 19 March 1472, Pierre Coustain, painter to the Duke of Burgundy, is required to work only for the Duke and his Court if he is to remain exempt from Guild authority. The document was published by W. H. J. Weale, 1863, p. 205; it is also referred to by P. Schabacker, 1972, p. 396, n. 56. J. Bartier, 1973–75, p. 32, points out that van Eyck's titles at Court were relatively common. The artist's house 'with a stone front' is mentioned by E. Panofsky, 1953, p. 178.

For the artistic patronage of the Burgundian Court in general and van Eyck's relation to it, see for instance J. Duverger, 1977; J. C. Smith, 1979, and E. Dhanens, 1980; pp. 34–59. The standard publication of all Court documents, as well as the few other that survive relating to van Eyck, is W. H. J. Weale, 1908, pp. xxvii–xlvii. E. Dhanens, 1980, p.44, stresses van Eyck's presumed work on Court decorations. The drawn copy after van Eyck's portrait of 1429 of Isabella of Portugal (illus. 3) has been mentioned by several authors, among them K. Bauch, 1967, especially pp. 85–91; and C. Sterling, 1976, pp. 33–4.

A careful review of contemporary documents (inventories, wills, etc.) relating to the art market in the southern Netherlands in the fifteenth century is provided by L. Campbell, 1976. Campbell stresses the

scarcity of documents about panel paintings, as well as their lower status, among the nobility (p. 189). For the Loyet reliquary of Charles the Bold (illus. 4) see Detroit, 1960, pp. 298–300, cat. no. 133.

The elaborate feasting and pageantry of the Burgundian Court is described by J. Huizinga, 1924, especially pp. 229–33; O. Cartellieri, 1929, especially pp. 119–63; R. Vaughan, 1970, pp. 141–50; A. Lafortune-Martel, 1984; and J. Goodman, 1985. Visual images of elaborate feasts are rare in the fifteenth century; for an analysis of the rather plain images that were done see P. D. La-Bahn, 1975; the miniature reproduced as illus. 2 is mentioned by LaBahn, pp. 155–56. For the importance of the Court functionary see P. Kauch, 1935; J. Bartier, 1955; W. Prevenier and W. Blockmans, 1986, p. 239; A. van Buren, 1986, p. 111; see also § 12 below. E. Panofsky, 1953, p. 179, thought that van Eyck's motto displayed a combination of pride and humility. For the motto see also R. W. Scheller, 1968. For Jan de Leeuw and his portrait see W. H. J. Weale, 1908, pp. 86–8; and K. Demus, F. Klauner and K. Schütz, 1981, pp. 173–74. The translation of the inscription on the portrait's frame is taken from E. Dhanens, 1980, p. 238.

4 *An Italian Courtier's Story*

I discuss van Eyck's *Arnolfini Double Portrait* in my 1990 article; much of what follows as well as some additional material and bibliography is found there.

Among those who have claimed the London double portrait represents Jan van Eyck and his wife Margaret is M. W. Brockwell, 1952; for further discussion and references about this issue see M. Davies, 1954, pp. 120 and 123. J. B. Bedaux, 1986, pp. 24–5, treats van Eyck's signature as a kind of courtly device. The early inventories mentioning the Arnolfini painting are published in M. Davies, 1954, p. 125.

For shoes and the Arnolfini portrait see H. Rosenau, 1942, p. 126. For shoe symbolism in general, Dr. Aigremont, 1909, especially pp. 55–6; E. Westermarck, 1921; and *Handwörterbuch des Deutschen Aberglaubens* (under *barfuss, schuh*, etc.). For the manuscript reproduced as illus. 7 see H. Martin and P. Laner, 1929, pl. 76; also E. Panofsky, 1953, p. 439 n. 2. For the dog, see for instance M. Leach, 1961, especially pp. 325–29; and B. Rowland, 1973, especially pp. 59–63. For the candle, *Handwörterbuch des Deutschen Aberglaubens* (under *kerze, hochzeit*, etc.); E. Westermarck, 1921, vol. II, p. 544; and C. Du Cange, 1954, vol. II, p. 83. The man's gesture is interpreted as blessing by L. Mirot and E. Lazzareschi, 1940, p. 91. For the possible religious significance of the mirror see R. Baldwin, 1984.

The connection between the Arnolfini portrait and the Louvre *Annunciation* (illus. 14) has been noted by H. Beenken, 1940, especially p. 135; and E. Panofsky, 1953, pp. 252–53 and 256. For prayer beads as betrothal gifts see E. Wilkins, 1969, p. 53. E. Dhanens, 1980, p. 203, emphasizes the domestic meaning of the dusting brush. M. Davies, 1968, pp. 50 and 51 n. 3,

mentioned the possibility that the bedstead carving could be of St Martha. For oranges – 'Adam's apples' – and Eve see J. Snyder, 1976. My colleague Walter Denny assisted with information about the oriental carpet in the painting. For oranges as the fruit of kings see S. Tolkowsky, 1938, p. 150. For the Duke of Burgundy's sense of dignity and restraint, see especially J. Huizinga, 1932; also O. Cartellieri, 1929, p. 65. For the Burgundian Court in general see, in addition to Cartellieri, R. Vaughan, 1970. For the miniature (illus. 16) see T. Kren, 1983, p. 11. For the development of courtly artifice see N. Elias, 1978. E. Dhanens, 1980, pp. 141–3, noted the similarity between the Arnolfini portrait and the engraving of Ansegisus and Bega (illus. 17). For the miniature (illus. 19) see S. Hindman, 1983. For the relation betwen the *Thesiad* miniature (illus. 18) and van Eyck see O. Pächt, 1977, pp. 68–70; and E. Dhanens, 1980, pp. 62–7. The relation of the Arnolfini portrait and the Charles Martel miniature (illus. 20) was mentioned in passing by M. Davies, 1954, p. 122.

E. Panofsky, 1934, p. 124, and 1953, p. 203, claimed that the signature and date had a legalistic function; J. Snyder, 1985, p. 112, noted the absence of the year's month and day in the date. Rarely mentioned by scholars, the chair carving is thought to represent unchastity overcome by the sacrament of marriage, according to J. B. Bedaux, 1986, p. 20. For the Grimani Breviary miniature (illus. 21) see *Brevario Grimani*, 1970, pp. 275–76. For the sexual mores of the Court of Burgundy see O. Cartellieri, 1929, pp. 115–16; R. Vaughan, 1975, pp. 165–66; and J. Huizinga, 1924, p. 97.

Biographical information on Giovanni Arnolfini is found in L. Mirot and E. Lazzareschi, 1940. For the Cenami family see L. Mirot, 1930. For the Book of Hours of Mary of Guelders (Staatsbibliothek, Stiftung Preussischer Kulturbesitz, Berlin, MS Germ. quart 42, fol. 19v), see E. Panofsky, 1953, p. 101; and J. Harthan, 1977, pp. 80–81. E. Panofsky, 1953, pp. 300–01, discusses the female donor wing added to the Louvre *Annunciation* (illus. 14). For Arnolfini's contacts at Court see also the record provided by the Court historiographer, Georges Chastellian, in his *Oeuvres*, especially vol. IV, 1865, pp. 33, 351 and 356. At the 'Historians of Netherlandish Art' conference, Cleveland, Ohio, 29 October 1989, Margaret D. Carroll gave a talk entitled '*Speculum Mercatorum*: Jan van Eyck's *Marriage of Arnolfini*', in which she suggested, among other things, that Arnolfini wished his image to impress the Court with his trustworthiness. For a telling mid-fifteenth-century example of the woes of a childless woman see I. Origo, 1957, especially pp. 165–87. For Giovanni Arnolfini's court case with his mistress see E. I. Strubbe, 1950. For the courtly love poem about Giovanna Cenami see L. Minot and E. Lazzareschi, 1940, p. 92. The Spanish inventory of 1700 recording the inscribed frame is found in M. Davies, 1954, pp. 126–27. The Pucelle *Annunciation* (illus. 22) is treated by J. Rorimer, 1957, p. 19.

5 *The Ecclesiastical Compact of a Secular Canon*

A complete bibliography of secondary sources on the van der Paele painting is contained in A. Janssens de Bisthoven, 1983, pp. 215–22. The following are the most important art historical publications of the last thirty years: E. Panofsky, 1953; A. Viaene, 1965; J. C. Opstelten, 1966 (discussing the Christ Child as startled by St George's clanking armour); L. Naftulin, 1971; D. M. Hitchcock, 1976; R. Terner, 1979; E. Dhanens, 1980, especially pp. 212–31; C. J. Purtle, 1982, especially pp. 85–97; and B. G. Lane, 1984. The Janssens de Bisthoven volume mentioned above also reprints all important documents relating to the painting, from the fifteenth century through to the nineteenth.

George van der Paele's biography has been most fully studied by R. de Keyser, 1971 and 1972. For the religious history of the period, including the place of secular canons, the following sources are useful: E. de Moreau, 1949; E. Delaruelle, E.-R. Labande and P. Ourliac, 1962–64, especially pp. 302–10; J. Toussaert, 1963; and F. Rapp, 1971. For secular canons at St Donatian's, see R. de Keyser, 1978.

The inscriptions on the van der Paele painting are given in full in A. Janssens de Bisthoven, 1983, as well as in E. Dhanens, 1980; the English translation in my text is taken from Dhanens, p. 212. The fact that the painting commemorates the endowment of the chaplaincies is stressed by D. De Vos, 1982, pp. 220–25. Van der Paele's foundations are most fully discussed by A. Dewitte, 1971. For the obsession with masses for the dead, as well as for the endowment of elaborate chaplaincies, see J. Chiffoleau, 1980, esp. pp. 332–33; and J. Chiffoleau, 1981.

The relation between the robe of St Donatian in the painting and the possessions of the Bruges church, as well as the possible link between the processional cross and van der Paele's religious interests, are elements brought out by A. Viaene, 1965, p. 264. The resemblance between the church in van Eyck's panel and the Church of the Holy Sepulchre in Jerusalem is discussed by C. Purtle, 1982, pp. 89–90; E. Dhanens, 1980, p. 222, stresses that none of van Eyck's buildings reproduce existing structures. That the sculptural elements in van Eyck's painting might refer to the concepts of the Church Priestly and the Church Militant has been suggested by Dhanens as well as by J. Snyder, 1985, pp. 110–11. E. Panofksy, 1953, especially pp. 7–8, argues that van Eyck included the viewer in his painted space; a view to my mind rightly qualified by J. S. Held, 1955, especially p. 207.

6 *Private Devotion in a Schismatic Church*

E. Panofsky (1953, pp. 183–84) tended to interpret van Eyck's figural devices in terms of a notion of the artist's presumed stylistic development. The Bruges *Adoration of the Magi* (illus. 34), apparently commissioned by a Spanish merchant, is illustrated and discussed in Janssens de Bisthoven, 1983, pp. 40–49; also by D. De Vos,

1982, pp. 37–8. Treatment of the tradition of donors either participating in, or envisioning, the Adoration of the Magi is given by F. O. Büttner, 1983, p. 77–84, and figs 5–21. For the work from the circle of Hugo van der Goes (illus. 3, 5, 36 and 37) see Büttner, p. 230 and fig. 13; also M. J. Friedländer, vol. IV, 1969, p. 69, no. 9.

For further discussion of the *Seven Sacraments Altarpiece* by Roger van der Weyden and his workshop see S. Koslow, 1972; P. Vandenbroeck, 1985, pp. 153–58 (with extensive bibliography); and C. Harbison, 1985, esp. p. 89. For a recent theory about the patronage of the work, see A. Chatelet, 1989. For the *Mass of St Gregory*, an important secondary source is U. Westfehling, 1982; all thirteen panels illustrated and discussed in this source had clerical donors. The Madrid example is mentioned by Janssens de Bisthoven, 1983, p. 213; and illustrated and described in M. J. Friedländer, vol. XI, 1974, p. 90, no. 201 (where the head of the cleric holding the tiara is said to resemble van Eyck's *Man with a Pink* – a painting whose attribution to van Eyck is now often doubted, as in E. Dhanens, 1980, pp. 371–72).

That the multiplication of masses for the dead represents a seizure of initiative by the laity is an interpretation found in J. Chiffoleau, 1981, p. 236. For further discussion of the importance of 'learned ignorance' and related concepts, and their role in fostering a lay visionary mentality, see my 1985 article. A general overview of lay devotion in the late Middle Ages is provided by E. A. Macek, 1978; and C. M. N. Eire, 1986, especially pp. 8–27. The Modern Devotion has been analysed and interpreted in almost all the religious histories of this period, such as the ones by E. Delaurelle, E.-R. Labande and P. Ourliac, 1962–64, esp. pp. 911–42; and F. Rapp, 1971, esp. pp. 243–48 (with bibliography); also the article by P. Debongnie, 1957, cols 727–47; and the study of R. R. Post, 1968. Justification for the wealth and display of the papal curia is one topic treated by H. Baron, 1938, especially pp. 29–31.

The issue of the numerous other artists working in Bruges during van Eyck's lifetime is treated by J. Duverger, 1955. According to a document published by W. H. J. Weale, 1863, p. 205, an artist working for the Burgundian Court in 1472 was forbidden by the Bruges painters' guild from working for anyone outside the Court; this document was also cited in P. Schabacker, 1972, p. 396, n. 56. The relation between the church of St Donatian and the ducal Court is discussed by E. de Moreau, 1949, esp. p. 70; see also E. de Moreau, 1947; and R. de Keyser, 1978, esp. pp. 591–92.

Treatment of Abbot Suger's ideas on art is given by E. Panofsky, 1979. St Bernard's ideas receive an interesting interpretation from M. Schapiro, 1977. The fifteenth-century outcry against the *schöne Maria* paintings is mentioned by A. Kutal, 1971, p. 108; and J. Snyder, 1985, p. 32. For the *Virgin of Jindrichuv Hradec* (illus. 43), see also A. Matějček and J. Pešina, 1950, p. 62 (no. 187); and for John Hus's attitude toward art, C. M. N. Eire, 1986, pp. 22–23. I have discussed the attitude of the leaders of the Modern

Devotion toward imagery in my 1985 article; see also the study of S. Ringbom, 1969.

The topic of George van der Paele's health has received attention from J. Desneux, 1958, especially p. 15; the same author's 1951 study; the studies by J. Dequeker, 1979, 1980, and 1983; and, most recently, B. G. Lane, 1990.

7 The Function of Religious Belief for van Eyck

I have used the analysis of religious feeling provided by C. Geertz, 1966; reprinted 1973, especially pp. 100–108. For the epitaph panel of Hendrik van Rijn, see the discussion in P. Vandenbroeck, 1985, pp. 25–8 (with bibliography). For van der Paele's health, see the references in the preceding section. Van Eyck's Bruges painting was interpreted as an epitaph by A. Viaene, 1965; and R. Terner, 1979. Van der Paele's grave relief is discussed most fully in V. Vermeersch, 1978, no. 180, pp. 172–73. E. Panofsky, 1953, p. 249, called Roger van der Weyden's world 'at once physically barer and spiritually richer than Jan van Eyck's'. It is Panofsky who is most responsible for the interpretation of van Eyck as an intellectually complex artist. D. M. Hitchcock, 1976, provides an extensive interpretation of possible symbolic reference in the painting's sculpture, floor, rug, jewels and embroidery.

8 The Doctrine of Mary

Van Eyck's four seated, red-robed Virgins have never been treated as a group; discussions of all these paintings are included in E. Panofsky, 1953; also E. Dhanens, 1980; C. J. Purtle, 1982; and B. G. Lane, 1984. The English translation of the inscription referring to the Virgin on the van der Paele panel and Dresden triptych is taken from E. Dhanens, 1980, p. 218. The first modern scholar to treat this hymn from the book of the Wisdom of Solomon was M. Meiss, 1945.

J. Pelikan, 1984, pp. 38–50, treats the Doctrine of Mary in the fifteenth century. For the controversy surrounding the doctrine of the Immaculate Conception see especially Le Bachelet, 1922, especially cols 1108–15; and W. Sebastian, 1958, especially pp. 228–34. For the traditional iconography of the theme in art, see M. Levi d'Ancona, 1957. Many other authors have discussed the Virgin's lion throne, the fruit in the Lucca *Virgin and Child*, and the carvings as well as the parrot in the van der Paele painting; among these might be mentioned in particular the detailed analyses of C. Purtle, 1982; and that of E. Dhanens, 1980. For a recent evaluation of the crystal carafe in the Lucca *Virgin*, see B. Madigan, 1984.

9 The Sacrament of the Altar

To my knowledge no previous observer has focused on the figure of Christ in van Eyck's religious paintings. Although he does not treat any of van Eyck's *Virgin and Child* images, L. Steinberg, 1983, has been a crucial

stimulant for my discussion. Treatment of the late medieval focus on the body of Christ is contained in Steinberg as well as in E. Delaruelle, 1955; G. Leff, 1956; H. Oberman, 1978; and J. Pelikan, 1984. L. Steinberg, 1983, pp. 157–59, discusses the fact that the Christ Child is never shown circumcised. In addition, the studies of C. W. Bynum are particularly stimulating; see her 1986 and 1987 publications. The Antwerp relic of the Holy Foreskin is mentioned in E. de Moreau, 1949, p. 377.

Eucharistic devotion is also treated by the last mentioned author, pp. 368–80; and by D. G. Dix, 1960, especially pp. 598ff; E. Delaruelle, E. -R. Labande, and P. Ourliac, 1962–64, pp. 748–52 (who mention Philip the Good's miraculously bleeding host, p. 751); J. Toussaert, 1963, especially pp. 195–204; and P. Browe, 1967. Toussaert, pp. 165ff and 180ff, analyses the number of hosts and amount of wine consumed in Bruges. J. Pelikan, 1984, pp. 52–9, discusses some of the theological controversy surrounding the Eucharist in the fifteenth century; and P. Browe, 1938, especially pp. 100–11, presents documentation about the miraculous appearance of the Christ Child during the eucharistic ceremony. This a topic also mentioned in E. Delaruelle, E.-R. Labande and P. Ourliac, 1962–64; p. 752; see also B. G. Lane, 1975, p. 479 and notes 20–24; and the same author's 1988 publication, especially p. 113. The contemporary obsession with seeing, found in such mystical writers as John Ruusbroec, is brought out by C. Eisler, 1986, especially p. 677.

I have treated donors' visions of the Christ Child as part of a larger theme of visions and meditations in my 1985 article; general treatment of the donor envisioning an episode from the life of Christ is found in F. O. Büttner, 1983. The prayer book of Philip the Good (illus. 50) is illustrated and discussed by L. Steinberg, 1983, p. 1 and fig. 1; see also J. Harthan, 1977, pp. 102–105.

The main source treating van Eyck's paintings as symbolic of the Mass is B. G. Lane, 1984; Lane's views on van Eyck's paintings had to some extent been anticipated by L. B. Philip, 1971; and C. Purtle, 1982. Many authors have preceded Lane in finding eucharistic meaning in early Netherlandish realism; among these may be cited U. Nilgen, 1967; C. Gottlieb, 1970 and 1971; and M. B. McNamee, 1972.

For the French illumination reproduced as illus. 51, see J. Backhouse, 1985, pp. 65–66 and fig. 61, p. 70. The south Netherlandish painting of the *Adoration of the Sacrament* (illus. 52) is discussed and illustrated in P. Vandenbroeck, 1985, pp. 35–8, no. 224. For the manuscript illumination reproduced as illus. 53, see R. Wieck, 1988, p. 106. O. Pächt, 1956, especially p. 275, questioned the creation of 'a new cryptic language' of symbolism in fifteenth-century Northern art. Fear about idolatrous worship of the host is discussed in the works relating to the Eucharist mentioned above, especially J. Pelikan, 1984, p. 55. Nicholas of Cusa's warning about excessive eucharistic worship is mentioned by

P. Browe, 1938, p. 166. I have previously discussed the views of Gabriel Biel on the relation of the Crucifixion and Communion in my 1985 review in *Simiolus*, especially p. 223.

10 *The Patrons of Domestic Religious Imagery*

Perhaps because of its relative simplicity, the Lucca *Virgin and Child* has never received extensive separate treatment; no previous studies have focused solely upon it. It is discussed in some detail by C. J. Purtle, 1982, pp. 98–126; one motif in it has recently received attention from B. Madigan, 1984.

In his 1955 publication, pp. 214–15, J. Held pointed out a need to consider the conflict between nobles and city-dwelling *vilains*. M. Schapiro has stressed sexual as well as religious tension in his 1945 study. The reader might also wish to consult the Marxist interpretation of B. Zülicke-Laube, 1963.

For a contract which specifies a bed painted 'ainsi quant par telle maniere que a present on fait les couches des seigneurs et bourgeois', and also 'de telle facon que on les fait en Brabant et en Flandres', as well as a Christ Child 'tout nudz', see L. Campbell, 1976, especially pp. 192–93. Doubts about the attribution of several works traditionally ascribed to Robert Campin have been raised in the same author's 1974 article; also by M. Sonkes, 1971/72, especially p. 204. The possible sixteenth-century Spanish origin of the Ince Hall *Virgin and Child* is discussed by U. Hoff and M. Davies, 1971, p. 34. And the attribution of the Louvre *Annunciation* is reviewed by, among others, M. Davies, 1972, pp. 236–37. For Campin's biography and patronage, see P. H. Schabacker, 1980. The numerous other artists working at the time in Bruges are analysed by J. Duverger, 1955. And for workshop practice, see L. Campbell, 1981.

The idea that the Lucca *Virgin* bears the traits of Margaret van Eyck is proposed by E. Dhanens, 1980, p. 234. L. Steinberg, 1983, pp. 14–15, mentions the importance of the Virgin's nourishment for the humanity of Christ. The role of precise and firm gestures in van Eyck's art is stressed by J. Taubert, 1975, especially p. 55. C. W. Bynum, 1984, 1986 and 1987, stresses the role of women in late medieval devotional imagery focusing on body, food and nourishment. For the painting of St Bernard receiving the Virgin's milk (illus. 59), see M. J. Friedländer, vol. x, 1973, no. 65, pl. 51.

The clergy's attempt to control pilgrimages and processions is discussed by C. Zika, 1988. J. Toussaert, 1963, pp. 141ff, mentions complaints about poor attendance at Mass. The Book of Hours of Joanna of Castile, showing the donor praying to a Rogerian image of the nursing Virgin and Child (illus. 60), is illustrated and discussed in J. Backhouse, 1985, p. 5 and fig. 4, p. 9.

11 *The Confession of Chancellor Nicolas Rolin*

The biography of Nicolas Rolin had been treated by A. Perier, 1904; H. Pirenne, 1907; G. Valat, 1912, 1913, 1914 (only up to the year 1430); and the political analysis of R. Berger, 1971. His burial rite, recounted by Chastellain, is recorded in H. Pirenne, 1907, col. 835. C. Hasenmueller, 1980, p. 88, n. 31, stresses the fact that Rolin is too large to leave the chamber in which he is kneeling. N. Veronée-Verhaegen, 1973, pp. 62–4, gives an analysis of the foundation of the Beaune hospital by Rolin and his wife Guigone de Salins; the phrase used in my text is taken from a document of 1443, quoted by S. N. Blum, 1969, p. 47.

Van Eyck's painting for Nicolas Rolin has been thoroughly studied by many modern observers. A complete bibliography up to 1953 is found in E. Michel, 1953, pp. 115–19. Among the numerous more recent studies are J. Snyder, 1967; E. Keiser, 1967; Z. Kepinski, 1969; H. Roosen-Runge, 1972; H. Adhémar, 1975; C. H. McCorkel, 1975; A. H. van Buren, 1978; C. Hasenmueller, 1980 (I am grateful to Professor Hasenmueller for making a copy of her article available to me); and M. T. Smith, 1981. There is also lengthy treatment of this painting in E. Dhanens, 1980, pp. 266–81; and C. J. Purtle, 1982, especially pp. 59–84. The Master of St Gudule's panel (illus. 72) is treated in the Detroit catalogue, 1960, cat. no. 27, pp. 133–35.

The purse of Rolin is published and discussed in E. Dhanens, 1980, pp. 276–79. The most recent and complete technical examination of the panel, discussing both the purse and the change in the Christ Child's arm, is by J. R. J. van Asperen de Boer and M. Faries, 1990. Dhanens also provides an interesting discussion of the garden and birds, pp. 274–76. The seignorial holdings of the Chancellor are detailed by, among others, H. Pirenne, 1907, col. 837, a source which also records Chastellain's general evaluation of Rolin, col. 883.

J. Snyder, 1967, pp. 169–70, stressed the relevance of the vineyard-covered hills in the painting to the land and income of Rolin. For the recent hypothesis that the landscape background of the Rolin panel records an identifiable location, see P. Schwarzmann, 1990. H. Adhémar, 1975, provides detailed information about Rolin's relation to his parish church of Notre-Dame-de-Chastel; A. H. van Buren, 1978, pp. 630–33, seconded this information. E. Keiser, 1967, relates various details, including the church above Rolin's hands as well as the floor tiles, to the Treaty of Arras. M. T. Smith, 1981, presents a hypothesis about the involvement of Nicolas Rolin's son, Jean, in the commission; she believes Jean may have ordered the work to encourage his father's pious donations around 1430.

The connection between early autobiography and confession is explored by T. C. P. Zimmerman, 1971. The nature and function of confession in the late Middle Ages is examined by H. C. Lea, 1896; J. Toussaert, 1963, pp. 104–22; and E. Delaruelle, E.-R. Labande and P. Ourliac, 1962–4, pp. 656–64. Contemporary confession manuals are detailed by P. Michaud-Quantin, 1962, especially pp. 68–97. These manuals are also treated in T. C. Price Zimmermann's study. The use of confession in the later fifteenth century and early sixteenth has received differing interpretations from T. N. Tentler, 1977; and L. G. Duggan, 1984.

It has previously been suggested that the lions on the capitals behind Rolin's head might stand for the Chancellor's zodiacal sign; see E. Dhanens, 1980, p. 276. Rolin's desire to transform his sinful state is stressed by, among others, C. Hasenmueller, 1980. J. Huizinga, 1924, p. 240, provides an analysis of the piety and pretention of Rolin's life and imagery. For the miniature reproduced as illus. 75, see the facsimile edition of *Les pétites prières de Renée de France*, 1920. H. van Miegroet, 1988, especially p. 125, discusses Gerard David's later use of a 'loggia of justice' device; van Miegroet also gives further reference to J. de Ridder, 1979/80, especially pp. 44–45, for a discussion of town–hall justice loggias. C. H. McCorkel, 1975, presents an interpretation of the crown in the Rolin painting as a Crown of Life. A different point of view on the meaning of the crown is assumed by E. Hall and H. Uhr, 1978.

For Rolin's overpowering interest in his parish church, see again the studies of H. Adhémar and A. H. van Buren. The oft-cited comments of Rolin's contemporaries, Georges Chastellain and Jacques de la Clerq, about his rather elusive combination of ambition and piety are taken from J. Huizinga, 1924, p. 240.

12 *Patronage by Burgundian Court Functionaries*

Burgundian Court functionaries have been studied by P. Kauch, 1935; and, especially, by J. Bartier, 1955. Extensive biographies of Bladelin, Braque, Gros, Berthoz, à la Truie and Chevrot are given by Bartier, in addition to numerous references to Rolin. Those who have previously mentioned the importance of the functionaries for art in this period are J. Bartier, pp. 271–83; W. Prevenier and W. Blockmans, 1986, p. 329; and A. H. van Buren, 1986, p. 111. For Bladelin's work (illus. 49), see my 1985 study, especially pp. 94ff and 105; for the Braque triptych, S. N. Blum, 1969, chapter 3, pp. 29–36; for the Berthoz triptych (illus. 78), the Detroit catalogue, 1960, cat. no. 19, pp. 108–112; and for Chevrot's work (illus. 38), S. Koslow, 1972; P. Vandenbroeck, 1985; and A. Chatelet, 1989. I have pointed out the prominence of lay patrons in Flanders in my 1986 article, especially p. 171. The small amount of documentation for Northern art has been indicated by, among others, W. Stechow, 1966, p. 3.

For the Court of Burgundy's patronage of art, see L. Campbell, 1976, especially pp. 188–89. Van Eyck's possible work for the Duke of Burgundy is treated by E. Dhanens, 1980, especially pp. 122–73. The fact that van Eyck was a Court functionary with the right to be interred in the ancient burial site of the counts is mentioned by Dhanens, p. 57. The rivalry between functionaries and nobility is discussed by J. Bartier, 1955, especially pp. 247–69, who also analyses the ways that the Third Estate tried to enter the ranks of the aristocracy, pp. 190–207. The discussions at the Burgundian Court of a non-hereditary nobility are mentioned by C. C. Willard, 1967, especially p. 45. The fact that Rolin bought tapestries is mentioned by H. Pirenne, 1907, col. 838.

Jodocus Vijd's patronage of the *Ghent Altarpiece* is fully treated by D. Goodgal, 1981, especially pp. 103–21; and the same author's 1985 article. For a treatment of the importance of private devotion in the fifteenth century, and for the art, see my 1985 study.

13 *Literary Sources for van Eyck's Art*

According to C. Hasenmuller, 1980, p. 68, the rabbits crushed beneath the columns in the Rolin painting represent the defeat of evil. E. Dhanens, 1980, p. 276, speculates on the association of the carved lion's head with Rolin's zodiacal sign, Leo. The seven supports for the bridge in the Rolin painting are given a symbolic reading by C. Hasenmueller, 1980, especially p. 56; the floor tiles are of great interest to E. Keiser, 1967. The interpretation of the historiated capital on the right side of the Rolin painting as representing Abraham and Melchizedek is followed by J. Synder, 1967, p. 170; and A. H. van Buren, 1978, pp. 620–21. Other interpretations have been given by C. de Tolnay, 1939, p. 50, n. 67 (Esther and Ahasuerus); E. Panofsky, 1953, p. 139 (the Justice of Trajan); and H. Roosen-Runge, 1972, p. 39–40 (Solomon and Sheba). That the landscape in the background of the Rolin painting is Burgundian, specifically taken around the city of Autun, is suggested by H. Adhémar, 1975, p. 16 and n. 48; this is followed by A. H. van Buren, 1978, p. 632; another suggestion is made by P. Schwarzmann, 1990. Van Buren also stresses the symbolic watchtower setting of the foreground scene. Both van Buren and H. Roosen-Runge use the twelfth-century commentaries of Honorius Augustodunesis in order to elucidate the meaning of the image.

Georges Chastellain's *Louenge à la très-glorieuse Vierge*, found in manuscripts in Brussels and Paris, was published in Chastellain's *Oeuvres*, vol. VIII, 1866, pp. 269–92. The fact that Chastellain wrote an inscription for a painting is documented in L. Campbell, 1976, p. 194. C. Purtle, 1982, pp. 177–85, gives the complete Little Office of the Blessed Virgin Mary; she also discusses its relation to the painting.

14 *Physical Format and Verbal Inscription*

A large bibliography for van Eyck's Dresden triptych is given in A. Mayer-Meintschel, 1966, pp. 29–31. The discovery of the date 1437 on the frame of the painting was first reported by H. Menz, 1959. Recent discussions of the work include.: E. Dhanens, 1980, pp. 242–51; and C. J. Purtle, 1982, pp. 127–43.

The importance of the triptych form in fifteenth-century Netherlandish art is stressed by S. N. Blum, 1969, especially chapter 1, pp. 1–16, 'The Emergence of the Triptych'; she discusses the Portinari triptych in particular in chapter 8, pp. 77–86. The idea that finely crafted frames give to a triptych a precious, reliquary-like appearance is mentioned by C. Eisler, 1969, especially p. 187. A discussion of the origins of the winged altarpiece in Germany, evaluating the various roles of relics and liturgy, is provided by D. L. Ehresmann, 1982. M. T. Smith, 1957–59, discusses the notion that

grisaille paintings on the exterior of triptychs may be related to Lenten practice. For a general evaluation of this phenomenon, see P. Philippot, 1966. For van Eyck's *Annunciation* diptych (illus. 69), see C. Eisler, 1989, pp. 56–61, especially pp. 52–53, for the physical evidence that the work was from the start a closable diptych.

That the Christ Child holds grapes in his left hand is claimed by C. Purtle, 1982, p. 131; Dhanens, 1980, does not mention the detail. Demands for the inclusion of specific genre-like details in a sculpted altarpiece are documented in a 1448 contract reprinted by L. Campbell, 1976, especially pp. 192–93.

The modern scientific analysis, revealing the originally planned banderoles in Roger van der Weyden's Bladelin triptych, is published and discussed by R. Grosshans, 1985, especially pp. 154–66. The fifteenth-century Hispano-Flemish copy of Roger's work which includes the banderoles (illus. 91) was published by T. Rousseau, 1950. I have discussed the visionary nature of Roger's work in a 1985 article, especially pp. 94ff and 105. Recent critical analysis and complete bibliography for Roger's *Seven Sacraments Altarpiece* is given by P. Vandenbroeck, 1985, pp. 153–58; Roger's *Mary Altarpiece* is analysed by R. Grosshans, 1981.

For the Colijns' epitaph the following sources may be consulted: Groeningemuseum, Bruges, 1969, cat. no. 52, pp. 113–14 and 150–52; and F. O. Büttner, 1983, p. 207 and fig. 160. For treatment of fifteenth-century Flemish woodcuts, almost all including banderoles or inscriptions, see L. Lebeer, 1953, especially pp. 198–216; for the woodcut reproduced as illus. 93, see A. J. J. Delen, 1924, pp. 62–65. My thoughts on the role of woodcuts with inscriptions leading to greater literacy have been aided by the discussion in M. Chrisman, 1982, especially pp. 103–22.

15 *A Litany to the Sacred Heart of Jesus*

Devotion to the Sacred Heart of Jesus has been outlined by J. Bainvel, 1924 and 1938; A. Hamon, 1953; and J. Stierli, 1958. Medieval and late medieval practices are focused upon by G. Constable, 'Twelfth-Century Spirituality', especially p. 45; and C. W. Bynum, 1987, especially pp. 55–56, 77 and 93. The Litany of the Sacred Heart is analysed by C. G. Kanters, 1926; and A. Feuillet, 1964. Late medieval devotion to the Sacred Heart in the Netherlands is the subject of a study by C. G. Kanters, 1928; Kanters includes excerpts from the writings of John Ruusbroec, Thomas à Kempis, Henri Harpius and Jean Mombaer, among others. See also K. Richstätter, 1925 and 1930 (the latter a collection of original sources). The fifteenth-century woodcut reproduced as illus. 94 is discussed by R. S. Field, 1965, no. 116.

The possible Italian patronage of the Dresden *Triptych* is discussed by E. Dhanens, 1980, pp. 242–51; Dhanens also mentions the possibility of the wife's involvement in the commission. The possibility that Nicolas Rolin's son, Jean, commissioned the Paris panel

from van Eyck has been put forth by M. T. Smith, 1981. The Master of St Gudule's portrait (illus. 95), which suggest a man's devotion to the Sacred Heart, is reproduced and discussed by G. Bauman, 1986, especially pp. 40–41.

The story of Catherine of Alexandria's life is recounted in the fourteenth-century *Golden Legend* of Jacobus de Voragine, 1969 edition, pp. 708–16. A. van Buren kindly informed me that she believes the costume worn by van Eyck's St Catherine dates from *c*.1375. The Duke of Berry's miniature of Christ tempted by the Devil with the Duke's castle at Mehun-sur-Yevre is reproduced and discussed by J. Longnon and M. Meiss, 1969, no. 121 (fol. 161v).

Study of the ascetic formula *nudus nudum Christum sequi* has been undertaken by M. Bernards, 1951 (citing fifty uses of the phrase from the fourth century to the fourteenth); and R. Gregoire, 1972 (listing forty-nine examples from Jerome to Thomas à Kempis). See also G. Constable, 1979; and J. Chatillon, 1974.

The translation from the *Imitation of Christ* used in my text is slightly altered from that by L. Shirley-Price, 1952, p. 144. C. Purtle, 1982, p. 129, identified the passage about St Catherine on the Dresden frame as coming from the consecutive antiphons at Vespers on the Feast of St Catherine, documented according to the use of the church of St Donatian in Bruges. The fifteenth-century German woodcut of the naked man presenting his heart to Jesus (illus. 97) is discussed in F. O. Büttner, p. 59; see also W. Schreiber, 1927, p. 26 (no. 1838).

16 *Architectural Style and Sculptural Symbolism*

The lack of stylistic precision in van Eyck's interiors was stressed by, among others, J. S. Held, 1955, especially p. 213. E. S. de Beer, 1948, argued that northern Europeans in the fifteenth century would have had little idea of the evolution of architectural style. E. Panofsky attempted in various ways to attribute specific meaning to the use of Romanesque architecture by van Eyck, and by other early Netherlandish artists: it could represent the Heavenly Jerusalem or, alternatively, the Synagogue; see his article of 1935, especially pp. 449–50, n. 28; and also his book of 1953. The relation of van Eyck's architecture, especially that in the Washington *Annunciation*, to buildings in Tournai has been outlined by T. W. Lyman, 1981; at Tournai, Lyman was able to account for the 'upside-down' elevation which Panofsky had claimed was 'archaeologically impossible'.

The increasingly intellectualized, textually based discussions of the Eucharist in the twelfth century have been analyzed by B. Stock, 1983, especially pp. 241–325; also useful is the review of Stock's book by S. G. Nichols, 1986. For the fourteenth century reaction to Scholasticism see G. Leff, 1956; and H. A. Oberman, 1978.

A classic theory about the close relation between architectural design and philosophical thought is provided by E. Panofsky, 1957. A recent critique of

Panofsky's position on the relation of Gothic architecture and Scholasticism is given by P. Crossley, 1988. P. Kidson, 1987, questioned Panofsky's related evaluation of Abbot Suger and the origins of Gothic architecture. C. J. Purtle, 1982, p. 134, points out that earlier scholars were more certain about the identification of the scenes represented in the Dresden capitals; she only believes that they may be 'associated with' or 'related to' biblical stories. The use of historiated foreground arches in paintings made during van Eyck's lifetime has been studied by K. Birkmeyer, 1961.

17 *Van Eyck's Modern Icon*

General bibliographic references, including discussion of dating, for the Berlin *Virgin in a Church* are found at the beginning of the notes for § 18 below. For the Antwerp panel the most complete discussion, with fullest bibliography, is in P. Vandenbroeck, 1985, pp. 174–78 (no. 411). Lengthy treatment is also given this work by E. Dhanens, 1980, pp. 295–301; and C. J. Purtle, 1982, pp. 157–67. The telling firmness of gesture in van Eyck's earlier paintings is emphasized by J. Taubert, 1975, especially p. 55. L. Silver, 1983, especially p. 96, claims that the Christ Child's face in the Antwerp panel is damaged and would originally have been much more expressive than it appears today. Silver and many others also stress the humanity of the mother and child group.

All recent discussions of the Antwerp painting have mentioned, in a general way, its dependence on a Byzantine prototype; this is particularly true of Silver, 1983. For the *eleousa* type of icon see the articles by K.-A. Wirth, 1958; and by M. Restle, 1967. The Cambrai icon was studied by J. Dupont, 1935. The notion that icons helped artists in the fifteenth century to create pictures of 'the subtlest emotional relationships' is presented at length by S. Ringbom, 1965. The idea that fifteenth-century artists found a visual truth in these images has been pointed out by C. Eisler, 1969, especially p. 187; also H. Belting, 1981; and L. Silver, 1983, especially p. 100. Roger van der Weyden's *Virgin and Child* (illus. 104) is treated in the Detroit catalogue, 1960, cat. no. 8, pp. 80–82.

The Holy Face paintings of van Eyck are discussed by E. Dhanens, 1980, pp. 292–94. The most complete discussion of the Bruges copy of this work is in A. Janssens de Bisthoven, 1983, pp. 163–74; and D. De Vos, 1982, pp. 228–29. Later copies of van Eyck's Antwerp *Virgin* are most fully discussed by Vandenbroeck; those more creative ones of the van der Paele composition are mentioned in A. Janssens de Bisthoven, 1983, pp. 210–13. The fifteen copies made of the icon of the Virgin in Cambrai (illus. 101) are discussed in J. Dupont, 1935.

Van Eyck's use of a motto has been previously analyzed by E. Panofsky 1953, especially p. 179; R. W. Scheller, 1968; and G. Künstler, 1972. E. Dhanens, 1980, pp. 179–80, has suggested a relation between van Eyck's use of pseudo-Greek letters and similar inscriptions on icons.

For the Council of Ferrara/Florence see A. Vogt, 1920; and E. Delaruelle, E.-R. Labande and P. Ourliac, 1962–64, pp. 529–72. For Albergati, see P. De Toeth, 1934. For a recent overview of critical opinion on van Eyck's Albergati portrait, see K. Demus, F. Klauner and K. Schütz, 1981, pp. 169–73. The suggested identity of the sitter in the Vienna painting is doubted by E. C. Hall, 1968 and 1971. E. Dhanens, 1980, pp. 282–91, accepts the date of 1438 recorded in the seventeenth century; see also the earlier discussion by M. Meiss, 1952.

For Duke Philip the Good and the Church, see in general R. Vaughan, 1970, pp. 205–38; and especially pp. 211–13 for ducal relations with the Council of Ferrara. The notion that van Eyck's marmoreal frames depended on a fourteenth-century Italian prototype by Pietro Lorenzetti is suggested by M. Cämmerer-George, 1967. The documents concerning van Eyck's work at the Court of Burgundy were collected and published by W. H. J. Weale, 1908, pp. xxvii–xlvii.

For the development of the doctrine of the Immaculate Conception, and in particular the Council of Basle's role in it, see X. Le Bachelet, 1922, especially cols 1108–15; also W. Sebastian, 1958, especially pp. 228–34. Duke Philip's opposition to the decrees of the Council of Basle is mentioned by R. Vaughan, 1970, p. 211; and in more detail by J. Toussaint, 1942, especially p. 12. The support that the Eastern Church gave to the doctrine of the Immaculate Conception is discussed by X. Le Bachelet, 1922, especially cols 904–56. For Heinrich von Werl, biographical information is given by S. Clasen, 1943 and 1944. The connection between Campin's Werl wings and the theologian's support for the Virgin is made by D. Jansen, 1984.

Van Eyck's work for the Duke of Burgundy is treated by E. Dhanens, 1980, pp. 122–73, among others; on p. 56 she speculates on the possibility that van Eyck was in some way incapacitated in his last years. For René of Anjou in general see A. Lecoy de la Marche, 1875 and 1879. Possible connections between René and van Eyck have been explored in several studies by O. Pächt, 1956 and 1977. To my knowledge a trip by van Eyck to Naples in 1438 has never been postulated. For René's interest in Eastern imagery see also O. Pächt, 1961. The importance of Flemish art, especially that of van Eyck, in Naples after René's arrival there is discussed by P. H. Jolly, 1976 (with further references). The *Madonna della Bruna* is reproduced and discussed in H. Aurenhammer, 1956, pp. 98–9 and fig. 10. Its later penetration into Bruges is mentioned by C. Emond, 1961, pp. 100–101; and H. Stalpaert, 1976, pp. 156–65.

18 *The Image and Experience of Pilgrimage*

One critic who felt the large size of the Berlin Virgin indicated the artist's immaturity was C. de Tolnay, 1938, p. 24. E. Panofsky, 1953, pp. 144–48 and 193–94, continued to support an early date for the Berlin panel, but felt that the Virgin's size was indicative of her position as the embodiment of the Church; M. Meiss, 1945, especially pp. 179–81; and E. Herzog, 1956, take

a similar position. Several scholars have recently supported a highly charged symbolic reading of the work, while opting for a date much later in the artist's career. These include C. J. Purtle, 1982, especially pp. 144–56; and J. Snyder, 1985, especially pp. 100–101. See also the balanced and cautious discussion by E. Dhanens, 1980, pp. 316–28. All recent sources emphasize that the work was originally part of a diptych, with a donor in a separate panel to the right.

Dhanens (p. 328) mentions the various churches that have been proposed as forming the model for van Eyck's portrayal; as does J. Snyder, 1973, especially p. 296 n. 7. In particular Dhanens, p. 328, mentions that the church at Tongeren has a gallery running under the clerestory windows like that in van Eyck's interior. Fifteenth-century Northern architecture is rarely given extensive treatment by scholars; the following general surveys are useful: L. Cloquet, 1907; P. Fierens, 1947; A. J. L. van de Walle, 1971; and L. Devliegher, 1975. L. B. Philip, 1971, especially pp. 116–64 ('Towards Criteria for Judging Eyckian Works'), emphasizes the importance of space and light in van Eyck's late works; as does J. Snyder, 1973. Both Philip, and Panofsky before her, emphasized the symbolic nature of the light in the Berlin panel.

The claim that 'there is in all Christendom no Gothic church having a full-fledged cathedral choir with radiating chapels that would face the West and not the East' is used as the basis for an interpretation of van Eyck's panel by E. Panofsky, 1953, p. 147. The orientation of the Tongeren and Tournai churches can be checked in maps of the cities contained in the Guide Bleu for *Belgique*, 1987, pp. 769 and 778–79. For the Tournai church see also J. Dumoulin and J. Pycke, 1985. The relation between van Eyck's painted architecture and that in Tournai has been studied by T. W. Lyman, 1981.

C. Gould, 1981, has studied the correspondence between the sources of painted and real light in some examples of Italian art. The use of linear perspective in Italian art is of course a large topic; the following sources are useful: S. Y. Edgerton, 1975; and J. White, 1987. For views on the Northern perspective, see White, pp. 219–35. The miniature scale of the Northern works is emphasized by J. S. Held, 1955, especially p. 207; Held also believes that the accurate perspectival representation of space should not be used as a criteria of development in Northern art (p. 207). C. Eisler, 1969, especially p. 187, points out the importance of precious enclosing frames in Northern art. E. Dhanens, 1980, pp. 325 and 390, emphasizes the importance of considering the larger size of the original frame on the Berlin panel.

S. Alpers is one of the strongest advocates of a theory of descriptive realism for Northern art; see her publications of 1979 and 1983; for the latter, especially pp. 44–5 and 178–80. E. Panofsky, 1953, strongly championed the notion of a totally symbolic realism in early Netherlandish painting. The Bruges Holy Blood relic is discussed by J. Toussaert, 1963, pp. 259–65; Philip the Good's bleeding host, given to him by Pope Eugenius

IV, is mentioned by E. Delaruelle, E.-R. Labande and P. Ourliac, 1962–64, p. 751. Miraculous cult statues are discussed by J. Sumption, 1975, pp. 270ff.

The subject of pilgrimages in late medieval Europe has been treated by many authors; among these are J. Toussaert, 1963, pp. 244–79; E. Delaruelle, E.-R. Labande and P. Ourliac, 1962–64, pp. 796–809; and J. Sumption, 1975, especially pp. 257–302. Also useful are F. Rapp, 1973; and J. van Herwaarden, 1983 (with further references). V. and E. Turner, 1978, pp. 140–71, provide a general discussion of Mary as an object of pilgrimage. The cult of Our Lady of the Fountain (or of the Dunes) is mentioned by J. Toussaert, 1963, p. 272.

C. Purtle, 1982, p. 149, is among those who have stressed the relation between the foreground Virgin in van Eyck's Berlin painting and the cult statue in the background; Purtle also mentions the parallel between the two candles flanking the statue and the two beams of light on the cathedral floor. For the cult of the Virgin in Tongeren see the publication *Onze Lieve Vrouw Oorzaak Onzer Blijdschap, Causa Nostrae Laetitiae*. E. H. van Heurck, 1922, pp. 171–78, discusses and reproduces the pilgrims' banners of Halle and other nearby cults; these are also mentioned by J. Toussaert, 1963, pp. 267–68. Van Heurck observes that pilgrimages to Halle were indulged by Pope Eugenius IV from 1432 onward (p. 177).

Van Eyck's pilgrimage in the service of Duke Philip the Good is discussed by, among others, E. Dhanens, 1980. For Campin's judicial pilgrimage, the most careful discussion is found in P. H. Schabacker, 1980. Stylistic evaluation of Campin's pilgrimage is provided by G. Troescher, 1967; and C. Sterling, 1969. For Roger van der Weyden's jubilee year pilgrimage, see T. H. Feder, 1966, especially p. 430. For a suggestion about the influence of this trip on Roger's art, see P. H. Jolly, 1981. Philip the Good's pilgrimages to Boulogne are discussed by A. Benoit, 1937; they are also documented in H. Vander Linden, 1940.

For pilgrims' medals see, for instance, J. van Herwaarden, 1974; G. Stam, 1982; and, particularly for the one reproduced as illus. 124, see R. M. van Heeringen, A. M. Koldeweij and A. A. G. Gaalman, 1987, especially pp. 78–79. Pilgrims' mirrors are analysed and related to artistic imagery by H. Schwartz, 1959, especially pp. 100–105. Peter Vischer's Nuremberg *Heiligtum* book is catalogued by L. Hain, vol. II, pt 1, p. 12, no. 8415. For the curving effects of Northern perspective, with the suggestion that convex mirrors contributed to this, see – in addition to Schwartz – J. White, 1987, especially p. 234.

The chief secondary source for the judicial use of pilgrimages is E. van Cauwenbergh, 1922. For both judicial pilgrimages and indulgenced journeys, the general sources on pilgrimage cited above are also useful. Pilgrimage as penance is treated by H. C. Lea, 1896, vol. II, especially pp. 130–35; Lea also discusses the great crowds at the Rome pilgrimage of 1450, pp. 209–10.

The doctrine of indulgences in the fifteenth century

receives treatment from E. Delaruelle, E.-R. Labande and P. Ourliac, 1962–64, pp. 810–20. Indulgenced prayers and images are treated in several of the writings of S. Ringbom, 1962 and 1965, especially pp. 23–30. This subject is treated in my article of 1985. For indulgenced prayer tablets see especially P. Vandenbroeck 1985, p. 154 (discussion of Roger van der Weyden's *Seven Sacraments Altarpiece*; with further reference to R. van de Ven, 1983, p. 16). For my previous treatment of the Master of St Catherine panel (illus. 127) see 1985, p. 114; see also M. J. Friedländer, vol. IV, 1969, no. 47, p. 50. For indulgenced images in general see also O. Schmitt, 1937; see also the references cited in the following section. For the inscription on the lost original frame of van Eyck's Berlin panel see, in particular, M. Meiss, 1945, pp. 179–80; my English translation is taken from Meiss. Devotional images with inscribed prayer wings are discussed by Ringbom, 1962 and 1965, and in my article of 1985 mentioned above.

Mental pilgrimages are discussed in general terms by J. Sumption, 1975, pp. 295ff; and in particular by J. van Herwaarden, 1983; and B. Dansette, 1979. The relation between pilgrimage and the development of landscape painting is given extensive treatment by R. L. Falkenburg, 1988.

Treatment of the contemporary criticism and wariness of excessive pilgrimages is found in the general sources mentioned above, especially J. Sumption, 1975; see also J. Huizinga, 1924, p. 145; G. Constable, 1976; and C. Zika, 1988. For René of Anjou's will specifying a substitute pilgrimage to be made after his death see O. Pächt, 1961, especially p. 410. A transcription of the original French document ordering payment to van Eyck for making a substitute pilgrimage for the Duke of Burgundy is found in W. H. J. Weale, 1908, pp. xxxi–xxxii. The Modern Devotion's promotion of mental pilgrimage is discussed by B. Dansette, 1979.

19 *Pretence and Scepticism in the Fifteenth Century*

For the narrative function of what are presumed to be early Eyckian works, see H. Belting and D. Eichberger, 1983; for the early period of van Eyck's life see also C. Sterling, 1976. My thanks to Maryan Ainsworth and Jeffrey Jennings for help in understanding the technical aspect of early Netherlandish art. For the problem of multiple hands revealed by technical analysis in the presumed works of Robert Campin, see M. Sonkes, 1971–72. For technical analysis of van Eyck in particular see J. Desneux, 1958; J. Taubert, 1975; and J. R. J. van Asperen de Boer and M. Faries, 1990.

The fact that van Eyck's works were repeatedly copied throughout the later fifteenth century and early sixteenth is stressed by L. Silver, 1983. The files of the Centre des Recherches Primitifs Flamands in Brussels contain numerous examples of this phenomenon as well.

For the Master E.S.'s engraving of 1466 of the Madonna at Einsiedeln see A. Shestack, 1967, cat. no. 67 (unpaginated). For the fanatical nature of especially

collective devotions in the Netherlands at this time, see especially J. Toussaert, 1963; for the Holy Blood relic in particular, Toussaert, pp. 259–66. For indulgences see, for instance, H. C. Lea, 1896, especially vol. III; A. Lepicier, 1906; and E. Delaruelle, E.-R. Labande and P. Ourliac, 1962–64, pp. 810–20. For complaints about the excessive proliferation of miraculous cult shrines, see C. Zika, 1988.

20 *A Different Perspective in the 'Ghent Altarpiece'*

The variety of theories about the meaning of the Rolin *Virgin* are contained in the secondary sources on the painting mentioned at the beginning of § 11 above. E. Panofsky, 1953, especially pp. 142–43, tried to map out some safeguards on the symbolic interpretation of early Netherlandish painting. Many critics have joined Panofsky in feeling that van Eyck's work is not a harbinger of a new age, so much as a manifestation of the prolix writings of an earlier time; among these is E. H. Gombrich, 1967, p. 29.

For Denys the Carthusian the following sources are useful: D. A. Mougel, 1896; K. Krogh-Tonningh, 1904; E. de Moreau, 1949, especially pp. 81–82 and 349–51; and K. Emery, 1988. A relation between Scholasticism and early Netherlandish art has been hypothesized by many scholars; among these might be cited E. Hall and H. Uhr, 1978.

The bibliography on the *Ghent Altarpiece* is large; it is well represented in D. Goodgal, 1981, pp. 370–87; see also the balanced treatment in E. Dhanens, 1980, especially pp. 72–121. Goodgal, pp. 103–21, gives the fullest treatment of the donor, Jodocus Vijd, and his wife, Elizabeth Borluut; see also Goodgal's article of 1985. E. Dhanens, 1976, studied the foundation for masses established by the donors. Goodgal is responsible for putting forward the name of Olivier de Langhe as a possible theological advisor for the work; see also her study of 1982. R. Baldwin, 1987, especially p. 199, emphasizes the conservative ideology of the work. The political connotations of the altarpiece have been the subject of investigations by L. B. Philip, 1971; and J. C. Smith, 1979.

S. N. Blum, 1969, treats all the known early Netherlandish triptychs that have survived in their original locations. W. Stechow, 1966, pp. 10–13, records the commission for Dirk Bouts's *Holy Sacrament Altarpiece* in the Church of St Peter in Louvain; the document perished in World War II.

21 *The Interpretation of Early Netherlandish Painting*

E. H. Gombrich, 1972, especially p. 15, stresses the fact that we do not know that the presumed symbolism of early Netherlandish art was commissioned to be included in the works. R. M. Frye, 1963, p. 24, points to the difference between taking theology as a relevant context for a creative work and believing the work to be an illustration of theology.

For Denys the Carthusian and the co-passion of

Mary, as well as its possible influence on Roger van der Weyden, see O. G. von Simson, 1953, especially pp. 14–15. The suggestion that Denys's work helped support the cult statue of the Virgin at Roermond was first made by D. A. Mougel, 1896, p. 36.

E. Panofsky, 1953, pp. 144–48, put forth the theory about the symbolic light in the Berlin *Virgin in a Church*. The idea that van Eyck may have produced works late in his life on speculation, or in order to appeal to a popular market, is suggested by E. Dhanens, 1980, pp. 55–56; Dhanens bases her theory on the repetition in 1438 and 1440 of the image of the *Holy Face*, which survives today only in later copies.

One example of a recent scholar who believes in the universality of religious meaning in early Netherlandish paintings, as well as in its embodiment in quite different external forms, is B. G. Lane, 1984. Different positions have been taken by R. Baldwin, 1987, as well as in my publications of 1985, 1985a, 1986 and 1990; see also the different views of J. Marrow, 1986.

E. Panofsky, 1953, p. 143, stated that we must determine 'whether or not a symbolical interpretation can be justified by definite texts or agrees with ideas demonstrably alive in the period and presumably familiar to its artists'; and that we must try to understand 'to what extent such a symbolical interpretation is in keeping with the historical position and personal tendencies of the individual master'. Panofsky also noted that 'a way had to be found to reconcile the new naturalism with a thousand years of Christian tradition' (p. 141); and that the 'imaginary reality [of van Eyck's work] was con-trolled to the smallest detail by a preconceived symbolical program' (p. 137). The fact that this theory reversed earlier notions of artistic creativity was stressed by O. Pächt, 1956, especially pp. 275–76; see also the remarks by W. E. Kleinbauer, 1971, pp. 55–56.

An example of a recent art-historical study that seeks to use medieval theological discourse to show the relation of imagery to concerns about the family is C. Hahn, 1986. A general evaluation of the relation between art and its historical context is provided by S. Alpers, 1977. For an interpretation of van Eyck's grinning St George, see J. C. Opstelten, 1966. My notion about the importance of the accidents and details of history is stimulated by Michel Foucault's works; and the review of them by D. Gress, 1986, especially p. 24. My interest in the fifteenth-century artist's sense of choice was first expressed in an article of 1984.

Michael Baxandall in his writings has tended to treat the work of art primarily as a material object; however fascinating, the parallels drawn by Baxandell between works of art and other material concerns in a society do have the effect of trivializing, or even denying, the spiritual strivings that may also lie behind the images. See, for instance, Baxandall's publication of 1980, especially p. 222, where the author evades the issue of German mysticism and turns instead to calligraphy, barrel-gauging and the physical properties of limewood; also relevant is Baxandall's book of 1985; and its review by M. Kemp, 1987. L. Silver, 1986, gives an overview of the current critical situation.

Bibliography

The Bibliography contains all references cited in abbreviated form in the Bibliographic Commentary. A selection of other items is also included.

Hélène Adhémar, 'Sur la Vierge du Chancelier Rolin de Van Eyck', *Bulletin de l'Institut Royal du Patrimoine Artistique, Bruxelles*, XV (1975), pp. 9–17.

Dr Aigremont, *Fuss- und Schuh-Symbolik und Erotik, Folkoristische and sexual wissenschaftliche Unter-suchungen* (Leipzig, 1909).

Svetlana Alpers, *The Art of Describing: Dutch Art in the Seventeenth Century* (Chicago, 1983).

——, 'Is Art History?', *Daedalus*, CVI (1977), pp. 1–13.

——, 'Style is What You Make It: The Visual Arts Once Again', *The Concept of Style*, ed. Berel Lang (Philadelphia, 1979), pp. 95–117.

J. R. J. van Asperen de Boer and Molly Faries, 'La *Vierge au Chancellier Rolin* de van Eyck: examen au moyen de la réflectiographie à l'infrarouge', *La Revue du Louvre*, XL (1990), pp. 37–49.

Hans Aurenhammer, *Die Marien-gnadenbilder Wiens und Niederösterreiche in der Barock-zeit* (Vienna, 1956).

Xavier Le Bachelet, 'Immaculée Conception', *Diction-naire de Théologie Catholique*, VII (Paris, 1922), cols 845–1218.

Janet Backhouse, *Books of Hours* (London, 1985).

J. V. Bainvel, 'Coeur Sacré de Jésus', *Dictionarie de Théologie Catholique*, III/1 (Paris, 1938), cols 271–351.

——, *Devotion to the Sacred Heart, the Doctrine and its History*; trans. E. Leahy (London, 1924).

Ludwig Baldass, *Jan van Eyck* (London, 1952).

Robert Baldwin, 'Marriage as a Sacramental Reflection of the Passion: The Mirror in Jan van Eyck's "Arnolfini Wedding"', *Oud-Holland*, XCVIII (1984), pp. 57–75.

——, Review of B. G. Lane, *The Altar and the Altarpiece*, in *Renaissance and Reformation*, n.s. XI (1987), pp. 197–202.

——, 'Textile Aesthetics in Early Netherlandish Painting', *Textiles of the Low Countries in European Economic History*, ed. Erik Aerts and John H. Munro (Louvain, 1990), pp. 32–40.

Hans Baron, 'Franciscan Poverty and Civic Wealth as Factors in the Rise of Humanist Thought', *Speculum*, XIII (1938), pp. 1–37.

John Bartier, 'L'Artiste et sa clientèle au temps des ducs Valois', *Bulletin de la Société des amis du musée de Dijon*, (1973–5), pp. 29–32.

——, *Légistes et gens de Finances au XVe siècle, Les con-seillers des Ducs de Bourgogne, Philippe le Bon et Charles le Téméraire* (Brussels, 1955).

Kurt Bauch, 'Bildnisse des Jan van Eyck', *Studien zur Kunstgeschichte* (Berlin, 1967), pp. 79–122.

Guy Bauman, 'Early Flemish Portraits, 1425–1525', *Metropolitan Museum of Art Bulletin*, XLIII (Spring 1986), pp. 1–64.

Michael Baxandall, *Giotto and the Orators: Humanist Observers of Painting in Italy and the Discovery of Pictorial Composition* (Oxford, 1971).

——, 'The Language of Art History', *New Literary History*, X (1979), pp. 453–65.

——, *The Limewood Sculptors of Renaissance Germany* (New Haven, 1980).

——, *Patterns of Intention: On the Historical Explanation of Pictures* (New Haven, 1985).

Jan Baptiste Bedaux, 'The Reality of Symbols: The Question of Disguised Symbolism in Jan van Eyck's *Arnolfini Portrait*', *Simiolus*, XVI (1986), pp. 5–28.

H. Beenken, 'Roger van der Weyden und Jan van Eyck', *Pantheon*, XXV (1940), pp. 129–37.

E. S. de Beer, 'Gothic: Origin and Diffusion of the Term; The Idea of Style in Architecture', *Journal of the Warburg and Courtauld Institutes*, XI (1948), pp. 143–61.

Hans Belting, *Das Bild und sein Publikum im Mittelalter* (Berlin, 1981).

Hans Belting and Dagmar Eichberger, *Jan van Eyck als Erzähler* (Worms, 1983).

Lloyd Benjamin, 'Disguised Symbolism Exposed and the History of Early Netherlandish Painting', *Studies in Iconography*, II (1976), pp. 11–24.

——, *The Empathetic Relation of Observer to Image in Fifteenth Century Northern Art* (PhD dissertation, University of North Carolina, Chapel Hill, 1973).

Albert Benoit, 'Les Pèlerinages de Philippe le Bon à Notre-Dame de Boulogne', *Bulletin de la Société d'Études de la Province de Cambrai*, XXXVII (1973),

pp. 119–23.

Roman Berger, *Nicholas Rolin, Kanzler der Zeitenwende im Burgundisch-Französischen Konflikt, 1422–1461* (Freiburg, 1971).

Rudolf Berliner, 'The Freedom of Medieval Art', *Gazette des Beaux-Arts*, n.s. 6, XXVIII (1945), pp. 263–88.

Matthäus Bernards, 'Nudus nudum Christus sequi', *Wissenschaft und Weisheit*, XIV (1951), pp. 148–51.

Karl Birkmeyer, 'The Arch Motif in Netherlandish Painting of the Fifteenth Century', *Art Bulletin*, XLIII (1961), pp. 1–20 and 99–112.

Shirley Neilsen Blum, *Early Netherlandish Triptychs: A Study in Patronage* (Berkeley, 1969).

——, 'Symbolic Invention in the Art of Roger van der Weyden', *Konsthistorisk Tijdskrift*, XLVI (1977), pp. 103–22.

John Bossy, 'The Counter-Reformation and the People of Catholic Europe', *Past and Present*, XLVII (1970), pp. 51–70.

——, 'Holiness and Society', *Past and Present*, LXXV (1977), pp. 119–37.

——, 'The Mass as a Social Institution, 1200–1700', *Past and Present*, C (1983), pp. 29–61.

——, 'The Social History of Confession in the Age of the Reformation', *Transactions of the Royal Historical Society, London*, n.s. 5, XXV (1975), pp. 21–38.

N. Boyadjian, *The Heart, its History, its Symbolism, its Iconography and its Diseases* (Antwerp, 1980).

Leo Braudy, *The Frenzy of Renown: Fame and Its History* (New York, 1986).

Brevario Grimani, ed. G. E. Ferrari, M. Salmi and G. L. Mellini (Milan, 1970).

Maurice W. Brockwell, *The Pseudo-Arnolfini Portrait* (London, 1952).

Peter Browe, *Die Eucharistischen Wunder der Mittelalters* (Breslau, 1938).

——, *Die Verehrung der Eucharistie im Mittelalter* (Rome, 1967).

F. O. Büttner, *Imitatio Pietatis, Motiv der Christlichen Ikonographie als Modelle zur Verähnlichung* (Berlin, 1983).

Anne Hagopian van Buren, 'The Canonical Office in Renaissance Painting, Part II: More About the Rolin Madonna', *Art Bulletin*, LX (1978), pp. 617–33.

——, 'Un Jardin d'amour de Philippe le Bon au parc du Hesdin: Le rôle de Van Eyck dans une commande ducale', *La Revue du Louvre*, XXXV (1985), pp. 185–92.

——, 'Thoughts, Old and New, On the Sources of Early Netherlandish Painting', *Simiolus*, XVI (1986), pp. 93–112.

Peter Burke, *Popular Culture in Early Modern Europe* (London, 1978).

Caroline Walker Bynum, 'The Body of Christ in the Later Middle Ages: A Reply to Leo Steinberg', *Renaissance Quarterly*, XXIX (1986), pp. 399–439.

——, *Holy Feast and Holy Fast; The Religious Significance of Food to Medieval Women* (Berkeley, 1987).

——, 'Women Mystics and Eucharistic Devotion in the Thirteenth Century', *Women's Studies*, XI (1984), pp. 179–214.

Monika Cämmerer-George, 'Eine Italienische Wurzel in der Rahmen-Idee Jan van Eycks', *Kunstgeschichteliche Studien für Kurt Bauch zum 70: Geburtstag von seinem schülern*, ed. M. Lisner and R. Becksmann (Berlin, 1967), pp. 69–76.

Lorne Campbell, 'The Art Market in the Southern Netherlands in the Fifteenth Century', *Burlington Magazine*, CXVIII (1976), pp. 188–98.

——, 'The Early Netherlandish Painters and their Workshops', *Le Dessin sous-jacent dans la peinture, Le Problème Maître de Flémalle-van der Weyden*, ed. D. Hollanders-Favart and R. van Schoute (Louvain-la-Neuve, 1981), pp. 43–61.

——, 'Robert Campin, the Master of Flémalle and the Master of Mérode', *Burlington Magazine*, CXVI (1974), pp. 634–46.

Otto Cartellieri, *The Court of Burgundy*, trans. M. Letts (New York, 1929).

Etienne van Cauwenbergh, *Les Pèlerinages expiatoires et judiciares dans la droit communal de la Belgique au moyen âge* (Louvain, 1922).

Albert Chatelet, 'Roger van der Weyden et le lobby polinois', *La Revue de l'Art*, LXXXIV (1989), pp. 9–21.

Georges Chastellain, *Oeuvres*, 8 vols, ed. Kervyn de Lettenhove, (Brussels, 1863–86).

Jean Châtillon, 'Nudum Christum Nudus Sequere, Notes sur les origines et la signification du thème de la nudité spirituelle dans les écrits de Saint Bonaventure', *S Bonaventura 1274–1974*, IV (Grottaferrata, 1974), pp. 719–72.

Jacques Chiffoleau, *La comptabilité de l'au-delà, Les hommes, la mort et la religion dans la region d'Avignon à la fin du moyen âge* (Rome, 1980).

——, 'Sur l'Usage obsessionel de la messe pour les morts à la fin du moyen âge', *Faire Croire* (Rome, 1981), pp. 235–56.

Miriam Chrisman, *Lay Culture, Learned Culture: Books and Social Change in Strasbourg, 1480–1599* (New Haven, 1982).

Sophronius Clasen, 'Heinrich van Werl O. Min., Ein deutscher Skotist', *Wissenschaft und Weisheit*, X (1943), pp. 61–72; and XI (1944), pp. 67–71.

L. Cloquet, *Les Maisons anciennes de Belgique* (Ghent, 1907).

Giles Constable, 'The Popularity of Twelfth-Century Spiritual Writers in the Later Middle Ages', *Renaissance Studies in Honor of Hans Baron*, ed. A. Molho and J. Tedeschi (Dekalb, Ill., 1971), pp. 5–28.

——, 'Twelfth-Century Spirituality and the Late Middle Ages', *Medieval and Renaissance Studies*, V (Chapel Hill, 1971), pp. 27–60.

——, 'Opposition to Pilgrimage in the Middle Ages', *Studia Gratiana*, XIX (1976) (Melanges G. Fransen, I), pp. 123–46.

——, 'Nudus Nudum Christum Sequi and Parallel Formulas in the Twelfth Century: A Supplementary Dossier', *Continuity and Discontinuity in Church History, Essays Presented to George Hunston Williams on the Occasion of his 65th Birthday*, ed. T. F. Church and T.

George (Leiden, 1979), pp. 83–91.

Jozef de Coo, 'A Medieval Look at the Mérode Annunciation', *Zeitschrift für Kunstgeschichte*, XLIV (1981), pp. 114–32.

William J. Courtenay, 'Nominalism and Late Medieval Religion', *The Pursuit of Holiness in Late Medieval and Renaissance Religion*, ed. H. A. Oberman and C. Trinkaus (Leiden, 1974), pp. 26–59.

Paul Crossley, 'Medieval Architecture and Meaning: The Limits of Iconography', *Burlington Magazine*, CXXX (1988), pp. 116–121.

Beatrice Dansette, 'Les Pèlerinages occidentaux en Terre Sainte: Une pratique de la "Dévotion Moderne" à la fin du Moyen Age? Relation inédite d'un pèlerinage effectué en 1488', *Archivum Franciscanum Historicum*, LXXII (1979), pp. 106–33 and 330–428.

Martin Davies, *The National Gallery, London*, II [Les primitifs flamands I, Corpus de la peinture 3, pt 2] (Antwerp, 1954).

——, *The Early Netherlandish School*, 3rd edn (London, 1968).

——, *Rogier van der Weyden* (London, 1972).

Natalie Zemon Davis: 'Anthropology and History in the 1980s', *Journal of Interdisciplinary History*, XII (1981), pp. 267–75.

——, 'Some Tasks and Themes in the Study of Popular Religion', *The Pursuit of Holiness in Late Medieval and Renaissance Religion*, ed. H. A. Oberman and C. Trinkaus (Leiden, 1974), pp. 307–36.

Pierre Debongnie: 'Dévotion moderne', *Dictionnaire de spiritualité*, III (Paris, 1957), cols 727–47.

E. Delaruelle, 'La Spiritualité aux XIVe et XVe siècles', *Cahiers d'Histoire Mondiale*, V (1955), pp. 59–70.

E. Delaruelle, E.-R. Labande and Paul Ourliac, *L'Église au Temps du Grand Schisme et de la crise conciliare (1378–1449)*, 2 vols (Paris, 1962–64).

A. J. J. Delen, *Histoire de la gravure dans les anciens Pays-Bas et dans les provinces Belges*, pt 1 (Paris, 1924).

Klaus Demus, Friderike Klauner and Karl Schütz, *Kunsthistorisches Museum, Katalog der Gemäldegalerie, Flämische Malerei von Jan van Eyck bis Pieter Bruegel d. Ä.* (Vienna, 1981).

J. Dequeker, 'Kan men uit Schilderijen iets leren over Ziekten in het Verleden?' *Onze Alma Mater*, XXIV (1980), pp. 46–57.

——, 'Polymyalgia rheumatica', *Spectrum International*, XXVI (1983), pp. 9–10.

——, 'Rheumatism in the Art of the Late Middle Ages', *Organorum*, XVI (1979), pp. 9–19.

Jules Desneux, *Rigeur de Jan van Eyck* (Brussels, 1951).

——, 'Underdrawings and Pentimenti in the Pictures of Jan van Eyck', *Art Bulletin*, XL (1958), pp. 13–21.

Paolo De Toeth, *Il Beato Cardinale Niccolò Albergati e i suoi tempi*, 2 vols (Viterbo, 1934).

Charles De Tolnay, 'Flemish Paintings in the National Gallery of Art', *Magazine of Art*, XXXIV (1941), pp. 174–200.

——, *Le ——— de Flémalle et les Frères van Eyck* (Brussels, 1939).

Flanders in the Fifteenth Century: Art and Civilization, exhibition catalogue, Detroit, Institute of Arts, 1960.

Luc Devliegher, *Kunstpatrimonium van West-Vlaanderen*, pt 2 [De huizen te Brugge] (Tielt, 1975).

Dirk De Vos, *Catalogue des Tableaux du 15e et du 16e siècles* (Bruges, 1982).

A. Dewitte, 'De Kapelanie-Stichtingen van Kanunnik van der Paele', *Biekorf*, LXXII (1971), pp. 15–20.

Elizabeth Dhanens, *Hubert and Jan van Eyck* (New York, 1980).

——, 'De Vijd-Borluut Fundatie en het Lam Godsretable, 1432–1979', *Mededelingen van de Koninklijke Academie voor Wetenschappen, Letteren en Schone Kunsten van België, Klasse der Schone Kunsten*, XXXVIII/2 (1976).

Dom Gregory Dix, *The Shape of the Liturgy* (London, 1960).

Georges Dogaer and Marguerite Debae, *La Librairie de Philippe le Bon* (Brussels, 1967).

Charles Du Cange, *Glossarium mediae et intimae Latinitatis*, 10 vols (Graz, 1954).

Jean Dumoulin and Jacques Pycke, *La Cathédrale Notre-Dame de Tournai, hier et aujourd'hui* (Tournai, 1985).

J. Dupont, 'Hayne de Bruxelles et la Copie du Notre-Dame de Grâces de Cambrai', *L'Amour de L'Art*, XVI (1935), pp. 360–66.

Lawrence G. Duggan, 'Fear and Confession on the Eve of the Reformation', *Archiv für Reformationsgeschichte*, LXXV (1984), pp. 153–75.

Jozef Duverger, 'Brugse Schilders ten tijde van Jan van Eyck', *Bulletin des Musées Royaux des Beaux-Arts de Belgique*, IV (1955), pp. 83–120.

——, 'Jan van Eyck as Court Painter', *The Connoisseur*, CXCIV (1977), pp. 172–79.

Samuel Y. Edgerton, *The Renaissance Rediscovery of Linear Perspective* (New York, 1975).

Donald Ehresmann, 'Some Observations on the Role of the Liturgy in the Early Winged Altarpiece', *Art Bulletin*, LXIV (1982), pp. 359–69.

Carlos M. N. Eire, *War Against the Idols: The Reformation of Worship from Erasmus to Calvin* (Cambridge, 1986).

Colin Eisler, review of C. Purtle, *The Marian Paintings of Jan van Eyck*, in *Art Bulletin*, LXVIII (1986), pp. 676–79.

——, review of S. Ringbom, *Icon to Narrative*, in *Art Bulletin*, LI (1969), pp. 186–88.

Norbert Elias, *The Civilizing Process: The History of Manners* (New York, 1978).

Kent Emery, 'Twofold Wisdom and Contemplation in Denys de Ryckel (Dionysius Carthusiensis, 1402–1471)', *Journal of Medieval and Renaissance Studies*, XVIII (1988), pp. 99–134.

Cécile Émond, *L'Iconographie Carmélitaine dans les anciens Pays-Bas méridionaux* (Brussels, 1961).

R. L. Falkenburg, *Joachim Patinir: Landscape as An Image of the Pilgrimage of Life* (Amsterdam, 1988).

Theodore H. Feder, 'A Re-examination through Documents of the first Fifty Years of Roger van der Weyden's Life', *Art Bulletin*, XLVIII (1966), pp. 416–31.

A. Feuillet, 'Le Nouveau Testament et le coeur de Christ, Études des principaux textes évangéliques utilisés par la liturgie du Sacré-Coeur', *L'Ami de Clergé*, LXXIV (21 May 1964), pp. 321–33.

Richard S. Field, *Fifteenth-Century Woodcuts and Metalcuts from the National Gallery of Art, Washington, D.C.* (Washington, D.C., 1965).

Paul Fierens, ed., *L'Art en Belgique du moyen âge à nos jours* (Brussels, 1947).

Jacqueline Folie, 'Les Oeuvres authentifiées des primitifs flamands', *Bulletin de l'Institut Royal du Patrimoine Artistique, Bruxelles*, VI (1963), pp. 183–256.

David Freedberg, *The Power of Images: Studies in the History and Theory of Response* (Chicago, 1989).

Max J. Friedländer, *Early Netherlandish Painting*, 14 vols, trans. H. Norden (New York, 1967–76).

Roland Frye, *Shakespeare and Christian Doctrine* (Princeton, 1963).

Clifford Geertz, 'Art as a Cultural System', *Modern Language Notes*, XCI (1976), pp. 1473–99.

——, 'Religion as a Cultural System', *Anthropological Approaches to the Study of Religion*, ed. M. Banton (London, 1966), pp. 1–46 (reprinted in C. Geertz, *The Interpretation of Cultures* [New York, 1973] pp. 87–125).

——, 'Thick Description: Toward an Interpretive Theory of Culture', *The Interpretation of Cultures* (New York, 1973), pp. 3–30.

E. H. Gombrich, 'Aims and Limits of Iconology', *Symbolic Images* (London, 1972), pp. 1–22.

——, *Art and Illusion: A Study in the Psychology of Pictorial Representation* (Princeton, 1969).

——, *In Search of Cultural History* (Oxford, 1967).

——, 'Light, Form and Texture in Fifteenth-Century Painting', *Journal of the Royal Society of Arts*, CXII (1964), pp. 826–49 (reprinted as 'Light, Form and Texture in Fifteenth-Century Painting North and South of the Alps', *The Heritage of Apelles* [London, 1976], pp. 19–35).

——, *The Story of Art* (London, 1962).

Dana Goodgal, 'The Central Inscription in the Ghent Altarpiece', *Le Dessin sous-jacent dans la peinture, Colloque IV, 1981*, ed. R. van Schoute and D. Hollanders-Favart (Louvain-le-Neuve, 1982), pp. 74–86.

——, *The Iconography of the Ghent Altarpiece* (PhD dissertation, University of Pennsylvania, 1981).

——, 'Joos Vijd: Donateur de *L'Agneau Mystique*', *Le Dessin sous-jacent dans la peinture, Colloque V, 1983*; ed. R. van Schoute and D. Hollanders-Favart (Louvain-la-Neuve, 1985), pp. 25–52.

——, review of C. Purtle, *The Marian Paintings of Jan van Eyck*, in *Renaissance Quarterly*, XXXVI (1983), pp. 590–94.

Jennifer Goodman, 'Display, Self-Definition and the Frontiers of Romance in the 1463 Bruges *Pas du perron fée*', *Persons in Groups: Behavior as Identity Formation in Medieval and Renaissance Europe*, ed. R. C. Trexler (Binghamton, N.Y., 1985), pp. 47–54.

Carla Gottlieb, 'The Living Host', *Konsthistorisk Tidskrift*, XL (1971), pp. 30–46.

——, 'Respiciens per Fenestras: The Symbolism of the Mérode Altarpiece', *Oud-Holland*, LXXXV (1970), pp. 65–84.

Cecil Gould, 'On the Direction of Light in Italian Renaissance Frescoes and Altarpieces', *Gazette des Beaux-Arts*, n.s. 6, XCVII (1981), pp. 21–25.

Reginald Grégoire, 'L'Adage ascétique "nudus nudum christum sequi"', *Studi storici in onore di Ottorino Bertolini* (Pisa, 1972), pp. 395–409.

David Gress, review of Michel Foucault in *New Criterion*, IV (April 1986), pp. 19–33.

Groeningemuseum, Bruges, *Anonieme Vlaamse Primitieven*, ed. D. De Vos (Bruges, 1969).

Rainald Grosshans, 'Infrarotuntersuchungen zum Studien der Unterzeichnungen auf Berliner Ältaren von Rogier van der Weyden', *Jahrbuch Preussischer Kulturbesitz*, XIX (1985), pp. 137–77.

——, 'Roger van der Weyden, Der Marien altar aus der Kartäuse Miraflores', *Jahrbuch der Berliner Museen*, n.s., XXIII (1981), pp. 49–112.

Hachette Guides Bleus, *Belgique, Luxembourg* (Paris, 1987).

Cynthia Hahn, 'Joseph Will Perfect, Mary Enlighten, and Christ Save Thee: The Holy Family as Marriage Model in the Mérode Triptych', *Art Bulletin*, LXVIII (1986), pp. 54–66.

Ludwig Hain, *Repertorium Bibliographicum*, 2 vols (Milan, 1948).

Edwin C. Hall, 'Cardinal Albergati, St Jerome and the Detroit St Jerome', *Art Quarterly*, XXXIV (1968), pp. 2–34.

——, 'More About the Detroit van Eyck: The Astrolabe, the Congress of Arras and Cardinal Albergati', *Art Quarterly*, XXXVII (1971), pp. 181–201.

Edwin Hall and Horst Uhr, '*Aureola* and *Fructus*: Distinctions of Beatitude in Scholastic Thought and the Meaning of Some Crowns in Early Flemish Painting', *Art Bulletin*, LX (1978), pp. 249–70.

Halle, 700 Jaar Mariastad (Halle, n.d.).

Auguste Hamon, 'Coeur (sacré)', *Dictionnaire de spiritualité*, II (Paris, 1953), cols 1023–46.

Handwörterbuch des Deutschen Aberglaubens, ed. Hans Bächtold-Stäubli, 10 vols (Berlin and Leipzig, 1927–42).

Craig Harbison, 'The Northern Altarpiece as a Cultural Document', *The Altarpiece in the Renaissance*, ed. P. Humfrey and M. Kemp (Cambridge, 1990), pp. 49–75.

——, 'Realism and Symbolism in Early Flemish Painting', *Art Bulletin*, LXVI (1984), pp. 588–602.

——, 'Religious Imagination and Art-Historical Method: A Reply to Barbara Lane's "Sacred versus Profane"', *Simiolus*, XIX (1989), pp. 198–205.

——, 'Response to James Marrow', *Simiolus*, XVI (1986), pp. 170–72.

——, review of B. G. Lane, *The Altar and the Altarpiece*, in *Simiolus*, XV (1985), pp. 221–25.

——, 'Sexuality and Social Standing in Jan van Eyck's Arnolfini Double Portrait', *Renaissance Quarterly*,

XLIII (1990), pp. 249–91.

——, 'Visions and Meditations in Early Flemish Painting', *Simiolus*, XV (1985), pp. 87–118.

John Harthan, *Books of Hours and Their Owners* (London, 1977).

Christine Hasenmueller, 'A Machine for the Suppression of Space: Illusionism as Ritual in a Fifteenth-Century Painting', *Semiotica*, XXIX (1980), pp. 53–94.

R. M. van Heeringen, A. M. Koldeweij and A. A. G. Gaalman, *Heiligen uit de modder, in Zeeland gevonden pelgrimstekens* (Zutphen, 1987).

Julius S. Held, review of E. Panofsky, *Early Netherlandish Painting*, in *Art Bulletin*, XXXVII (1955), pp. 205–34.

J. van Herwaarden, 'Geloof en geloofsuitingen in de late middeleeuwen in de Nederlanden: Jerusalembedevaarten, lijdens-devotie en kruiswegverering', *Bijdragen en Mededelingen betreffende de Geschiedenis der Nederlanden*, XCVIII (1983), pp. 400–29.

——, 'Geloof en Geloofsuitingen in de Veertiende en Vijftiende eeuw. Eucharistie en Lijden van Jezus', *Hoofsheid en devotie in de Middeleeuwse Maatschappij*, ed. J. D. Jansens (Brussels, 1982), pp. 174–207.

——, *Pelgrimstochten* (Bussum, 1974).

Erich Herzog, 'Zur Kirchen-Madonna van Eyck', *Berliner Museen*, VI (1956), pp. 2–16.

Emile H. van Heurck, *Les Drapelets de Pèlerinages en Belgique et dans les pays voisins* (Antwerp, 1922).

S. Hindman, 'The Iconography of Queen Isabeau de Bavière (1410-1415): An Essay in Method', *Gazette des Beaux-Arts*, n.s. 6, CII (1983), pp. 102–10.

D. Michael Hitchcock, *The Iconography of the van der Paele Madonna by Jan van Eyck* (PhD dissertation, Princeton University, 1976).

Ursula Hoff and Martin Davies, *The National Gallery of Victoria, Melbourne* [Les primitifs flamands 1, Corpus de la peinture 12] (Brussels, 1971).

Donald R. Howard, *The Three Temptations: Medieval Man in Search of the World* (Princeton, 1966).

Johan Huizinga, *Homo Ludens: A Study of the Play-Element in Culture* (Boston, 1955).

——, 'De Kunst der Van Eyck's in het leven van hun tijd', *De Gids*, LXXX/2 (1916), pp. 440–62; and LXXX/3 (1916), pp. 52–82.

——, 'La Physionomie Morale de Philippe le Bon', *Annales de Bourgogne*, IV (1932), pp. 101–29.

——, *The Waning of the Middle Ages*, trans. F. Hopman (London, 1924; repr. New York, 1984).

Dieter Jansen, 'Der Kölner provinzial des Minoritenordens Heinrich van Werl, der Werl Altar und Robert Campin', *Wallraf-Richartz-Jahrbuch*, XLV (1984), pp. 7–40.

A. Janssens de Bisthoven, *Musée Communal des Beaux-Arts (Musée Groeninge), Bruges* [Les primitifs flamands 1, Corpus de la peinture 1], 3rd edn by M. Baes-Dondeyne and D. de Vos (Brussels, 1983).

Penny Howell Jolly, *Jan van Eyck and St Jerome: A Study of Eyckian Influence on Colantino and Antonello da Messina in Quattrocento Naples* (PhD dissertation, University of Pennsylvania, 1976).

——, 'Rogier van der Weyden's Escorial and Philadelphia *Crucifixions* and their Relation to Fra Angelico at San Marco', *Oud-Holland*, XCV (1981), pp. 113–26.

Joseph A. Jungmann, *The Mass of the Roman Rite: Its Origins and Development*, trans. F. Brunner (New York, 1959).

C. G. Kanters, *Commentaire des Litanies du Sacré Coeur* (Brussels, 1926).

——, *La Dévotion au Sacré Coeur de Jésus Christ dans les anciens Etats des Pays-Bas (XIIE–XVIIE siècle)* (Brussels, 1928).

P. Kauch, 'L'Apparition d'un nouveau groupe social aux Pays-bas bourguignons: celui des fonctionaires', *Revue de l'Institut de Sociologie Solvay*, XV (1935), pp. 122–29.

Emil Keiser, 'Zur Deutung und Datierung der Rolin-Madonna des Jan van Eyck', *Städel-Jahrbuch*, n.s. I (1967), pp. 73–95.

Martin Kemp, review of M. Baxandall, *Patterns of Intention*, in *Zeitschrift für Kunstgeschichte*, L (1987), pp. 131–41.

Thomas à Kempis, *The Imitation of Christ*; trans. Leo Shirley-Price (London, 1952).

Zdzislaw Kepinski, 'Madonna Kanclerza Rolin', *Rocznik historii sztuki*, XXXI (1969), pp. 107–61.

Rafael de Keyser, 'Chanoines seculiers et universités: Le Cas de Saint-Donatien de Bruges (1350–1450)', *The Universities in the Late Middle Ages*, ed. Jozef IJsewijn and Jacques Paquet (Louvain, 1978), pp. 584–87.

——, 'De Kanunnik van der Paele', *Spiegel Historiael*, VI (1971), pp. 336–43.

——, 'Paele, Joris van der', *Nationaal Biografisch Woordenboek*, V (Brussels, 1972), cols 673–77.

Peter Kidson, 'Panofsky, Suger and St Denis', *Journal of the Warburg and Courtauld Institutes*, L (1987), pp. 1–17.

W. Eugene Kleinbauer, *Modern Perspectives in Western Art History* (New York, 1971).

Susan Koslow, *The Chevrot Altarpiece* (PhD dissertation, New York University, 1972).

Thomas Kren, ed., *Renaissance Painting in Manuscripts: Treasures from the British Library* (New York, 1983).

K. Krogh-Tonningh, *Der letzte Scholastiker* (Freiburg, 1904).

Gustav Künstler, 'Jan van Eycks Wahlwort "Als Ich Can" und das Flügelaltärchen in Dresden', *Wiener Jahrbuch für Kunstgeschichte*, XXV (1972), pp. 107–27.

Donald Kuspit, 'Traditional Art History's Complaint Against the Linguistic Analysis of Visual Art', *Journal of Aesthetics and Art Criticism*, XLV (1987), pp. 345–49.

Albert Kutal, *Gothic Art in Bohemia and Moravia* (London, 1971).

Patricia D. LaBahn, *Feasting in the Fourteenth and Fifteenth Centuries: A Comparison of Manuscript Illuminations to Contemporary Written Sources* (PhD dissertation, St Louis University, 1975).

Agathe Lafortune-Martel, *Fête Noble en Bourgogne au XVe siècle, Le Banquet du Faisan (1454): Aspects politiques, sociaux et culturels* (Montreal, 1984).

Barbara G. Lane, *The Altar and the Altarpiece: Sacramental Themes in Early Netherlandish Painting* (New York, 1984).

——, 'The Case of Canon van der Paele', *Source*, IX (1990), pp. 1–6.

——, '"Ecce Panis Angelorum": The Manger as Altar in Hugo's Berlin Nativity', *Art Bulletin*, LVII (1975), pp. 476–86.

——, *Flemish Painting Outside Bruges, 1400–1500: An Annotated Bibliography* (Boston, 1986).

——, 'Sacred vs Profane in Early Netherlandish Painting', *Simiolus*, XVIII (1988), pp. 107–15.

Henry Charles Lea, *A History of Auricular Confession and Indulgences in the Latin Church*, 3 vols (Philadelphia, 1896).

Maria Leach, *God Had a Dog* (New Brunswick, N.J., 1966).

Louis Lebeer, 'Le Dessin, la gravure, le livre xylographique et typographique', *Bruxelles au XVe siècle* (Brussels, 1953), pp. 187–216.

A. Lecoy de la Marche, *Le Roi René: Sa Vie, son administration, ses travaux artistiques et littéraires d'après les documents inédites des archives de France et d'Italie*, 2 vols (Paris, 1875 and 1879).

Gordon Leff, 'The Fourteenth Century and the Decline of Scholasticism', *Past and Present*, IX (1956), pp. 30–41.

Alexis M. Lepicier, *Indulgences: Their Origin, Nature and Development* (London, 1906).

Mirella Levi d'Ancona, *The Iconography of the Immaculate Conception in the Middle Ages and Early Renaissance* (New York, 1957).

Suzanne Lewis, *The Art of Matthew Paris in the Cronica Majora* (Berkeley, 1987).

Herman Vander Linden, *Itinéraires de Philippe le Bon, duc de Bourgogne (1419–1467) et de Charles, Conte de Charolais (1433–1467)* (Brussels, 1940).

Jean Longnon and Millard Meiss, *The Très Riches Heures of the Duke of Berry* (New York, 1969).

Thomas W. Lyman, 'Architectural Portraiture and Jan van Eyck's Washington *Annunciation*', *Gesta*, XX (1981), pp. 263–76.

Christine Hasenmueller McCorkel, 'The Role of the Suspended Crown in Jan van Eyck's *Madonna and Chancellor Rolin*', *Art Bulletin*, LVIII (1975), pp. 516–20.

John F. McGovern, 'The Rise of New Economic Attitudes – Economic Humanism, Economic Nationalism – During the Later Middle Ages and Renaissance, AD 1200–1550', *Traditio*, XXVI (1970), pp. 217–53.

M. B. McNamee, 'The Origin of the Vested Angel as a Eucharistic Symbol in Flemish Painting', *Art Bulletin*, LIV (1972), pp. 263–78.

Ellen Allard Macek, 'Fifteenth-Century Lay Piety', *Fifteenth-Century Studies*, I (1978), pp. 157–83.

Brian Madigan, 'Van Eyck's Illuminated Carafe', *Journal of the Warburg and Courtauld Institutes*, XLIX (1984), pp. 227–30.

R. Maere, 'Over het Afbeelden van bestaande Gebouwen in het Schilderwerk van Vlaamsche Primitieven', *De Kunst der Nederlanden*, I (1930–31), pp. 201–12.

James Marrow, 'Symbol and Meaning in Northern European Art of the Late Middle Ages and Early Renaissance', *Simiolus*, XVI (1986), pp. 150–69.

Henri Martin and Ph. Laner, *Les Principaux Manuscrits à peintures de la Bibliothèque de L'Arsenal à Paris* (Paris, 1929).

Antonin Matějček and Jaroslav Pešina, *Czeck Gothic Painting, 1350–1450* (Prague, 1950).

Anneliese Mayer-Meintschel, *Niederländische Malerei 15. und 16. Jahrhundert* (Dresden, 1966).

Millard Meiss, '"Highlands" in the Lowlands, Jan van Eyck, the Master of Flémalle and the Franco-Italian Tradition', *Gazette des Beaux-Arts*, n.s. 6, LVII (1961), pp. 273–314.

——, 'Light as Form and Symbol in Some Fifteenth Century Paintings', *Art Bulletin*, XXVII (1945), pp. 175–81.

——, '"Nicolas Albergati" and the Chronology of Jan van Eyck's Portraits', *Burlington Magazine*, XCIV (1952), pp. 132–44.

Henner Menz, 'Zur Freilegung einer Inschrift auf dem Eyck-altar des Dresdener Gemäldegalerie', *Jahrbuch der Staatliche Kunstsammlungen Dresden* (1959), pp. 28–29.

Edouard Michel, *Musée du Louvre, Département des peintures, Catalogue raisonné des peintures du moyen âge, de la renaissance et des temps modernes: Peintures flamands du XVe et du XVIe siècle* (Paris, 1953).

Pierre Michaud-Quantin, *Sommes de casuistique et manuels de confession au moyen âge (XII–XVI siècles)* Louvain, 1962).

Hans J. van Miegroet, 'Gerard David's *Justice of Cambyses: exemptum justiciae* or political allegory?', *Simiolus*, XVIII (1988), pp. 116–33.

Leon Mirot, 'Les Cenames (Études Lucquoises, IV)', *Bibliothèque de l'École des Chartes*, XCI (1930), pp. 100–68.

Leon Mirot and Eugenio Lazzareschi, 'Un Mercante di Lucca in Fiandra – Giovanni Arnolfini', *Bolletino Storico Lucchese*, XII (1940), pp. 81–105.

E. de Moreau, 'Les Familiers des ducs de Bourgogne dans les canonicats des anciens Pays-bas', *Miscellanea Historica in honorem Leonis van der Essen* (Brussels, 1947), pp. 429–37.

——, *Histoire de l'Église en Belgique*, IV [L'Église aux Pays-Bas sous les ducs de Bourgogne et Charles Quint, 1378-1559] (Brussels, 1949).

D. A. Mougel, *Denys le Chartreux* (Montreuil, 1896).

E. James Mundy, *Painting in Bruges, 1470–1550: An Annotated Bibliography* (Boston, 1985).

John H. Munro: 'Economic Depression and the Arts in the Fifteenth-Century Low Countries', *Renaissance and Reformation*, VII (1983), pp. 235–50.

Lawrence Naftulin, 'A Note on the Iconography of the van der Paele Madonna', *Oud-Holland*, LXXXVI (1971), pp. 3–8.

Stephen G. Nichols, review of B. Stock, *The Implications*

of Literacy in *Speculum*, LXI (1986), pp. 208–13.

Ursula Nilgen, 'The Epiphany and the Eucharist: On the Interpretation of Eucharistic Motifs in Medieval Epiphany Scenes', *Art Bulletin*, XLIX (1967), pp. 311–16.

Heiko A. Oberman, 'Fourteenth-Century Religious Thought: A Premature Profile', *Speculum*, LIII (1978), pp. 80–93.

——, 'Some Notes on the Theology of Nominalism, with Attention to its Relation to the Renaissance', *Harvard Theological Review*, LIII (1960), pp. 47–76.

Carra Ferguson O'Meara, 'Isabella of Portugal as the Virgin in Jan van Eyck's Washington Annunciation', *Gazette des Beaux-Arts*, n.s. 6, XCVII (1981), pp. 99–103.

Onze Lieve Vrouw Oorzaak Onzer Blijdschap, Causa Nostrae Laetitiae (Tongeren, 1979).

J. C. Opstelten, 'De Miskende St Joris van Jan van Eyck', *Oud-Holland*, LXXX (1966), pp. 107–10.

Iris Origo, *The Merchant of Prato: Francesco di Marco Datini* (New York, 1957).

Otto Pächt, 'The "Avignon Diptych" and its Eastern Ancestry', *De Artibus Opuscula XL, Essays in Honor of Erwin Panofsky*, ed. M. Meiss (New York, 1961), pp. 402–21.

——, 'Panofsky's "Early Netherlandish Painting" – II', *Burlington Magazine*, XCVIII (1956), pp. 267–79.

——, 'René d'Anjou et les van Eyck', *Cahiers de l'Association Internationale des Études Françaises*, VIII (1965), pp. 41–67.

——, 'René d'Anjou Studien, II', *Jahrbuch der Kunsthistorischen Sammlungen in Wien*, LXXXIII (1977), pp. 7–106.

Erwin Panofsky, *Abbot Suger on the Abbey Church of St Denis and its Art Treasures*; 2nd edn by G. Panofsky-Soergel (Princeton, 1979).

——, *Early Netherlandish Painting*, 2 vols (Cambridge, Mass, 1953).

——, 'The Friedsam Annunciation and the Problem of the Ghent Altarpiece', *Art Bulletin*, XVII (1935), pp. 433–473.

——, *Gothic Architecture and Scholasticism* (New York, 1957).

——, 'Jan van Eyck's Arnolfini Portrait', *Burlington Magazine*, LXIV (1934), pp. 117–27.

——, *Studies in Iconology: Humanistic Themes in the Art of the Renaissance* (New York, 1939).

Richard J. Parmentier, *The Sacred Remains: Myth, History and Polity in Belau* (Chicago, 1987).

Lee Patterson, 'On the Margin: Postmodernism, Ironic History, and Medieval Studies', *Speculum*, LXV (1990), pp. 87–108.

Jaroslav Pelikan, *The Christian Tradition*, IV [Reformation of Church and Dogma, 1300–1700] (Chicago, 1984).

Arsene Perier, *Un Chancelier au XVe siècle, Nicolas Rolin, 1380–1461* (Paris, 1904).

Les Pétites Prières de Renée de France, pref. F. Carta and G. Bertoni, 3rd edn (Modena, 1920).

Lotte Brand Philip, *The Ghent Altarpiece and the Art of*

Jan van Eyck (Princeton, 1971).

Paul Philippot, 'Les Grisailles et les degrès de realités', *Bulletin des Musées Royaux des Beaux-Arts de Belgique, Bruxelles*, XV (1966), pp. 225–42.

Henri Pirenne, 'Nicolas Rolin', *Biographie Nationale de Belgique*, XIX (Brussels, 1907), cols 828–39.

Walter Prevenier and Wim Blockmans, *The Burgundian Netherlands* (Cambridge, 1986).

Carol J. Purtle, *The Marian Paintings of Jan van Eyck* (Princeton, 1982).

Francis Rapp, *L'Eglise et la vie religieuse en Occident à la fin du Moyen Age* (Paris, 1971).

——, 'Les Pèlerinages dans la vie religieuse de l'Occident médiéval aux XIVe et XVe siècles', *Les Pèlerinages de l'antiquité biblique et classique à l'occident médiéval*, ed. F. Raphael *et al.* (Paris, 1973), pp. 117–60.

M. Restle, 'Eleousa', *Lexikon der Marienkunde*, I (Regensburg, 1967), cols 1550–54.

E. K. J. Reznicek, 'Realism as a "Side Road or Byway" in Dutch Art', *Studies in Western Art, Acts of the 20th International Congress of the History of Art*, ed. M. Meiss, II (Princeton, 1963), pp. 247–53.

Karl Richstaetter, *Illustrious Friends of the Sacred Heart of Jesus*, trans. M. E. Merriman (London, 1930).

——, *Medieval Devotions to the Sacred Heart* (London, 1925).

J. H. A. de Ridder, 'Gerechtigheidstafeleren in de 15de en de 16de eeuw, geschilderd voor schepenhuizen in Vlaanderen', *Gentse Bijdragen tot de Kunstgeschiedenis*, XXV (1979/80), pp. 42–62.

Sixten Ringbom, 'Devotional Images and Imaginative Devotions: Notes on the Place of Art in Late Medieval Private Piety', *Gazette des Beaux-Arts*, n.s. 6, LXXIII (1969), pp. 159–70.

——, *Icon to Narrative: The Rise of the Dramatic Close-up in Fifteenth-Century Devotional Painting* (Abo, 1965).

——, '*Marie in Sole* and the Virgin of the Rosary', *Journal of the Warburg and Courtauld Institutes*, XXV (1962), pp. 326–30.

Heinz Roosen-Runge, *Die Rolin-Madonna des Jan van Eyck, Form und Inhalt* (Weisbaden, 1972).

James J. Rorimer, *The Hours of Jeanne d'Evreux, Queen of France* (New York, 1957).

Helen Rosenau, 'Some English Influences on Jan van Eyck', *Apollo*, XXXVI (1942), pp. 125–28.

Theodore Rousseau, 'A Flemish Altarpiece from Spain', *Metropolitan Museum of Art Bulletin*, IX (1950), pp. 270–83.

Beryl Rowland, *Animals with Human Faces* (Knoxville, 1973).

Peter Schabacker, '*De Matrimonio ad Morganaticum contracto*: Jan van Eyck's "Arnolfini" Portrait Reconsidered', *Art Quarterly*, XXXV (1972), pp. 375–98.

——, 'Notes on the Biography of Robert Campin', *Mededelingen van de Koninklijke Academie voor Wetenschappen, Letteren en Schone Kunsten van België, Klasse der Schone Kunsten*, XLI (1980), pp. 3–14.

Meyer Schapiro, 'The Aesthetic Attitude in Romanesque Art', *Romanesque Art* (New York, 1977), pp. 1–27 (originally published in *Art and Thought – Issued in*

Honor of Dr Ananda K. Coomaraswamy on the Occasion of His Seventieth Birthday, ed. K. Bharantha Iyer [London, 1947], pp. 130–50).

——, '"Muscipula Diaboli," the Symbolism of the Mérode Altarpiece', *Art Bulletin*, XXVII (1945), pp. 182–87.

R. W. Scheller, '"Als ich can"' *Oud-Holland*, LXXXIII (1968), pp. 135–39.

Otto Schmitt, 'Ablass', *Reallexikon zur Deutschen Kunstgeschichte*, I (Stuttgart, 1937), cols 78–81.

Wilhelm Schreiber, *Handbuch der Holz- und Metal-laschnitte des XV. Jahrhunderts*, IV (Leipzig, 1927).

Peter Schwarzmann, 'La Ville de Stein am Rhein à l'arrière-plan dans "La Vierge au Chancelier Rolin" de van Eyck?' *Gazette des Beaux-Arts*, n.s. 6, CXV (1990), pp. 104–08.

Heinrich Schwarz, 'The Mirror of the Artist and the Mirror of the Devout', *Studies in the History of Art, Dedicated to William A. Suida on his Eightieth Birthay* (London, 1959), pp. 90–105.

Wenceslaus Sebastian, 'The Controversy over the Immaculate Conception from after Scotus to the End of the Eighteenth Century', *The Dogma of the Immaculate Conception: History and Significance*, ed. E. D. O'Connor (Notre Dame, 1958), pp. 213–70.

Alan Shestack, *Master E.S.: Five Hundredth Anniversary Exhibition* (Philadelphia, 1967).

Larry Silver, 'Fountain and Source: A Rediscovered Eyckian Icon', *Pantheon*, XLI (1983), pp. 95–104.

——, 'The State of Research in Northern European Art of the Renaissance Era', *Art Bulletin*, LXVIII (1986), pp. 518–35.

Otto G. von Simson, '*Compassio* and *Co-redemptio* in Roger van der Weyden's *Descent from the Cross*', *Art Bulletin*, XXXV (1953), pp. 9–16.

A. Mark Smith, 'Knowing Things Inside Out: The Scientific Revolution from a Medieval Perspective', *American Historical Review*, XCV (1990), pp. 726–44.

Jeffrey Chipps Smith, *The Artistic Patronage of Philip the Good, Duke of Burgundy (1419–1467)* (PhD dissertation, Columbia University, 1979).

Molly Teasdale Smith, 'On the Donor of Jan van Eyck's Rolin Madonna', *Gesta*, XX (1981), pp. 273–79.

——, 'The Use of Grisaille as a Lenten Observance', *Marsyas*, VIII (1957–59), pp. 43–54.

James Snyder, 'The Chronology of Jan van Eyck's Paintings', *Album Amicorum J. G. van Gelder*, ed. J. Bruyn, J. A. Emmens, E. de Jongh and D. P. Snoep (The Hague, 1973), pp. 293–97.

——, 'Jan van Eyck and the Madonna of Chancellor Nicolas Rolin', *Oud-Holland*, LXXXII (1967), pp. 163–71.

——, 'Jan van Eyck and Adam's Apples', *Art Bulletin*, LVIII (1976), pp. 511–15.

——, *Northern Renaissance Art* (New York, 1985).

Micheline Sonkes, 'Le Dessin sous-jacent chez Roger van der Weyden et le problème de la personalité du Maître de Flémalle', *Bulletin de l'Institut Royal du Patrimoine Artistique, Bruxelles*, XIII (1971–72), pp. 161–205.

Dan Sperber, *On Anthropological Knowledge* (Cambridge, 1985).

H. Stalpaert, *Bruggse devotieprenten van Onze-Lieve-Vrouw* (Sint-Andries, 1976).

G. Stam, 'Souvenirs uit heiligen plaatsen', *Vroomheid per dozijn* (Utrecht, 1982), pp. 7–11.

Wolfgang Stechow, *Northern Renaissance Art, 1400–1600: Sources and Documents* (Englewood Cliffs, N.J., 1966).

Leo Steinberg, *The Sexuality of Christ in Renaissance Art and Modern Oblivion* (New York, 1983).

Charles Sterling, 'Études Savoyardes I: Au temps de duc Amédée', *L'Oeil*, CLXXVIII (1969), pp. 2–13.

——, 'Jan van Eyck avant 1432', *Revue de l'Art*, XXXIII (1976), pp. 7–82.

Josef Stierli, 'Devotion to the Sacred Heart from the End of Patristic Times down to St Margaret Mary', *Heart of the Savior: A Symposium on Devotion to the Sacred Heart*, ed. J. Stierli (New York, 1958), pp. 59–108.

Brian Stock, *The Implications of Literacy: Written Language and Models of Interpretation in the Eleventh and Twelfth Centuries* (Princeton, 1983).

Lawrence Stone, 'The Revival of Narrative: Reflections on a New Old History', *Past and Present*, LXXXV (1975), pp. 3–24.

E. I. Strubbe, 'Een episode uit het leven van Giovanni Arnolfini', *Handelingen van het Genootschap voor Geschiedenis, Société d'Émulation*, LXXXIX (1952), pp. 67–81.

Jonathan Sumption, *Pilgrimage: An Idea of Medieval Religion* (London, 1975).

Johannes Taubert, 'Beobachtungen zum schöpferisches Arbeitsprozess bei einigen altniederländischen malern', *Nederlands Kunsthistorisch Jaarboek*, XXVI (1975), pp. 41–72.

Thomas N. Tentler, *Sin and Confession on the Eve of the Reformation* (Princeton, 1977).

Rudolf Terner, 'Bemerkungen zur Madonna des kanonikus van der Paele', *Zeitschrift für Kunstgeschichte*, XLII (1979), pp. 83–91.

Keith Thomas, *Religion and the Decline of Magic* (New York, 1971).

E. P. Thompson, 'Anthropology and the Discipline of Historical Context', *Midland History*, I (1972), pp. 41–55.

Samuel Tolkowsky, *Hesperides: A History of the Culture and Use of Citrus Fruits* (London, 1938).

Jacques Toussaert, *Le Sentiment religieux en Flandre à la fin du Moyen Age* (Paris, 1963).

J. Toussaint, 'Philippe le Bon et le Concile de Bâle (1431–1449)', *Bulletin de la Commision Royale d'Histoire, Académie Royale de Belgique, Bruxelles*, CVII (1942), pp. 1–126.

Richard C. Trexler, 'Florentine Religious Experience: The Sacred Image', *Studies in the Renaissance*, XIX (1972), pp. 7–41.

——, 'Reverence and Profanity in the Study of Early Modern Religion', *Religion and Society in Early Modern Europe 1500–1800*, ed. K. von Greyerz (London,

1984), pp. 245–69.

Georg Troescher, 'Die Pilgerfahrt des Robert Campin, Altniederländische und südwestdeutsche Maler in südostfrankreich', *Jahrbuch der Berliner Museen*, IX (1967), pp. 100–34.

Victor Turner and Edith Turner, *Image and Pilgrimage in Christian Culture: Anthropological Perspectives* (New York, 1978).

G. Valat, 'Nicolas Rolin, chancelier de Bourgogne', *Memoires de la Société eduenne, Autun*, n.s. XL (1912), pp. 73–145; XLI (1913), pp. 1–73; and XLII (1914), pp. 54–148.

Paul Vandenbroeck, *Catalogus Schilderijen 14e en 15e eeuw* (Antwerp, 1985).

Richard Vaughan, *Philip the Good: The Apogee of Burgundy* (London, 1970).

——, *Valois Burgundy* (London, 1975).

R. van de Ven, 'Het boek bedrijf te Diest gedeurende de 15de en 16de eeuw', *Handschriften uit Diestse kerken en kloosters*, exhibition catalogue (Diest, 1983), pp. 13–29.

Valentin Vermeersch, *Grafmonumenten te Brugge voor 1578*, 2 vols (Bruges, 1978).

Nicole Veronée-Verhaegen, *L'Hôtel Dieu de Beaune* [Les primitifs flamands I, Corpus de la peinture 13] (Brussels, 1973).

A. Viaene, 'Het Grafpaneel van Kanunnik van der Paele', *Biekorf*, LXVI (1965), pp. 257–64.

A. Vogt, 'Florence, Concile de', *Dictionnaire de Théologie Catholique*, VI (Paris, 1920), cols 24–50.

Jacobus de Voragine, *The Golden Legend*, trans. and adapted by G. Ryan and H. Rippenberger (New York, 1941; repr. New York, 1969).

A. J. L. van de Walle, *Gothic Art in Belgium*, trans. J. A. Kennedy (Brussels, 1971).

John Ward, 'Hidden Symbolism in Jan van Eyck's Annunciations', *Art Bulletin*, LVII (1975), pp. 196–220.

W. H. J. Weale, *Hubert and Jan van Eyck: Their Life and Work* (London, 1908).

——, 'Inventaire des Chartes et Documents appartenant aux Archives de la Corporation de Saint Luc et Saint Eloi à Bruges', *Le Beffroi*, I (1863), pp. 210–22.

Uwe Westfehling and Schnutgen-Museum der Stadt Köln, *Die Messe Gregors des Grossen, Vision-Kunst-Realität* (Cologne, 1982).

Edward Westermarck, *The History of Human Marriage*, 3 vols (London, 1921; repr. New York, 1971).

John White, *The Birth and Rebirth of Pictorial Space*, 3rd edn (London, 1987).

Eithne Wilkins, *The Rose-Garden Game* (London, 1969).

Charity Cannon Willard, 'The Concept of True Nobility at the Burgundian Court', *Studies in the Renaissance*, XIV (1967), pp. 33–48.

Karl-August Wirth, 'Eleousa', *Reallexikon zur Deutschen Kunstgeschichte*, IV (Stuttgart, 1958), cols 1297–1307.

J. E. Ziegler, 'The Medieval Virgin as Object: Art or Anthropology?', *Historical Reflections*, XVI (1989), pp. 251–64.

Charles Zika, 'Hosts, Processions and Pilgrimages: Controlling the Sacred in Fifteenth-Century Germany', *Past and Present*, CXVIII (1988), pp. 25–64.

T. C. Price Zimmermann, 'Confession and Autobiography in the Early Renaissance', *Renaissance Studies in Honor of Hans Baron*, ed. A. Molho and J. Tedeschi (Dekalb, Ill., 1971), pp. 123–40.

Monika Zülicke-Laube, 'Die "flandrische Manier" und die Entdeckung der bürgerlichen Welt der Städte', *Wissenschaftliche Zeitschrift der Karl-Marx-Universität Leipzig*, XII (1963), pp. 429–44.

List of Illustrations

All measurements are in centimetres.

Index